PARIS PRIMITIVE

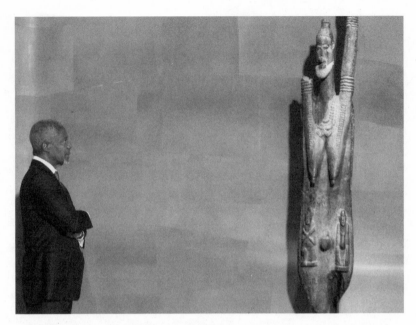

UN Secretary General Kofi Annan contemplates a "pre-Dogon" statue at the Musée du Quai Branly, June 2006. AP Images/Francois Mori.

The University of Chicago Press CHICAGO & LONDON

PARIS PRIMITIVE

Jacques Chirac's Museum on the Quai Branly

SALLY PRICE

SALLY PRICE divides her time between the United States (where she is the Duane A. and Virginia S. Dittman Professor of American Studies and Anthropology at the College of William and Mary) and Martinique (which serves as her base for research and writing). Her books include *Primitive Art in Civilized Places* (also published by the Press) and, most recently, *Romare Bearden: The Caribbean Dimension* (coauthored with Richard Price).

The University of Chicago Press, Chicago 60637
The University of Chicago Press, Ltd., London
© 2007 by Sally Price
All rights reserved. Published 2007
Printed in the United States of America

16 15 14 13 12 11 10 09 08 07 1 2 3 4 5

ISBN-13: 978-0-226-68068-2 (cloth)
ISBN-10: 0-226-68068-1 (cloth)
ISBN-13: 978-0-226-68070-5 (paper)
ISBN-10: 0-226-68070-3 (paper)

Library of Congress Cataloging-in-Publication Data

Price, Sally.
 Paris primitive: Jacques Chirac's museum on the Quai Branly / Sally Price.
 p. cm.
 Includes bibliographical references.
 ISBN-13: 978-0-226-68068-2 (cloth: alk. paper)
 ISBN-10: 0-226-68068-1 (cloth: alk. paper)
 ISBN-13: 978-0-226-68070-5 (pbk.: alk. paper)
 ISBN-10: 0-226-68070-3 (pbk.: alk. paper) 1. Musée du quai Branly—History. 2. Ethnological museums and collections—France—Paris—History. 3. Ethnology—France—History. 4. France—Social life and customs. I. Title.
GN36.F82P3756 2007
069.0944'361—dc22
 2007011572

♾ The paper used in this publication meets the minimum requirements of the American National Standard for Information Sciences—Permanence of Paper for Printed Library Materials, ANSI Z39.48-1992.

Contents

tinents, the arts of pre-conquest eras, or any other homogenizing gloss, they are—in the contexts that form the focus of this book—being envisioned, presented, and interpreted by their promoters as a class of artistic production that coheres on the basis of some shared characteristic. Were this not the case, there would be no need to group them in a special museum. No need to gloss them with a term, no matter how sensitively chosen. And no need to raise the issues that lie at the heart of this book. What characteristic, after all, could be claimed to unify them? Certainly not geography, since they were made in every part of the globe, from Alaska to Australia, from Guinea to Guyana, from Mexico to Malaysia. Nor could we justify grouping them in terms of historical period, since they date from prehistoric times to the present, with everything in between. And social or cultural factors don't work either, since they span thousands and thousands of highly distinctive religions, kinship systems, forms of political organization, and economic niches in the world. The argument has sometimes been made that what unites these arts is their original role as instruments of ritual, but in that case we would have to include much of Italian Renaissance art in the package.

As others have noted, what is in fact shared by the objects under discussion here is that they (or rather their makers) have been cast by both Western traditions of scholarship and Western "commonsense" thinking as dramatically Other and, yes, Primitive—whether on grounds of religion, technology, literacy, barefootedness, or some other dimension of their lives. With apologies to politically correctified readers who cringe at the words "primitive art," I have decided not always to avoid the term when I am alluding to the object of this gaze. The fact that it is awkward and jarring makes it especially appropriate, in my view, for a discussion of attitudes toward the extremely varied arts that it has been used to embrace. After all, the gay community's appropriation of the word "queer" shows how effectively a word can be turned into mordant defiance of its original connotations.

Note Also That . . .

Budgetary figures are quoted in francs, euros, or dollars, depending on the date and the source. In the decade 1992–2002, the franc varied in value between 13 and 21 U.S. cents. In 2002 the euro was put into circulation at a rate of 6.56 francs/euro. As this book goes to press, a euro is worth about US$1.30.

Unless otherwise indicated, all translations in this book are my own.

Opening Notes

One on Museum Names

Writing in English about institutions whose proper names are in French, I have allowed myself stylistic discretion about whether to use the French or an English equivalent in particular contexts. I sometimes refer to the Musée de la Marine, for example, as the Naval Museum. For similar reasons there are places where I follow the common French practice of using acronyms, referring to the Musée National des Arts d'Afrique et d'Océanie as the MNAAO or MAAO, the Musée de l'Homme as the MH, and the Musée National des Arts et Traditions Populaires as the MNATP. Paris's newest museum, which opened in June 2006 and forms the centerpiece of this book, is the Musée du Quai Branly, or MQB. Finally, while in French texts the capitalization of these names varies, I have used the standard English convention—for example, the museum that appears in my sources both as the musée du Louvre and the Musée du Louvre takes its fully capitalized form in this book.

And Another on "Primitive Art"

Terminology presents a dilemma. I balk at the idea of settling on a euphemism for "primitive art," as if that could legitimize the category, sanitize its legacy, and satisfy the exigencies of the politically correct. Whether the arts in question are promoted as "*art nègre*," "tribal arts," the arts of certain con-

Where to Begin

This is a story, one of many possible narratives, of primitive art in Paris . . . and therefore in France. Where shall we set the opening scene?

A nearly sacred tradition places it in front of exhibit cases in the Trocadéro Museum of Ethnography, with the young Pablo Picasso playing the starring role. That encounter between artist and African masks in the dust and clutter of an anthropology museum triggers a decisive turn in the history of art as we know it. Its emblematic image is *Les Demoiselles d'Avignon,* and its legacy is nothing less than a revolutionary, and multifaceted, reconceptualization of artistic creativity that is to dominate the entire twentieth century.

But there are other possibilities. We could eschew the connection with "modern art" in favor of a longer-range art history, focusing on ethnographic collections first exhibited in, and then exiled from, the Louvre. That would take us all the way back to 1830, when artifacts of ethnographic interest collected by early explorers were displayed in a section of the Louvre palace known as the Musée Dauphin. That beginning replaces a story that belongs to the history of modern art with one that turns on a more museological question: How did these objects come to be exhibited in the halls of the Louvre in the early nineteenth century, where had they gone by the early twentieth, and what brought a select few of them back again in 2000?

Or we could begin at a midpoint in that story, in 1920, when an "anarchist

art critic," Félix Fénéon (1861–1944), published with great fanfare a controversial plea to have "remote arts" granted admission to "the grandest museum in the world."[1]

In fact, we wouldn't even have to launch the story in Paris. The opening scene could instead be set in 1943 New York, where a young French anthropologist named Claude Lévi-Strauss, fleeing persecution as a Jew, stands before a Northwest Coast Indian exhibit at the American Museum of Natural History and dreams of one day seeing such objects stand shoulder to shoulder with the most universally acknowledged masterpieces of world art.[2]

In the intervals between these various beginnings, we bump into other distinguished figures. There's poet and art critic Guillaume Apollinaire, who as early as 1909 proposed admitting to the Louvre "certain exotic masterpieces whose effect is no less moving than that of beautiful specimens of Western statuary."[3] Or art dealer Paul Guillaume, who wrote, "Because no other art has exerted such a direct influence on the plastic arts of our era, *art nègre* will gain entrance to the Louvre as a necessary explanation."[4] There are the contributors to a 1954 issue of *Le Musée Vivant* devoted to the question "Will *art nègre* go to the Louvre?"[5] And there's André Malraux—writer, public intellectual, and France's first minister of culture—who in 1976 advocated the Louvre's embrace of what he was calling "*arts primordiaux.*"[6]

However it's told, this is a story that belongs to a society in which politics, intellectual life, and the art world flow seamlessly together, in which the State maintains tight control over things cultural, and in which museums are key instruments in the power plays of creative and ambitious men.[7] A story of relationships between men and objects, it's a story that turns equally on personal relationships between the men themselves.

I begin, then, not with historical antecedents (there will be time to get back to them), but with a more recent meeting between two pivotal players—an event that glows with the radiance of a Primal Moment for recognition of the arts in question.

The Primal Moment

. . . has been documented as taking place in 1990 at the Royal Palm Hotel in Mauritius, in the Indian Ocean.

Jacques Chirac was no longer prime minister and not yet president of the Republic. According to one version of the story, he had, in his role as mayor of Paris, flown to Mauritius to preside over a major conference on *francophonie* (cultural issues involving the French-speaking world beyond continental France).[1] Others say he was just on vacation (relaxing, as he liked to put it, "with toes fanned out")[2] and note that the elegant Royal Palm Hotel was his favorite vacation destination.[3]

We can assume that he was not put up in any of the fifty-seven Junior Suites, four Tropical Suites, seven Palm Suites, three Garden Suites, or eight Senior Suites (the French have always been good at classification). Perhaps he didn't even stay in the Penthouse. And although he might have been quite comfortable in one of the hotel's three Presidential Suites (each spread out over 264 square meters and boasting abundant luxuries), one could also imagine him having his bags unpacked in the more spacious Royal Suite, a two-story accommodation "regularly used by members of State and royalty for maximum privacy" and equipped with a private garden, terrace, pool, and butler.[4]

"The magnificent Royal Palm is, unquestionably, one of the world's finest hotels . . . set in a breathtaking location, on the northern shores of Mauritius, this truly enchanting hotel is the epitome of understated luxury and classical elegance. The service (with a staff-to-guest ratio of three to one) is simply unparalleled. Attentive, yet highly discreet, the warm and gracious staff are there to satisfy your every whim and desire. . . . Personal valet service in each suite ensures you need not lift a finger to unpack. . . . Each suite is set within abundant tropical gardens, and enjoys views towards the calm crystal waters of Grand Baie, offering stunning views of the soft powder-white, palm-fringed beach and the azure blue lagoon beyond. The famed Royal Suite is unrivalled in its sumptuous opulence. One of its two grand bathrooms boasts its own hamman [Turkish bath] and outside you'll find your own private infinity pool."[8]

With the Royal Suite occupied, the second Jacques in this drama might (still in my imagination) have slept in one of the Presidential Suites. Unlike Chirac, who sometimes came to the hotel on official State business, art dealer Jacques Kerchache was in Mauritius on vacation—"a tourist sporting *la barbe à la Gainsbourg et lunettes d'intello*," as one journalist described him.[5] A "Gainsbourg beard," not easily translated with its connotations intact, alludes to singer/actor/director Serge Gainsbourg (1928–1991), a French culture hero and "the dirty mouth of French pop" whose perpetual three-day growth was part of his carefully cultivated "cig-dangling-from-lips, lecherous persona"[6]—a self-presentation that fit well with the lyrics of his songs, which were banned in at least five European countries and vehemently condemned by the Vatican. The comparison must have pleased Kerchache, who loved being called a French Indiana Jones[7] and was rarely without a cigarette. And the thin-rimmed "intello's glasses" that he wore reinforced the eccentric image that he cultivated, reminding us that his life story paralleled, in certain ways, that of André Malraux, both of them having, for example, spent time in prison (one in Gabon, one in Cambodia) for activities that fell under the legal definition of art theft.

Did the two Jacques meet poolside? In one of the gourmet restaurants? Working out in the gym? We are not told. As Kerchache described the encounter, he walked up to the Paris mayor "out of the blue," having seen a magazine photo of him in which the book he (Kerchache) had coauthored on African sculpture was lying on the desk. "That thick book published by Mazenod that's in the photo, was it part of a photo opportunity or are you really interested in the subject?" he blurts out. The mayor is said to have looked up in surprise, at which the tourist continues, "Allow me to introduce myself. I'm Jacques Kerchache." "Not only have I read that book," Chirac replies. "I also bought fifty copies of it to present as gifts to friends of mine."[9]

A journalist who's heard the story from Chirac offers a similar version of the conversation:

Chirac exclaims, "Ah! Kerchache! Your book, I've read it at least three times! What a pleasure to meet you!" And he invites him to lunch. The two men spend the rest of their vacation talking about African masks, pre-Columbian zemis, and Chinese mortuary figures, denouncing the colonialist prejudices of primitive art scholars, and discussing the relevance of aesthetic criteria for unsigned works of art in societies without writing. Chirac is in seventh heaven.[10]

Kerchache's version continues:

We spent the next two weeks talking from morning till night about the cultures of the world. And one day Chirac explains that the city of Paris—of which he was the mayor—was opposed to celebrating the 500th anniversary of Columbus's discovery of America because that would exclude the Indians. Right away, I'm proposing to do an exhibition centered on Indians of the Caribbean. "Ah, yes, the Taino, who speak an Arawakan language," he replied, just as naturally as could be. And then he opened up his secret garden to me, disclosing the extent of his knowledge and revealing to me convictions that fit perfectly with my own. Our friendship [complicité] was sealed. The Taino exhibit would stand as its testimony.[11]

Kerchache was in his late forties, a man who had "traveled the world on foot, on camelback, and in dugout canoes, from the Caribbean to Malaysia, and assembled a critical inventory of some ten thousand objects."[12] He'd also put together an impressive collection of exotic insects.[13] He was to enjoy a decade of friendship and collaboration with Chirac before succumbing to throat cancer during a trip to Mexico—he'd refused, up to the end, to make concessions to the disease. Some saw him as a kind of Rasputin or éminence grise.[14] For Chirac he was a personal soul mate, a fellow soldier in the war against cultural elitism, whether at a gala Paris museum opening or in the dust of a Central American archaeological excavation.[15] Their closeness, based heavily on their shared passion for art beyond the European orbit, was boundless. And it was as responsible as any single factor for bringing about the recent reshufflings in the Paris museum world and changes in the delicate relationship between traditional Euro-based art history and the works it once so unquestionably excluded.

We need, at this point, to know a bit more about each of them.

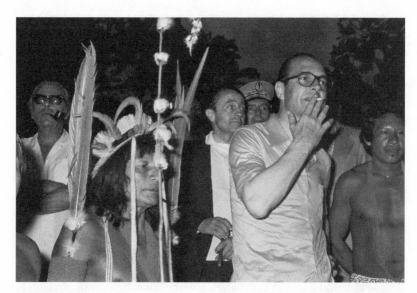

Jacques Chirac with Amerindians in Maripasoula, French Guiana, 1975. Photo: Henri Griffith.

The President's Secret Garden

For him, the Indian tribes of the Caribbean, gone today,
are as important as the men of the Italian Renaissance
or the eighteenth-century Austrian composers. . . .
Interested in every form of creativity, he's an avid reader
and a true lover of poetry. . . . His erudition is
incontestable.*

Sitting down for an interview in the 1980s, Jacques Chirac begins by declaring questions of an "intimate" nature off-limits.[1] There is to be no discussion, for example, of his marriage. But he talks freely of his parents and grandparents, and paints a nostalgic portrait of his childhood, describing himself as an only child, a late child, a spoiled child, and a mother's boy. His parents' first child, Jacqueline, the older sister he might have had, died before her second birthday, and Jacques wasn't born until a decade later.

> My mother was always very attentive to every aspect of my well-being. When I had homework to do, no one was allowed to make any noise in the house. If she had friends over, they were told not to make noise since it would bother the little one. At four o'clock she'd bring me a banana. . . . My parents were quite comfortable, without of course being wealthy. In their eyes nothing was too good for me.[2]

Chirac was born in Paris and attended its most prestigious schools, but looking back on his life, he portrays himself more as a country boy, pegging his personal identity to Corrèze—the sparsely populated *département*

*Philippe Madelin, *Jacques Chirac: Une biographie* (Paris: Flammarion, 2002), 796–97.

where his parents had grown up, best known for its cattle breeding, hydro-electric power, and modest level of industry. Although Chirac's childhood and early adulthood were spent in Paris, his political career (in the 1960s, 1970s, and even 1980s) was launched through positions in Corrèze. He served as a member of the municipal council of a provincial town there and was a member (and then chairman) of the Corrèze General Council. He also served as representative to the National Assembly for Corrèze until 1995, the year he became president of France.[3] And when it came time to establish a museum focused on his presidency (something along the lines of presidential libraries in the United States), it was built in Corrèze. In the mid-1980s, well into his life as a national figure, he claimed to feel ill at ease and even "allergic" to the high society and urban manners of the capital and boasted that during his six years as prime minister and ten years in government he'd gone to cocktail parties a total of only three or four times. "I don't dine out," he said. "And I don't frequent society people. These are not people I know."[4]

What he did always enjoy (still according to his self-portrait) were museums. As an adolescent he became fascinated with Asian art and archaeology and began hanging out in museums, developing a special affection for the Musée Guimet, France's museum of Asian art. A passion for foreign poetry and modern sculpture and painting soon followed. The chance to meet Fernand Léger and spend time in his studio ranks high in his reminiscences of his teenage years. By the time he was twenty, these interests had led him to serious study of philosophy and world religions, "Hinduism and Shintoism, picking up Buddhism along the way—the religions that left their mark on History."[5] A passionate aficionado of sumo wrestling, he continues even today to take time out to attend matches during his State visits to Japan. Indeed, it's sometimes hard to decide, from news reports in France, whether his trips to Japan are on State business with wrestling matches tagged on in his spare time, or the other way around.

Some accounts of his life expand the list of his early interests in cultures beyond the Hexagon to include African and Native American art. His Russian teacher, a Monsieur Delanovitch, is said to have nurtured his interest in the cultures of the Far East. And Georges Pompidou, known to discourse at length about the difference between Baule and Senufo masks, was a hero for Chirac, one of whose personal projects was to build a collection of books on the civilizations of the world—India, China, Japan, and beyond.

As a player on the national political scene, he initially preferred to keep these interests to himself. After all, one journalist muses, how was he to aspire to the presidency of the Republic if his indifference to Montaigne and

Julien Gracq, or his interest in Vishnu and Krishna, were to come to the attention of voters? Better to cultivate the image of someone who read mystery novels and listened to military marches. If François Mitterrand came across as a well-read mystic, Chirac claimed more the soul of an anthropologist, looking to the arts for explanations of the human condition, but judging from the great bulk of biographical material that has accumulated about his life, he was largely successful in keeping this side of his life out of his public persona as a political figure. Chirac's particular brand of cultural relativism has sometimes appeared to call into question sacred articles of faith in France. He has been known, for example, to hold forth on the idea that the conception of human rights in China, where Confucianism places Man as the servant of Society, cannot be expected to follow that in France, where Society is meant to be in the service of Man: "He says it," writes a journalist. "And he shocks."[6]

It seems to have been his friendship with Kerchache that allowed Chirac to work his fascination for world cultures into his political career. The Taino exhibit of 1994 was a key event in bringing it out of the closet, and he eventually began to draw on it more publicly. In February 1996 he dropped in unannounced at the Musée Guimet as a group of students from the École du Louvre were being lectured on the Jomon period in Japanese art. As the lecturer attempted to regain composure from this presidential surprise, Chirac sat down among the students, posing questions and expressing his passion for Japanese medicinal figures known as Dogous.[7] It has also been reported that in a State luncheon for the prime minister of Japan held shortly after France's resumption of nuclear tests in the Pacific, he managed to avoid engagement of that potentially explosive subject by leaning on his knowledge of Japanese history and culture, spending the meal in deep discussion with Ryutaro Hashimoto (Japan's minister of trade and industry who soon after became prime minister) about the meaning of the "bear's claw" ideogram in Japanese, followed by an equally intense debate about the reasons for the failure of the Mongol invasions of Japan in the late thirteenth century.[8] Stories are told, as well, about the invitations he received to deliver lectures on "erudite subjects" in Japan and the notes he provided for André Malraux when *Le Musée imaginaire* was being written.[9]

What, one might ask, are we to make of these anecdotes? Are they the apocryphal vignettes promoted by a world leader who wants to be appreciated for his scholarly astuteness? Was this "secret garden" being hidden from view in the interests of political viability? Was it being selectively leaked out for the same purpose? Or did it reflect a genuine immersion in cultural realities beyond the Hexagon? Because I believe the question is crucial to answer

if we are to understand developments in French museums in the early twenty-first century, I allow myself a digression here to consider the evidence.

During a trip to Paris in 2005 to do research for this book, I spoke with Marie Mauzé, coauthor of a book entitled *Arts premiers,* published in March 2000 to provide background for the new Louvre wing that was about to open in an area known as the Pavillon des Sessions.[10] She shared with me her file of correspondence, including an exchange of letters initiated by Jacques Chirac. The first letter congratulated the two authors for the clarity, erudition, and high visual quality of their book, declaring it a precious asset for visitors to the museum. Two weeks later a longer letter arrived. In it the president offered a reflection on the book's illustration of a headdress of quetzal plumes in the ethnographic museum of Vienna and the caption that identified it as "part of the treasures that Cortés received from the Aztec emperor Montezuma."[11] Remembering, the president wrote, that Montezuma and his predecessors traditionally wore a triangular diadem encrusted with turquoise, and finding no reliable data to suggest that Montezuma ever wore the type of headdress pictured in the book, might there not be some error? The letter continued:

> I therefore did a bit of research and actually went to Vienna, where I viewed the headdress, which is indeed very beautiful and of which I took a photo that I include with this letter. I have come to the conclusion that the plumed headdress did not figure among the gifts given by the Aztec sovereign to Hernan Cortés in 1519.
>
> I believe I can safely say that plumed headdresses of this sort belonged in reality to the costumes of the gods and that they were worn by priests who were embodying divinities. I believe one can say that hundreds of headdresses of this nature were in existence at the time and that tens of them were brought back to Europe.
>
> This hypothesis appears to be confirmed by the fact that the only extant example, which is today in Vienna, came from the private collection of a German nobleman of small fortune, the Count Ulrich de Montfort. Luckily, it was well preserved and cared for. It is therefore the only one to have survived over the centuries. Its uniqueness is probably the reason for its having been viewed in the 19th century as an imperial Aztec crown, which evidence proves to be a mistake.
>
> Research shows that the history of this headdress goes back to 1575. It is listed, along with other plumed objects, in the inventory of Count Ulrich de Montfort's collection as a "variety of plumed objects of Moorish confection." In 1590 the rest of the collection was bought by the Archduke Ferdinand

du Tyrol. His collection, under the name Ambraser, found its way to Vienna in the 19th century. This property of the Hapsburgs was then transferred in 1880 to the government and placed in the anthropology and ethnography department of the Natural History Museum of Vienna.

In 1928, the ethnographic collection of this department became the present-day Musée d'Ethnologie.

One can assert, it seems to me, that the plumed headdress was not brought from Spain to Austria by descendants of the Hapsburg family.[12]

The letter sparked a revision in the text. Between the first and second printing of *Arts premiers,* the authors replaced their original depiction of the headdress's history with the version favored by Chirac.

Having grown up in a country where presidents are more likely to be found in baseball stadiums than in museums of culture, and trained as a scholar to maintain a critical stance toward personal self-presentations, I was dubious that the president of the Republic would have taken time out from his official duties to research the attribution of a plumed headdress from sixteenth-century Mexico. I listened with raised eyebrows to Mauzé's assertion that she considered the letter to be the true fruit of Chirac's interest in such artifacts.

Over dinner a few days later with Philippe Descola, who holds the chair formerly occupied by Lévi-Strauss at the Collège de France, and Anne-Christine Taylor, who had recently become director of research and teaching for the Quai Branly Museum, I reported my skepticism about Chirac's Aztec research, and Descola offered an account of the one and only time he had spoken with the president. Summoned to the presidential palace for some minor and quickly handled matter, he was about to leave for a thesis defense, scheduled for an hour later, when Chirac began asking him, in his role as an Americanist, about details of the migration of Arawakan Indians to the Greater Antilles in the pre-Columbian period. Descola recounted how he kept looking at his watch, worrying about being late for the thesis defense, and how Chirac kept engaging him in conversation about the Arawak. For Descola (like Mauzé), the story about the president taking a real interest in the provenance of a plumed headdress was abundantly believable.

Others scoffed. Some found his lecture at the opening of the Taino exhibit both interminable and politically motivated, or cited with understandable derision the story that he had translated the entire œuvre of Pushkin from Russian and was preparing it for publication by Gallimard.[13] What was I to make of the president's claims about his research? A colleague who tipped me off to a forty-two-page booklet entitled *The Treasures of Montezuma:*

Fantasy and Reality[14] shed some interesting light on the matter. This publication, on sale for 5.45 euros in the Vienna museum shop in both German and English, refutes the widespread myth that the headdress in question belonged to Montezuma. Could Chirac have missed picking up a copy during a museum visit designed to answer this very question?

It was also possible, I realized, that he had taken his clue from the Internet, where a text posted on the museum's website explains: "Part of the fame of this artefact is due to the persistent rumour that this headdress once belonged to Montezuma, penultimate king of the Aztecs [but] research has shown that there are no proofs for this assumption," and goes on to recount how the Archduke Ferdinand of Tirol had probably bought it from Count Ulrich of Montfort.[15] Chirac's letter, however, which mentioned neither the booklet nor the website, gave no indication that the corrective research was other than his own.

Ultimately, there can be no doubt that the details of foreign cultures and their history are genuinely close to Jacques Chirac's heart and that he attends to them with some passion, even as he holds the rudder for the ship of State. But it seems equally certain that images of the president as a scholarly authority on non-Western cultures transports his reputation, like that of the plumed headdress, into the realm of myth.

The Passionate Connoisseur

Indefatigable traveler, driven by an insatiable curiosity,
sensitive and rapturous soul, free spirit and determined
character, he embraced the world for a half century with
the gaze of an artist and an enthusiasm inspired by the
poets. Jacques Kerchache was my friend.*

Like Jacques Chirac, Jacques Kerchache was a man of strong and undeterrable vision. Their friendship played itself out in terms of their mutual passion for the art and cultures of the world, but at another level, what Chirac admired in Kerchache had to have been something deeper and more personal—his powerful passions, unbridled bravura, unquestioned opinions, and aggressive determination. "I don't know what I loved most about him," Chirac has written, "the soundness of his vision, the force of his convictions, or his immense generosity. He approached life with passion and voluptuous pleasure. He realized his dreams with an exceptional obstinacy, overcoming all obstacles, galvanizing all energies."[1]

Before he met Chirac, Kerchache was known mainly to the relatively closed society of "primitive art" collectors in Paris. Exploring their world in the mid-1980s, I knew his name and heard bits of gossip about his ethics, but his reputation as an art dealer was not significantly different from that of many of his colleagues. The fact that one person I interviewed called him a "shark" did not seem particularly noteworthy, given other comments I was hearing about the profession. And when the head of the commission explor-

*Jacques Chirac, in *Jacques Kerchache: Portraits croisés,* edited by Martin Bethenod (Paris: Musée du Quai Branly/Gallimard, 2003), 6–7.

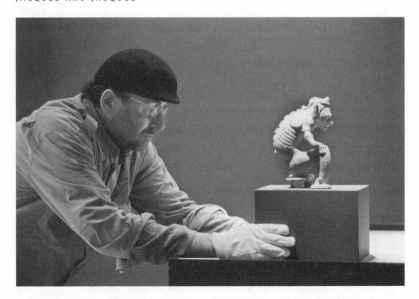

Jacques Kerchache preparing for the Taino exhibit at the Petit Palais, 1994. Photo: Sophie Anita, courtesy of Marine Degli.

ing greater exposure for primitive art in Paris museums later characterized him as "pugnacious, capable of the most extreme enthusiasms and the most virulent angers, and passionate to the point of intolerance,"[2] he was citing personal qualities not lacking, in lesser degrees, by many others in the field.

In 1990 Kerchache's highly mediatized campaign to exhibit masterpieces of primitive art in the Louvre and his alliance with Chirac, followed up by his coordination of the 1994 Taino exhibition, propelled him into prominent view, and he remained front and center, frequently interviewed in the press, until his death in 2001. A major volume published in his memory, *Jacques Kerchache: Portraits croisés,* assembles sixteen testimonies by people who knew him, a few excerpts from things he wrote, and lavish full-color photographs of his elegant 35,000-volume library,[3] in homage to his voracious appetite for collecting books. In many of the articles I've read about him, he assumes the mantle of a tragic figure, defiantly pushing aside the throat cancer that was to take first his voice and then his life just a year after being man of the hour at the inauguration of the Louvre's new wing, for which he had fought so hard.

A journalist who interviewed him a year before his death described him: "This Don Quixote, lankier and spindlier than ever, alive with irony behind those smoky glasses, and speaking in his wounded, almost inaudible voice, has the smile of someone who's just played a clever trick on destiny." Ker-

chache is boasting to him about his momentary triumphs over the cancer that had been attacking his body since 1975. "I fell ill after the Taino exhibit, but by some miracle I got better! Passion can really keep you going!" Asked for his life's story, Kerchache begins with memories of his grandparents, members of the Communist Party, and his grandmother's practice, every Sunday, of hanging a sign around her dog's neck that said "Ask for *l'Humanité,* mouthpiece of the Communist Party." His parents met, his story goes, in the factory in Paris where they had both been working thirteen- to fourteen-hour shifts since the age of fourteen. In 1936 they left for Spain to join the international brigades but soon returned to France, where their son was born in 1942.[4]

The grandmother's politics, the dog's sign, the factory shifts—we can't be sure which details to chalk up to his gift for storytelling. He was famous for the vivid stories of capturing butterflies in a "savage nighttime jungle" that contributed to his success in selling exotic insects he'd bought the day before at auction.[5]

When he was twelve, his widow Anne recounts,[6] the family returned to Spain on vacation, and it was in Toledo that the young Kerchache caught sight one day of his television hero, Max-Pol Fouchet, "the prototype of a man of passion who could talk about every culture in the world with the same enthusiasm, and without any hint of hierarchy."[7] Running up and announcing his "passionate admiration" for him, Kerchache gets his mother to invite Fouchet back to the hotel for a drink. Scheduled to return to France the next day, Fouchet changes his plans and spends the next three days taking Jacques around Toledo, showing him how to "see"—"everything from a bolt in a cathedral door to a painting by Picasso."

Kerchache clearly told the story a number of times, with some variation in the details. Another version[8] (perhaps referring to a later trip to Spain) had the two of them setting off for Madrid and the Prado, where the young apprentice was introduced to Bosch, Brueghel, Velázquez, and Goya, "knowing nothing, but overcome with passion" for what he was viewing. When asked whether he knows much about Picasso, the cocky teenager replies that he could "toss off four or five Picassos in a minute" but is quickly humbled by Fouchet, who sets up a "work schedule" for this boy who is becoming like a son to him. It's the beginning of an intensive

> Max-Pol Fouchet (1913–1980) was born in northwestern France but spent his teenage years and young adulthood in Algiers, where he worked as an assistant in a museum (laying the groundwork for his future as an art critic) and became a close friend of Albert Camus as well as other writers and artists. Poet, novelist, essayist, musicologist, and indefatigable traveler, he hosted long-standing programs in both radio and television, speaking on subjects that ranged from literature and art to contemporary social problems.[9]

period of reading everything he can get his hands on and taking in every museum exhibit in sight.

Artist Sam Szafran, another lifelong friend ("a little like my brother," says Kerchache), writes that when they first met, Kerchache was just sixteen, but he had already opened his first art gallery, thanks to the support of his parents. Anne Kerchache clarifies the story. Art dealer Iris Clert was having financial problems, and a friend of Jacques's parents agreed to pay the rent for six months in exchange for letting him take over her tiny gallery on weekends. Once the six months were over, Kerchache made a deal to use the profits from his sales toward the rent and was thus able to continue. Soon after that he opened a larger gallery of his own on the rue de Seine, where he remembered selling framed paintings for a mere 700 francs and tallying up sales at the end of an exhibition on the back of a beer coaster. On, then, to Cannes for his first "extramural" exhibit. His reminiscences continue: "Who should be the first two people who walk into that exhibit, but Picasso and Michel Leiris! I can still feel the three-ton weight of shaking the hand of the artist I admired the most in the whole world. . . . I hardly have to tell you that I didn't dare say a word! For me, studying Picasso should be a universal requirement, like learning English or history and geography." Like all good stories, the Cannes incident has variants. As Kerchache's wife heard it, Jacques was just fourteen when he spotted Picasso and ran up to him to shake his hand, after which he refused to wash his own hand for a week.[10]

Iris Clert arrived penniless in Paris from her native Greece and became active in the French Resistance during World War II. After opening "the smallest gallery in Paris" in 1956, her flamboyant character and theatrical exhibit openings gained her celebrity status as "the priestess of the artistic avant-garde" until financial difficulties and shifts in the art world effectively ended her reign. She died, "forgotten," in 1986.[12]

His collecting expeditions also began at an early age. In 1961 an art dealer landed him a job collecting art objects in Southeast Asia (India, Ceylon, Indonesia, Malaysia, Burma, Vietnam, and Thailand) and the first of his many trips to Africa came four years later. As he described his experiences, "I was able to take part in festivals, hunt with the young men, and have discussions with the elders. . . . [A]fter several months of immersion in the villages I would end up being accepted."[11] It was one of these sojourns among the natives that turned somewhat dicey.

After staying nine months in Gabon, the elders showed me some wells where missionaries had thrown a lot of reliquaries during the First World War. Most of them were in pieces. They told me to take whatever I wanted. I took back about twenty. There were only one or two of them in Europe, and when I exhibited them in my gallery it set off a minor revolution and provoked a lot of

jealousy. . . . When I returned to Gabon I was denounced because I hadn't declared them to customs. True, because I had no idea what forms I was supposed to fill out. I was under arrest for several days and then freed once I'd paid the exportation fees.[13]

Others have told the story a bit differently. According to Sam Szafran, Kerchache was imprisoned for six months in "horrifying" conditions and released, in extremely poor shape, only through the intervention of Robert Badinter, a politician who was later to serve as minister of justice under François Mitterrand.[14]

After closing the rue de Seine gallery in 1980, Kerchache spent the better part of the next nine years traveling the world from Mexico and South America to Turkey and Asia, but most frequently in Africa, where, he told a reporter, "I stayed entire nights with the old men, trying to understand the artistic system, . . . learning about the journey of initiation by which each artist is exposed to the expressive styles of other cultures."[15] His conclusion: that artists in non-Western societies undergo a long and arduous apprenticeship, and that many of them also occupy important positions in their society as priests, chiefs, kings, blacksmiths, or diviners, serving as intermediaries between visible and invisible worlds.[16] (We must assume that women are not part of the story.) His goal: a comprehensive critical inventory, to be posted on the Internet, of artworks from beyond the Western orbit. Preferring not to get tangled up in polemical quibbles over terminology, he avoided expressions such as *arts premiers,* talking simply of "statues," and indeed the great bulk of what fell within his purview was three-dimensional in form. By all accounts, he was driven by an obsessive missionary zeal, "turning the planet upside down in his relentless quest and plunging equally into museum storerooms and the venomous heart of jungles"[17] in his determination to record the arts of (as both he and Chirac put it) the three-quarters of the world's humanity that were unrepresented in the Louvre.

Kerchache assembled an impressively voluminous library with special strengths in African art, but his aesthetic judgment is portrayed by everyone who knew him as being based on visual contemplation of the forms themselves and an inherent, uncanny sense of quality rather than on reading or other forms of scholarship. His wife points out that his total lack of interest in school when he was a boy got him expelled a number of times for "insolence."[18] And Germain Viatte (the former director of Paris's Museum of Modern Art who became a central player in Chirac's plans for upgrading primitive art in Paris museums) has remarked that Kerchache "was not a prisoner of our professional and scientific assumptions."[19] Sam Szafran de-

scribes watching one day as Jacques's mother handed him a package containing an object his father had just brought back from a trip abroad. The young Kerchache is said to have taken it in his hands and, without even needing to remove it from its wrapping, declared with perfect confidence that it was "*de la merde*," a lowly piece of airport art. Once unwrapped, the object of course bore out the assessment he'd been able to make effortlessly with a quick touch of its form.[20]

Kerchache's reputation tested the boundary between creator and viewer, positioning him very close, in the perception of his friends, to artistic authorship of the pieces he singled out for approval: "It was as if Jacques was himself the sculptor. . . . I never considered him a dealer, but rather a creator." . . ."For me, it was as if he was himself the painter or creator." And descriptions of his relationship to art objects are shot through with emotion and physicality: "He had a sort of physical passion for the works, the most beautiful of which left him literally gasping for breath, on the verge of fainting or aphasia." Others writing in the book that commemorates Kerchache's life portray him in similar terms: "He derived an immense pleasure from touching the objects. . . . His relationship with the objects was much more physical than intellectual, based on a need to touch them, to manipulate them, to possess them. . . . He sometimes expressed his love for objects in physical terms; quite a few times I came upon him overcome with tears before certain masterpieces. . . . When I found him unpacking pieces [for an exhibit of Taino art], his eyes were welling up with tears, and he was caressing the objects in a state of profound joy. The idea of an unquestionable masterpiece that was so important to him was linked to climactic pleasure."[21] Or, as a close associate put it, "He liked to think of the art object as above all a body, something to be caressed with the hand and with the eye, imbued with a magical force, a soul in wood that was alive and quivering."[22] Kerchache himself remarked, "With African sculpture, you need to allow yourself to be invaded; you have to come close to it, frequent it, appropriate it, love it, give it time, open your sexuality to it."[23]

Although Kerchache was married and had two daughters, it is clear that his personal life was dominated by relationships with men. Except for an interview with his wife and a brief statement by a young artist who met him for the first time at the end of his life, all the contributions to the volume of "crisscrossing portraits" are by men—some of them art-world colleagues, others intimate friends, together creating an homage permeated with tender affection. Author and songwriter Jean-Pierre Lang, for example, describes meeting "Jackie" in a cabaret when they were both eighteen. "It was love at first sight. We were propelled into a friendship that made us much more than

brothers, more like Siamese twins. We were nearly inseparable, day and night, for years, sharing discoveries, intuitions, travels. We used to look for places on the map where there weren't any roads, and that's where we'd go." Producer Michel Propper met him at age fifteen when Kerchache was thirty. They saw each other frequently, and Kerchache took him on as a traveling companion and photographer for trips designed to fill in his inventory of world art, including an intensive three-month tour of museums throughout the United States and Canada in 1976 and another in Nicaragua in 1982. Jean-François Prat writes about meeting him when they were both twenty-five and participating in the social gatherings devoted to discussion of objects, not because he had any interest in primitive art, but solely out of friendship. Or again, Sam Szafran describes being integrated into the "total symbiotic trinity" of Jacques and his parents: "Jacques and I were as close as two brothers could be. A passionate relationship, marked sometimes by fallings-out that could be quite violent [but] a relationship of infinite tenderness, of true love."[24]

Journalists found Kerchache an intriguing figure and sometimes waxed rhapsodic about his life. One, for example, described it as "a story *à la Tintin*" (Tintin being the swashbuckling hero of a popular comic book series) and asserted that he was "more at home in jungles and swamps than in Parisian living rooms."[25]

Others who knew Kerchache saw him in a less flattering light, and the attacks on his honor were a constant thorn in his side. Charges of dishonesty, ethical baseness, and ruthlessness in his collecting methods and business dealings hounded him throughout his life, wounding him deeply. A writer for the newspaper *Libération* wrote that

> even within a profession that is not known for its saints, he has been accused of every act deserving of a hanging. Admittedly, taking masks from an African village or exporting Khmères as contraband didn't used to be considered so reprehensible. But in 1967 an exhibit of reliquaries in his gallery in Saint-Germain created a serious uproar from the authorities in Gabon. Kerchache was quick to respond by asserting that looting was a way of saving artworks from destruction, but that time he still had to return the reliquaries to their country of origin.[26]

A writer in *Le Monde* alluded to those for whom he was an "incarnation of the devil,"[27] and an article in *Le Point* noted that while some viewed him as a distinguished connoisseur, unrivaled in his knowledge, others considered him "an Indiana Jones given to playing fast and loose with objects in

questionable ways."[28] Kerchache's friends are unanimous in portraying him as a man dominated by a need to be in absolute, total control, but also as being relatively thin-skinned in the face of criticism. He saw himself as the victim of cruel and unjustifiable hounding by people jealous of his knowledge, his visible success, and his privileged relationship with the president. "I often saw him at the end of the day," wrote a friend, "totally beaten, and ready to abandon the whole project—which of course his courage would always prevent him from doing."[29] Art dealer Alain de Monbrison, who first knew Kerchache because their parents were close, has described his longtime friend as someone whose "passionate" relations with clients could swing between "fusion and rupture," and acknowledged that Kerchache had many detractors, "people who showed no hesitation in . . . reducing his remarkable career as a dealer to a matter of simple looting."[30]

Good-bye, Columbus

I have a special tenderness for cultures that have been unjustly ignored. For example, when all of Europe celebrated Christopher Columbus with blaring trumpets, my choice was to honor people who'd been the victims of the discovery of the New World.*

"L'art des sculpteurs taïnos: Chefs-d'œuvre des Grandes Antilles précolombiennes, musée du Petit Palais, 24 février–29 mai."[1] The Taino exhibit marked the official beginning of the Chirac-Kerchache partnership. Opening in 1994, thus a bit after the intended commemorative moment, it was inaugurated by Chirac, still a year away from becoming president. His televised speech, far from a mere formality by the mayor of Paris, has been described as a "brilliant lecture about the sculptures made by this Caribbean people who were annihilated by the Spanish conquerors in the sixteenth century."[2] And he was the one to take journalists on a guided tour of the exhibit when it opened.[3] Kerchache was ecstatic in reminiscing about their plans to pull it off.

> I worked very hard to get together the eighty masterpieces in the exhibit, and as for him, he offered me the Petit Palais! Deal sealed. The first exhibition in the world devoted entirely to this civilization that had fallen victim to humanity's first genocide was going to take place in Paris. He told me that if he

*Jacques Chirac, on the occasion of André Malraux's ashes being admitted to the Panthéon, quoted in "Interview de M. Jacques Chirac Président de la République," *Le Figaro*, 23 November 1996.

ever became president of the Republic, his one big project would be the premier arts![4]

Picking up on a piece of the Western imaginaire that has persisted for centuries, Kerchache depicted the Taino as a "hedonistic" society, a "sort of terrestrial paradise" blessed with an abundance of rich and varied foods, in which "little value was placed on work."[5] His essay in the exhibition catalog asserts (without citing sources) that in this "society of leisure, where nature is very generous, providing an abundance of fish, crustaceans, and wild fruits," the needs of the entire population were taken care of by having servants of the chief work just two hours a day.[6] Not surprisingly, some reviewers of the exhibit followed suit, asserting, for example, that "the luxuriant nature of a perpetual springtime satiated them with the fruits of the earth and fish and game, which they left cooking on the barbecue as they lay in their hammocks, cradled by the trade winds and smoking their cigars."[7]

Responsible scholarship on Taino culture, however, paints a different portrait, citing the sophistication of their agriculture; their mastery of such crafts as woodworking, weaving, and pottery; the variety of methods they had developed for fishing; and the construction of canoes that could hold up to 150 people.[8] One book takes fifty dense pages to describe Taino subsistence techniques, calling them "sophisticated" and commenting repeatedly on the "vast knowledge" Tainos had of the natural environment.[9] Even without straying from the exhibition catalog edited by Kerchache, one learns (in an excellent summary of Taino culture by Manuel A. García Arévalo) that the Taino "employed instruments and techniques for cultivation that bore witness to a profound knowledge and great mastery of their physical environment."[10] And an anthropologist writing in *Connaissance des Arts* repeatedly drove the point home for readers of that art magazine: "The eternal image of the Taino as a happy-go-lucky, nonchalant people, leaving their hammocks to dive into the sea before Columbus's caravels, is the product of mythology. . . . The so-called simplicity of the Taino is a false impression, an optical illusion." He went on to cite the popular idea of Tainos operating according to the principle that it's easier to pick a wild fruit than to cultivate plants, for which, he wrote, there is absolutely no supportive evidence.

Abundance without effort or difficulty is of course a myth. The Taino, like anyone else, went to great pains to assure their subsistence. . . . The indigenous peoples of the Greater Antilles neither lived a simple life nor followed their desires of the moment. They had the know-how and the mastery that stand behind the organization of a complex society.[11]

A sixteenth-century engraving depicting a Taino couple as Adam and Eve before the Fall served as an effective introduction for visitors to the Petit Palais exhibition. But what Christopher Columbus saw in Taino art in 1492 was not always what Jacques Kerchache chose to see five centuries later. Columbus reported "many statues representing the figures of women and many well-executed masks." Visitors to the Petit Palais saw "few female figures and no masks."[12] One reviewer asserted that the exhibit "dealt with the more spectacular and well-known examples and gave little new information about the people and the uses and significance of their art."[13] This assessment foreshadowed many of those for Kerchache's more ambitious installation of primitive art in the Louvre six years later. As Kerchache expressed the rationale for highlighting the aesthetic quality of objects on display, "My selection [for the Taino exhibition] follows directly in the path that I've taken over the past thirty years. I abstract out what I call the seductive elements of an object—the moment it was made, the material in which it was executed, its dimensions, and the name and origin of the artist—in order to focus on one single thing: the artist's ability to arrive at creative plastic solutions."[14]

Getting into the head of unknown artists by contemplating the results of their handiwork was a fundamental goal for Kerchache throughout his career as a connoisseur. For the Taino this involved, as he put it, "recourse to deduction and analogy . . . since [he claimed] the chroniclers themselves never made any mention of Taino artists." His focused reading of the sculptural forms then allowed him to muse in print about the recruitment and training of Taino artists:

> Positioned at the center of cultural and social life, they were selected according to rigorous criteria from the behique or cacique or niTaino classes [curers, chiefs, and aristocrats, respectively] and underwent extremely elaborate training in order to take on this important, secret duty. The pleasure they took, so obvious from the form of these sculptures, allows us to suppose that there was very strong competition among artists.[15]

André-Marcel d'Ans, writing in the *Quinzaine Littéraire*, commended the design of the Taino exhibition, singling out the lighting, "so discreet that nothing comes in the way of an appreciation of the objects."

> It's possible to approach the objects from every perspective, choosing whether to focus on detailed analysis, the richness of the materials, or the magic of the patinas and their erosion; or else simply lose oneself in a wonder-struck contemplation of the timeless beauty of the exhibited works.[16]

He was less impressed by the archaeological commentary on the pieces, but pointed admiringly to a book by Irving Rouse, published two years earlier, that he felt could well serve as an exhibit catalog, both for the impeccable quality of its scholarship and the heavy overlap between its illustrations and the objects in the exhibit.[17] Unfortunately, he reported with regret, Rouse cast doubt on the attribution for the exhibit's most spectacular piece—a post-Columbian figure incorporating crocheted cotton, shells, seeds, molten glass, and rhinoceros horn that Rouse thought might come from Africa.[18] Kerchache's catalog raised no questions about the object's authenticity.

Some of the newspaper coverage of the Taino exhibit was marked by a gap between universalizing commentary by the journalist and the more culture-specific content in quotations from Chirac. An article in *Le Figaro* introduces the exhibit in terms of a stereotyped vision of generic inhabitants living in an imagined primitive world:

> "Primitives" have the grandeur to wish to communicate a great deal with almost nothing . . . imposing the essential form of things with simplicity. Their materials are poor and austere. Their forms are so concentrated that they endure over the centuries, even if the universe of beliefs and symbols that inspired them has long been forgotten.[19]

Comments by Chirac, interviewed by this same journalist, are of a different kind, reflecting his characteristic effort to master facts about particular cultures and suggesting that he had studied conscientiously such resources as the exhibition catalog's essays by Rouse and García Arévalo. He cites the prehistoric origin of the Taino in Venezuela; their migration to Puerto Rico, Hispaniola, and western Cuba; their reputation as a gentle people; the size of their population at its height; its reduction to just two hundred people by the mid-sixteenth century; and the role of forced labor, malnourishment, disease, and suicide in their decimation. He cites the Arawakan etymology of their name. He talks about the sophistication of their society, the structure of their political and religious authority, and the symbolism of their three-pointed sculptures, making remarks on particular objects in the exhibition that, while not extensive, are free of generic stereotypes. Whatever else one might say about his engagement with these arts, it's clear that his love of them—and his appreciation for their ties to specific, highly varied cultural universes—is genuine.

The State of Culture

The intervention of the [French] State is omnipresent. . . .
[I]t exerts direct control on the majority of museums in
matters of expertise as well as in the training, hiring, and
promotion of personnel.*

This chapter offers background on the relationship between museums and governmental agencies in France at the end of the twentieth century, the period when plans for the elevation of *arts premiers* were actively under way. Intended to lay out some of the building blocks of the French system, it brings in technical details that some readers may wish to skim through lightly. Subsequent chapters will return to the more specific story of the Chirac/ Kerchache undertaking, exploring ways in which the personal backing of the president of the Republic has led to polemics and controversies of a special sort.

Museums in France are solidly under the thumb of the State. National museums are "institutions of the State," which keeps particularly tight reins on their State-certified curators. One indication of how far this goes is the prohibition on marriages between a museum curator and the son or daughter of an auctioneer.[1]

The principal governing body for French museums, the Direction des Musées de France (French Museums Board) or DMF, part of the Ministry of Culture, has traditionally played a determining role in the creation and functioning of major museums.[2] For any museum falling under its purview, "not

*Élise Dubuc, "Le futur antérieur du Musée de l'Homme," *Gradhiva* 24 (1998): 72–73.

a single piece can be purchased, sold, exchanged, or even accepted as a gift without the approval of the Ministry of Culture."[3] While purchasing and accepting gifts are everyday business in French museums, it's only in exceptional circumstances, after a very complex review process, that objects can be sold or exchanged. As Germain Viatte, a central actor in the events to be described in this book, put it in 2000, "French national collections are imprescriptible and inalienable goods."[4] And Jean Paul Barbier explained in 2006 that his reason for "ceding" portions of his massive Geneva-based collection to France was that, in contrast to the United States where museums are free to de-accession pieces, French holdings "belong to the State and cannot be relinquished unless a law is passed in Parliament, which is an extremely complex procedure."[5] Clearly, this becomes an important consideration in debates over repatriation.

In the final years of the twentieth century, the rigidity of France's long-standing system began to cause concern, and a number of efforts to fine-tune the State's role in the museum world followed. As Nélia Dias wrote in 1991, "The heavy dependence of French museology on public authority creates its fragility, making it more vulnerable than in other European countries to political influences."[6] And a study of the French museum world published in 2005 remarked that "the excessive centralization of national museums created a heaviness and an inflexibility that slowed down decision making and constituted a brake on the dynamism of the institutions."[7] Some of the revisions that resulted from critical reflection in this period introduced more precision concerning the State's role, and others gave major museums increased autonomy over their budgets and administrative dealings. The loosening of the State's grip on museums, which began to be felt in the 1980s, is a trend that continues today.

Jacques Sallois, director of the DMF from 1990 to 1994, has provided an overview of the evolution of relations between museums and the State, first warning his readers that "the cohort of 'national museums' conform to no coherent plan and defy all efforts at systematic and rational classification."[8] At the time of the French Revolution, he writes, the "hegemonic ambitions" of Paris to create a "modern Athens" by uniting the nation's treasures in the capital vied with the concern of the nascent Republic to establish an equitable sharing of its artistic resources. Originally called the *National* Museums Board (Direction des Musées Nationaux), the governing body also officially recognized twelve important *musées de province* and distributed to them portions of the art seized in French conquests, but the relationship between the State and these local institutions was weak and poorly defined. In 1945 the board's name was changed to *French* Museums Board, and it was given

the charge of overseeing two categories of museums—*classés* and *contrôlés* (classified and supervised—see below).

In 1991 a decree laying out specific powers of the long-standing authority of the DMF was adopted, defining its responsibility for "promoting State policies concerning museological patrimony and organizing cooperation among the various public authorities in this domain."[9] And in 2002, after much debate, a law was passed that granted virtually all museums in France—State, local, and even privately run—the status of a *musée de France,* affording them both advantages and responsibilities. It created a commission to oversee this family of museums, the Haut Conseil des Musées de France, composed of a member of the National Assembly, a member of the Senate, five representatives of the State named by the minister of culture, five representatives of territorial collectivities, five persons representing different categories of museum personnel, and five additional "qualified personalities." The law placed museums under the scientific and technical control of the State, giving it the right to perform studies and inspections in order to verify the conditions in which they perform their missions. The fine for abusing their designation as a *musée de France* was set at 15,000 euros.[10]

Until the 2002 law homogenized the status of France's museums under the title of *musées de France,* the specific relationship of a given museum to the State varied according to its classification. *Musées nationaux* (national museums) were owned by the State; most were directly supervised by the DMF and staffed by national curators (certified as such by a rigorously competitive national examination at which only six or seven candidates per year received passing grades). *Musées classés* (the major provincial museums) were owned by regional, departmental, or municipal authorities who managed their budgets, but they were directed by national curators appointed and paid by the State. There were more than a thousand *musées contrôlés* (supervised museums) in which curators were appointed and paid by local authorities. And still other museums (including châteaux) were defined along different dimensions such as whether they were run by associations or foundations.

Today the DMF is "administratively responsible for thirty-four national museums under the aegis of the Ministry of Culture, [providing] technical and scientific support, advice and control for 1,200 museums in towns, *départements* and regions, and ensuring the general orientation, animation and coordination of French museums."[11] Its mission has also been described as one of "proposing and putting into action State politics regarding museographic heritage, handling the State's scientific and technical control over *musées de France,* and overseeing the geographic distribution and scientific

coherence of the entire network of museums," thus guarding, for example, against redundancies in the system.[12] In recent years the DMF has seen an erosion in its blanket authority, with some museums earning greater autonomy as *établissements publics* (autonomous public institutions, see below) and with a trend toward decentralization lending increased power to regional bodies concerned with cultural projects. And inspections of museums by the DMF have been coming under increasingly frequent criticism. Curators complain: "We are a ship with a cracked mast, broken oars, and no rudder, in the hands of a captain who is all powerful but in control of nothing."[13]

A few museums in France are affiliated with ministries other than the Ministry of Culture. Sallois cites four that fall under the Ministry of Education, the most important being the Muséum National d'Histoire Naturelle of which the Musée de l'Homme is a part. Others—including the Musée de la Marine, which has long shared a building with the MH—are under the Ministry of Defense.[14]

On the financial side of things, the Réunion des Musées Nationaux (Union of National Museums), or RMN, created in 1895 and reorganized in 1991, oversees such matters as entrance fees, public museum incomes, and the publication of art books. In 1990 France reluctantly softened its long-standing opposition to treating museums as market-driven institutions, and the RMN now offers for sale (both online and through museum shops) museum-related items from art reproductions, CDs, books, games, and posters to luxury goods in the realms of home furnishings, fashion accessories, and jewelry. Its power has been eroded since the 1990s by the trend toward increased autonomy in a number of national museums.[15]

Museums under State control have traditionally had little say over budgetary and administrative decisions. During the late twentieth century, however, a number of major museums gained greater autonomy. The pioneer in this trend was the National Museum of Modern Art,[16] newly installed in the Centre Pompidou in 1977, which overcame the opposition of the DMF (understandably reluctant to see an erosion of its power) to become recognized as an *établissement public*, directly under the Ministry of Culture. Other museums—including the Louvre, Versailles, the Musée d'Orsay, the Musée Guimet, and, most recently, the Musée du Quai Branly—followed suit. Since 2002 it has even been possible for local (e.g., municipal) museums to apply for the status of an *établissement public*.[17]

All these details of the administrative structure of museums deserve to be seen in the context of a more general conceptualization of the State's role in society, which gives it responsibility for providing equal access to everything from health care and employment to education and culture. Andrea Kupfer

Schneider asserted in 1998 that close to 1 percent of France's national budget was going to the creation of museums and the promotion of cultural activities throughout the country—$41 per person, compared to $1.43 per person in the United States.[18] The contrast is underscored by the fact that France has a minister of culture, often a particularly prominent member of the government, while the United States does not. Indeed, the only "brief flirtation" of the United States with a minister of culture, quipped Roger Shattuck in the *New York Review of Books,* was, tellingly, with one from France: in 1962 Jacqueline Kennedy convinced France's first minister of culture, André Malraux, to escort the *Mona Lisa* to the United States for temporary exhibition in the National Gallery and the Metropolitan Museum.[19] The comparison could be drawn even more broadly, setting France in a Europe-wide context where (with the possible exception of England[20]) there is significantly stronger State support for culture than there is in the United States. Shattuck notes that "the closest the United States has come to establishing a federal agency for culture has been its sponsorship of the National Endowment for the Arts" but that the total budget for that agency comes to only "about one-tenth of the Italian government's contribution to major opera houses."[21]

The prominent place of culture in French national identity has given the country's presidents a direct role in museum affairs. Georges Pompidou was a pioneer in presidential "great works" (*grands travaux*) with the multi-faceted center at Beaubourg; Giscard d'Estaing made the Musée d'Orsay a personal project; and Mitterrand left his legacy in the form of a national library, a new opera house, architectural additions to the Louvre, and the Grande Arche de la Défense. Another indication of their involvement in things cultural is that presidents are frequently the featured speakers at openings of museums and exhibitions.[22]

The vision of museums as State institutions means that projects initiated by presidential decree operate through a special dynamic within the general structure, enjoying a degree of autonomy that simultaneously facilitates their efficient realization and foments strong divisions between supporters and opponents. It also means that a presidential undertaking focused on the arts of non-French cultures becomes highly charged and pulls other members of the nation's family of museums into the debate. Once Chirac's proposal for a museum of primitive art was announced, the fate of a whole range of Paris institutions was put up for discussion. How was the mission of the Musée de l'Homme, slated to lose its ethnographic holdings to the new project but retain its archaeological and paleontological collections, to be redefined? How would the Palais de la Porte Dorée—founded as a colonial museum, rebaptized a museum of overseas France, later converted to a museum of African

and Oceanic art, and finally emptied out for Chirac's new museum—reflect its past as it became France's museum of the history of immigration? How were the arts of, say, Indonesia, to be divided up between the new museum and Paris's museum of Asian art? What impact would the new museum have on France's museum of popular arts and traditions, under discussion for conversion into a museum of France and Europe[23] and possible relocation to Marseille? Which museum should house the arts of Amazonian Indians and their Maroon neighbors in the tropical forest of French Guiana, who are citizens of France and therefore Europe? Even the naval museum was slated for relocation as part of a process frequently referred to as a game of musical chairs.

The two museums most quickly and directly pulled into the debate—the Musée des Arts d'Afrique et d'Océanie at the Porte Dorée and the Musée de l'Homme in the Palais de Chaillot—occupied different niches within the system, and this introduced complications in plans to draw on their collections for Chirac's proposed project. After leaving behind its identity as a colonial museum (thus, under the supervision of the Ministry of the Colonies), the Porte Dorée museum was, like most other national museums, placed under the authority of the Ministry of Culture. The MH occupied a more atypical position because of being part of the nation's Museum of Natural History, which comes under the Ministry of Education and Research; it has always been seen as an instrument of education and research as much as a display window for material culture. When its original chair in "ethnology of present-day and fossilized man" split into two positions in 1967 (creating a new chair in prehistory), and then split again four years later, the Musée de l'Homme became an aggregate of three separate "laboratories"— prehistory, biological anthropology, and cultural anthropology—without any administratively unifying head.[24]

Deeper penetration into the organizational structure of the French museum world would introduce a complex set of cross-cutting categories. Besides the national museums, there are regional and municipal museums, public and private museums, museums run by foundations and others by associations—none of which is directly relevant to the present discussion. Later sections will show how the juridical statuses of particular museums, and their placement under one or another ministry, have played an important part in the museological "musical chairs" leading up to the realization of Jacques Chirac's presidential legacy.

The Grandest Museum
in the World

The Louvre is the fruit of a long evolution that was
imposed on it, mainly through political decisions.
As a national . . . symbol, it is a field for the exercise
of power.*

James Hall, writing in the *Times Literary Supplement,* played "a parlour
game [of] singling out the greatest museum from each of the past three cen-
turies . . . not just in terms of the collections' breadth and depth, but also
their museological significance." In his appraisal, the Louvre garnered first
prize for the eighteenth century, the Victoria and Albert Museum for the
nineteenth, and New York's MoMA for the twentieth.[1] That may be a ten-
able view from Britain, but advocates of the Chirac/Kerchache proposal
didn't see it the same way. For them, the Louvre had been, was, and always
would be *"le plus grand musée du monde."* Indeed, once President François
Mitterrand elevated it to the "Grand Louvre" in the 1980s, its supremacy
was confidently projected into the future. As Kerchache put it, "The Grand

*Geneviève Bresc-Bautier, "Les musées du Louvre au XIXᵉ siècle: Les collections
archéologiques et ethnologiques dans le conservatoire de l'art classique," in *Le musée et les
cultures du monde,* edited by Émilia Vaillant and Germain Viatte (Paris: École nationale du
patrimoine, 1999), 54. Because a literal translation doesn't produce a particularly workable
English text in this case, I have opted for more of a gloss than a phrase-by-phrase equiva-
lent. The full text in French is *"Ce musée . . . est le fruit d'une longue évolution qui lui a été
imposée, et, le plus souvent, par des décisions politiques. Car le Louvre, musée national et sym-
bolique, est le champ où le pouvoir peut créer, démontrer et se manifester. Il fait partie de
l'ensemble plus vaste encore de la culture d'État, où l'État détermine une politique nationale."*

Louvre has become the central site for the recognition of art forms for the century to come."[2]

The Louvre began its life history as a medieval fortress designed by King Philippe-Auguste (1165–1223) to provide protection against invaders from the Channel Islands. The origin of its name, say some, has been "lost in the darkness of time."[3] Others speculate that it derives from an association with wolves (*loups*)—either because it was built on land belonging to a hunter charged with protecting the populace from wolves (*un lieutenant de la louveterie*)[4] or because Philippe-Auguste first intended it to serve as a wolf kennel.[5] Subsequent monarchs made adjustments—tearing down the tower, adding wings, connecting it to the Tuileries Palace, and introducing a series of architectural styles in the process. In the sixteenth century, François I converted it into a palace and began installing artworks, including its most famous painting, *La Joconde* (*Mona Lisa*). The Louvre continued to serve as the residence of French kings until Louis XIV abandoned it for Versailles in 1682, initiating a century of relative neglect for the buildings.

It was not until August 1793 that a public museum, exhibiting six hundred works of art, was opened in the Palais du Louvre.[6] Later, ethnographic curiosities brought back by explorers—as well as nautical instruments, scale models, statues, and paintings intended to celebrate French naval victories—were placed in the Louvre Palace as a "naval and ethnographic museum" known as the Musée Dauphin, which opened its doors in 1830.[8] In the 1870s Jules Ferry, whose vision included a radical distinction between "superior" and "inferior" races, agitated for removal of the "savage" artifacts from the company of fine-art masterpieces—that is, for their departure from the Louvre.[12] His campaign coincided with preparation for the Exposition Universelle of 1878, to be housed in the newly built Palais du Trocadéro, which eventually became the new home of the ethno-

Superlatives can be tricky, and they're highly adaptable to promotional ends. Calling the Louvre "*le plus grand musée du monde*" could mean either the biggest or the greatest . . . the wording in French doesn't distinguish. In fact, both claims have been made. A 2005 Internet site about France, for example, asserted that its 60,000 square meters made it "the largest museum in the world" (beating out the Metropolitan Museum in New York with only 58,820 square meters). *The Guinness Book of World Records* figures size differently and gives the prize to the Smithsonian, on the grounds of its collections, which total 140 million objects (compared to the Louvre's roughly 400,000). Translations of *le plus grand musée du monde* into English make it clear, however, that size is not all that's being claimed. A CD-ROM put out by the Louvre refers to it in English as "the greatest museum in the world," as does at least one French government site,[7] and the context of numerous other uses of the phrase shows that something more momentous than sheer size is being communicated.[9] Some writers avoid the ambiguity by describing it as "the most prestigious" museum in the world.[10] For Jacques Kerchache, it was "the most beautiful museum in the world."[11]

graphic collections. Transfers were made over the years, and by 1904 there were no longer any ethnographic materials in the Louvre buildings.[13]

Is the Louvre a comprehensive museum of world art? Many people perceive it as such, including Jacques Chirac, who has thrown his weight behind the idea that the Louvre has a "universal vocation."[14] A June 2005 "Message from the Director" on the Louvre's website also adopted that position:

> From the outset, the Louvre has embodied the concept of a truly "universal" institution. Universal in the scope of its collections, it is also universal in its appeal to some 6 million visitors every year: a 21st-century museum rooted in 200 years of innovation.[15]

Others, including the Louvre's former director Pierre Rosenberg, have insisted that the museum was never meant to be universal in its collections. As they have pointed out, the curatorial departments that have evolved over the centuries are very specifically delineated, though the classification has been adjusted over the years as categories of art have been redistributed within the French museum world. In 1986, for example, post-1848 paintings were removed from the Louvre to be exhibited in the newly opened Musée d'Orsay.[17]

In 812 Charlemagne created the louveterie to protect the people and their animals against wolves (loups). The person charged with "keeping the place" (tenant le lieu) was the lieutenant de louveterie, a hunter chosen for his skill, his knowledge of the landscape, and his reputation as a person of high moral standards. The position was abolished in 1787 but reinstated ten years later. Today these voluntary civil servants are appointed by the prefect for a (renewable) period of six years. They must be between twenty-one and sixty-nine and have possessed a hunting license for at least five years. They must be knowledgeable about the habits of wild animals, respectful of the environment, diplomatic with farmers, and attentive to security. And they must keep, at their own expense, at least four dogs dedicated exclusively to the pursuit of wolves, foxes, wild boars, and other animals threatening to the peace of the countryside. Today they number over fifteen hundred, including thirteen women.[16]

During the 1980s, with the support of President François Mitterrand, the Louvre underwent a fundamental transformation. Its juridical status was elevated to an *établissement public* (giving it greater administrative autonomy), alterations were made in the use of its facilities (including the removal of government offices from the building), and it took on a striking new look in its very architecture (through the famous glass pyramid that now serves as the main entrance). These changes, taken together, earned it a new name, the "Grand Louvre," but left intact its previous organization in seven sections. The museum's website boasts that "since the launch of the Grand Louvre project, museum attendance has doubled, rising to an annual average of 5.7 million visitors."[18]

In 2003 a department of Islamic art was added, with a new wing scheduled

Jules Ferry (1832–1893) served in a number of political posts, from mayor of Paris, ambassador to Greece, and member of the National Assembly to minister of public instruction. In this last role, he successfully oversaw the passage of the laws that provide free public education in France. His views on racial difference gave France and other European nations special cultural responsibilities: "The superior races have a duty to civilize the inferior races. . . . I maintain that the nations of Europe are fulfilling this superior obligation of civilization ad-mirably, with magnanimity and honesty. Who would deny that in India . . . there is more justice, more enlightenment, orderliness, and public and private virtue since the English conquered it? And is it possible to deny that it was good fortune for those miserable populations of equatorial Africa to fall under the protection of France or England?"[20]

to open in January 2009 at a projected cost of US$67 million.[19] As of this writing, its eight de-partments are defined as follows:

- Paintings: European schools from the thir-teenth century to 1848
- Sculptures: European sculptures from the Middle Ages and the Renaissance to 1848
- Prints and Drawings: works on paper, prints, drawings, pastels, and miniatures
- Decorative Arts: jewelry, tapestries, ivories, bronzes, ceramics, and furniture from the Middle Ages to 1848
- Egyptian Antiquities: vestiges from the civilizations that developed in the Nile Valley from the late prehistoric era (4000 B.C.) to the Christian period (4th century A.D.)
- Greek, Etruscan, and Roman Antiquities: works from the Greek, Etruscan, and Roman civilizations, from Neolithic times (4th millennium B.C.) to the 6th century A.D.
- Near Eastern Antiquities: the ancient civiliza-tions of the Near East from the first settle-ments, which appeared more than ten thousand years ago, to the advent of Islam
- Islamic Art: over a thousand works, most of which were intended for the court or a wealthy elite, spanning thirteen hundred years and three continents

Down with Hierarchy

The project is based on the president's intention, based
on a deep conviction, to affirm that there is no hierarchy
of cultures.*

It has become a tradition in France for every president to realize at least one
major project that will stand as a monument to his role in history. "Each head
of State, or monarch as we might call them, wants to make his mark in stone,
to build palaces and museums that will one day bear his name."[1] Louis XIV
may have set the monarchical example when he built the Palace of Versailles.
Known as presidential *grands travaux,* these projects have been surrounded,
both before and after, by extensive politically fueled controversy over their
initial raison-d'être, their location in the capital, their architectural design,
the name by which they are to be known, the people appointed to carry them
out, their class connotations, and more. In the end, each has left a highly
visible mark on the Paris skyline. The Pompidou Center, the Louvre's glass
pyramid, the new opera house and national library, and the Grand Arch of
the city's Defense quarter are all fulfillments of presidential dreams, proud
survivors of years of heated debate over their existence.

In its early stages, Jacques Chirac's dream was not the monumental mu-
seum of primitive art that opened some fifteen years later in the shadow of
the Eiffel Tower. Determined to distinguish his legacy from those of his pre-

*Jacques Kerchache, quoted in Francis Rambert, "Jacques Kerchache: 'Pas de hiérar-
chie des cultures,'" *Le Figaro,* 13 April 2000.

decessors, whose *grands travaux* he faulted for being "too ostentatious, too costly, and too Parisian,"[2] and declaring his intentions during a period when France's economy was suffering a downturn, he promised that he was not going to "invest in concrete."[3] So the original plan was more physically modest. At the same time, it was more conceptually (and politically) radical, and more in keeping with the lifelong goal of his friend Kerchache—the establishment of a new department in the Louvre Museum centered on the arts that moved both of them so deeply.

The proposition enjoyed a highly respectable pedigree in twentieth-century France. As early as 1909, writer and art critic Guillaume Apollinaire had pleaded the case in the *Journal du Soir,* arguing that

> an effort needs to be made in favor of certain arts that have been completely neglected up to now. To date works of art from Australia, Easter Island, New Caledonia, New Hebrides, Tahiti, the various regions of Africa, Madagascar, etc. have hardly been shown except in ethnographic collections, where they serve as curiosities and documents, thrown in pell-mell with the most vulgar, ordinary objects and the natural products of their regions. The Louvre should take in certain exotic masterpieces whose effect is no less moving than that of beautiful specimens of Western sculpture.[4]

The Louvre made no such concession, but proponents of the idea kept it alive. In 1920 art critic Félix Fénéon surveyed "twenty ethnographers and explorers, artists and aestheticians, collectors and dealers"[5] on the question of whether "distant arts" (*arts lointains*) should be admitted to the Louvre.[6] Paul Guillaume, a protégé of Apollinaire who became "the most prestigious African art collector and dealer in the period between the two World Wars,"[7] was emphatic: "Because no other art has exerted such a direct influence on the plastic arts of our era, *art nègre* will gain entrance to the Louvre as a necessary explanation."[8] The response to these articles was generally positive, and a department store in Paris even opened a section devoted to *art nègre.*[9] Much of the ensuing debate seems to have had to do with doubts about finding candidates for inclusion that met adequate standards of aesthetic quality: Was the sculpture "hideous" (Salomon Reinach, curator of National Antiquities)? Might one be able to identify "a few very pure specimens" suitable for display (Jos Hessel, a collector/dealer)? Would it be "paradoxical to compare the babblings of civilizations that have remained in their infancy . . . with the most perfect works of human genius" (Jean Guiffrey, curator of paintings at the Louvre)?[10] Again, nothing budged.

At midcentury Claude Lévi-Strauss, who was to become the towering

center post of anthropology in France, was implicitly lending support to Fénéon's position. In 1943, standing before displays of Northwest Coast Indian artifacts in New York's American Museum of Natural History, he mused: "The time is not far away, I believe, when collections from this part of the world will leave the anthropology museums and take their place in museums of fine art."[11] A 1954 article in *Le Musée Vivant,* commending a museum in Arles for mounting a five-year exhibition sequence on the arts of Africa, Oceania, and America, declared that *art nègre* "has entered our world like a ferment of youthfulness. Rarely have we seen a foreign influence this deep and this durable."[12] And André Malraux said it again in the 1970s: "Many people want to see *art nègre* in the Louvre, and it will enter."[13]

In 1982 the opening of the Rockefeller Wing of the Metropolitan Museum of Art in New York increased the frustration of those whose propositions to curators at the Louvre had been met, time and time again, with opposition. Commentators spoke of the Louvre's "glacial response" and "gnashing of teeth"[14] over the suggestion that such art should be introduced into their domain. The agitators saw their dream being realized in other parts of the world, while France persisted in endorsing a traditional definition of the societies that qualified as producers of the "fine" arts. At the same time in Paris, François Mitterrand's elevation of the Louvre and his declaration that the Grand Louvre was "the greatest museum in the world for all of humanity" rubbed further salt in the wound and triggered Jacques Kerchache's decision to go public.[15] Systematically tracking down influential individuals who could be enlisted in support of his goal, he produced a manifesto, "So that the masterpieces of the entire world may be born free and equal. . . . For an eighth section of the Grand Louvre."[16] Published on 15 March 1990 as a full page of *Libération,* it carried the signatures of 148 international personalities—writers, artists, critics, dealers, curators, academics, and political figures, from Jorge Amado and Hélène Cixous to Matta and Léopold Sédar Senghor. A number of prominent French anthropologists also endorsed the idea: Marc Augé, Georges Balandier, Simone Dreyfus-Gamelon, Maurice Godelier, Françoise Héritier-Augé, Michel Leiris, and Denise Paulme-Schaeffner. Claude Lévi-Strauss's name does not appear on the document. When I spoke with him in 2005, he was clear about the reasons for his opposition.

> I believe it was a very big mistake. The Louvre Museum is not at all a universal museum. The Asian art collections that used to be in the Louvre are now in a separate museum. The role of the Louvre is to bring together all that has formed the traditions of France and the Western world. And just as China and

"So that the whole world's master-pieces may be born free and equal. . . . For an eighth section of the Grand Louvre.

"The Grand Louvre of the twenty-first century will form the reference point for the most note-worthy aspects of all existing forms of art. And yet nothing is being envisioned in terms of integrating objects from African, American, Arctic, Asiatic or Oceanic cultures in what would thus become the eighth section.

"In effect, despite the support in principle of this proposition that is provided by the highest author-ities of the Republic, the project appears to have been stalled by the Grand Louvre's administration at several levels. This resistance is especially cause for concern in light of the fact that specifications for the distribution of space are due in the near future. If no action is taken, the France of 1989 will have given its blessing, through a kind of blindness not unlike that which was used to justify the *nuit coloniale* [colonial oppression], to the exclusion for decades to come of the major works of art produced by three-quarters of the world's population.

"We [the undersigned] de-mand the immediate opening/establishment of the eighth section of the Louvre."

Japan have their museum, so should the *arts pre-miers* or *arts primitifs* have theirs. The Louvre is already much too big![17]

The manifesto was a declaration of war, and the battle lines were clearly drawn. On one side were those who felt that the arts of Africa, Oceania, and the Americas had for too long been ignored, dis-dained, unloved, or "forgotten," that their relega-tion to the dusty clutter of anthropology museums was partly to blame, and that the solution was to ad-mit them to the hallowed halls of the Louvre. The opposition was more of a coalition between dif-ferently motivated parties—curators at the Louvre, who were staunchly protecting what they saw as a qualitative distinction between the collections already in place and the proposed intruders, and curators at the Musée de l'Homme, who were desperately fighting the confiscation of collections that had long represented a third of their patri-mony.

By the time Chirac began going public with his position (for example, in his preface to the 1994 Taino exhibit catalog), the rhetoric was already well established, and it was picked up frequently in the press. Most statements centered on outrage that "three-quarters of the world's humanity" was ex-cluded from "the greatest museum in the world." Three-quarters was sometimes rendered as four-fifths,[18] depending on how the world was being di-vided up (with Asia being added to the triumvirate of Africa, Oceania, and pre-Columbian America), and "the greatest" sometimes became "the most beautiful" or "the most prestigious." But the basic contrast held firm. For soldiers in the Kerchache camp, the arts in question had far too long been unknown, neglected, or dis-dained. It was time to assert the "equality of cultures,"[19] by making a place for the "forgotten arts" in the highest temple of civilization. Chirac became a particularly prominent spokesman, repeatedly declaring that "there is no more of a hierarchy of arts than there is among peoples" and calling it "deeply

As all this began bubbling into the realm of possibility, a new item surfaced in the discourse. The term *arts premiers* was proposed as a way out of the linguistic trap that such terms as *art nègre, arts lointains, art tribal, arts exotiques, arts sauvages, arts primordiaux,* and of course *art primitif* had created for people who wished to convey respect for the arts in question. In early debates about how to give recognition to "the forgotten arts" in Paris museums, *arts premiers* was the label of choice. But before long, arguments began to be voiced that it carried the same inaccuracies and derogatory connotations as its politically incorrect predecessors, and planning committees charged with naming the new museum turned to its nomenclatural competitors—*musée des arts et des civilisations, musée de l'Homme, des arts et des civilisations,* and eventually *musée du quai Branly.* Writers and publishers, however, continued to find it an attractive catchword. In the spring of 2000, the covers of magazines such as *Télérama, Connaissance des Arts,* and *Arts d'Afrique Noire* announced the Louvre's inclusion of "*arts premiers*" in large bold letters, books entitled *Arts Premiers* were on sale in bookstores and museum shops, and the best-selling CD-ROM called *Chefs-d'œuvre et civilisations: Afrique, Asie, Océanie, Amériques* carried a second subtitle: *Les Arts premiers au Louvre.* Newspaper editors, too, held on to the term, including it in the headlines of countless articles. In 2006 entries for upcoming books on Amazon.fr give reason to believe that the term has settled in as a permanent fixture of art discourse in France.[20]

shocking and regrettable" that three-quarters of the world's humanity was unrepresented in the Louvre.[21]

Events both in and out of France periodically added fuel to the fire and increased the sense of possibility. In 1994 and 1995, for example, the Grande Halle de la Villette hosted exhibits in which Tibetan artists, Navajo sand painters, and Australian Aborigines created artworks in the presence of spectators.[22] And in London, the exhibit Africa: The Art of a Continent set Kerchache's head spinning. Not only was the art on display visually exciting, but the Royal Academy of Arts, one of the most venerated institutions of art in Europe, was showcasing the aesthetic taste of a single man (the artist/collector Tom Phillips)—an enticing precedent for a connoisseur who dreamed of curating a space at the Louvre according to his own very personal vision.[23]

✳

During the mid-1990s, a period when their arts were being upgraded for display in the Louvre and a new museum of "*arts premiers,*" what did the Quin-

tessential Others of western Europe represent to most folks in France? When human beings, rather than art objects, found their way into Europe, how were they being perceived? And what roles did they play for the great majority of people in France who had little reason to care about the downsizings and upgradings of State museums or the relative merits of aesthetics versus ethnography? While Chirac and Kerchache were passing over Christopher Columbus in order to celebrate Taino Indians in the Petit Palais; while presidential committees were working on a plan to give cultural products from Africa, Oceania, and the Americas their due in Paris museums; and while curators at the Louvre were swallowing the idea of pagan fetishes within shouting distance of the *Mona Lisa*, attitudes toward cultural difference were also being fought out in the streets, in the courts, in cemeteries, and even on the soccer field.

Any exploration of ethnicity in France, especially one written for American readers, needs to acknowledge that the words "cultural diversity" do not carry the same meaning in France that they do in England or the United States. Rather than referring to ethnic differences within a national society, they more frequently come up in debates on globalization and U.S. cultural/commercial hegemony. In that context, France becomes the minority party, fighting a battle against "Anglo-Saxon" domination, particularly in such matters as language and the film industry. As Chirac has put it:

> The American model for integration is based on juxtaposing communities that are both different from each other and unequal. In contrast, France makes an effort to take men and women from elsewhere and melt them into a single community centered on shared values. This approach is at once more generous and more ambitious.[24]

So, while cultural specificities (sumo wrestling as a Japanese tradition, African fertility figures as world-class art, ancestor worship in Oceanic societies, and so forth) are valued in their home settings, in scholarly works, and in museums, they are discouraged in the context of day-to-day life in France. There *laïcité*, that uniquely French version of church/state separation, holds sway, trumping rights of cultural difference when they come into conflict.[25] This is long-standing government policy. As one critic expressed it, "The Republic claimed to be universal, but its universalism was built around numerous exclusions: it did not like difference."[26] Or, as Chirac has said, "In France, all citizens are daughters and sons of the Republic. . . . There are no categories of French. There are only citizens, free and equal in their rights."[27]

22/6/94. By a unanimous vote, the European Union "shuts the door on immigrant workers," adopting a resolution restricting the entry of immigrants and banning their employment except under specific circumstances and even then only for limited periods of time. The reluctant Belgian minister of the interior remarks that "Europe is building a fortress against foreigners."

15/7/94. A survey published in *Le Figaro* finds that 31 percent of people in France endorse the expulsion of immigrant workers as the most effective means to combat unemployment.

14/11/94. In Amiens violent clashes break out between youths and the police following the release of four teenagers who participated in the gang murder of an Algerian.

21/2/95. In Marseille Ibrahim Ali, a black seventeen-year-old from the Comoro Islands, is killed with a bullet to the head by three followers of presidential candidate Jean-Marie Le Pen's extreme rightist party, the Front National.

26–27/2/95. Le Pen pledges to expel three million immigrants in the space of seven years.

1/5/95. The body of Brahim Bourham, a twenty-nine-year-old Moroccan, is fished from the Seine in front of the Louvre after he was attacked by three skinheads taking part in a massive demonstration in support of the Front National.

18–19/6/95. Agence France Presse releases an assessment of the ever-mounting popularity in France of the Front National, "based on anti-Semitism, racism, xenophobia, and a nostalgia for fascism and Nazism, [and] led by a man who has called Nazi gas chambers a 'minor detail' of the Second World War." It notes Le Pen's victory in three major cities, on a platform arguing for the expulsion of illegal immigrants, a reinforcement of security measures, and a national policy giving job preference to citizens.

13/1/96. Lawyers demand 1.6 million francs in damages for a video game created by the son of a Front National politician, in which the president of SOS Racisme is allegedly depicted as a prowler with a bone through his nose.

24–25/6/96. Le Pen protests the presence of players from Overseas France (Martinique, Guadeloupe, French Guiana, New Caledonia) on the national soccer team.

24/9/96. Le Pen repeatedly states his belief in "the inequality of races."[28]

I have profound respect for cultural and religious identities, but I am convinced that they should never come before national identity and citizenship. A shared cultural heritage is an essential ingredient of this citizenship. When the things that separate us are overvalued to the detriment of those that bring us together—for example, language, words, turns of phrase that develop in this or that *banlieue*—integration is not well served, and the risk of ghettoization increases. We need to do the opposite. We need to bring alive the notion of a cultural fatherland.[29]

The national identity in question follows a dominant model that was firmly in place before immigrants constituted such a large segment of the population and in which Catholicism is the unmarked category. This explains, for example, the calendar of national holidays (Ascension, Whit Monday, Assumption, All Saints' Day, etc.).[30] It also lay behind earlier restrictions on parents giving babies names other than those on the calendar of saints' names or belonging to recognized "historic figures."[31] Similarly, adults in the French Caribbean, the descendants of enslaved Africans, have vivid memories of reading in schoolbooks about "our ancestors the Gauls."

At one level, the key goal is protection of "cultural exceptionalism," the rejection of cultural hegemony (understood: by the United States). At a national level, the struggle is against "communitarianism," displays of ethnic/cultural difference that are defined as divisive within the society.[32]

This, then, is the logic behind France's ban on official recognition of ethnic identity. Census takers, prohibited from recording ethnic or religion-based identity, are charged with distinguishing people only as "French" or "foreigner." In the overseas department of French Guiana, for example, the significant Brazilian, Haitian, Maroon, Chinese, and Antillean populations are unquantified except by their status as citizens, foreigners with residence papers, or illegal immigrants, though of course what matters most in actual understandings of daily life, what constitutes the staple of discussions among real people, are exactly those ethnic labels that are banned in State documents.

Jacques Chirac's three-year battle to win official UNESCO support for "cultural diversity" was finally rewarded in October 2005 by the adoption of the "Convention on the Protection and Promotion of the Diversity of Cultural Expressions" (unanimously approved except for the United States and Israel, and described in the press as "a way of fighting against the United States' monopoly of power"). Aimed at "freeing cultural expression from the rigid rules that control international commerce," it declared that cultural products should not be treated exclusively in terms of their commercial value and authorized countries to take "appropriate measures" to protect their cultural patrimony. Chirac commented that the convention "opened up hope for a globalization that was more respectful of the identity of peoples."[33]

The privileging of national culture (while at the same time promoting the appreciation of foreign cultures in such controlled settings as museum displays) lies behind the idea of France's famous "civilizing mission" and lends a distinctive tone to representations of its colonial past. Chirac's 1996 exhortation[34] for the French to take pride in the country's rich contribution to Algerian society, for example, was written into law a decade later, requiring university research programs to "accord to the history of the French presence overseas, notably in North Africa, the place that it merits." Article 4 (removed under pressure a year later) included a requirement for children to receive indoctrination in this direction:

> School programs shall recognize in particular the positive role of the French presence overseas, notably in North Africa, and accord to the history and sacrifices of combatants from these territories who fought on the side of the French the eminent place to which they are entitled.[35]

Might one conclude that the erasure of cultural hierarchies in France is a site-specific undertaking?

A woman charged with producing a sociological report on attendance at the Louvre once cornered me after I presented a lecture there to ask my advice about how to determine the degree of interest among Antilleans. Because she was not allowed to ask visitors whether they were, for example, Martiniquan or Guadeloupean, she wondered whether I thought asking them what language they spoke at home and keeping track of how many said "Creole" would be a reliable indicator. Unfortunately for her project, I was quite sure that, in the context of a Parisian art museum, Antilleans (who are bilingual in Creole and French) interviewed by a Parisienne with all the personal signs of upper-class identity would choose to respond by evoking the Francophone side of their life at home.[36]

Getting Started

In 1996, amidst the upheavals and concerns that the
announced fusion of two distant institutions naturally
inspires, a formal planning committee was constituted,
under the direction of Jacques Friedmann.*

In 1995 Chirac's election to the presidency of the Republic gave him the
means to get the ball rolling. Standing before the glass pyramid of the Grand
Louvre on 14 November, his minister of culture, Philippe Douste-Blazy, an-
nounced that a committee would be formed to study the options for pre-
senting primitive art in the Louvre.[1] As reported in *Le Monde,* the goal was to
determine ways for "works of art from Africa, Oceania, and the two Ameri-
cas, so unloved by the public authorities, to enter the Holy of Holies, that is
the Louvre Museum."[2]

Hurdles were clear from the start, and presidential muscle was viewed as
the only way to get over them. As one journalist commented:

> In order for a project of this size to be carried out, it's only determination at
> the summit of State power that can overcome the inertia of corporatism and
> the reticence of finance ministers, never enthusiastic about spending the kind
> of money involved in such undertakings. That's why, despite all the grum-
> bling, despite the unfortunate consequences that it's bound to have for some
> people, . . . Jacques Chirac, lover of the Taino, was right to throw his weight
> behind the grand museum of *"arts premiers"* that he so believed in. Camou-

*Stéphane Martin, "Genèse d'un projet," *Connaissance des Arts* 571 (April 2000): 51.

flaged behind the commission headed by his friend Jacques Friedmann and advised by the collector Jacques Kerchache, the president of the Republic has taken action.[3]

Objections were immediately raised from disparate camps. Voices from the Louvre argued that their museum, in contrast to the Metropolitan Museum of Art in New York, had never been intended to be "universalist," that Paris had always distributed collections among institutions with clearly different mandates, and that Asian art, for example, was doing just fine in the Guimet Museum.[4] Others felt that the display of some hundred "exceptional" specimens of African and Oceanic art would end up being seen as a kind of tokenism, an excuse for the failure to create a more consequential valorization of the cultures in question. Still others argued that if ethnographic artifacts (especially those that had been exhibited in the Trocadéro Museum) were to be "upgraded" to art objects, the appropriate setting would be the National Museum of Modern Art in the Pompidou Center rather than the Louvre, given the role of early twentieth-century artists such as Picasso in recognizing their aesthetic value and bringing them to the attention of art lovers.[5] And there was a vehement outcry at the Musée de l'Homme, where a beleaguered workforce and a number of vocal allies cried foul at the idea of dismantling[6] a venerable scientific and educational institution and turning its contents into what they saw as meaningless instruments of titillation for the elite.

Almost from the beginning, the debate showed signs of shifting from an exclusive focus on the Louvre toward a more ambitious plan that would include the creation of an entire museum for the arts under discussion. As Emmanuel de Roux wrote in *Le Monde*, "The question of 'primitives' in the Louvre is just a preliminary for a decision with much heavier consequences."[7]

On 23 January 1996, Jacques Friedmann, a close personal friend of Chirac "since the dawn of time,"[8] was named head of the committee by Prime Minister Alain Juppé and given six months to turn in his report.

His charge: to gather information on the views of scientific and cultural experts regarding the future of the arts in question within the Paris museum world. Members of what became known as the Friedmann Commission included, in addition to Jacques Kerchache, the president-director of the Louvre, the director of the National Museum of Natural History (of which the Musée de l'Homme

Jacques Friedmann (b. 1932) graduated from the École Nationale d'Administration (one of France's prestigious *grandes écoles*) and went on to take top positions in both government and business, for example, as cabinet director under two prime ministers and president/CEO of Air France and AXA-UAP, a multinational financial-insurance conglomerate.

was a part), the director of the Naval Museum, the director of the French Museums Board, the director of the Museum of African and Oceanic Art, a representative of the Ministry of Education, a legal adviser, an Americanist archaeologist, an Asianist anthropologist, and an Africanist art historian.[9] A nonagenarian Claude Lévi-Strauss, named honorary president, did not attend the meetings but contributed his opinions on a regular basis. Over the course of eleven intense (and sometimes tense) meetings, the group debated, not only numerous questions concerning the establishment of a new museum (where it should be housed, what it should be called, which museums should contribute their collections, and under which ministry it should be placed), but also the status of the carefully selected masterpieces to be installed in the Louvre. Would they be there temporarily in order to give museumgoers a sneak preview of arts they would be able to see in the new museum once it was built? Or would they become a permanent part of the Louvre?

The Friedmann Commission submitted its report to the president in August and announced its conclusions to the public on 13 September 1996.[10] Declaring the distinction between an art museum and an ethnological museum to be the remnant of an obsolete way of thinking, it recommended the establishment of a "museum of man, arts, and civilizations" to be housed in the Aile Passy (west wing) of the Palais de Chaillot, then home to the Naval Museum and the Musée de l'Homme. It would be an autonomous public institution (*établissement public*) under the joint authority of the Ministry of Culture and the Ministry of Education and Research, with a surface area of 31,000 square meters (of which 8,000 would be for underground storage) and an opening date of late 2001 or 2002. Its collections, taken from both the Musée des Arts d'Afrique et d'Océanie and the Musée de l'Homme, would include the arts of Africa, Oceania, and the indigenous Americas, as well as those arts of Asia that were not represented in the Musée Guimet. It could also include the traditional arts of Europe—with the exception of France, whose arts were already covered in Paris's Museum of Popular Arts and Traditions. It would incorporate programs of education and research and, "like all contemporary museums worthy of the name," would house a library, a *médiathèque*, an auditorium, movie theaters, and space for temporary exhibitions.

To free up space for the new museum, the Naval Museum would be transferred to the Porte Dorée, once the MAAO collections were moved out. And the Museum of Cinematography would leave the Palais de Chaillot for installation in the Palais de Tokyo.

The Commission also endorsed the establishment of a *vitrine* (display

window) or *antenne* (annex) to the new museum in order to showcase 150 to 200 selected masterpieces. This annex would open in the Sessions area of the Louvre in late 1999, with a budget of 30 million francs and a surface area of 1,400 square meters.

On 7 October 1996, the Élysée made it official as Chirac announced his decision to create a "museum of civilizations and *arts premiers.*" Interviewed a few weeks later on the occasion of his decision to move André Malraux's ashes into the hallowed space of the Panthéon, he spoke of his dreams for the new museum.

> We can have an extraordinary assemblage—on one side the newly renovated Musée Guimet for Asia, and on the other the future Trocadéro Museum with Africa, pre-Columbian America, Southeast Asia, the Arctic, and Oceania—in short, three-quarters of the world's humanity. This Trocadéro Museum will be at once a museum of man, of civilizations, and of arts with, I insist, a double dimension, both artistic and scientific. And its showcase in the Louvre will display in an appropriate setting some incontestable masterpieces. That way, people can admire an exceptional Fang statue at the Louvre and also discover, at the Trocadéro Museum, the history of that statue as well as its meaning in an ethnological, religious, and geographical context. We're talking about inventing a new kind of establishment at the Trocadéro.[11]

In February 1997 Chirac's prime minister, Alain Juppé, announced the formation of a planning commission, the Mission de Préfiguration du Musée de l'Homme, des Arts et des Civilisations, which would be composed of representatives from the relevant museums as well as other personalities and would be headed by the former director of the National Museum of Modern Art, Germain Viatte.[12]

Working out of two small rooms in the Louvre, Viatte was first faced with the job of "putting out fires" that had flared up at the Musée de l'Homme.[13] Within a month he was contesting the museum's claims that its unified purpose (i.e., the close working relationship among its three constituent departments of prehistory, biological anthropology, and cultural anthropology) would be threatened by the transfer of ethnographic collections to the future museum.

> We need to consider the unity of the Natural History Museum, but we might also question its reality. Does it make any sense on the ground? The behavior of certain laboratories, such as ethnology [cultural anthropology], suggests that it doesn't. It strikes me that the old debate about the aesthetic or ethno-

Germain Viatte (b. 1939) came to Chirac's museum project from a background in modern and contemporary art, largely through work at the Musée National d'Art Moderne of the Pompidou Center. He nurtured a particular interest in the "marginal arts of eastern Europe" and the arts of Asia. Outside of Paris, he was actively involved in the directorship of museums in Marseille and participated in the creation of a museum of African, Oceanic, and Amerindian art in that city. He served as director of the Museum of African and Oceanic Art from 1999 until it closed in 2003.[15]

graphic value of primitive art collections is completely obsolete and that it's simply being used as a way of masking power plays and interpersonal rivalries.[14]

Viatte and the working groups under him had a great deal on their plate: to inventory relevant collections in the Musée de l'Homme and the Musée des Arts d'Afrique et d'Océanie, plan for new acquisitions and new storage space, settle questions concerning the targeted audiences, figure out the respective attention to be given research and education, decide how to integrate contemporary materials, build relationships with other institutions (and their curators) both in Paris and internationally, set up a plan for making architectural decisions, deal with the administratively thorny issue of establishing a museum answerable to two ministries (culture and education), and make decisions about whether it should be independent (like the Pompidou Center) or attached to the French Museums Board.[16] There was also mediation to be done between the Louvre's director, Pierre Rosenberg, who (together with his senior curators) wanted his museum's participation in this affair to be as temporary as possible, and Jacques Chirac, who (like his friend Kerchache) envisioned the Louvre's eighth section as a long overdue, and permanent, solution to the "hierarchy of cultures." Even decisions about which parts of the world should be represented came up for debate. Kerchache argued for excluding Asia on the grounds that it had nothing up to the standards of the African, Oceanic, and American pieces he had selected.[17] For the Louvre galleries, he reluctantly agreed to include what Bernard Dupaigne has dismissed as "a few rotting sculptures from lost tropical islands in Indonesia, purchased from dealer friends of his."[18] The final selection included, among the 110 objects on display, just seven from Asia, of which five were Indonesian.[19]

Fundamental questions regarding the participation of people from outside the European orbit came into play as well. According to what I've been told by participants in the debates, Chirac often spoke of *arts premiers* and *peuples autochtones* in the same breath and brought up the possibility of calling on the latter to help in the presentation of the former. But others argued that eliciting the participation of living people from the cultures in question would get the museum involved with identitarian politics, which would in

turn take the project in the direction of ethnic militancy, and that social un-
rest would be the inevitable result. At some level it was a question of whether
to allow proponents of non-French cultural principles to have input into
what was, after all, an official French undertaking. So while "native voices"
were gaining significant ground in the museums of many countries around
the world, from Canada to New Zealand, there was real reluctance in Paris
to share authority over the presentation of exhibited materials with repre-
sentatives of different ways of seeing the world, even when they (or their fore-
bears) were the artists.[20]

And, finally, there was the issue of what to name the new museum. Sev-
eral members of the Friedmann Commission, including Françoise Cachin
(director of the DMF) and Jean-Hubert Martin (director of the MAAO), fa-
vored Chirac's original choice, "Musée du Trocadéro," in recognition of the
historic role of the Musée de l'Homme's parent institution. Inclusion of the
term "primitive art" was clearly out of the question from the beginning, but
"*arts premiers*" enjoyed sporadic approval as an acceptable substitute, as the
names "Musée des Arts Premiers" and "Musée de la Civilisation et des Arts
Premiers" were floated in early discussions. And press reports made frequent
mention of a "Musée de l'Homme, des Arts et des Civilisations" or a "Musée
des Arts et Civilisations."

Cohabitation

The [new Socialist] minister of education is working
to heal wounds among the academics who've been
sickened by the "brutal methods of the former
majority."*

The original launching of efforts to create a museum of art from Africa,
Oceania, and the Americas in Paris had been made possible by Chirac's rise
to the presidency in 1995, and during his first years in office, backed by a con-
servative government, he enjoyed something close to carte blanche. In that
politically solidary environment, Chirac had been free to make appointments
from his circle of friends and allies—men (for the most part) who shared a
vision in which aesthetic and ethnographic considerations worked together,
but in which the first of these was given clear priority[1]—and important steps
had been taken toward his goal of elevating *arts premiers* in the French mu-
seum world. The Friedmann Commission had been convened and had sub-
mitted its supportive conclusions, a presidential decision to create both a
museum of arts and civilizations and a "showcase" in the Louvre had been
announced, a committee (Conseil Scientifique pour la Préfiguration du
Musée de l'Homme, des Arts et des Civilisations) had been constituted to
work out a wide range of theoretical, philosophical, and practical consider-
ations, and Germain Viatte, a veteran of the art museum world, had been put
in charge.

*Emmanuel de Roux, "Grands travaux—Les chantiers se bousculent sur la colline de
Chaillot," *Le Monde,* 13 October 1997.

Cohabitation (*left to right*): Maurice Godelier, Jean-Michel Wilmotte, Jacques Kerchache, Stéphane Martin, and Germain Viatte, 2000. © Le Figaro Magazine. Photo: Véronique Prat/Figaro Magazine, courtesy of the Musée du Quai Branly. This photo was originally published in Daubert 2000c, captioned *"Les cinq sorciers du musée Chirac"* (the five sorcerers of the Chirac museum).

In 1997 the outcome of legislative elections redrew the political map, and Chirac, a conservative,[2] found himself leading the country in the company of a Socialist prime minister, Lionel Jospin.[3] The country entered a five-year period of "cohabitation," and museum planning followed suit. Funding of the multimillion-euro project was in danger of being denied unless the new leftist ministers of education and culture, Claude Allègre and Catherine Trautmann, would give a green light to this rightist-authored project.

Months prior to the legislative elections, Prime Minister Alain Juppé's appointment of Viatte to head the powerful planning committee had been seized on by critics, who read it as an imbalance between the concerns of art and anthropology, and now the Jospin camp was in a position to step in. Taking advantage of a veritable panic in the Chirac entourage that funding for the project would be denied by the Socialists, Jospin asked Allègre to solicit the advice of Maurice Godelier, a distinguished anthropologist and political supporter. Godelier's reaction was that presidential backing presented an exceptional opportunity, and that the key would be to turn the project into a truly postcolonial museum. With that goal solidly in mind, he accepted Allègre's invitation to become the museum's scientific director, and the committee became co-chaired, with an official division between "museological" and "scientific" responsibilities, carried respectively by Viatte and Godelier.

This division reflected at once the political sharing of power between the right and the left and the dual sponsorship of the museum by the ministries of culture and education.

Godelier had long been supportive of the fundamental principles behind the museum project. A signatory of Kerchache's 1990 manifesto, he was convinced that the Musée de l'Homme could not be saved and spoke about the proposed museum as a gesture that would put masterpieces from the whole world on an equal basis, showing that art history is not a matter of "progress" and that no one society has a monopoly on creativity. But he also had a more specific role in setting priorities for the project. He wanted to assure that visitors to the museum could "pass from the joy of seeing to the joy of knowing" thanks to the availability of information on the societies behind the works on display.[4]

As he wrote later, the plan he laid out to Chirac and his cabinet was vertebrated by five goals. The museum

. . . was to be a resolutely postcolonial museum, helping the public to step back and take a critical view of Western history.

. . . was to draw heavily on history, and especially the history of the societies whose objects were held in our museums.

. . . was to strive to combine two pleasures: that of art and that of knowledge . . . serving as a research center and a center of higher learning that would train young people, a portion of whom were to come from Africa, Asia, Oceania, and the Americas, to be both curators and researchers.

. . . was also to be the place and the opportunity for scientific and cultural collaboration with the countries where the objects originated.

. . . was to fulfill a function that was both political and symbolic, given its presence in an increasingly multicultural Western country like France, where immigration-related racism and xenophobia not only still exist but are on the rise.[5]

To implement these goals, he proposed complementing the four geographically defined departments of Africa, Oceania, Asia, and the Americas with a fifth department devoted to issues that concerned people around the globe. "Interpretive spaces" next to the exhibit areas would offer information on five existential questions that were at once universal and culture-specific in that every society raised them but each answered them in a unique

way—relations with the invisible world, structures of power, the life cycle, economics and exchange, and representations of nature.[6] An important reason not to restrict the museum to a continent-by-continent organization, he pointed out, was in order to bring European cultures into the picture.[7] This would go far toward countering the "us/them" vision of cultural difference, by presenting (for example) Christian rituals alongside those of societies viewed by museumgoers in an exoticizing light.

The Louvre, too, was to be equipped with an "interpretive area" separate from the exhibit spaces. Godelier's proposal to make information available recognized that, as he put it, "a museum is not a book whose pages are pasted up on the wall to be read. Nor is it a university where courses are taught." Rather, the interpretive material was to provide an accompaniment to the original pleasure of viewing, allowing visitors to explore at their own pace, in their own way. It was there to educate, but also to "encourage dreaming and set the imagination free."[8]

One discussion point in the implementation of interpretive materials concerned their physical placement in relation to the objects for which they offered contextualization. The dominant feeling within the committees was that aesthetic contemplation was best achieved through quiet communion with the object, and that the distraction of ethnographic information should be kept at a distance. Kerchache was a particularly outspoken advocate of this position:

> We're constantly faced with the seductiveness of things that can influence our gaze and distract us from the sculpture itself. I reject all those temptations. They get in the way of critical judgment and prevent access to the work itself, which should be uniquely focused on the artist's integrity, his project, his gesture, the courage of his volumes, regardless of his culture or the function, whether ritual or purely aesthetic, of the object. For that, there's no need for ethnographic translation.[9]

Kerchache's oft-stated goal was to "get as close as possible to the intent of the artist,"[10] and he was adamant that the object itself, cleansed of "ethnographic translation," was uniquely equipped to reveal that intent.[11] Cultural contextualization, he argued, represented interference with the communion between a great work of art and a sensitive viewer.[12] Other committee members seconded this approach, agreeing that a sculpture, by its very form, revealed eloquently how the artist was thinking, what aesthetic problems he was dealing with, and what strategies he was utilizing in his sculptural solu-

tions.[13] The discussion then turned to the establishment of an interpretive area separate from the exhibited objects rather than an integration of ethnographic information in the exhibit space itself.

On 30 December 1998, in the midst of these discussions, Stéphane Martin, who had been serving as vice president of the future museum for over a year, was appointed president-director. His presence put a drag on Godelier's more interpretation-oriented vision for the museum, and the two of them proved fundamentally unsuited, by both goals and personalities, for harmonious cohabitation.

> "A graduate of the École Nationale d'Administration and a member of France's Cour des Comptes, Stéphane Martin oversaw the Pompidou Center from 1989–1990 before taking over the Museum of Music and Dance. He served as chief of staff to Culture Minister Philippe Douste-Blazy from 1995–1997 while simultaneously assuming the vice presidency of the Musée de l'Homme, des Arts et des Civilisations."[15]

For more than three years, Godelier pushed his agenda energetically, meeting on a regular basis with Kerchache and Viatte. He also collaborated with Kerchache in the creation of a CD-ROM to be used in the interpretive space of the Louvre exhibit.[14] But personal frictions, internal tensions, and the difficulty of realizing an agenda that seemed in many ways to compromise the lifelong ambition of a very driven man who enjoyed the solid backing of the president of the Republic were overwhelming. One indication of how little importance museum personnel were giving to contextualization is that when the CD-ROM won two national prizes (one for the best CD-ROM on culture, the other for the best CD-ROM, period), no one other than Godelier attended the award ceremony. Listened to at the beginning, Godelier found his ideas increasingly blocked over time. In January 2001, after three frustrating years of battling for attention to cultural context in an otherwise aestheticizing conceptualization for the museum, he "threw in the sponge, . . . slamming the door" behind him.[16] As Élise Dubuc put it, after two years of cohabitation, the planning committee's efforts to hammer out a project that either met approval from the two parties or was powerful enough to make one of them give in "had attained the scale of a great epic battle."[17]

Godelier's replacement, Emmanuel Désveaux, an anthropologist who specialized in North American Indian cultures, was by all accounts a far weaker warrior in the battle for an anthropological vision, lacking both the stature and the combative spirit of Godelier. For the next four years, he filled the position, but the art-establishment members of the organizational team were essentially free to determine the shape of the future museum, with little if any pressure to make concessions concerning the balance between aesthetic and ethnographic considerations.

Then, a year before the museum's opening, Désveaux was replaced by Anne-Christine Taylor, a specialist on Amazonian Indian cultures. Many anthropologists viewed her appointment as a small victory for their beleaguered constituency and were guardedly optimistic that she would be able to engineer a contextualizing dimension to the museum. But in the seven years since the high-profile appointment of Godelier as Germain Viatte's dynamic counterpart, authorized to push for a revolutionary postcolonial vision, the position had been drastically downsized and largely leeched of power to influence the museological program. The dividing line that had by then been institutionalized between museological and "scientific" responsibilities meant that contextualization in the exhibits was excluded from her field of action, and that her charge was largely limited to the administration of educational programs (many of them for young schoolchildren) and short-term posts for visiting researchers. One reflection of the authority she was given is that the department she heads consists of six people, while that of Viatte's successor, Jean-Pierre Mohen, boasts no less than sixty-six. And while Godelier had envisioned fifteen research positions (ten French, five foreign), each lasting some four years, the research posts eventually advertised by the museum in 2006 specified periods of one to twelve months and were awarded to three graduate students and four recent PhDs.

In-House Rumblings

Opting for an artistic presentation with an anthro-
pological sauce might appear to be the height of
consensus, but . . . in trying to play both ends
one risks a cacophony that will please no one.*

From Jacques Chirac and Germain Viatte on down the line of command,
there were repeated assertions, both in the press and in conversations I had
with members of the MQB team in Paris, that the battle between aesthetic
and ethnographic presentations had ceased to provide a useful axis of dis-
cussion.[1] At the same time, my conversations with a large number of an-
thropologists who had at some point taken part in the process suggested that
it was still a burning issue and a significant tool for political and intellectual
control of the museum plans.

One sore point was the roster of experts selected to guide the project,
which included a heavy representation of collectors and dealers and relatively
few anthropologists.[2] Access to the press became a precious commodity, and
feelings ran high when it was denied. One supporter of the new museum sent
a photocopy of an article expressing reservations about the project to a col-
league with a handwritten note: "The press campaign of [. . .] continues.
They've even started calling on second-string players. 'Le Monde' refused my
text with no explanation. Maybe you'll have better success."

Participants in the process who felt that their voices were not being prop-

*Nélia Dias, "Esquisse ethnographique d'un projet: Le Musée du Quai Branly," *French
Politics, Culture & Society* 19, no. 2 (2001): 86.

erly respected occasionally became involved in clashes that tested the collegial cordiality of committee members. In 1997 Jean-Hubert Martin (then director of the MAAO and a member of the Friedmann Commission) addressed a four-page letter to the minister of culture, Catherine Trautmann, charging that a European-American network was being privileged at the expense of participation by people from the cultures to be represented and that an aesthetic canon based on a "classic pre-colonial primitivism" was being promoted. The letter ended by saying that if things didn't improve in the committee, he and several of his colleagues were prepared to terminate their cooperation with the project.

In 1998 two members of the Conseil Scientifique became particularly exercised about the way things were being handled and wrote first one and then (receiving no reply) another letter to co-directors Viatte and Godelier, detailing their concerns. Noting that the selection of objects to be exhibited in the new Louvre wing were being made by a single individual, Jacques Kerchache, on the grounds of the objects' "major artistic interest," Claude Baudez and Jean Jamin lamented that no working definition of that term had ever been set out. As they saw it, he had based his choices on two considerations—first, a Western privileging of objects, preferably in stone and wood, that were characterized by symmetry, purity in their lines, equilibrium in their volumes, and a smooth or polished patina; and second, the objects' conformity with an early twentieth-century primitivism that was operative in the encounter between artists such as the cubists and tribal art. Kerchache's exclusive focus on sculpture, they suggested, would give museum visitors the erroneous impression that "primitives" expressed themselves only in three-dimensional materials. Rather than showcasing the personal favorites of a single person, they asked, wouldn't it be more fitting to celebrate the creativity and originality of the arts of other cultures by choosing provocative pieces of greater diversity—artworks made of materials such as feathers or obsidian, unusual forms such as Ashanti ironwork, and so on? And why not take into consideration the available knowledge about particular forms, for example, choosing the well-documented Tupinamba club collected by Thevet rather than a stone mask from Teotihuacán about which nothing is known? (Answer: The mask from Teotihaucán, though decidedly unexceptional from an aesthetic point of view, had been owned by both Diego Rivera and André Breton.[3]) They requested the creation of an ad hoc work group to discuss these issues.

The response (which came four months after their first letter and one month after the second) began by accusing the complainers of "persistent misunderstandings" about the functioning of the Mission de Préfiguration

and of a lack of respect for persons of recognized competence, most notably Monsieur Jacques Kerchache, without whose initiative none of them would have had the privilege of being involved in planning a museum of *arts premiers*. It then laid out, in legalistic language, the directives of the Mission, in which the two directors of the project were responsible for submitting proposals regarding the enrichment of collections to the State, in which the preselection committee for acquisitions was charged with expressing opinions on the directors' choices, and in which the Scientific Council's job was to assist the directors of the project in their functions. Neither the Scientific Council nor any work group, they explained, was authorized to elaborate a selection of objects for the Louvre annex.[4]

The fact that the letter was signed by both Germain Viatte and Maurice Godelier showed that the fault lines erupting in the organizational structure were not purely a matter of incompatibility between aesthetic and ethnographic views. Beneath the contentious tone of such exchanges lay serious issues concerning the basis of evaluative judgments by anthropologists and art experts, but there was also a grain of truth lurking in Viatte's claim that these arguments were tied into "power plays and interpersonal rivalries"—or at least that they came over time to involve antagonisms on a highly personal level. In any case, the animosities that developed did little to promote cooperative decision-making, and defections from the committees were sometimes the final result.

The atmosphere for those working on the organization of the new museum was also affected for several years by the presence of an unusually directive woman who had served at Chirac's right hand when he was mayor of Paris and who, partly on the basis of past loyalty, joined the Quai Branly team as secretary general, directly under the president-director, Stéphane Martin. Quite a few people described to me how she ruled the operation with an iron hand, instigating procedures (from locked office doors, pre-opened mail, and security badges to, one said, personal harassment of an intimate nature) that instilled fear in some, brought tears to others, led to resignations, and generally set a tone of "gratuitous authoritarianism." Appraisals of her years at the helm were rife with references to nightmares, infantilism, Hitlerian tactics, military commandos, and the Roi Ubu.[5] One former staff member remarked, "If you saw how [she] and [Stéphane] Martin worked in the most absolute secrecy, you would have thought they weren't building a museum, but rather an atomic bomb." Submissive compliance was mandatory, and in the space of four years, half of the museum's employees were reportedly replaced in favor of "more docile" colleagues.

Playing a central role in these accounts was a large Labrador named Heur-

tebise, who came to work regularly with his mistress, had the run of the offices, and often required care by museum staff. The secretary general is said to have declared herself distinctly unsympathetic to anyone who didn't love animals. I was told that she shared her bed with Heurtebise and required her human bedmates to do the same, though I took this less as a factually reliable report than as the kind of folklore that often gets attached to a colorful personality. When he turned ten, the entire Quai Branly staff was invited (and strongly encouraged) to attend a birthday party at the home of his mistress. After several difficult years, even her unswerving loyalty to two presidents (one of the museum, the other of the Republic) couldn't overcome the deleterious effect she was having on employee morale, and in 2003 Chirac appointed her to a new position as *maître des requêtes* on the Conseil d'État. At which point, everyone agreed, things began to move much more smoothly toward realization of the museum.[6]

The virtually unanimous reading of the project by anthropologically leaning participants and observers was that decision-making power had been jealously guarded by aesthetically leaning members of the team. Numerous insiders to the process assured me that committees were stacked in order to rubber-stamp Kerchachian decisions. On the acquisitions committee, a specialist on one continent would be asked his opinion on objects from areas of the world about which he had no expertise, while his advice on pieces he knew from top to bottom would be thrown out whenever it went against Kerchache's aesthetic reading. "Everything was decided unilaterally," concluded a former curator from the Musée de l'Homme. "They could have spared themselves all the so-called meetings of reflection, which served for nothing. Nothing but a decoy."[7] But it wasn't simply a matter of disciplinary affiliations. An art historian who occupied a position at the top of the hierarchy, but whose ideas about the museum differed from those of Martin and Viatte, echoed Godelier's allusions to symbolic humiliations—telling me how (for example) he was required to leave his identity card at the security desk when he entered the building and to get written permission each time he wanted to enter the storage area.

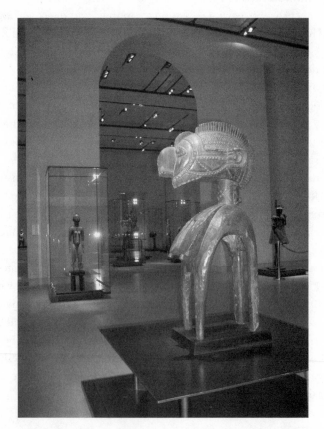

Pavillon des Sessions, Musée du Louvre, 2005. Photo: Sally Price.

A Dream Come True

African fetishes under the same roof as the *Mona Lisa*,
savage masks within striking distance of the Venus
de Milo, . . . the unthinkable has happened.*

The era of disdain is behind us. "Primitive art" has just
entered the Louvre.†

On Thursday, 13 April 2000, the newly designed Pavillon des Sessions was inaugurated jointly by President Chirac and Prime Minister Jospin. One hundred and seventeen exquisite sculptures, some culled from museum holdings and others purchased from well-known collectors, were on display in France's most prestigious temple of art. Early reviews noted that this new section of the Louvre was "impossible to find,"[1] but for those in the know, there was a new entrance at the Porte des Lions, more aesthetically modest than the grand entrance at the glass pyramid, but offering direct access (at least on those days when it was open) to the African, Oceanic, Asian, and American exhibits.[2]

The installation design was praised all around. Architect Jean-Michel Wilmotte, working in close collaboration with Jacques Kerchache (known for his special gifts in the art of lighting), had successfully realized stylistic continuity with other halls of the Louvre, utilizing the same stone floor, the

*Emmanuel de Roux, "Les sculptures de quatre continents font leur entrée au Louvre," *Le Monde*, 14 April 2000.

†Jacques Kerchache, "Au regard des œuvres," in *Sculptures: Afrique, Asie, Océanique, Amériques,* edited by Jacques Kerchache (Paris: Réunion des Musées Nationaux, 2000), p. 17.

same white molding, and simple glass cases, widely spaced.[3] There was no visible evocation of exoticism. As Stéphane Martin explained the idea behind the exhibit design, "African art has always suffered from being unrecognized for its autonomous qualities. Our goal is to present it in a context that allows people to appreciate its intrinsic value."[4] Kerchache wanted to allow the objects "space to breathe," using the 1,400 square meters for just some 120 objects. The normal number of objects for that surface area, he told an interviewer, would be 3,000.[5] One journalist described it as a "Zen environment,"[6] and another dubbed it "a presentation completely free of all mise-en-scène."[7] Others have argued that, on the contrary, its clean sparseness constitutes a well-known mise-en-scène, one that explicitly evokes an upscale art-gallery environment.

Kerchache had eschewed new discoveries in his selection of pieces to display—virtually every object was a veteran of earlier publications and exhibitions, as Africanist art historian Jean-Louis Paudrat pointed out.[8] "Excellence of form," Kerchache insisted, had been the determining factor—not material quality, monumentality, rarity, ritual or functional use, and not even prior ownership. Nevertheless, one couldn't help but note some familiar names on the labels. As one reporter put it, "Shades of artists and famous collectors drift among the cases."[9] Pieces from the collections of Pablo Picasso, André Breton, Paul Guillaume, Helena Rubenstein, Max Ernst, and Claude Lévi-Strauss carried their pedigrees proudly. Peter Mark, reviewing the new galleries in *African Arts,* commented:

> For many objects in the Pavillon des Sessions, the viewer learns more about their (post-African) pedigree in French collections than their African provenance. . . . Are the curators trying to tell us something? Are we to accept that the sculpture is important, not because of the significance [for a Benin bronze plaque] of metal-casting in Benin or the inherent qualities—ethnographic or even aesthetic—of the work itself, but rather because it has the imprimatur of five European collections?[10]

What, besides the pedigree, was on the labels? A reviewer in *Le Figaro* was impressed: "Beauty has not been the only criterion for selection. Knowledge has been equally privileged. You notice it as soon as you enter the area devoted to Africa. There, just as in the following three areas, a label mentions the country of origin for each piece."[11] For most visitors, however, it seemed that contextualization (whether geographical, historical, or ethnographic) had not been a top priority. Objects floated in space, separated from each

other like estate homes in a gated community. Identifying labels were placed at some distance as if proximity would somehow contaminate the central activity of aesthetic appreciation. It was impossible not to marvel at the forms themselves, all stunningly beautiful or simply enchanting in this "aggressively aestheticizing"[12] exhibition, but it was not so easy to know what they were or where in the world they had been created. As one reviewer put it, "The visitor needs to wander around before finding a label on the wall."[13] Another: "It's a shame that the labels, those precious explanatory vignettes, have not been placed near the objects on exhibition."[14] One of the reviewers who picked up on this feature, Annie Coppermann, commented that the artworks were "too solitary. No explanation is provided, and the discreet designations, sometimes quite distant from the sculptures, leave the visitor hungry for information."[15] "It's difficult to visit this exhibit without the catalog," she went on, but at nearly six pounds and with a 340-franc price tag, that volume wasn't the sort of exhibit guide that people were likely to have in hand while strolling through the galleries.[16] Visitors could scout out the pockets placed around the galleries and look through them for the large clipboard-like card that carried the description of a particular object, but little help was offered for finding the right card, and many of them got returned to the wrong pocket, making the search for background on some of the objects an exercise in frustration.[17] Nor were audio tours available. Kerchache explained this choice: "The reason I didn't allow those little gimmicks to put in the ear is because you don't look at art through earphones!"[18]

Jacques Kerchache's preference for separating visual presentation from contextualization was not limited to the work of artists from Africa, Oceania, America, and Asia—he subjected his second passion to the same treatment. An Amazon.com review of his book *The Hand of Nature: Butterflies, Beetles, and Dragonflies*[19] complains that "no information is provided about the insects, not even their names. If you wonder if you recognize an insect, there is no way for you to check. If you see an insect that you'd like to learn more about, too bad. If you'd like to use the book as a teaching tool, you can't unless you're able to identify the insects yourself."

. . . But let's leave the beetles behind and get back to the Louvre. In addition to the wall labels and the pockets of cards, an "interpretive area" was provided for visitors wishing to supplement their visual contemplation with background information. The existence of that area was not signaled in the main galleries, however, and most people walked by the entrance to it without noticing its existence. Tucked back behind an area devoted to Oceania, it offered ten computer stations, each equipped with *Chefs-d'œuvre et civili-*

sations: Afrique, Asie, Océanie, Amériques, the prizewinning CD-ROM that had been prepared under the direction of Maurice Godelier and Jacques Kerchache. Having heard of it by the time of my next visit, I managed to find the space, only to discover that six of the ten computers were down (a situation that others claimed was not unusual) and none of the others were in use. Two dog-eared books were available for consultation: *Sculptures: Afrique, Asie, Océanie, Amériques* (the exhibition catalog edited by Kerchache) and *Jacques Kerchache: Portraits croisés* (the book of homages that was published after Kerchache's death).

The only other offering of the interpretive area was a film projected on a large screen at the front. Expecting to see scenes from some of the geographical/ethnographic areas featured in the galleries, I was surprised to watch as the camera panned over the library of André Breton, focusing on books, ceramics, masks, and paintings in the artistically cluttered home of this father of French Surrealism whose collection had provided several of the masterpieces displayed in the exhibition galleries.[20]

The Breton film's predecessor on the screen had been a film on Kerchache. A film that I later viewed at the MQB, apparently the one shown in the Louvre, depicted Kerchache in five roles—"the adventurer," "the collector," "the visionary," "the perfectionist," and "a particular gaze."[21] The first showed Kerchache in Africa in the 1960s, bravely crossing a jungle bridge of lianas in shorts and a pith helmet. The other four sections were filmed when cancer had already reduced his voice to a hoarse whisper, but in spite of the evident pain, he made the effort to express his feelings, his philosophy, his relationship to the objects of his passionate affection. In the second section, he is caressing an elongated figure and discoursing on its sensuality. In the third section, which shows him in a suit and long overcoat sweeping through the galleries of the Louvre, a decidedly dramatic effect is created as the camera switches into subtle slow motion to depict the museum visitors around him. In the fourth, he's wearing a turtleneck and adjusting the lighting to the very millimeter. And the final scene is an interview in his study.

What were visitors meant to retain from this part of the museum? How were they to balance the creativity of the artists whose works were displayed in the galleries versus the aesthetic sensitivities of French men who had validated them for a European audience? The interpretive space seemed designed to discourage museum visitors from exploring the cultural worlds in which the objects on exhibit had been created.

A basic stumbling block in establishing the new galleries had concerned the limits of the Louvre's mandate. With impressionist art now making its

principal residence the Musée d'Orsay and modern art settled in at the Centre Pompidou, the Louvre was in a good position to confirm its purview as ending at 1848. The great bulk of artifacts from the Musée de l'Homme and the Musée des Arts d'Afrique et d'Océanie, however, had been fashioned more recently, and thus would have failed to qualify for inclusion on chronological grounds. The solution: a combination of careful selection to favor archaeological pieces and perhaps some creative reevaluation of the dates of particular objects.

Not everyone was happy to see these new artworks take up residence in the Louvre. As one journalist put it, "The *Mona Lisa* must be surprised, but at least she's still smiling. Not so for the curators, who wanted nothing of these Oceanic fetishes, these figures from Gabon, these Inuit masks."[22] Their opposition to the entry of primitive art in the Louvre was deeply felt. When plans were made for a pre-opening preview of the exhibit, the president-director of the Louvre, Pierre Rosenberg, refused to allow his name to appear on the invitation.[23] And during Chirac's speech at the inauguration of the galleries, "Rosenberg stood behind him making faces."[24]

Once the deed was done, the most delicate question became whether it was to be permanent or temporary. Rosenberg was clear about his position:

> The Louvre does not have the vocation of presenting the arts of every civilization in humanity. Our collections have the more modest goal of illustrating the art of the Western world from the Middle Ages to the mid-nineteenth century, plus that of the civilizations of antiquity from which it sprang. That job is quite enough for us. In 2004 the Quai Branly Museum will be presenting the totality of its collections, and it makes no sense for its visitors to be deprived of the opportunity to see the great works that we'll be temporarily sheltering here.[25]
>
> It would have been absurd for the Louvre to keep the best Chinese masterpieces when Asian art was installed in the Musée Guimet, or Manet's *Olympia* when art from the second half of the nineteenth century went to the Musée d'Orsay. We certainly hope that when the Quai Branly Museum is built it will not be giving up its best pieces to an exhibit in the Louvre.[26]

People on the other side of the issue were equally definite. "Is this a preview of the museum being built on the Quai Branly?" a reporter for *Le Figaro* asked Kerchache on the day of the Louvre opening. "Absolutely not," came the answer. "This is for eternity. This will never budge."[27] But most observers saw it as a matter of simple power politics. As Lévi-Strauss told me, "It was

an idea pushed by the president of the Republic, and once he's no longer there, after a few years it will all go back to the Quai Branly."[28]

Whatever the ultimate destiny of *arts premiers* in the Louvre, they are as of this writing enjoying their corner of the museum, drawing smaller crowds than the halls devoted to Italian paintings or Greek statues, but holding their own as Louvre-level masterpieces. In the spring of 2003, a celebration was held to mark the first three years of the gallery's existence. Emma Stratton, an eleven-year-old from California identified as the two millionth visitor, was honored in great ceremony.[29]

The spirit of Jacques Kerchache, who had died two years earlier, was the dominant presence. The multi-authored volume dedicated to his memory, *Portraits croisés*, was timed to be published for the occasion, and Jacques Chirac opened the ceremony with a passionate homage to the gallery and to his friend, whose drive and vision stood behind it. "More than two million gazes have fallen on these pieces culled from every continent," he declared, "more than two million visitors have come to begin a wondrous voyage into the heart of these distant arts."

> Could one possibly imagine a more extraordinary voyage than this one, fascinated as we are by the power of the effigies, the perfection of form, and the creativity of these sculptures? . . . The new emotion produced by the works now surrounding us, and the opening of minds that they inspire, are the source of new relationships founded on understanding, mutual respect, dialogue, and exchange, relationships that deserve to come into play at a moment when the destinies of different peoples intermingle as never before. At this time of identitarian tensions that all too often promote intolerance and a rejection of others, at this time of spreading globalization heavy with the menace of uniformization, it is respect for cultural diversity and intercultural dialogue that, more than ever, can guarantee peace. To know each other better is to understand each other better, it's to respect each other better, it's to live together.

More than half of his 1,500-word speech was a moving homage to his friend Jacques Kerchache, whose name had just been given to the Reading Room of the future Quai Branly Museum.

> I remember Jacques Kerchache, exhausted but radiant, placing the display cases to the exact millimeter, balancing himself on a ladder in order to position each lighting fixture, adjusting the presentation of each object with infinite care, and rereading the labels with the precision and demanding atti-

tude that characterized everything he did. The galleries that we've just visited are the mirror of his soul. They were his final act. They are the reflection of his love for the objects and their creators. For beyond the formal perfection of each work of art, Jacques Kerchache admired first and foremost the artist, a man of inspiration, sensitivity, and genius. . . . Jacques Kerchache's involvement, his competence, and his sensitivity have advanced intercultural dialogue.[30]

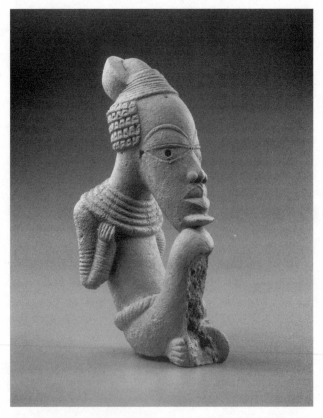

Nok terra-cotta statue purchased by France in 1998. © Photo SCALA, Florence. Musée du quai Branly.

Artifactual Question Marks

Even if you're careful you can still have problems.*

13 April 2000. The gala opening of the new galleries at the Louvre, inaugurated "in lyrical accents"[1] by the president of the Republic, was a front-page event that sent hundreds of journalists jousting for original angles on the story. Not surprisingly, challenges to the accuracy of factual claims about the art were quick in coming. Within five days Reuters reported that an anthropomorphic sculpture on display, identified as having been made during the seventeenth or eighteenth century on Easter Island, was a fake. Laboratory analysis showed, it said, that the wood was not from the *toromiro* tree sacred to ancient Easter Islanders, but rather a kind of acacia from Tahiti. And it cited the authority of an Oceanic specialist who declared that it was "a skillful fake, but a fake nonetheless." The very next day, however, Polynesian experts presented detailed documentation on the history of the object in Paris collections that erased any doubt about the statue's authenticity.[2]

Other challenges, many of them turning on ethical questions, were less quickly put to rest. There was, for example, a prolonged debate over two terra-cotta sculptures from the Nok civilization (500 B.C.–200 A.D.). The French State had purchased them in 1998 from Samir Borro, a dealer in Brus-

*Germain Viatte (referring to the Nok statues in the Louvre), quoted in Clothilde Warin, "Fallait-il un nouveau musée?" *Epok* 56 (June 2005): 51.

sels widely reported to traffic in illegally imported art from Nigeria. The price: 2.5 million francs, part of a 150 million–franc budget for new acquisitions of *arts premiers*. The director of UNESCO, which had agreed to co-sponsor the exhibition, was notable by his absence from the opening ceremony on 13 April, and he indignantly demanded an explanation for the museum's apparent complicity with illicit traffic in archaeological artifacts.[3]

A journalist for *Libération,* Vincent Noce, got on the case the very day of the opening, asserting that the presence of these statues in the Louvre reflected the museum's blatant disregard for international conventions prohibiting the exportation of such figures from Nigeria, where they had first been unearthed by tin miners.[4]

The tempest over Noks in the Louvre brought other cases to public attention as well. It was pointed out, for example, that the MAAO had purchased two Noks in 1989 and 1992, with two more coming in from the Barbier-Mueller collection in 1996, and that Djenné statues from Mali had also entered the collection—all without much notice and in clear violation of national laws, UNESCO conventions, and the guidelines of the International Council of Museums (ICOM).[5]

In the animated back-and-forth that followed in the press, curators responsible for the Louvre exhibit did their best to avoid blame. Stéphane Martin, president of the Musée du Quai Branly (which had responsibility for the Louvre gallery), conceded that the circumstances of the statues' departure from Nigeria were well known but suggested that "playing ostrich" about the illicit market would not really have helped matters (since the traffic would continue to exist regardless of whether the Louvre got involved), and that in any case it was important to exhibit Nok culture in the company of the "summit" of world art (i.e., works in the Louvre). "It's better to have them on exhibit than back there in their caves," he suggested, calling on a logic that had long been used by others to justify the pillage of art from Africa and other corners of the non-Western world.[6] His claim to have consulted both UNESCO and ICOM several times and received a green light was vigorously denied by both organizations.[7]

The newly appointed minister of culture, Catherine Tasca, found herself in the unenviable position of inheriting what was being called a "poisoned dossier"[8] and, as one of her first on-the-job duties, having to deflect charges regarding a project that had direct presidential backing. She explained that an agreement had been made with the Nigerian minister of culture a few months earlier (7 February), authorizing the Louvre's acquisition of not two, as initially reported, but three sculptures.[9] In the agreement, France pledged support for research and exchange with Nigerian curators, but its attempt to

extend the provisions to allow for future acquisitions was refused.[10]

However, that hardly settled matters. The document wasn't signed until a year and a half after France had bought the sculptures from the dealer in Brussels, a friend of Jacques Kerchache.[11] And its authenticity was called into question, since it was presented to the Nigerian president precipitously during a State visit without going through the normal diplomatic channels, had some provisions crossed out without being initialed, and lacked the customary initialing by the two parties on its first six pages. The Nigerian ambassador in Paris denied being present at the signing of the agreement, noted the lack of a certificate of exportation, and objected that the document had not been submitted to the National Heritage Commission of Nigeria for approval, as required.[12]

Chirac was in the eye of the storm, having interceded personally with his Nigerian counterparts, beginning in 1998, in an effort to smooth over the sale. The secretary general of ICOM requested that the pieces be returned to Nigeria. British archaeologist Lord Colin Renfrew, who had come to Paris to celebrate the thirtieth anniversary of UNESCO's convention against illicit traffic, apologized for making comments critical of his host country and then lashed out:[13]

> Great men of State should have the perspicuity to realize that the protection of the shared human patrimony is a matter which goes beyond chauvinism. This is not an honourable request to be made by a head of State. I regret that the president of Nigeria acceded to that request, but I criticize above all the head of State of France for making it. . . . I can think of no more shaming circumstance than this double prostitution of a nation's heritage—not just the initial illicit export but this flagrant repetition of the offence. . . . It is regrettable that a head of State took it upon himself to act in such a dishonorable manner, contrary to international law with regard to these objects.[15]

"The collector . . . pays poor villagers to take him to the houses of traditional healers, to hidden shrines in caves and to sites of traditional agricultural rituals associated with the fields of village farmers. [The collector defends his practice by telling a journalist:] 'Oh, they are just put out there to rot. No one places any value on them. If we didn't rescue them, these beautiful masks would simply be allowed to disintegrate.'

"'Why are they put out there?' [the journalist] asked.

"He replied, 'As part of some ceremony, they leave them there to rot.'

"'What will the farmer think when he returns to his ritual site and the mask isn't there?'

"'Oh, he'll probably just think the mask rotted away to earth faster than usual.'

"'And the ritual objects in the caves?'

"'Well, the cave I showed you a picture of . . . I just photographed the masks and other artifacts and left them there.'

"'Why?'

"'Well, it was close to town and well known and people might have gotten upset.'"[14]

"The most highly prized pieces come from the region of Sokoto, from Katsina in northern Nigeria, and especially from the plateau of Bauchi, near Jos, where vestiges of the Nok civilization are found under the ground. Since colonization the Nigerian laws are explicit: all archaeological pieces taken from the earth are the property of the State, and exportation is prohibited. Nevertheless, since the early 1990s, a considerable hemorrhage has been emptying Nigeria of the earliest evidence of its past."[19]

The *Journal of Museum Ethnography* published Frank Willett's equally angry reaction,[16] and Africom, an organization of African curators, accused the museum of legitimating the pillage and traffic in art.[17] Germain Viatte protested that the museum's actions were entirely legitimate: "By buying objects like these from private sellers and placing them in public collections, the museum is in fact serving a higher purpose."[18]

Meanwhile, the case of several other objects from the Nok culture that police had seized in a Paris auction house was brought before a court in Paris, and the judges rendered their decision on 20 October 2000. Reproaching the Nigerian authorities for being unable to specify the dates on which the objects had left the country and for having failed to produce a proper classification of them, they declared the Nigerian legislation inadmissible because it was written in English rather than French. And when the Nigerian embassy protested that they had never been informed about the case coming up for trial, a representative of the court explained that the person sending out the notice had inadvertently addressed it to Niger rather than Nigeria.[20] In November 2000 another Nok statue entered France, this time going to collections of the Museum of African and Oceanic Art, which were already slated for transfer to the Quai Branly. The three-faced figure was a gift from Roger Azar, a French businessman "with a prominent presence in Congolese financial affairs who also has a passion for African art."[21] A communiqué from the Quai Branly Museum declared that "these objects were acquired according to legal procedures and under the control of the relevant French and foreign authorities."[22] To my knowledge, there was no follow-up.

Twenty months after the earlier controversy over the Louvre's Nok statues broke in the press, Stéphane Martin announced that the problem had been fixed via a negotiated settlement that recognized Nigeria's juridical ownership of them but gave them "on loan" to France for a period of twenty-five years.[23] (There is some confusion about the exact terms. In 2005 Germain Viatte told a reporter that the statues would stay in France "thirty or fifty years," but in 2006 he wrote that the agreement lasted for a renewable twenty-five years.[24] And in September 2005, when I spoke with the person in charge of handling such matters for the MQB, she told me that a "memorandum of understanding" had just been concluded that morning

that allowed France to hold the pieces for thirty-seven years—see "Behind the Hairy Wall," below.)

But before going further with this subject, a digressive caveat is in order.

It's important to recognize that debates over the legitimacy of one or another policy concerning the ownership of archaeological artifacts constitute part of a complex can of worms within which it would be naive to aim for simple, evident, definitive, or entirely comfortable conclusions. The recent flood of writing on cultural property rights makes it abundantly clear that the responsibilities for illicit traffic are multiple, that any regulation of them involves difficult trade-offs (e.g., between international, national, religious, ethnic, and even individual interests), and that the passage of time further muddies what might otherwise seem to be clear principles of ownership.[25] Both those (e.g., many in France) who insist on the inalienability of museum holdings once they enter a collection and those (e.g., many in North America) who argue in favor of selective repatriation are players in an ethical and legal minefield.

In the case of the Quai Branly Museum, most of the charges concerning the legitimacy of particular artworks or acquisition policies have been set in the context of international laws and conventions. But philosophical consideration of those laws and conventions introduces questions about their historical and cultural justification that don't deserve to be swept under the rug. A recent article by Kwame Anthony Appiah takes a hard look at the very definition of "cultural patrimony," pointing to a problematic conflation of the ideas of a "people" and a "nation" that has the effect of unsettling absolutist positions regarding property rights and repatriation. He writes:

> Most of Nigeria's cultural patrimony was produced before the modern Nigerian state existed. We don't know whether the terra-cotta Nok sculptures, made sometime between about 800 B.C. and 200 A.D., were commissioned by kings or commoners; we don't know whether the people who made them and the people who paid for them thought of them as belonging to the kingdom, to a man, to a lineage, or to the gods. One thing we know for sure, however, is they didn't make them for Nigeria. Indeed, a great deal of what people wish to protect as "cultural patrimony" was made before the modern system of nations came into being, by members of societies that no longer exist.[26]

In a similar spirit, David Lowenthal, calling repatriation claims "dodgy," points to the fictional nature of the essentialized, enduring ethnicities that are used to justify them:

There are no well-attested, long-enduring, pure, unchanged social or cultural entities. Every people are hybrid, every legacy multiple, every society hetero-geneous, every tradition as much recent as ancient. All cultures are compages stemming from manifold antecedents.[27] ·

I once had a T-shirt from the African Studies Association with a motto on the back declaring: "No condition is permanent." This simple fact, applicable to both (culturally/ethnically defined) peoples and (politically constituted) nations, raises real questions. Is a nation's obligation toward material trea-sures that are found within its borders best conceptualized as "ownership" or "trusteeship"? Do such antiquities automatically belong to the State, or may they be owned by individuals? Should legally recognized owners (whether in-dividuals, cultural groups, or States) be allowed to sell such treasures? To ex-port them? To destroy them? And under what conditions?[28] Appiah recounts the well-known story of the Taliban's destruction of "blasphemous" Bud-dhist art, following unsuccessful attempts by concerned scholars and cura-tors in Switzerland and Afghanistan, together with moderate Taliban offi-cials, to secure UNESCO's permission for exporting them out of Afghanistan for safekeeping.[29] And he cites negotiations regarding a Greek vase and an Etruscan candelabrum in the Getty collection, following the Italian govern-ment's plea to "give back to the Italian people what belongs to our culture," which ended in a successful agreement for repatriation. "I confess," writes Appiah, "I hear the sound of Greeks and Etruscans turning over in their dusty graves: patrimony, here, equals imperialism plus time."[30]

The political and legal twists and turns of cultural property negotiations are often as intricate as the ethical ones. A recent story reported in the *New York Times* involves the illegal sale of a ceremonial vessel from the Persian Empire, its seizure by federal prosecutors, and lawsuits by a group of Amer-icans injured in a suicide bombing in Jerusalem, first against Iran (as a po-litical ally of Hamas) and then against the Oriental Institute of the Univer-sity of Chicago (which holds Iranian artifacts). The plaintiffs' goal is to force the sale of Iranian antiquities in order to produce the $300 million that they were awarded by the court, but which the United States cannot seize because of legal principles that effectively immunize a foreign government against such seizures.[31]

Now, sobered by the realization that no position on these matters is be-yond critical discussion, let's get back to the Louvre.

One reflection of curatorial discomfort about the circumstances sur-rounding the acquisition of particular objects in the museum, easily missed by visitors or catalog readers, can be found in the credit lines for published

pieces. Kerchache declared: "We have taken care to publish the complete pedigree of each of the objects on display."[32] Most items in the Pavillon des Sessions wear their provenance proudly: former collection of André Breton, of Guy Joussemet, of Charles Ratton, of Claude Lévi-Strauss, et cetera. Some of them have quite detailed information on their original entry into Europe: work collected by Denise Paulme and Deborah Lifchitz between 25 May and 30 May 1935 in the village of Yayé on the cliffs of Bandiagara and given to the Trocadéro Museum of Ethnography in 1935, work collected by Jean Guiart in the north of the island of Ambrym in September 1949 for the French Oceanic Institute, and so on.[33] And many of the catalog entries are quite specific about the site at which the object was originally found; a statue from the Republic of the Congo, for example, was "collected by Robert Lehuard in 1924 in the village of Mayama (subgroup Wumu), about 65 kilometers north of Brazzaville."[34]

The Nok statues are the exception to the rule, with no information on their pasts—no mention of their excavation from Nigerian tin mines or their clandestine exportation from the country, and no "former collection of" entry, for which the name of a notorious dealer in Brussels would have to have been inserted. Instead they are identified rather tersely, via a simple "Musée du quai Branly."[35] Germain Viatte later maintained this telling distinction in a book focused precisely on the museum's acquisitions policy.[36] It is not by chance that his caption for figure 18 (a statue from Burkina Faso) specifies "Former collection of Samir Borro," but that his caption for figure 3 (the notorious Nok, acquired from the same source) does not.

The decision to suppress certain kinds of information about the origin of particular artworks must have been argued with some passion in committee meetings, at least once Viatte was joined by a director of research in 1997. Maurice Godelier's idea was that each object should be presented in terms of four dimensions—its formal (aesthetic) properties, the way it was used in its original setting, the nature of the society where it was made, and the history of its arrival in French collections. This last dimension, he argued, would be a good way to get into both the complex story of relations between France and the objects' original societies and the interesting biographies of the people responsible for the arrival of objects in French collections. He cited a seated figure from Guinea-Bissau as an example:

[This statue] comes from the island of Karavela in the Bissagos islands (Guinea-Bissau), and represents a goddess. As far as we know, it was kept in the house of a headman and was stolen by a lieutenant of the French navy [Pierre Auguste Eugène Aumont] at the start of the nineteenth century. On

the order of the French government, the lieutenant had led a punitive expedition against this group on the pretext that they had earlier attacked a French ship, though in reality this attack had been a response to France's failure to pay for the meat and fresh water that their ships regularly took on at this spot. Several villages were laid waste, and in one of the huts the officer [Aumont] noticed some strange objects, which he took. A century later his descendants donated them to the Musée de l'Homme.[37]

In the end, however, the CD-ROM presented each object under only three of the four headings: "aesthetics of the object," "purpose of the object," and "society of origin." Mention of Godelier's fourth component, the circumstances of the object's collection, is limited to an optional line or two below the mention of its region, culture, inventory number, material, height in centimeters, date, and former owners.[38]

For objects seized as nineteenth-century spoils of war (such as the Guinea-Bissau statue), no ethical or legal guidelines tainted their entry into European collections. Rather different considerations apply to objects that were clandestinely excavated and secretly exported a century later in defiance of national laws and international agreements (such as the Nok terra-cottas), especially when they were purchased with State funds from a dealer known for his involvement in illicit traffic. The museum's differential treatment of objects entering the collection in these two ways is hardly surprising, but it does deserve to be recognized. As in many other cultural settings, the silences in a museum gallery speak volumes.

The ethics of acquisition also came up in the context of a gift to Jacques Chirac, offered on the occasion of his sixty-fourth birthday by his "counselor for *arts premiers*" (presumably Kerchache) and his colleagues. The press soon seized on the fact that the ceramic ram, dating from the Middle Ages, had been exported illegally from the Djenné region of Mali. Had it been donated to a museum, arguments for its return would have encountered a clear legal problem, since objects entering State collections are by law virtually inalienable. As an individual owner, however, Chirac was free to send it back to Mali, but not before the incident fed charges that his new museum project was encouraging the international traffic in art objects ("second only to the traffic in drugs, and equal to that in arms") and that the primary beneficiaries were presidential cronies.[39]

Other artifactual questions entered the discussion as objects moved out of their long-standing anthropological setting in the Musée de l'Homme. A writer for *Le Nouvel Observateur*, for example, cited a new law, adopted 20 December 2001, that opened the way for museums to apply in very ex-

ceptional cases to a State-run commission for permission to de-accession pieces of low scientific value in order to provide money for the purchase of others that were "more interesting." Would the Musée de l'Homme's fifteen Kota reliquaries from Gabon be judged uselessly redundant? "Once they were 'restored,' that is, cleaned up from all the messy stuff tied to their ritual function [he went on], any one of these objects, so in fashion among collectors, would fetch an astronomical price on

> Mali's numerous archaeological sites have ceramics and statuettes from the fifth to sixteenth centuries. "The most famous one, on the outskirts of the city of Djenné, has been known since 1940. Its terra-cottas—pottery, figurines, mounted horsemen, masks—are often remarkable."[40]

the market."[41] And eyebrows were raised about the invitation to Jean Paul Barbier, director of the Barbier-Mueller Museum in Geneva, to join the planning committee for the new museum just after he had sold the French State 276 Nigerian works of art for the sum of 40 million francs. The situation became even more questionable later, when about half of the museum's 22.85 million-euro acquisitions budget was set aside for purchases from the Barbier-Mueller collection.[42] Mightn't this risk mixing worlds that should be kept independent? More than one observer considered the possibility. Men like Jacques Kerchache, Jean Paul Barbier, and Georg Baselitz have always vehemently rejected the idea that they are in any sense "dealers," on the grounds that they don't (or rather, don't any longer) maintain galleries. But critics argue that their active engagement in the sale of primitive art from their own collections and those of close friends should disqualify them from being given voice on committees with multimillion-euro budgets for the acquisition of primitive art.[43]

There was widespread concern about the inflationary effect the museum's acquisitions were bound to have on the art market. In the 1990s Nok terracotta heads went for about 60,000 francs, and 600,000 would have bought a magnificent, rare, meter-tall Nok statue seen by two reporters in a Parisian gallery in 1997.[44] Compare that with the 2.5 million francs that France paid for the Nok statues in the Louvre in 1998, and one begins to have an inkling of the upside potential involved. Many critics cited the 18 million francs that the MQB paid to a private collector for an androgynous *uli* figure from New Ireland.[45] One, claiming that price to be ten or twenty times the object's normal market value, mused in print about what the sale would do for the value of the two other *uli* figures known to exist in the world, one of them owned by a certain collector who had been Chirac's friend for over thirty years and served as an adviser to the president.[46]

Other commentators were less concerned about the financial question marks hovering over the *uli* than the interpretive ones. An essay by Lorenzo

Jean Paul Barbier, whose collection numbered some seven thousand pieces before he sold a healthy slice of it in the 1990s, was described in 2006 as "the greatest collector [of primitive art] in the world, but also an anthropologist of staggering erudition." The radio host who introduced him in these terms was then treated to a taste of his anthropological erudition via his clarification of the difference between Africans and Pacific Islanders: "The African," he explained, "is a farmer, a man who is attached to the land, who struggles in order to subsist. And this hardship is reflected in his sculpture. African sculpture is the sculpture of a man who's suffering. . . . But in Oceania people have very easy lives, just the way life in the Caribbean islands was before the Spanish arrived in 1492. In Oceania you've got breadfruit, you've got yams, you've got quantities of root crops, you've got fruit everywhere. All you have to do is bend over to scoop up from the sea enormous shells holding a whole kilo of perfectly edible flesh. You've got fish that you can catch by spearing without even getting your thighs wet. You live in a way that bears no relationship to the horrifying life of a peasant in Mali. *Vous comprenez?*"[49]

Brutti, an Oceanic specialist and ethnographic film-maker who was project manager of the CD-ROM *Chefs-d'œuvre et civilisations,*[47] illustrates the problem of competing readings. He notes that Kerchache's description of this figure, which glosses its plumed crest as a cock's crow and characterizes it as a symbol of virility, goes directly against the findings of Brigitte Derlon, an ethnographic specialist on the society from which this object came. Derlon's research shows that the figure's plumes represent a local bird, *Dicranostreptus megarhynchus,* and not a cock, *Gallus domesticus.* Both Kerchache and Derlon note that the figure is hermaphroditic, combining male and female attributes. However, while for the connoisseur (working on the basis of his discerning eye) "masculinity is dominant" in this "male figure," the anthropologist (working on the basis of firsthand knowledge of the artist's culture) explains that the crest is a reference to the feminine universe.[48]

Clearly, the assignment of financial value and the depiction of ethnographic origin are not unrelated to each other, particularly when the latter produces attributions of age. Brutti cites a house post from the Solomon Islands to illustrate the thorniness of competing claims regarding both age and ethnographic meaning. This wooden sculpture of an embracing couple came under scrutiny after Kerchache dated it to the seventeenth century, citing the results of carbon-14 tests, while an ethnographer, Sandra Revolon, denied that it could be more than a century old. People Revolon knew from having lived several years in the area had talked to her about the sculptor, Karibwongi Ragerage, born about 1860, who was their great-grandfather. In support of Revolon's assessment, Brutti quotes cautions by the head conservationist for French museums, Christiane Naffah, who has pointed out that carbon-14 dating for objects from the past three hundred years is unreliable for a variety of reasons and characterized the results of such

testing as "not very significant." And in any case, even if laboratory techni-
cians can help to date the wood that was used, they have no way of knowing
when it was that the artist turned it into the sculpture now exhibited in the
Louvre. As Naffah stressed (referring to her team's preparation of objects for
the Pavillon des Sessions), "One must never forget that the dating refers to
the material, and not to the crafting of the work."[50] Why, then, push the ear-
lier date? Brutti notes cryptically that a donation to a State museum (in this
case from Jean Paul Barbier and Monique Barbier-Mueller) brings with it a
major tax credit, calculated according to the object's appraised value. That,
of course, is significantly influenced by an estimate of its age.[51]

The iconographic meaning of this Solomon Island figure, like that of the
uli from New Ireland, was also the subject of in-house controversy. Ker-
chache's description on the CD-ROM provides a connoisseur's reading of
the visual form and its symbolism:

A house post from the Solomon Islands. © Photo SCALA, Florence.
Musée du quai Branly.

In spite of the simplicity and crudeness of the material, the subject is treated with extreme delicacy. The play of the arms and legs and the hands gently placed on the woman's lower back are full of sensuality, devoid of vulgarity. . . . Through this primordial couple, the sculptor has been able to convey the sacred character of this essential act for the perpetuation of the clan. . . . All is signified with such subtlety, with such dignity, that this tenderly clasped couple emerges from the material in total intimacy.

Brutti points out that the anthropologist's description of this same figure, based on intensive fieldwork in the area, goes in a rather different direction:

This post comes from a ceremonial house reserved for the exclusive use of men. . . . It represents a sexual encounter between a wealthy man and an *aurao*—a sacred prostitute who embodies a malevolent spirit called Matorua. At night this androgynous spirit wanders along isolated paths looking for a solitary person, takes a male or female form depending on the sex of its victim, and seduces him or her. When the couple makes love, as portrayed on this post, the human victim contracts a fever which leads to certain death.[52]

I cite just one more of the many instances in which Kerchache's "infallible eye" could see things that went sharply against the intent of the artist whose work he was describing. On the CD-ROM, his description of a figure sculpted as decoration on a Kanak ceremonial house comments that "the ear openings play, humorously, with the solids and voids."[53] The anthropological specialist on these carvings, Roger Boulay, points out, however, that the sculpture reflects "the tradition of tearing the earlobe (previously opened for aesthetic reasons) during mourning."[54] Like the murder by a malevolent spirit that Kerchache preferred to see as a tender embrace, this sign of grief and loss has been transformed into whimsical play in the fertile imagination of the connoisseur.

✶

In a review of my book *Primitive Art in Civilized Places*, an art critic for *Newsweek* warned tongue-in-cheek that the ethical questions it raised might well "deprive the reader of the warm fuzzies he usually gets standing before the display cases at the local ethnographic museum."[55] What, then, are readers to make of the questions raised in the preceding pages here? Is it really fair to point the finger at a European museum for purchasing a statue that would

otherwise be owned by a wealthy collector and made accessible to far fewer people? Why should it matter whether a twentieth-century art connoisseur sees a particular statue in terms of cock's combs and therefore "virility" when according to our best information the nineteenth-century sculptor saw it in terms of an Oceanic bird associated with female essences? And how troubling can it be to learn that the "delicately expressed sensuality" of the embracing figures from the Solomon Islands was intended to depict the deadly encounter between a malevolent spirit and its human victim? Might the issues raised in this chapter do nothing more than spoil the "warm fuzzies" for genuine enthusiasts of non-Western art?

There is no lack of testimonials about people from the countries represented in the Pavillon des Sessions experiencing a strong, culturally inflected variant of the warm fuzzies as they stood before cases displaying art from their homeland. I've often encountered, both in the press and in conversations in Paris, reports of the heartfelt pride that visitors (often diplomats) from this or that continent have expressed at seeing such creativity exhibited in a setting as prestigious as the Louvre. As a journalist for *Paris-Match* wrote:

> For visitors from the countries that produced these artworks, the Pavillon des Sessions is an amazing site for identitarian awareness. Security guards have several times found offerings placed at the foot of certain pieces. . . . Heads of State, like tourists and workers from underdeveloped countries, are proud to see that their culture is in the Louvre.[56]

We have no reason to doubt the veracity of these endearing scenes or to be dismissive of the depth of emotion some people have felt at seeing their culture represented in such an impressive setting. I once witnessed a similar encounter myself, visiting the monumental anthropology museum in Mexico City with two Zinacanteco Indians at the end of a summer's fieldwork in Chiapas and watching their excitement as they addressed the female figures in a life-size diorama, in Tzotzil, as if they were speaking to their wives back home. But none of this erases the need to take other aspects of the situation into consideration as well. An endorsement of the return of valuable possessions to the society from which they were exported (once some agreement has been reached about how that "society" should be defined) is still a legitimate argument to feed into the larger debate. And the preciousness of native understandings concerning works of art—about imagery, about symbolism, about value, about ritual function, and even about whether or not to end their lives in a termite nest—needs to be taken seriously, regardless of the

frustration it may create for European (and other) museum acquisition programs or the annoying doubt that it may introduce into the connoisseur's otherwise unchallenged authority.

The fact that three central aspects of museum objects—the prices paid for them, discrepancies between their symbolic associations for connoisseurs and for natives, and competing assessments of age—are so fully excised from the extraordinarily comprehensive documentation that goes into catalogs like that for the Pavillon des Sessions (or websites like that for the MQB) tells us something about how exceedingly sensitive these issues are.

Trouble at the Trocadéro

Dust-covered cases, cluttered objects, yellowed labels,
and disillusioned and discouraged anthropologists
without the [financial] means to do their jobs.*

To understand how the upgrading of primitive art left its mark on the larger museum world of Paris, we'll need to begin with some historical background.

On the eve of the Universal Exposition of 1878, France's ethnographic collections were widely dispersed. Some were in archaeology or natural history museums in small coastal towns where explorers and other travelers had returned from their voyages. Others were in the Louvre's Musée Dauphin, the natural history museum, the national library, the colonial museum, and the museum of antiquities. Some were even in the artillery museum, where a "picturesque" exhibit of seventy-eight arm-bearing mannequins, made from plaster on the basis of skulls in the natural history museum, represented "different savage races."[1]

In 1877 a decision was taken to unite these diverse collections under one roof, forming a Muséum Ethnographique des Missions Scientifiques, attached to the Ministry of Public Instruction, in order to celebrate the exploits of French explorers and, more generally, the French nation. Thus, the spotlight was on the individuals who selected and collected the objects at least as much as on the peoples that produced them.[2] (This phenomenon will come

*Bérénice Geoffroy-Schneiter, *Arts premiers* (Paris: Assouline, 1999), 37.

up again in our review of the Musée du Quai Branly.) The Palais du Troca-
déro, then under construction for the Universal Exposition of 1878, was
chosen as the home for this new museum, which
thereby became the Musée d'Ethnographie du Tro-
cadéro.

It was at the Place du Trocadéro, named after a 1823 French victory over the Spanish in the town of Trocadero, that the Universal Declaration of Human Rights was signed in 1948. Renamed the Parvis des Libertés et des Droits de l'Homme by President Mitterrand in 1985, it serves frequently as a site for demonstrations involving human-rights issues.

The enthusiasm and support that the museum
enjoyed in its early years was short-lived, and by
1907 it was already suffering from "incessant
battles" and a severe lack of funding. During the
1930s, in an atmosphere marked by the rise of
Nazism in Germany, a large number of scientists
and other intellectuals in France became politically
involved in the Popular Front. Those in the Tro-
cadéro Museum were particularly active in leading
the struggle for "a new humanism," which centered on combating fascism,
racism, and imperialism. One of them, Paul Rivet, served as president of the
committee of antifascist intellectuals, focusing on the lessons of anthropol-
ogy and describing the mission of what was about to become the Musée de
l'Homme under his direction as a window on oppressed cultures and "a bas-
tion of antiracism."[3] Rivet viewed anthropology as a solidly militant disci-
pline whose main arm was education and whose principal goal was to reach
as much of the population as possible with its research and its humanistic
message.

In preparation for Paris's Universal Exposition of 1937, the Trocadéro
building was razed and an impressive replacement, the Palais de Chaillot, was
erected on its foundations to house the exhibits. This gave the ethnography
museum, which had by then become "dust-ridden and cluttered," its chance
for a major "resurrection" as the Musée de l'Homme,[4] and for some years it
was seen as a model museum. Its days of glory were again short-lived, how-
ever, as budgetary belt-tightening after the Second World War curtailed its
activities and cut back on its personnel. Attendance declined sharply, and
things only got worse in the subsequent decades.

The problems that hounded the Musée de l'Homme were of several sorts,
some tied to the museum's administrative structure and place within the
world of State-run museums, others to the physical limitations of the build-
ing, and yet others to the evolution of the discipline of anthropology in
France. Ethnographic research was gradually turning away from interest in
material culture, focusing more and more on aspects of culture such as kin-
ship, belief systems, and oral traditions—a shift that contributed importantly
to the marginalization of the Musée de l'Homme.[5] Representatives of the

museum staff and outside supporters found themselves having to agitate constantly for increased recognition of the museum's role in scientific research, public education, cultural life of the nation, and international relations—generally without tangible results.

In 1941 a fourteen-page document written in the wake of a new law altering the organization of *musées nationaux* included a plea to end the Musée de l'Homme's exclusion from that category. "Every [other] nation that possesses colonies," it noted—citing in particular the United States, Holland, and Germany—"has recognized the critical role of ethnographic science by creating numerous institutions of education, research, and publication (in Germany, 16 museums and 26 academic chairs), thus producing personnel with the qualifications not only to conduct scientific research but also to contribute to administration of the colonies and to foreign policy." Reclassifying the Musée de l'Homme as a "national museum" (and thus giving it authority over related museums in the provinces), it argued, would facilitate coordination with the nation's provincial museums, promote intermuseum exchanges, redistribute collections among storerooms with too much or too little space, and allow for the creation of a chair in primitive art at the École du Louvre. "It is not possible for France," it warned, "which was the first nation to create an ethnographic establishment (in 1877) and which possesses the second most important colonial empire in the world, to treat the ethnographic disciplines as a luxury."[6]

During the entire second half of the twentieth century, the Musée de l'Homme managed to maintain its programs of exhibition and research. But with its reputation for anti-Nazi political activism a fading memory, paralyzed by inadequate funding, and beset by internal squabbles that were pointed out now and again in the press, it experienced a steady erosion in attendance and an ever-increasing pessimism about its future as a viable institution.[7] It went through a particularly sluggish period in the postwar years, when severely reduced budgets and the four-year exile of Paul Rivet for political activism[8] caused it to lose much of the ground gained during its "resurrection" in the late 1930s. Toward the end of the 1950s, anthropologist Louis Dumont, who had begun his career during the early years of the MH and was deeply committed to it as an institution, was sufficiently pessimistic about its future that he recommended "a severing of the umbilical cord" that tied it to the Museum of Natural History.[9] Despite continued proposals for its renovation and reorganization, little of substance was ever implemented, and the museum began to be seen as a dust-ridden, moribund attic.

Some of the concerns involved the physical plant. A 1967 plea by the director of the International Council of Museums' Centre de Documentation,

for example, reiterated a proposal, apparently first made in 1937, to move the Musée de la Marine out of the Palais de Chaillot in order to free up space for the overcrowded halls of the Musée de l'Homme. Moving the Naval Museum to the Porte Dorée, it argued, would provide more adequate space for both museums, each of which was struggling to maintain its programs in a situation that was "painful for the staff and dangerous for the collections."[10]

By 1972 the museum's academic chair in ethnology, originally occupied by Paul Rivet, had been replaced by three chairs with more specialized designations, leading to further organizational problems that severely undermined the smooth functioning of the museum for decades.[11] Already an underling of the Muséum National d'Histoire Naturelle, and therefore lacking decision-making power in budgetary matters, it now consisted of three independent "laboratories"—ethnology, prehistory, and physical anthropology—that had no overarching director to coordinate their interactions. The long history of weak support from the State created an atmosphere that fueled personal rivalries and the tripartite structure exacerbated the divergence of scholarly concerns, testing the collegiality of an institution struggling to keep its head above water. As one writer politely put it, "It is not certain that this type of three-part direction has been beneficial to the establishment."[12] The tension that reigned within the museum sometimes erupted publicly. In 1972, to cite but one example, the anthropologist who had just assumed his duties as director of the ethnology department became the "victim of an internal cabal" and was summarily fired by his colleagues, but then immediately reinstated by the State on the grounds that they had no authority over the appointment, which had been made by the president of the Republic.[13]

Recurrent pleas from the museum staff for a director of their own, someone who would be a voice for the three departments in deliberations of common concern, were repeatedly brushed aside both by the parent body (the Muséum National d'Histoire Naturelle) and by the government. An external report requested by Prime Minister Lionel Jospin in 1988 and submitted in 1990, for example, recommended that the Musée de l'Homme be given greater scientific and administrative autonomy (i.e., greater independence from the MNHN) and that a position be created for a director who would coordinate policy, research and educational activities, budgetary decisions, and so forth among its three departments.[14] These recommendations were never implemented. In 1992 Jack Lang (then minister of both education and culture) attempted to address the Musée de l'Homme's problems by recommending budgetary autonomy for it, but that, too, went unimplemented. And in November 1994, the administrative council of the MNHN met in private and voted (apparently at half-past midnight) to downgrade the Mu-

sée de l'Homme to a "service" under its authority. In this atmosphere, with colleagues making public accusations about one another and taking each other to court, it is hardly surprising that attendance at the Musée de l'Homme dropped precipitously—from 350,000 visitors in 1985 to 175,000 a decade later. And it in a sense paved the way for planners of Chirac's museum (Germain Viatte's Mission of Prefiguration) to submit their report without having consulted the Musée de l'Homme.[15]

The vision of the Musée de l'Homme as a museological disaster area, losing its battle with physical decrepitude, rife with internecine friction, and "crumbling under the dust and immobility of its hierarchy,"[16] appeared again and again in the press. One report[17] documents a "venomous" relationship between Bernard Dupaigne (director of the MH's ethnology department) and Henry de Lumley (director of the Muséum National d'Histoire Naturelle and the prehistory department of the MH), quoting a seething letter sent by Dupaigne to the Friedmann Commission, charging de Lumley with unrealistic stubbornness, a refusal to enter into dialogue, isolated thinking, and an imperious demand for obedience. De Lumley, a faithful supporter of Chirac's political ambitions, also came under attack for serving as director of four different institutions at once and for an excessive appetite for power. To make matters worse, the Musée de l'Homme's relations with other museums were more conflictual than cooperative, as seen, for example, in its alleged refusal to loan pieces for exhibits elsewhere in Paris.[18] Germain Viatte wrote of the museum's "budgetary crises, authority crises, the lack of a director responsible for the entire museum, continuous weakening of the patrimonial and museum science functions as well as staff reductions," and pointed out that proposals to solve its problems, dating from the 1960s, had never had any serious effect.[19] A 1990–91 study of those museums that came under the Ministry of Education, led by anthropologist Françoise Héritier-Augé, painted the Musée de l'Homme as catastrophic in every respect—inadequate finances, deteriorating physical plant, lack of qualified personnel, and an environment of intellectual and moral vacuity.[20] Some of the display cases, it pointed out, hadn't been touched since the founding of the museum, as staff spent all their time on research, to the neglect of exhibitionary concerns. Fifty years after the museum's founding, a mere 50,000 of its 250,000 objects were properly inventoried.[21] And labels still carried references to "French Sudan," despite that former colony's attainment of independence, as Mali, over thirty years earlier.[22]

There was also discussion about the mid-century turn in French anthropology, which tipped the balance away from studies related to material culture, toward less physically tangible issues involving social structure, religion,

power, and orality. As Claude Lévi-Strauss pointed out, "While it is becom-
ing increasingly difficult to collect bows and arrows, drums and necklaces,
baskets and statues of divinities, it is becoming easier to make a systematic
study of languages, beliefs, attitudes, and personalities."[23] And there was the
practical consideration that research based on collecting objects and remov-
ing them from their original settings had become more problematized than
fieldwork based on talking with people. Anthropological interest in material
culture lost significant ground, and with it went the pivotal role that had been
played by the Musée de l'Homme. Museums began to be viewed as "sites of
memory," writes Jean Jamin, either intellectually and physically abandoned
by anthropologists (which reduced their role to one of simple conservation
of objects) or assigned a commemorative role in the discipline.[24]

One attempt at revitalizing the Musée de l'Homme was undertaken in the
mid-1980s, and it was then prime minister Jacques Chirac who inaugurated
the exhibit, Masterpieces of the Musée de l'Homme, in June 1987, to mark the
museum's fiftieth anniversary and the first stage of the building's renova-
tion.[25] Emmanuel de Roux, writing in Le Monde, was duly impressed by the
central hall where Chirac spoke, which seemed miraculously to have doubled
in volume. But it was only part of the museum to have received a make-
over, and elsewhere in the building there was much—much too much—still
to be done. Somber metal cases, 1930s-style, formed monotonous lines in
dead exhibit spaces; labels signaled geographical origins using the names of
colonies that had long since been rebaptized as independent nations; the not
infrequent theft of exhibited objects regularly went unnoticed and unpun-
ished; the staff offices were reminiscent of "prehistoric shelters"; and acousti-
cal problems in the projection room were dealt with by sticking a series of egg
cartons on the ceiling. Henry de Lumley courageously outlined his plans for
future improvements, pointing out that what he needed was very little com-
pared to the amounts that were being poured into the Musée d'Orsay, but a
cold shoulder from the Ministry of Finance and the stench of internecine
quarrels within the museum's tri-discipline staff combined to cast a gloomy
shadow over his vision of future glory.[26]

In 1989 President François Mitterrand announced a major renovation of
the museum, but the funds failed to come through (due, some have argued,
to the organizational ineptitude of MH administrators), and the project
evaporated.

When de Roux revisited the situation in 1992,[27] he concluded that the
Musée de l'Homme (together with two other museums . . . we'll get to them
later) was "paralyzed by a long-term illness, which, if not treated in a matter
of months, will degenerate into a coma." For years, he wrote, these museums

have been vegetating in a dust-ridden museography, ravaged by repeated crises and abandoned by museumgoers. Relations within the staff constituted a "latent civil war that poisons any impulse for reform." Three years later he returned to the museum but found no improvement: "Saying that the collections are poorly exhibited is a euphemism. The presentation wavers somewhere between a bad comic-strip décor and the back room of an attic."[28]

It was in this lugubrious atmosphere that plans were advanced to dust off the nearly three hundred thousand objects in the collection of the ethnology department and elevate them to what was seen by proponents of the new museum to be conceptually higher ground as masterpieces of world art. For many of the artifacts, this could be seen as their second salvation, since they had entered the museum after being rescued from disintegration in caves, termite nests, or abandoned shrines in outlying villages of the world by missionaries bent on eradicating pagan idols, local looters with connections to the market, or clandestinely acquisitive Western visitors—"salvation" and "rescue" representing, of course, a perception not necessarily shared by the objects' makers.

Resistance Movement

*Muséum en danger, non à la dispersion des collections.**

Despite all the negative assessments, workers at the Musée de l'Homme, from curators to custodians, weren't about to go down without a good fight. The campaign they mounted in its defense was swift, multi-pronged, sustained, and very angry. Words started flying as soon as Kerchache's manifesto hit the press in 1990. His charge that African objects were "castrated" when they entered an ethnological laboratory was countered indignantly by Marie-Claude Dupré: "He seems to think we have constipated brains," she retorted, "but his presentation strips the objects bare and presents them less in terms of their aesthetic character than as sources of titillation. . . . The proposed exhibit in the Louvre will amount to nothing less than dildos for tired intellectuals."[1]

Others joined in, expressing their shock and indignation at Chirac's proposal. Anthropologist Louis Dumont, writing in *Le Monde*, chastised Lévi-Strauss (diplomatically naming him only by his title as honorary president of the Friedmann Commission) for supporting what amounted to "a burial of

*Banner carried by museum employees, marching in protest over the planned transfer of Musée de l'Homme collections, quoted in Lucien Degoy, "Plus de deux mois de grève totale des personnels du Palais de Chaillot: Partie de bras de fer au Musée de l'Homme," *L'Humanité*, 18 January 2002.

anthropology, not only in terms of the conservation and exhibition of objects, but also in terms of research and communication with the public."[2] Calling it a "vicious" project, he charged that to speak of *arts premiers* was to impose the Western concept of "fine arts" on cultures where it did not exist. Whatever problems there were at the Musée de l'Homme, he wrote, could be addressed and corrected without destroying the entire institution, and in any case proponents of Chirac's museum were exaggerating those problems in order to advance their project. As another anthropologist put it, "When you want to drown your dog, you first say it has rabies."[3]

Henry de Lumley (director of the Musée de l'Homme's department of prehistory and longtime director of its parent body, the Muséum National d'Histoire Naturelle) was particularly outspoken, arguing that the original calling of the Musée de l'Homme to promote an integral understanding of man (as the French like to put it[4]) had, if anything, become even more relevant than when the museum was founded. What we need now more than ever, he said, is a museum that communicates respect for cultural identities in all their diversity, a museum that reflects "a political and philosophical commitment to openness and tolerance."[5] In 1996, battling his museum's threatened demise, he presented his plan for injecting new life into the Musée de l'Homme, making it a Musée *de la Vie* de l'Homme—a place to discover the vast multitude of cultures and belief systems that humans have evolved, from Paleolithic times to the present.[6]

Some of those whose institutional bases were pulled into the game of musical chairs adopted a qualifiedly cooperative attitude. Even Bernard Dupaigne—the director of the Musée de l'Homme's ethnology department who later penned a vitriolic condemnation of the Louvre/MQB project—was said in 1996 to be in favor of the proposal.[7] So, too, was Jean-Hubert Martin, then director of the Musée des Arts d'Afrique et d'Océanie. Admiral Bellec, head of the Naval Museum, was reluctantly resigned to moving it out of the Chaillot Palace if he had to, though he set hard conditions on location, space, and financial support.[8] The director of the Museum of Popular Arts and Traditions, Michel Colardelle, who had long been endorsing a move from Paris to Marseille, was pleased when his proposal was accepted, with a tentative transfer date of 2006.

In a sense, advocates of both of the opposing camps were arguing that the quarrel between aesthetics and anthropology was an outdated, irrelevant issue. Each felt confident that they could take care of the other's concerns: those favoring a renovation of the anthropology museum, like Lumley, denied that a reinvigorated MH would neglect the aesthetic dimension, and those working on a more art-centered museum argued that their plan was to

include ample ethnographic contextualization. It was clear, however, that the two ends of this tug-of-war had quite different priorities in terms of the presentation of visual form and contextual interpretation.

As the *arts premiers* project continued to take on clearer shape, staff at the Musée de l'Homme organized their combat. On 2 and 3 October 1996, just days before Chirac was scheduled to announce his decision to create a new museum, the administrative and scientific councils of the National Museum of Natural History (parent organization of the Musée de l'Homme) met and adopted two motions.[9] The first "categorically opposed" the Friedmann Commission's report, arguing that to separate ethnology from the rest of the museum's concerns would undermine the fundamental integrity of the institution. The second evoked the museum's need to implement renovations responsive to its vision for the future of its research programs and educational goals. The urgency of the cause inspired museum staff to adopt the most advanced means available for enlisting support. In November 1996, long before most offices in France even considered replacing the nation's Minitel system with Internet access, or their fax machines with e-mail accounts, the Comité de Défense du Musée de l'Homme sent out an e-mail to potential sympathizers. Its three-point statement ("What is the Musée de l'Homme? How is it being threatened? What do we want?") called for an end to plans for the creation of a museum of *arts premiers* and support for renovation of the Musée de l'Homme, and ended with an invitation to join the struggle.

While the proposal for a new museum marched slowly but steadily toward official adoption, virulent opposition continued to be mounted from various parts of the Musée de l'Homme. In June 1997, to cite but one of many outcries, the director of the biological anthropology department, André Langaney, went public in *Libération,* tying the debate into an indictment of the French educational system and damning Chirac's proposal as "racist and aberrant."[10] The fascist right, he charged, had put together a few representatives of the rich, overeducated minority and given them the job of maintaining the exclusion of people whose physical appearance, culture, religion, or customary behavior kept them out of the narrative of French history as taught in schools. Citing the "pathetic" attention paid to the world outside France and to immigrants and their (French) offspring, he charged an ethnocentric educational system with failing to recognize that different solutions to common problems of society (including those of French citizens whose ancestry did not go back to the ancient Gauls) constituted a valuable enrichment. This, he said, was at the heart of the Musée de l'Homme's mission. But deprived of support and working with derisory funding, the museum was

easy prey to a lobby of collectors and antique dealers who were pushing a "discredited president to implement a princely caprice" that would replace an educational institution with an exotic art museum run by people who judge objects by their prices on the market or the star status of the people who stole or possessed them. Funds that should have been earmarked for the Musée de l'Homme, he wrote, are being siphoned off to pay a collector ("a self-styled scientific adviser") to sack science at the museum. He ended by calling on Claude Allègre, the minister of education, to oversee a restoration of the educational role of the Musée de l'Homme, and on Catherine Trautmann, minister of culture, to "stick her nose into the fetid dossier of *arts premiers*" both to ferret out the misuse of public monies and to expose the theft and pillage that it was promoting in Africa.

By April 2001 a committee taking the name of Patrimony-Resistance had been formally constituted and was publishing bulletins with extensive information on various threats to the several museums being lined up for the game of musical chairs. Membership included academics from several disciplines, curators, librarians, archivists, and museum workers at all levels concerned with perceived threats not only to the Musée de l'Homme, but also to the Museum of Popular Arts and Traditions, the Museum of African and Oceanic Art, the National Research Institute, and other sites of cultural or scholarly activity. As one of their bulletins put it, "A day rarely passes without some new site of destruction. Two days ago we learned that the library of the National School of Fine Arts was being dismantled, and yesterday that the anatomy collections of the Medical School Museum were being removed from that establishment."[11] Ethnographic filmmaker Jean Rouch was particularly active in the group, evoking the legacy of the Musée de l'Homme's founders, leaders in the Resistance movement against Nazi occupation during the war. Under discussion were such issues as sponsorship, the dispersal of collections, subcontracting to the private sector, the illicit traffic in archaeological artifacts, and commercialization. Protest messages were addressed to every relevant government official.

Every journalistic outlet in Paris joined in the fray. Anne-Marie Romero, writing in *Le Figaro*, reported that Chirac, "pushed by his éminence grise of primitive art, the art dealer Jacques Kerchache, had, with a flick of the pen, crossed out the Musée de l'Homme" and replaced it with an art museum.[12] She called attention to the reaction of shock among anthropologists that the project was being masterminded by a collector/dealer. She rehearsed ethical questions that were being raised about acquisitions for the new museum, including the inclusion of a major collector on the steering committee after he had accepted 40 million francs from its budget. And she cited anthropologists

who were upset at the level of decontextualization that they saw at the heart of the enterprise. "These are sacred objects," she quoted an Africanist as saying, "but for collectors they're just figurines. It's as if the Sainte-Chapelle were gutted in order to show off the stained-glass in a better light." The director of the Americanist section was particularly bitter. "They march into my space and finger twenty objects they want. But what good does it do to label an image a 'plumed serpent' if viewers are kept in the dark about Mesoamerican beliefs that cast the plumed serpent as a benevolent animal whose plumes are more precious than gold?" The article continued, listing the "shadowy areas" and "silences" that created an atmosphere of nervous uncertainty at the Musée de l'Homme—silence about plans for the museum's administrative status as an institution, silence about the future recruitment of its personnel, silence about the physical plant, silence about the disposition of the museum's Asian holdings, and silence about a 200 million–franc budget that the museum was slated to receive for renovations. And it ended with a familiar charge that the new museum project would encourage the international traffic in illicit art.

Jacques Friedmann, a "refined mediator" and normally inclined to conciliation,[13] flew into an uncharacteristic rage, lambasting Romero in a letter to the editors for packing untruths, innuendos, biases, and defamatory statements into every paragraph of her long article.[14] Where did she get the idea that his commission proposed replacing the Musée de l'Homme with an "art" museum when in fact the proposal was clearly for a museum of "arts and civilizations"? And what was this talk of "shadows" or "silences," when the committee worked in collaboration with the directors of both the Musée de l'Homme and the Musée des Arts d'Afrique et d'Océanie and reports were issued on a regular basis? How could anyone possibly feel that they were left in the dark? Friedmann expressed indignation that a journalist would question the expertise of Jacques Kerchache when she hadn't ever met him or allude to him as a dealer when in fact he'd closed his gallery many years earlier. What have we come to, he asked, when a journalist is willing to go to press without even taking the trouble to verify her sources? Romero's reply (printed below his text) was a brief defense, pointing out among other things that if some of the sources had not been double-checked with members of the Friedmann Commission, it was only because they had abruptly canceled the interviews she had arranged with them.

Three years later Romero renewed her denunciation of the new museum organizers' disdainful treatment of personnel at the Musée de l'Homme in a lengthy article that then went on to list numerous other problematical aspects of the project.[15] Letters addressed to the president, the prime minister,

and the relevant ministers, she reported, had all gone unanswered, delegations had been refused audiences, and the president, who alone agreed to receive them, replied only that he had "taken note" of their position. Two hundred employees, she wrote, have been asking the same question for five years: "What is our future?" No one answers. Is it because no one knows? No one dares to say? What is clear is that the Musée de l'Homme has become an annoyance, an obstacle to the plans. And as for the wholesale transfer of the Musée de l'Homme's library holdings, Romero challenged, what exactly is the art museum staff at the Quai Branly expected to do with all the scientific treatises on primate molars and Neolithic trepanation that they're taking on?

It was not only in the press that the war was fought. A strike to protest the dismantling of collections at the Musée de l'Homme, begun on 19 November 2001, was followed for two months. Employees at all levels joined in. Security guard Demba Sow, of Senegalese origin, for example, saw the museum as an antidote to the xenophobic politics of Jean-Marie Le Pen and declared that if he were told to help transport the collections, he intended to disobey orders.[16] And he was not alone. Depending on which newspaper article you chose to believe, up to 90 percent of the employees joined forces in the strike.[17] Petitions to stop the dismantlement of the museum were passed out to every visitor, including large numbers of schoolchildren, who added their signatures without really understanding what was going on. In December employees of the Quai Branly Museum who showed up at the Musée de l'Homme with orders to prepare the collections for transfer were unable to get into the building. There was also support for the protesters from abroad—from the director of the American Museum of Natural History in New York, the director of the Anthropology Museum in Osaka, and anthropologists in Italy and England, to cite but a few.[18]

Representatives of the Musée de l'Homme painted a picture of systematic obfuscation in response to their efforts to communicate with organizers of the new museum and to hear details concerning the takeover of their collections: "They play with us for three or four days, sending us from one section of the Ministry of Education to another. On 30 November [2001] they said 'We are not aware of the dossier.' A week later [a delegation from the Musée de l'Homme] was received by the Ministry of Research and presented numerous arguments in great detail, but the only reply was that 'as advisers to the project, we are not authorized to give you a reply.' And finally, arriving at Matignon [office of the prime minister] we were—very warmly, I must say—turned back by the police."[19]

Other opponents of the proposed museum questioned it on a variety of grounds. A commentator writing for *Le Nouvel Observateur*, for example,

asked why it would be necessary for the new museum to confiscate all 300,000 objects from the Musée de l'Homme when only 10 percent of that would ever be on display. "On the hillside of Chaillot, laboratories stripped of their contents will have to manage with what they've been left—bones, prehistoric tools, and trinkets devoid of value on the market."[20] And André Langaney challenged Germain Viatte, "You want to make an exhibit of 5,000 very beautiful objects? Take the 5,000, or even 10,000, pieces that you consider the most beautiful from the Musée de l'Homme. But leave us the 250,000 others so we can continue our exhibitions with objects that have no interest for the art market but help us explain how birth, marriage, death, illness, and religion function in the different societies."[21] Besides, it was argued, the transfer of collections was completely illegal, since no curator at the Musée de l'Homme had ever received orders to give up even a single object, but had merely been handed a schedule for the departure of objects drawn up unilaterally by directors of the Musée du Quai Branly.[22] And there was more than simple eyebrow raising over the appearance of financial profit among friends of the president as the museum's acquisition fund was used to pay prices that some judged to be well over their market value. An ancestor figure from New Ireland, for example, caused considerable comment after the State bought it for 18 million francs from Parisian art dealer Alain Schoffel, who subsequently retired to a château in the French countryside.

It's important to note, however, that not all anthropologists aligned themselves with the MH protests. Even within France the anthropological community was far from unanimous in its opposition to the proposed changes. Endorsements of the idea of a new museum by Claude Lévi-Strauss and Maurice Godelier were particularly important because of their stature within the profession. But many others loaned their voices as well, countering the MH-based protest movement with attempts to find a positive outcome that would both recognize the value of the MH and contribute to building a more up-to-date presentation of anthropology in the Paris museum world. In March 1998 the Association for Research in Social Anthropology (APRAS) organized a colloquium devoted to "anthropological perspectives on the new Musée de l'Homme." The flyer announced: "The aim is to give voice to anthropologists who feel that the renovation of the Musée de l'Homme should not be limited to an increase in funding and space, but that it should also be the fruit of true reflection about what a museum of man, arts, and civilizations should be in the 21st century. . . . Before closing the debate, we will propose a toast, glasses upraised, to the health of the new Musée de l'Homme."[23] Emmanuel de Roux, writing in *Le Monde,* claimed that by December 2001, fully half of

those who had been employed in the ethnology department of the Musée de l'Homme had agreed to work with the Quai Branly Museum.[24]

When I spoke with Paris-based anthropologists in 2005 and 2006, many of them felt that the anthropological community had been less than courageous in defense of their discipline, often citing the tendency for personal rivalries and infighting to interfere with the promotion of common concerns. Some of them expressed regret that the Musée de l'Homme hadn't received more unified support from academics, as opposed to employees of the museum. Others, arguing that the fate of the Musée de l'Homme was sealed at the very beginning, faulted their colleagues for not participating more actively in molding the MQB in order to counterbalance the aestheticizing and primitivizing direction it was taking under Kerchache's influence. And I heard complaints that the kind of outrage that had been voiced by agitators such as Jean Rouch and André Langaney was counterproductive and a reflection of the museum's past inability to take advantage of the opportunities that had been presented by earlier governments for the conceptual and physical renovation of the museum. Had they been less inept in picking up on support that the Socialists in government had several times tried to extend to the museum, several people argued, the vision of cultural difference conveyed in Paris museums would have gone in a very different direction from the presentation that ended up being implemented at the Quai Branly.

Viewed in a certain light, what divided anthropological supporters of Chirac's project from its detractors was their divergent reading of the kind of anthropology on which the Musée de l'Homme had been founded and its ability to speak to the social and cultural realities of the twenty-first century. For one side, that anthropology represented an important ideological stand against racism, a bastion of respect for cultures beyond the European orbit. For the other, it was a legacy of colonialism, an institution promoting evolutionist thinking that had long ago lost its relevance in a world of ever-increasing globalization. As three concerned academics argued in Le Monde, "The debate is no longer really between art and anthropology, but rather between two outdated conceptions of these two domains."[25]

There can be no doubt that the relationship between art and anthropology in Paris had changed radically over the course of the twentieth century. James Clifford, emphasizing that "the boundaries of art and science (especially the human sciences) are ideological and shifting," has chronicled changes in the vision of anthropology in Paris during the first several decades of the twentieth century and traced the influence of these developments on the goals and strategies of the anthropology museum.[26] In the 1920s, he

writes, "the contexts of science and art bled into each other," largely in re-
sponse to those involved with surrealism, a movement that shared with
ethnography an intense interest in exotic worlds—one working to make the
exotic familiar, the other to make the familiar exotic. The Trocadéro Mu-
seum translated this fascination into material displays, presenting its hold-
ings in unlit, disorganized clusters of mislabeled curiosities that allowed vis-
itors to "journey into full barbarism." Clifford points out that by 1937, when
the Trocadéro was razed to make way for a new Musée de l'Homme, the
domains of modern art and ethnology had become more distinct, and the
new director, Paul Rivet, issued a formal injunction against treating artifacts
aesthetically.[27]

Others have pointed out that during what has been called "the century of
Lévi-Strauss," French anthropologists showed little interest in material ob-
jects.[28] "Researchers turned their attention to areas of anthropological sci-
ence that had become more highly valued, such as kinship, mythology, and
politics, assigning low priority to the study of objects, especially in terms of
their presentation in museums."[29] Some of the people I spoke with in Paris
traced Maurice Godelier's lack of success in turning the museum project
more forcefully toward anthropological concerns to the fact that he had al-
ways worked on areas such as economic systems, kinship, and politics, and
had no significant background in material culture.

Commenting on a draft of the present book, Godelier offered some per-
sonal reflections on the historical context. During the nineteenth century,
he wrote, France and England both gave serious support to historical and
cultural institutions such as libraries and ethnographic museums. But after
the First World War, while the English maintained that support, the French
bourgeoisie turned its interest instead toward art and modernism. Paradox-
ically, he continued, Picasso and the surrealists re-created an interest in the
Musée de l'Homme, but now as the site of exotica and poetic mystery rather
than as an historical or ethnographic resource. After the Second World
War, this unique marriage of art and anthropology—what Clifford has
described as "ethnographic surrealism" and Godelier as a joint world of
"artists, boxers, curators, anthropologists"—faded, at which point the Mu-
sée de l'Homme began its long agony.[30]

Twenty years ago one of the central players, Michel Leiris, talked to me
about how the collections in the Trocadéro Museum had become associated
with outdated and disorderly cabinets of curiosity.[31] It was because of an ex-
plicit desire to stress that anthropology was a legitimate *science,* he said, that
when the collections were rehoused in the Palais de Chaillot, the wooden
cases were replaced by austere metal ones and laden with exhaustive ethno-

graphic contextualization. In the 1930s hierarchy for material culture, the re-casting of objects from curios to scientific specimens through increasingly didactic labels, was clearly perceived as an elevation of their value.

Seen against this background, the current recontextualization of these same objects from scientific specimens to works of art might be read as con-tinued proof of the power of political and cultural climates to determine the significance of objects that have been stripped of their original (native) meanings.

<p style="text-align:center">*</p>

In spring 2003 the Musée de l'Homme's ethnographic galleries were closed continent by continent—Africa on 2 March, Oceania on 10 March, America on 16 March, Asia and the Arctic world on 20 April.[32]

Colonies and Crocodiles

The paradoxes of the Porte Dorée museum are numerous.*

The 300,000 artifacts of the Musée de l'Homme were not all that was being envisioned as the future holdings of Chirac's new museum. Across town, on the eastern border of Paris, another imposing building housed 25,000 to 30,000 equally dust-ridden artifacts that were being eyed for rehabilitation. This museum at the Porte Dorée (next to the Bois de Vincennes), a direct offspring of the Colonial Exposition of 1931, was originally intended to present the economic, cultural, and natural history of French expansion. The frescoes in its Hall of Five Continents, for example, were designed to portray France's political, economic, and moral contribution to its colonial possessions.[1] Crowned by a 1,300-square-meter bas-relief[2] depicting French overseas possessions, and boasting a massive bronze statue of *La France civilisatrice* (France the civilizer) as a Minerva-like figure, it had gone through a series of identities over the years intended to downplay its past as a monument to colonialism.

Just three years after its inauguration, it was rebaptized as a museum of overseas France, though it continued to fall under the authority of the Min-

*Dominique Taffin, "Les avatars du musée des Arts d'Afrique et d'Océanie," in *Le Palais des Colonies: Histoire du Musée des Arts d'Afrique et d'Océanie*, edited by Germain Viatte (Paris: Réunion des Musées Nationaux, 2002), 180. See also Taffin 2000.

istry of Colonies until 1960. By the late 1950s, France, cut off from its former presence in Indochina and on the verge of losing Algeria, had become a nation less unanimous in pride over its colonial expansion, and there was already talk of reorienting the museum toward the arts of Africa and the Pacific. André Malraux picked up on the museum's practice of "privileging art objects at the expense of ethnographic objects,"[3] redefined it as a museum of African and Oceanic art, and moved it administratively from the Ministry of Colonies to the new Ministry of Culture. It continued to suffer from organizational problems and did not achieve the status of a "national museum" until a decade later.[4]

In spite of its official designation as an art museum, however, it had come over time to be best known for its aquarium, popular among schoolchildren and frequently emblemized by images of the crocodiles that made it their home. Its proximity to the Vincennes Zoo only exacerbated the image. Appointment to the directorship of this "Cayenne of museums," one commentator declared, constituted a "definite disgrace" and was tantamount to being exiled from the profession.[5]

In 1992 the recently appointed director, Cécil Guitart, developed a plan to breathe new life into the MAAO, with a multidisciplinary agenda, coordinated exhibitions, redesigned interior spaces, a network of relations with African and Oceanic museums and research centers, and an invigorated link between traditional and contemporary arts.[7] The catchword used in discussions of this plan was "a dialogue of cultures." But the mid-1990s became a turbulent period for the museum's directorship—Guitart's long-serving predecessor, who had been dismissed in 1992 for negligence, was reinstated by the courts two years later for a several months-long return after which an interim director (Africanist Étienne Féau) took over until the appointment of Jean-Hubert Martin (curator of the 1989 Magiciens de la Terre mega-exhibition, a

Sometimes cast as "the end of the world," French Guiana is a tiny outpost of Europe on the South American continent. Once the site of France's notorious penal colony, it is now used to launch missiles into space. The capital, Cayenne, has always inspired purple prose, including the following reactions by an early twentieth-century geographer and a mid-twentieth-century anthropologist:

"Cayenne: the town where the buzzards, those predators with metallic, funereal feathers, half-crow, half-vulture, have appointed themselves as reprocessing agents for the garbage system. . . . Cayenne: it's an incoherence of races, a confusion of colors, a Tower of Babel of languages, a Babylon of imported vices, a Capernaitical shambles of family, an imbroglio of kinship, as well as a den of gold miners and convicts, a place of force and degradation, dazzle and gloom, gold and garbage!"[6]

"The passengers in the van confirm everything I've heard about the destitution and decadence of Cayenne. The descriptions of the city that have been told to me were so unfavorable that I expected the worst, but in fact, Cayenne is even more down-and-out than it was possible for me to foresee. . . . The houses are terribly dilapidated. Vultures roam the streets."[8]

signatory of Kerchache's 1990 manifesto, and a man said to be eyeing the directorship of the future museum of *arts premiers*).

The program for a "dialogue of cultures" fell victim to the upheavals (though the expression was picked up a decade later as a leitmotif of publicity for the Quai Branly Museum), and the MAAO was left to vegetate. In 1999 Jean-Hubert Martin, who had by then been replaced by Germain Viatte, commented that the museum had not changed in any significant way since the 1930s. "It has no elevator, no restaurant, no cafeteria, no real conference room nor even a movie projection room. . . . [I]ts public galleries make it one of the most old-fashioned national museums. Those who are nostalgic value it highly as a remnant of 'the museum of days gone by.'"[9]

In this environment, the decision to create a new museum of *arts premiers* was seen by some insiders as a promise of rebirth for the MAAO collections, and the staff put up significantly less resistance to the move than did their colleagues at the Musée de l'Homme.[10] The building's origin as a monument to French colonialism had given it a very different image from the Palais de Chaillot, which was so closely associated with the political left and the Resistance during the Second World War and located in a building whose front terrace had been baptized "Human Rights Square." But more importantly, the MAAO's collections had already been assigned an identity as art objects, and the curators responsible for them were well suited to assume positions in another museum of art. A number of them simply moved with the collections, taking on key responsibilities in the future museum of *arts premiers*. Beginning in 1999 Germain Viatte served both as director of the MAAO and as museological director of the Quai Branly Museum. Two Oceanists, two Africanists, and a documentalist at the MAAO also took on senior positions at the MQB.

By the time the Porte Dorée palace was emptied of its collections of African and Oceanic art in early 2003, multiple suggestions had been made for new occupants. Early plans to use the Palais de Chaillot for Chirac's museum had opened the possibility of moving the Naval Museum into the Porte Dorée—a suggestion opposed by the director of the Naval Museum.[11] Other ideas that were floated saw it as a monument to art deco architecture or as an appendage of the adjoining zoological park. And Germain Viatte proposed using it as a site for reflection on "contacts, exchanges, and relations between European nations and the world beyond."[12]

In July 2004 Prime Minister Jean-Pierre Raffarin announced preliminary plans to convert the Porte Dorée palace into a center for the history of immigration. Created on paper in early 2005 as a *groupement d'intérêt public* (and not officially a museum since it possessed no collections), the future

center was given until 2007 to assemble audiovisual materials, archives, and other ingredients for its elevation to the status of an *établissement public* and the opening of its exhibition spaces.

Could the establishment of the new center be viewed as a turn back to the Porte Dorée's original focus on France's meaningful Others in the context of colonialism? Jacques Toubon, the president-designate, affirmed that "neither the relationship between colonization and immigration nor the situation of persons from the overseas departments and territories will be neglected."[13] At the same time, some might have found it ironic (and simultaneously logical) that just as doors were closing on the museum originally established as "a center for propaganda and teaching designed to give young people a clear vision of the extent and power of France in the largest sense,"[14] an alternative homage to the colonial past was being adopted by the French State. The official announcement of the Porte Dorée's new identity came on 25 February 2005, only two days after the National Assembly passed its law requiring recognition of France's positive contribution to its former colonies (see "Down with Hierarchy," above).[15]

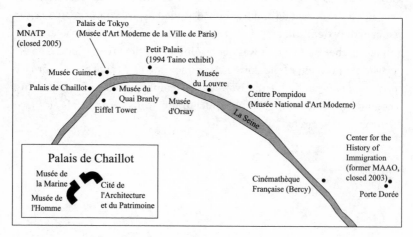

Map of Paris, showing sites mentioned in the text.

Musical Chairs

Any transformation in one French museum—whether
creation, renovation, or relocation—creates
transformations in others as well.*

Some museums die, others are regenerated, others are
born. And there are some that, de-baptized, travel with
or without their collections.†

Over a dozen years, Paris museums danced to a number of different tunes in
a politically orchestrated game of musical chairs.[1] Our focus so far has been
on the two main players, the Museum of African and Oceanic Art and the
Musée de l'Homme, whose collections were slated for moves into new quar-
ters (across town and across the Seine, respectively) and merger in a museo-
logical "shotgun marriage."[2] But the identities and locations of a number of
other museums were also jostled in the process, most notably the National
Museum of Popular Arts and Traditions (MNATP). Replaying the game in
fast-forward will allow us to bring in the fuller set of participants.

The initial plan, endorsed by the Friedmann Commission, was for the
collections of the MH and the MAAO to be combined in the west wing (Aile
Passy) of the Chaillot Palace, then home to the MH and the Naval Museum.
Much discussion turned on alternatives for this latter—new docking places
for, as an article in *Le Monde* put it, "the Trocadéro flotilla."[3] At the begin-
ning there was talk of contributing to ongoing efforts toward decentraliza-
tion by moving it to a seaport such as Saint-Malo, Lorient, Brest, or Cher-
bourg, on the argument that it should be located in a site with a naval

*Élise Dubuc, "Le futur antérieur du Musée de l'Homme," *Gradhiva* 24 (1998): 73.
†Martine Segalen, *Vie d'un musée, 1937–2005* (Paris: Éditions Stock, 2005), 287.

history. The east wing of the Chaillot Palace was also invoked, but vetoed because its current occupant, the National Museum of French Monuments, was already slated for a major makeover there. Some suggested locating both the Naval Museum and Chirac's new museum of primitive art in the Chaillot Palace, but that would have meant squeezing the latter, sending European ethnography to the MNATP, and moving a number of laboratories to the Jardin des Plantes, and the idea was quickly dropped.[4] Another plan was to move the Naval Museum into the space freed up at the Porte Dorée by the departure of the MAAO. Étienne Féau, a curator at the MAAO who was in favor of this plan, felt that "moving into the beautiful building at the Porte Dorée would double its space and its attendance. It would be appropriate to place maritime collections above the magnificent aquarium, and in the painted and sculpted décor of the old Museum of Overseas France, which represents a general homage to the navy."[5] The minister of culture, Catherine Trautmann, instead proposed leaving the Naval Museum where it was and installing the combined collections of the MH and the MAAO in the Palais de Tokyo—a more attractive solution for the director of the Naval Museum who was relieved not to have to abandon his dock in the center of Paris.[6]

In the midst of all the debate, fire broke out in the Palais de Chaillot, damaging the two museums devoted to French monuments and cinema and putting increased pressure on plans for their futures.[7] One idea that was floated, but only briefly, was to move the French Cinémathèque, founded in 1936 and a fixture of the Palais de Chaillot's east wing since the 1960s, to the Palais de Tokyo. That structure, built in 1937 for the International Exposition of Art and Technology, housed both national and municipal modern art collections until the Pompidou Center was established in 1977. Once Chirac decided to create a new building for the combined collections of the MH and the MAAO, Trautmann gave up her idea of using the Palais de Tokyo for them and announced a competition for plans to develop it as a space devoted to contemporary artistic expression. Since January 2002, this center has been hosting the latest in artistic activity, broadly defined, emphasizing its special commitment to public accessibility by staying open until the after-movie hour of midnight.[8]

Noises were made along the way for integrating ethnographic collections with the modern art in whose history they had played such a pivotal role. That option would clearly have triggered a rather different debate, fanning the flames of controversies sparked by the temporary pairing in 1984 of "modern" and "tribal" objects in New York's Museum of Modern Art,[9]

but no serious proposition was advanced for the Pompidou Center to take them on.

As for the MNATP, the story of its transformations could be viewed as ending triumphantly with a magnificent new building on the Mediterranean in the heart of France's second largest city, Marseille.[10] Or it could be read more tragically, like that of the Musée de l'Homme, as a noble experiment that weathered a series of setbacks thanks to the dedication of its personnel and ultimately died, to be reincarnated as (or replaced by) a lavishly funded new museum with a sharply altered character. We'll need to make a brief digression into its past in order to contextualize the decisions that were made concerning its future.

Together with the MH, the MNATP traced its roots back to the Trocadéro Museum of Ethnography, where a "gallery of France" was inaugurated in 1884, six years after the exhibits devoted to Africa, Asia, and Oceania.[11] Once the Palais du Trocadéro was demolished in 1935, to be replaced by the new Palais de Chaillot, a department of popular arts and traditions was established, with Georges Henri Rivière (who had been working under the MH's founding director, Paul Rivet) as its director. At the completion of the new building, the MH was installed in the west wing (Aile Passy), but Rivière, who had a personal falling-out with Rivet,[12] set up offices and a gallery in "crowded, precarious, and temporary" spaces divided between the basement and attic of the building's east wing (Aile de Paris) and, at the same time, placed his embryonic museum under the sponsorship of the department of fine arts of the Ministry of Education, thus breaking ties with the MH's parent body, the Muséum National d'Histoire Naturelle.[13] Over the next half century, this charismatic figure was to leave "a strong mark on museum anthropology in France, which developed in large part by building around, expanding, or contesting his ideas."[14]

Rivière immediately began what was to become an extended uphill battle for adequate quarters. In 1950 he pleaded his case to an Economic Council, arguing that what he wanted was

> not a sumptuous formal building [with] marble columns and domes [but rather] a simple building—practical, functional, flexible . . . and modern, preferably situated in a park to allow the possibility of hosting popular festivals.[15]

In 1952 Paris's Jardin d'Acclimatation—a grassy area at the edge of the Bois de Boulogne that had been used to exhibit exotic animals, and then ex-

otic peoples, at the end of the nineteenth century—was chosen as an appropriate site for a future museum intended to be at once popular (anti-elitist), national (projecting French identity), and scientific (distinct from "folklore" through its commitment to rigorous scientific methods).[16] But the museum remained homeless until 1972, when it finally opened its own doors there, in a modernistic building of glass and steel. Like the Musée de l'Homme, the MNATP included a strong research component, with many of its curators employed through the Center for French Ethnology (CEF), part of the National Center for Scientific Research (CNRS).

It wasn't long before the popularity implied in the museum's name began to fade. Many blamed its remote location (asserting, for example, that its address on the avenue du Mahatma Gandhi was unknown to taxi drivers[17]); others faulted what they saw as an overly narrow focus on rural France in the postwar years;[18] and one observer pointed to the floor rags catching roof leaks in front of the display cases as evidence of an "architectural failure."[19] People also complained of inadequate parking, an "unwelcoming" entrance, and the lack of a restaurant.[20] And there were debates about elitism in the very structure of the French museum world that gave priority to fine arts at the expense of humbler forms of cultural expression.[21] But whatever the reasons, attendance dropped precipitously from 160,000 visitors per year during its first decade to a paltry 66,000 in 1990,[22] and museum personnel were deploring the frequency of "eight or ten visitors a day."[23] As with the Musée de l'Homme, the word "dust-ridden" was frequently invoked by observers. And as with the Musée de l'Homme, there was occasional talk of "fratricidal" discord among its staff.[24] Multiple suggestions were made, some for its rehabilitation, others for the dispersal of its collections into more viable geographical, chronological, or thematic groupings. Even as its orientation was being debated, it did its best to attract the public that it so needed for its future existence—piercing its "blind" walls to create windows and venturing beyond its traditional focus on rural France by mounting exhibits on more diverse subjects such as the role of ethnographic museums and the history of AIDS.[25]

During the first two decades of its residence at the Bois de Boulogne, Jean Cuisenier, more of an academic sociologist than a museum curator, served as director of both the museum and the Center for French Ethnology. When he stepped down in 1989, Martine Segalen became director of the CEF, but the directorship of the museum was given to five different people in the space of six years, and it wasn't until 1996 that the position was filled on a more permanent basis. Michel Colardelle, an archaeologist, campaigned actively for fundamental reorientations in the museum's mission, advocating more at-

tention to contemporary phenomena (citing tattooing as a worthy example) and an expansion of the focus from France to Europe more generally. He also argued (along with others) for moving it from its moribund location, first talking about a more central location in Paris, and then throwing his weight behind the idea of Marseille.[26] Much of the debate about its future turned on the same issues as those being invoked regarding other museums in Paris, especially the rivalry between "aesthetic" and "scientific" goals. Colardelle, writing in 1998, characterized the environment as one of "reciprocal contempt" between curators (who gave aesthetics priority) and academics (who were committed to research).[27]

Proposals were made for installing the MNATP in the Palais de Tokyo, on the idea that the proximity of the Palais de Chaillot, the Musée Guimet, the Musée du Quai Branly, and the MNATP would create an attractive assemblage of museums on cultures of the world.[28] But Catherine Trautmann vetoed the idea, and in 1999 a decision was taken to move the collections to Marseille. Like workers at the MH, those at the MNATP felt not only "bitterness at realizing that their project had become obsolete, but also sadness (or rage) at not having been able to take care of the problems from the inside."[29] As part of the plans to close the museum, the CNRS also decided to terminate the CEF, which was done in January 2006.

During the summer of 2005, the MNATP put on a final exhibition—Lumières sur les ATP, a nostalgic homage to Georges Henri Rivière[30]—and closed its Parisian doors for the last time. Its replacement, with an expanded mandate embracing "encounters between North and South, between East and West,"[31] was scheduled to open with a new institutional identity in a historic section of France's second largest city, rebaptized the Museum of European and Mediterranean Civilizations (MCEM, but popularly known as the Mucem).[32] Unlike the MNATP, the Mucem will be granted the status of an *établissement public.*[33]

By the time the music quieted down (in the spring of 2006), the map of French museums had been profoundly altered, as had the distribution of their respective missions.[34]

The Louvre, under new directorship since Rosenberg's retirement in 2001, had become less hostile to the presence of its new, more exotic inhabitants, though a visitor could still have trouble tracking down their corner of the palace and some of the computers that offered contextualization of the artworks were still on the blink. Work had begun on an ambitious project to cover the Visconti courtyard with a sail-like roof made up of small glass disks, creating a spectacular new wing for the Islamic collections.[35] And the

museum had expanded geographically as part of a politics of decentraliza-
tion, with the first of several projected "annexes" under construction in the
city of Lens, in northern France, scheduled to open in 2009 and discus-
sions under way about a foreign branch for the Arab world, to be built in
Abu-Dhabi.

The Musée de l'Homme was making a courageous effort to recuperate
from the excision of three vital organs (ethnographic collections, library, and
photothèque), mounting exhibitions on such diverse subjects as dragons and
childbirth.[36] Plans were being developed for its future focus on "relations be-
tween man and nature," with architectural renovations, scheduled to begin
in 2008, providing 2,500 square meters of permanent exhibition space at a
cost of 70 million euros. The focus was to be on six themes: "the invention of
man, the idea of nature, the origins of the human species, human nature, hu-
man societies and their development, and new technologies and the future
of the biosphere."[37]

At the Porte Dorée, the ever-popular aquarium was getting ready for the
June opening of an exhibition entitled Fish and Crocodiles of Africa: From
the Pharaohs to the Present Day. And in the halls emptied of their African
and Oceanic art, workers were busy assembling documents and audiovisual
materials for the National Center for the History of Immigration, scheduled
to open in April 2007. While that preparation was under way, the center held
a three-day symposium in the French national library to reflect on the rela-
tionship between colonization and migration.

The French Cinémathèque had vacated the east wing of the Palais de
Chaillot and taken up residence on the eastern edge of Paris (Bercy). Its new
home was an eye-catching building designed in 1994 by Frank Gehry for the
American Center (founded in 1931 to promote U.S. culture), but abandoned
less than two years later when the center suffered a budgetary collapse.[38]

The National Institute of Architecture (focused on contemporary trends
in architecture) had moved into the east wing of the Palais de Chaillot,
where it merged with the more historically oriented Museum of French
Monuments (begun in 1882 as a "Museum of Comparative Sculpture") and
the École de Chaillot (a school for "heritage architects" founded in 1887) to
become a City of Architecture and Heritage (Cité de l'architecture et du
patrimoine).[39]

The Naval Museum, whose first two centuries had been spent in the
Louvre, had successfully weathered the various storms of the 1990s and stayed
the course in the west wing of the Palais de Chaillot.

The Palais de Tokyo, so frequently raised as an option for housing one or

another pawn in the game, was actively hosting events centered on new directions in the arts.

The modernistic building on the avenue du Mahatma Gandhi, valiantly fought for by Georges Henri Rivière and staunchly defended by personnel of the MNATP, stood virtually empty. The one exhibition space that was spared removal to Marseille (the "cultural gallery") was closed to the public, though school groups and researchers could visit it by special appointment. There had been talk of using the building for the administration of *francophonie* (programs aimed at French-speaking peoples around the world), but no one seemed to be in a hurry to lay claim to the site, where the library was still functioning and objects from collections of both the MNATP and the MH were being prepared for their transfer to Marseille.[40] Meanwhile, just down the road on the avenue du Mahatma Gandhi, a gossamer-like "cloud of glass" designed by Frank Gehry was being built to house the Louis Vuitton Foundation for Art and Culture.

The private three-year-old Musée des Arts Derniers (Museum of Last Arts), opened in contestational response to the rise of "*arts premiers*," was preparing a July exhibit focused on works by contemporary artists that addressed the history of pillage on the African continent.[41]

Several hundred miles to the south of Paris, a site at the foot of Marseille's historic Fort Saint-Jean was on the verge of being refitted for conversion into a showcase for the civilizations of Europe and the Mediterranean. There collections from the MNATP plus new acquisitions and forty thousand European objects from the Musée de l'Homme would take on a new, more globalized identity. Construction was to take place between 2007 and 2010, for inauguration of the museum in 2011.

And one of the last available expanses of Parisian real estate, on the Quai Branly, was being readied for a spectacular new museum to showcase what everyone was trying hard not to call primitive art.

How did observers respond to the reconfiguration of Paris's museum world? Some felt that if the goal was to erase cultural hierarchies, the new alignment was a step backward. Listen to Anne-Christine Taylor, a senior insider to the Quai Branly project:

> In terms of any scientific or intellectual agenda, the reconfiguration of the landscape of the major museums is an absolute absurdity. At a time when anthropology and other social sciences have been relativizing and deconstructing traditional notions of culture, nature, the nature/culture division, the separation between Europe and exotic cultures, and the opposition between

"high" and tribal civilizations, . . . a time when the colonial past is striking back at us with violence, what do we find ourselves with? We find ourselves with a museum of non-European cultures (the MQB), a museum of man-in-nature (the future MH), a museum of "European cultures" whatever that means (the Mucem), and finally a center for the history of immigration (the Porte Dorée), designed in a sense to drown the fish of the colonial past.[42]

The Turn to Concrete

The French have a strong tradition of both State
intervention in the cultural life of the people and
State-supported architecture.*

In the midst of all this, the museum's site had crossed the Seine, and the orig-
inal plan of renovating an existing building had been dropped in favor of cre-
ating a totally new one. In February 1998 Chirac announced his decision to
build it on a 25,000-square-meter piece of land belonging to the State at the
Quai Branly on the Left Bank. The space, which was used for Paris's annual
Foire Internationale d'Art Contemporain, was said to be one of the most cov-
eted in the capital, and part of the plan was to divide the site into parcels and
sell some of it in order to finance the museum.[1]

The Socialist minister of culture, Catherine Trautmann, had argued in-
stead for using the Palais de Tokyo, a more modest option that Friedmann
was ready to accept, out of nervousness that Chirac's museum would not go
forward without her support. But Maurice Godelier stepped in, pointing to
the detrimental effect of squeezing a 28,000-square-meter museum into a
16,000-square-meter space, which would put offices in a second location and
storage areas in a third. In the end Trautmann gave in, and the Chirac camp
rejoiced. Five months later, after committees had completed exploratory
studies of the site's technical, juridical, and financial feasibility, Chirac con-

*Andrea Kupfer Schneider, *Creating the Musée d'Orsay: The Politics of Culture in France*
(University Park: Pennsylvania State University Press, 1998), 14.

firmed the decision publicly at the traditional 14 July garden party celebrating the French Revolution.[2]

The new address offered a way out of the controversies over what to call the future museum, and it was quickly rebaptized the Musée du Quai Branly. Some observers, citing the case of the Pompidou Center, saw this choice as a strategic ploy for setting up another name later on—the Musée Jacques-Chirac.[3]

In 1941 a portion of the Quai d'Orsay, on the Left Bank of the Seine, was renamed the Quai Branly, in honor of Édouard Branly (1844–1940). Although little known abroad, he is considered in France as being the inventor of wireless telegraphy, and his name is taken as a symbol of the alliance of science and technology. He is best known for his research concerning radio conductors and particularly his so-called *coherer.* Branly became Commander of the Order of St. Gregory the Great in 1899 and was nominated Chevalier of the Legion of Honour in 1900 for "having discovered the principle of wireless telegraphy." There is a bust of Branly on the Promenade du Luxembourg in Montmartre.

The Quai Branly site was as controversial as every other aspect of the project. To supporters, its proximity to the Ministry of Foreign Affairs gave it an attractive symbolic association with international diplomacy, and its projected use of advanced communicative technologies made appropriate its links to Édouard Branly and the Eiffel Tower (which had served as a radio tower during the Second World War and a television antenna after that). Detractors pointed to the failure of earlier building projects on the site, most notably the abandonment of construction on an international conference center,[4] some concluding that it was "cursed."[5] Others thought that a more populated part of Paris would have been better suited to the ambition of museum planners to create maximal accessibility, citing the Pompidou Center as a successful, more urbanized placement.[6] And residents of the area organized massive protests, arguing that it would be an eyesore and, incidentally, block the view of the Seine that represented a considerable factor in local property values. Concessions were made to their arguments through architectural constraints that set a limit on the height of the building (nothing over 25 meters) and required the integration of 7,500 square meters of garden areas.[7]

Six months after the Quai Branly was chosen as the site of the future museum, an architectural competition was launched. The project's special challenges, as pointed out in the press, included the architectural constraints, a demanding set of residents at its borders, and the task of designing an interior space for arts that were in many cases made for settings without walls.[8]

By December 1999 the eighteen-member jury had narrowed down the fifteen-candidate short list (trimmed from 120 initial submissions) to three ranked finalists—those of Jean Nouvel (French), Peter Eisenman/Felice Fanuele (American), and Renzo Piano (Italian).[9] The winning contract quickly

went, by decision of the president, to Nouvel's proposal, "ambitious but discreet, the antithesis of a national palace," which reflected the collaboration of landscape architect Gilles Clément and the "lighting juggler" Yann Kersalé.[10] Intended by Nouvel to "avoid all the habits of Western architecture"[11] and to give priority to ecological considerations (recyclable materials, natural sources of energy), it was to be completed in 2004.

Three months later Nouvel's plan went on view for visitors to the Pompidou Center.[12] An American journalist interpreted Nouvel's design as an attempt to replicate, in concrete, "the elongated shadow of the Eiffel Tower, which is just a few minutes' walk away."[13] The architect's own statement of what he wanted to achieve makes no mention of famous landmarks. Rather, it evokes a dreamlike space permeated with spiritual presences.

> It's a space marked by the symbols of the forest, the river, and obsessions with death and oblivion. . . . It's a haunted space, inhabited by the ancestral spirits of the men who, awakening to the human condition, invented gods and beliefs. The place is unique and strange. Poetic and disturbing. . . . In a gentle shift, a Parisian garden becomes a sacred grove and the museum dissolves into its depths.[15] . . . [It's] a snake or lizard into which you walk and discover not so much a building as a territory—a zoo really.[17]

At the same time, plans began to get quietly under way for less material aspects of the museum. Taking the Pompidou Center as a model, the idea was to create a multimedia conglomerate that would function at once as a research center, educational institution, theater and concert hall, and general host to a wide variety of cultural activities. As Stéphane Martin put it, "The idea is to create something like a 'cultural city,' a place for meetings, exchanges, and debates about primitive art, a place that's alive and open to the world, advancing understanding of modes of social life that are different from those we're familiar with."[19]

Nouvel's design took these goals into account in multiple ways. Hanging over each end of the main exhibition area would be a mezzanine for tempo-

Jean Nouvel (b. 1945) studied at the School of Fine Arts in Bordeaux and then at the National School of Fine Arts in Paris, specializing in urban architecture. Known especially for the impressive Fondation Cartier, he is the recipient of numerous architectural prizes, including for the Institut du Monde Arabe and the Lyon opera house. He has left his mark on architecture throughout the world, from Germany, Austria, Denmark, Spain, and Switzerland to Brazil, Japan, and the United States.[14] Just two weeks before winning the competition for the Quai Branly Museum, he was awarded the contract for an extension of the Reina Sofia Museum in Madrid.[16] Photos of Nouvel lend support to the impression of him as "someone who has sometimes cultivated a rather satanic self-image."[18]

rary exhibitions. A third mezzanine in the middle was planned for multimedia resources—interactive computer stations at which the public could learn about the societies and cultures whose arts were represented in the museum. More contextualizing information would be built into two leather-covered structures bordering a sinuous path flowing through the exhibition space itself. Documentaries, archival films, and art films would be shown in a 100-seat theater, and larger events would take place in a 500-seat auditorium facing a sunken outdoor amphitheater. A reading room off the main entrance hall would provide books, magazines, and computer programs for the general public, while a rooftop *médiathèque* and rare book room would make more specialized resources available to students and researchers.

Some observers were less than seduced by Nouvel's plan, citing the risk that it would produce a showcase for colonial clichés and outdated visions of culture. As two anthropologists wrote soon after the architect's model went on view at the Pompidou Center:

> The Musée du Quai Branly now has its architect, but has it found its principle? . . . The plan to divide the exhibition space into "culture areas" and to subdivide these into "ethnicities" suggests that the goal is to project a map of societies and human cultures. . . .
>
> A museum shouldn't be an alignment of closed boxes. . . . The objects should be allowed to evoke multiple worlds, open onto each other. . . . Instead of inscribing them in a tradition or anchoring them in a homeland, we need to free them from their ethnographic straitjackets and restore the multiple references that are continually being rethought, altered, borrowed, and reinvented.
>
> Museography, in its task of selection and classification, uses objects to represent the ethnicities that are commonly associated with them. There are Dogon people because there are Dogon masks. This circular reasoning acts to bolster the impression of authenticity, constructing monads in the form of museum cases, each of which is intended to embody one and only one culture, with the objects presented serving as both logo and vestige. From room to room, the visitor is invited to travel through a world of ethnicities, following a vision of the global primitive that appears to predate all other known modes of classification.
>
> The idea of constructing a "natural history" of human varieties around the world has become unacceptable. Anthropologists no longer believe that their job is to take discrete entities from an imagined simultaneity outside of time and identify and catalog them, or place them on file cards and in museum cases. It's no longer a matter of describing each one's rites, its collective

representations, its customs, and its objects so that they can be lined up and labeled in an ethnographic gallery. No society, regardless of how "primitive" and "ahistoric" it may appear to be, is ever a closed universe.[20]

Or, as I had written in a similar spirit the year before:

While scholars once strained to discern the stylistic essences of particular arts in particular cultures, they are now directing their gaze more frequently toward the doorways where artistic and aesthetic ideas jostle each other in their passage from one cultural setting to the next. While the emphasis was once on abstracting back from an overlay of modernity to discover uncorrupted artistic traditions, modernization now lies at the heart of the enterprise, providing a springboard for explorations of cultural creativity and self-affirmation. And while the site of artistic production was once located in lineages of convention within bounded communities, it now spreads into the global arena, pulling in players from every corner of the world, from every kind of society, and from every chamber of the artworld's vast honeycomb.[21]

Preparing the Transplants

Among the discoveries was a *nkisi* figure that hadn't
been removed from its leather wrapping and protective
sack since it was acquired in 1897!*

Once wrenched from the Musée de l'Homme, and more quietly surrendered by the Musée des Arts d'Afrique et d'Océanie, the collections destined for implantation in the yet-to-be-built Musée du Quai Branly were transferred to laboratories in the Hôtel Berlier, a glass-sided building at the southeast edge of Paris. Over a period of three years (October 2001–October 2004), the objects were treated, one by one, to the most advanced museological makeover in the world.[1]

Journalists visiting the Berlier were impressed by complex networks of pipes, humming machines, mini–vacuum tubes equipped with soft brushes hanging from the ceiling, scanners, . . . and everywhere glues, gels, solvents, acrylic resins, demineralized water, and hands in white surgical gloves busily readying objects for their new life at the Quai Branly. Seventy to eighty technicians trained at schools specializing in heritage conservation were removing every speck of dust, every tiny bug, and every trace of mold. Garbed in immaculate white lab coats, they labeled, measured, weighed, inventoried, cleaned, repaired, disinfected, and photographed each piece in what one observer described as a "religious silence":

*Gilles Bounoure, "Le 'chantier des collections' au musée du quai Branly," *Arts d'Afrique Noire* 131 (2004): 50.

They cleaned ancestral spears from the Amazon with a dry duster, used a super-fine ophthalmologist's needle to mend minuscule pearls decorating sumptuous Asian costumes, took a supple brush to repair scarring marks on Cambodian baskets, revived the bright colors on a plumed mask from New Hebrides, and reattached the golden ornaments on a wooden horse from Vietnam . . . all with a slow precision and loving attention to the objects under their care.[2]

For each object—whether made of stone, metal, bone, leather, ivory, bark, shell, plant fibers, feathers, or even spiderwebs—the process began with the assignment of a bar code. Then, utilizing any original documentation that was available, often handwritten archives and fading black-and-white photos, workers recorded as much as possible of its museological background, its legal status, its connection to other pieces, its geographical origin and subsequent history, its physical condition, and other pertinent data. This information was recorded using a digital cataloging program known as TMS (The Museum System), which rationalizes the process, incorporates efficient means to update information, and facilitates communication with other major museums that use it, such as the Smithsonian in Washington, the Tropenmuseum in Amsterdam, and the National Gallery in London.

Disinfection was handled by nitrogen-filled containers in which boxes containing objects made of organic materials were deprived of oxygen for a period of two weeks at a temperature of at least twenty-five degrees centigrade. Objects suffering from mold were transferred to the national library and treated with ethylene oxide.

Photographers then took over, creating high-resolution images of each piece, and treating 370 selected objects to digitalized imaging in three dimensions, spending as much as a whole week on a single object.

Conservator Christiane Naffah, who directed this whole phase of the project, organized two teams with six-hour work shifts, managing to complete her assigned task exactly on schedule, unlike many other aspects of the MQB project. She stressed that the whole objective focused on preventative conservation, as opposed to restoration. The idea was to prepare objects in such a way as to protect them from deterioration, in preference to dealing with them after they had problems. A State-run committee charged with overseeing such matters authorized a small number of exceptions to this approach for objects that were certified as being in advanced states of deterioration. These were entrusted to the Centre de Recherche et de Restauration des Musées de France (C2RMF) for repairs. All the others were handled in line

with Naffah's philosophy of preventative conservation: "Restoring ends where hypotheses begin."[3]

By October 2004 the Berlier team had completed its mission and closed its doors, and some 300,000 objects—systematically inventoried, weighed, measured, cleaned, fumigated, photographed, cataloged, and in a few cases repaired—had been packed in sealed containers and moved to temporary storage areas in the nation's François Mitterrand Library, just a few hundred meters away, awaiting their transfer to the new museum. The cost: 15 million euros.

Behind the Hairy Wall

31AUG-JFK/CDG, AA#44@18:05
26SEPT-CDG/JFK, AA#121@17:50*

I first visited the Quai Branly Museum in September 2005 as the $300 million building project moved into its final phase. A decision had just been handed down from the presidential palace that the museum would open on 20 June 2006, but there was still much work to be done before the building, let alone the installation of exhibits, was ready. The construction site was blocked off from the street by a wall of corrugated metal on which several rotating billboards touted a variety of commercial products and others announced the future museum. Top models in seductive Kookaï fashions vied for attention with the rotund (and equally seductive) figure of the museum's mascot, a terra-cotta figure from Mexico.[1] Looking toward the building, one could see the upper half of the Eiffel Tower rising majestically into a clear blue sky. In the other direction, just across the river, the Palais de Chaillot, former home to the bulk of the Quai Branly collections, revealed no hint of the loss of its treasures.

An expansive exterior wall of the building was already alive with dense vegetation. Fifteen thousand plants—representing 150 species from Japan, China, the United States, and central Europe—composed a lush vertical forest that glistened in the sunshine of a magnificent late summer day.

*PalmPilot entries, 2005.

The concept of what one museum document referred to as the "hairy wall"[2] grew out of landscape architect Patrick Blanc's thirty-year fascination with plants that take root in environments such as boulders, tree barks, and rocky spring beds rather than in soil. By affixing two layers of polyamide felt to a metallic framework, he created a cushion of air between the supporting wall and the plants, whose root growth is favored by the capillarity and moisture-retaining properties of the felt. The plants, approximately twenty per square meter, receive water and nutrients from holes in hoses that drop from the top of the wall and are controlled by electrical panels. Weeds have no way of invading the plants, and the system requires minimal maintenance, though annual prunings are planned.

At each of our visits that month, Richard Price and I were checked in at a security desk and handed visitors' badges before taking the elevator to one of the several floors of offices, which were in full swing and buzzing with activity. Germain Viatte, a key player from the very beginning, had reached mandatory retirement age just weeks earlier but was staying on in a small office at least until the opening. Out of his window, he showed us with evident excitement a central wall of the construction that had been exposed just that day. His former, more spacious office next door was now occupied by Jean-Pierre Mohen, who had taken over as director of museology.[3] Across from his desk an interior wall densely punctuated with shallow felt pockets provided the backing for another vertical forest—this one more modestly scaled, but equally bursting with fresh vegetation.

We were received cordially by everyone we asked to see and heard detailed explanations of the ongoing plans from those responsible for different aspects of the project—temporary exhibits, outreach projects, library holdings, *médiathèque* accessibility, relations with countries that were represented in the exhibits, research facilities, and more.[4] Even details of the physical plant came under discussion during those meetings. We were told, for example, that if we had come a few weeks earlier, the offices would have been considerably dingier, since chemicals in the solution used to water the wall of plants turned out to leave grimy deposits on the glass, cutting out the sunlight, and the windows had just undergone their first rigorous scrub-down.

Speaking with different members of the team, I sensed an excitement about this project that, after so many years in the planning, was on the verge of completion. Excitement, but also some understandable anxiousness about whether it would be fully ready by the deadline that had just been set at the Élysée Palace. Some areas seemed to be under more confident control than others.

It quickly became clear that my presence was cause for mild concern. People who were on record as having taken decisions favoring a "purely aesthetic" approach showed themselves eager to persuade me of their commitment to ethnographic contextualization, and one concluded my interview

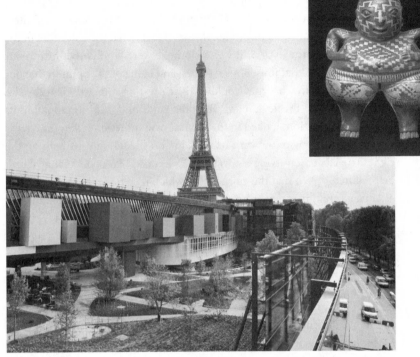

The Musée du Quai Branly (inset: the *chupícuaro*). Photo: Fred Dufour/AFP/Getty Images. Inset: © Photo SCALA, Florence. Musée du quai Branly.

with him by asking, rather tensely, whether he had just served as my "informant." Each one, understandably, asked rather gingerly whether my book in progress was specifically about the Quai Branly Museum. Each one, aware of my critique of aspects of the Paris primitive art world, attempted to downplay the aesthetic dimension and show me how much the museum would be permeated with an anthropological sensitivity.

A visit with the archaeologist responsible for the part of the museum dealing with the Americas afforded a serendipitous opportunity to make a small contribution to the enterprise. André Delpuech had been appointed just weeks earlier and felt properly humbled by his charge to oversee ethnographic representations of everything from Amazonian tribes and pre-Columbian Aztecs to Indians of the U.S. Southwest and the Canadian Arctic. Because he knew of the work Richard Price and I had done with Maroons in the Guianas ("Africans in America," as some authors have dubbed them), he explained that a display on their cultures, designed before he came on board, was being used to provide a bridge between the area devoted to Africa

and the area devoted to the Americas. Calling up on his computer a picture of the tall narrow case, he pointed to the two stools at the bottom, the carved combs and embroidered caps above that, and the large colorful centerpiece—a handsome patchwork textile that had entered the collection of the Musée de l'Homme in 1938. It was a cloth we were familiar with from our own past work in that museum's reserves, and being of the opinion that objects should retain what they could of their pre-museumized identities, we both gasped. The textile, a man's shoulder cape, and thus horizontal in its intended orientation, looked in the vertical case something like a dress displayed in a store window with its neckline on the left and its hem on the right. The label identifying its origin as "Saramaka, French Guiana" didn't help matters, given that the village from which it came (correctly identified as Langa Tabiki in the plan he showed us) is the capital of a quite different Maroon nation, the Paramaka, who speak a different language and are based several hundred kilometers to the east of the Saramaka . . . and that both the Saramaka and the Paramaka are based, not in French Guiana, but in Suriname.

Clearly, no one person, no matter how well read, can master the ethnography of every culture in the Americas. But scholars capable of providing authoritative information on each area have always been readily available. If the Maroons were to be represented in a case, why hadn't we, or one of the other scholars with firsthand knowledge of Maroons, been consulted? Fortunately it wasn't too late, so we explained that there were three things to fix: the cape should be shown horizontally, its label should attribute it to the Paramaka Maroons instead of the Saramaka Maroons, and the correct location of Langa Tabiki was the independent Republic of Suriname, not the French overseas department of Guyane. We stressed that we would be happy to reply by e-mail about any other questions concerning Maroon materials that came up before the museum's inauguration and said we were looking forward to seeing the Maroon case, with these details corrected, when we returned to Paris in 2006.

The September visit also opened a window onto the museum's position regarding the sensitivities of peoples whose arts are in the collection. Séverine Le Guével, head of international relations, explained to me that her job included taking care of Stéphane Martin's international correspondence and travel arrangements, supervising long- and short-term loans to and from other countries, overseeing public relations with foreign museums, and developing cooperative projects with countries represented at the Quai Branly. The part I was most interested in hearing about was the handling of claims

for repatriation, and she made a valiant effort to lay out the logic of the museum's approach.

The key, as she explained it, was keeping an open dialogue at the diplomatic level. For the Nok statues, for example, discussions with the Nigerian government had lasted over five years, culminating (in September 2005) in a memorandum of understanding that granted the museum the right to keep the statues for an initial thirty-seven-year period, after which their status could be brought up for discussion again. The danger, she said, alluding to a request for repatriation from Ecuador, was setting a legal precedent. A claim had also been made by Maoris, but the New Zealand government understood that it would be very much against the country's interests to create "tensions" with France.

The issue of human remains in museums came up in the course of the discussion. Her argument included several strands:

> First, the bodies have never functioned as human remains. Secondly, they were (for the most part) *given* to the explorers who brought them back, not stolen or taken without permission.[5] Plus, they're not identified. We don't know who they belong to. Thus, they've become art objects; they've become ethnographic objects. That makes a difference. Therefore, they should be preserved like art objects, and can't be destroyed. . . . And it's also important to consider all the objects that contain human remains. If we were to honor the claims for everything that contained human remains, it would mean giving away the *entire collection* of the Musée du Quai Branly—anything that contains a bit of bone, anything that contains a skull. . . .

Distinguishing bodies that hadn't "functioned as human remains" (been embalmed? been through funeral rites?) and asserting that some kind of human remains lurked in all of the more than 300,000 objects in the MQB collection didn't seem like ideas worth pursuing. But there was a more fundamental matter—"a rather delicate issue," as she put it.

> We at the Quai Branly, as elsewhere in France, have decided to respect the principle of *laïcité* [separation of church and state, very roughly equivalent to secularism]. Therefore, we do not take into consideration any claim based on religion or ethnicity. That's important. . . . We're a public institution, a secular institution operating in the public domain. If you allow the legitimacy of one religion, you allow them all, and then they all cancel each other out. That would put every place in the world on the same level! . . . Giving credit to all

the claims would be to cancel out all of them. . . . If you really believe that these things have a profound meaning, well, the museum isn't made for that. The museum is not a religious space.

Emerging from this interview, what struck me as most extraordinary was less the specific arguments than the fact that the MQB had entrusted cultural property claims to one person (admittedly, a person of considerable personal charm and visibly well qualified to participate in the diplomatic encounters on which the approach hinged) who was shouldering several other aspects of the museum's operation at the same time. This was in sharp contrast to museum organizations outside France in which attention to the thorny issues of cultural property were playing an increasingly prominent role, following explicit policies adopted on the basis of intense debate by formally constituted committees, and in some cases eliciting the advice of special "native advisory committees" from the cultures represented in the exhibits.

The MQB's position on cultural property rights had, nevertheless, been voiced by more central players. Germain Viatte, for example, discussed the issue in an October 1999 interview, and his remarks went very much in the same direction as Le Guével's. Asked about how the museum planned to handle claims made on religious or ethnic grounds, he began by citing the pleasure that people from outside Europe took in museum displays of their religious artifacts—Japanese visitors to the Louvre quietly expressing their devotion before a Buddhist statue; Maoris placing leaf offerings before objects in a museum in Wellington, New Zealand; and Buddhists appreciating the Musée Guimet for providing a place of respect for their faith. But, he went on, the museum remains a secular institution, and that raises some very delicate problems that have no easy answers—for example, how to deal with objects that are not supposed to be exhibited, like Australian *churingas*.

France is both universalist and secular. We need to recognize that [museum collections] belong to the history of our own country, but also to cultures that may have disappeared, or be on the way out, or be hoping for cultural revival. We need to take all this into account, but without giving in to a kind of paternalism, confining other people to their particularities and reserving universalism exclusively for ourselves because we're worried about being "politically correct." We cannot give in to claims for restitution like those presented to the English for the Parthenon marbles or the Benin bronzes. But what we can do is set in motion international collaboration designed to find viable

compromises between different, often incompatible interests, for example, between restitution and the protection of objects.[6]

The museum's president, Stéphane Martin, also laid out the logic of the museum's position:

We are not in the business of buying ourselves a clear conscience vis-à-vis the non-Western world or becoming an "apology museum," relaying messages based on the heritages of [cultural/ethnic] communities the way museums in Canada and the United States do for Indians. In France we have a more objective vision of culture. It's free of all instrumentality (nationalistic, pedagogic, etc.), though it's becoming more and more difficult to defend. . . . In my view, the argument for returning the contents of museums to their countries of origin is a rejection, pure and simple, of the museum's calling, which is to show the "Other"—which means, by definition: outside of its original environment. Art objects are also ambassadors for their culture, and in that capacity they're an element in the dialogue between peoples.[7]

The impact of the French notion of *laïcité* on the exhibition of objects from non-European cultures is clarified in an article about a 2001 "exhibition-installation" at the Museum of African and Oceanic Art in which Australian *churinga*s were presented in semi-invisibility: "Although they are bathed in light, the objects hide from the gaze that attempts to capture them: the closer one gets the less visible they become. . . . The idea is to leave visitors not with the memory of an object in its materiality, but the memory of an idea about the religious nature of the object in its culture of origin."[8]

Was the museum showing disrespect for Australian cultures by exhibiting sacred objects that, in their original culture, should not be seen by non-initiates? Not in the least, asserted two anthropologists, as they laid out a perspective fully in line with statements being made by personnel at the MQB. After all, they went on, the fundamental function of a museum is to make its collections accessible to as many people as possible.

If it's understandable that oppressed, minority, native peoples, as part of their political and identitarian strategies, act in this way [choosing when and to whom they want to share aspects of their culture], it could hardly be said that museums are fulfilling their mandate if they allow themselves to be pushed around, however legitimate the cause may be. . . . Restricting access to *churinga*s in a museum would amount to placing visitors in the role of non-

initiates in the Aboriginal religious system, that is, casting them as believers, which of course they are not. A museum that honors such a request is not only going against the principle of *laïcité,* but also acting as if its job is to accept the religious laws of the cultures whose objects it owns, in some sense giving itself the job of assigning a sacred status to the sacred beliefs of others.[9]

Disallowing claims that are based on ethnic or religious identity can also be seen as a logical consequence of the ideology in France that privileges a sense of national unity over religious or ethnic identities and in which "communitarianism" is viewed as a divisive force that endangers the unity and harmony of civil society.[10]

A second particularity of the MQB position on cultural property is that the discourse is so fully phrased in terms of international diplomacy with foreign governments. Elsewhere in the world, discussions more often take place with representatives of minority cultural/ethnic groups. In the United States, for example, Zuni Indians successfully petitioned for the removal of a war god from the exhibit case of the Museum of Modern Art in New York.[11] And in the Netherlands, the Leiden Museum of Ethnology recently returned a tattooed, mummified Maori head to Maori curators at the Te Papa Museum in New Zealand.[12] Participants in these negotiations recognized fully that "dialogue" was something entered into by real people, not abstract constructions like cultures—that cultures don't dialogue . . . people do. And that the issues in question were not something to be entrusted to government officials in national capitals. But the position of the MQB, as it was explained to me during my visits, was that negotiations were conducted with representatives of nations, not cultural groups within nations. And they were to proceed through diplomatic persuasion at the ambassadorial level, not through recognition of culturally specific visions of sacred property. The third world was recognized, but not the fourth.

*

The September trip reminded R. P. and me of how much we have always liked Paris. We made nostalgic visits to the sites of our three year-long stays in the city, visited halls in the Sorbonne where we had taken courses and given lectures, saw old friends, ate any number of memorable meals, and walked the streets into the wee hours. As we prepared to leave, we looked back at the monthlong visit and marveled at the elegance of Paris and the security of an urban environment that had allowed such delicious midnight strolls.

Then, just a few weeks later, another side of French urban life hit the news-

stands. The background was a modified replay of issues that had dominated political debates during Le Pen's bids for the presidency.[13] Le Pen himself had dropped temporarily off the front page, but the minister of the interior, Nicolas Sarkozy, was not a bad understudy. A definite front-runner in the next presidential elections, he was hanging his chances on a tough stance toward illegal immigration and a "war without mercy" against crime in the working-class neighborhoods.[14] His use of the words *racaille* (thugs, rabble, or scum) and *voyous* (hoodlums, hooligans) to describe the targets of his aggressive program was particularly incendiary in the immigrant communities, largely from North Africa, that were housed in squalid high-rises on the outskirts of Paris and other French cities, with substandard access to bathrooms, heat, and personal security. High rates of unemployment and the recurrent experience of being treated as second-class citizens created frustrations that brewed just beneath the surface. Second-generation Muslims—born in France, educated in French schools, speaking French, and legally entitled to every right of citizenship—were finding that the name Mohammed on a job application was a pretty good guarantee of rejection. During a visit to one such neighborhood, Sarkozy was pelted with stones and bottles.[15] It was clear that the tiniest spark would ignite the anger on a grand scale.

And it does. In suburban Clichy-sous-Bois, three teenagers flee police who either are or are not pursuing them (depending on whose version is told), and take refuge in an electrical substation, where two of them are electrocuted. The three weeks of destruction that follow, first in Clichy-sous-Bois, but soon across the nation including the center of Paris, are close to the worst unrest modern France has ever known. On one night alone, fourteen hundred cars are torched. Desperate to put an end to violence that shows no sign of abating, the government reactivates a law created during the war with Algeria, giving local officials the power to declare curfews at their discretion, to censor press coverage, and to step up sanctions on rioters. Sarkozy declares that immigrants picked up by the police for participating in the disturbances, even those whose residence papers are fully in order, should be deported.[16]

At the beginning, the focus is on stemming the violence rather than addressing its root causes. But as the rampage shows signs of subsiding, observers begin formulating explanations. Some cite unemployment, others poverty, and still others Islamist extremism and a negative attitude toward assimilation.[17] A nationally prominent philosopher, Alain Finkielkraut, creates a storm with openly racist assertions that the riots are an "ethno-religious" phenomenon, totally unrelated to social conditions. Particularly interesting from an anthropological point of view is the assessment of Bernard Accoyer, the parliamentary leader of Chirac's Gaullist party, who

In 2004 the youngest person in the entire French Republic to attain a baccalaureate degree was the child of a polygamous household. Mohamed Diaby grew up in poverty in Abidjan, one of his father's sixteen children with two wives, and came to France at thirteen, just months before taking the competitive final exams.[19]

declares that the problem is Muslim polygamy. Sarkozy, as well as the secretary of the Académie Française and the junior employment minister, also make pointed references to polygamy as a key factor in the unrest.[18] These comments are quickly condemned by public statements and newspaper editorials evoking everything from the social costs of single-parent households to the high frequency of mistresses and outside children among non-immigrant Frenchmen,[20] but the European gaze on polygamous marriage (and by extension any deviation from Western cultural norms) has clearly entered the debate.

Trouble on the street often goes hand in hand with glorification in more upscale settings, and the events of fall 2005 in Paris were no exception. Less than a week after government officials proposed that a Muslim lifestyle was the root cause of the rampage, an homage to Islamic culture opened in a spectacular building designed by Jean Nouvel, the same architect who designed the Quai Branly Museum.[21] And even as cars burned outside, the Louvre was upgrading its Islamic galleries through renovation of the Visconti courtyard (in the museum's most prestigious area, between the Greco-Roman antiquities and the *Mona Lisa*), quadrupling the space previously accorded to Islamic art. For Chirac, it was a gesture intended to "reaffirm the essential contribution of Islam to our [French] culture."[22] Henri-Pierre Jeudy has commented on this power of museums to cancel out, at least for the duration of a visit, the more disturbing realities of life on the streets outside.

> Their management of culture, purified of its conflicts and accidents thanks to the innocence of museum exhibiting, represents an ideal form of intellectual survival in the face of threats, more or less real, of the destruction of local identities. . . . Walking through a museum can create a confusing feeling of being removed from the city outside. . . . The temptation to stay inside after closing time is always there, even if few have acted upon it.[23]

The "innocence" of museum exhibits is clearly more apparent than real, conveying a deceptively comforting impression that harmony among cultures of the world can be achieved through the respectful treatment of material objects.

Glass, Gardens, and Aborigines

One has the impression that the museum is a
simple open shelter set in a wood.*

As collections from the Porte Dorée and the Palais de Chaillot made their
way to the Quai Branly, the architectural vision they embodied was left de-
cidedly behind. Nothing about the MQB's physical plant harks back to the
monumental palaces of the late nineteenth and early twentieth centuries.
Visitors encounter no colonnades, no grand archways, and no formal gar-
dens, and "the right angle is a rare beast."[1] The Palais de Chaillot's magiste-
rial view of the Eiffel Tower across an imposing esplanade has been replaced
by a quiet intimacy with that same landmark. The Porte Dorée's giant fres-
coes celebrating French colonial conquests have received what might be con-
sidered a postcolonial response in contemporary work by Aboriginal artists
from Australia. The main building is suspended over a lush expanse of green-
ery, with the supporting columns inside (of which no two are exactly alike)
positioned according to a "skillfully calculated haphazardness"—all this
combined with "random shimmerings of light to evoke sunbeams piercing
the forest canopy."[2]

It's almost as if the architect had taken Georges Henri Rivière's 1950 dream
for the MNATP ("not a sumptuous formal building [with] marble columns

*Jean Nouvel, "Lettre d'intention" (1999), quoted in Musée du Quai Branly, "Un mu-
sée composite: Une architecture conçue autour des collections," 2006, 1.

and domes . . . [but] modern, preferably situated in a park") and propelled
it daringly into the twenty-first century, treating it to engineering feats un-
imaginable a half-century earlier.

The museum sits in an 18,000-square-meter garden filled with trees and
bushes, pebbled paths, hillocks, and ponds. Toward the Seine there are oaks
and other tall trees, while the opposite side is planted in magnolias and cherry
trees. Around the piles supporting the main museum building, grassier
species create a marshy undergrowth. A large sunken hollow forms a natural
outdoor amphitheater that faces its indoor counterpart, the 500-seat Claude
Lévi-Strauss Auditorium. The subtle evocation of a tortoise shell is omni-
present, "outlining the shape of a glade, in the design of a bench, rising from
a pathway in the guise of a mossy rock, or set in the midst of the garden as a
creeper-covered shelter." The rationale here is that the tortoise is "a mythic
creature holding a special place in the animistic and polytheistic cosmogo-
nies whose sacred works are collected by the museum."[3] As the museum's
press kit explains:

> In Asia, the cosmophoric tortoise Bedawang (a mythical being from times be-
> fore incursion of Balinese polytheistic influences) carried the universe on its
> back; in Africa (Dogon Country), the seat upon which a guilty party is placed
> to make his confession is a tortoise; in Amazonia, some peoples shape their
> tribal camps like tortoises, with the tail pointing towards the river—an es-
> sential marker in the midst of the forest.[4]

The bibliographic sources for this picturesque trip around the world are not
indicated in the MQB literature that touts universal turtledom.

The contributions of two contemporary artists from New Zealand,
Michael Parekowhai and Fiona Pardington, were chosen for a window dis-
play visible to visitors as they walk through the garden. Exceptions to the mu-
seum's general focus on objects from the past, these photographic series, each
of which evokes elements of Maori historical and contemporary realities,
were not yet in place when I visited the museum in the summer of 2006.

On the north side (toward the Seine), a 12-meter-high transparent wall
protects the site from the noise of traffic along the quay. Composed of 184
sheets of glass held in place by a network of steel, it both shields the museum
with a symbolic barrier and provides visual access to it. As in the rest of the
plan, orderly repetition has been scrupulously avoided; the slender spears
that assure the wall's stability lean against it at different angles and at varied
intervals. The gently curved partition is embellished at four points with clus-
ters of evocative symbols—nowhere identified or deciphered, but apparently

from Mesoamerican, Easter Island, Chinese, and Pygmy sources. It also doubles as a billboard, displaying announcements of current and upcoming events at the museum. At its western end is the wall of vegetation, a much mediatized feature of the architecture that's found inside as well, in the form of densely planted walls gracing the offices of the museum's president and three senior colleagues. Beneath it all, a 20-meter-deep "subterranean fortification" extends for 750 meters to prevent water from seeping into the museum's underground areas.[5]

The museum is made up of four separate buildings, joined by underground passages and upper-level covered walkways. Integral to Nouvel's plan was the idea of giving each one a distinct signature. One would be covered with vegetation, another would be "encased in armor," the third would be a long footbridge, and the fourth would be "classic." At the western end of the glass wall, then, the Branly Building boasts its wall of plants on the north side (facing the Seine). The adjacent Auvent Building (like the Branly's southern side) sports exteriors in a "samurai spirit," with "orange metal elements in the form of Japanese swords" designed to control the tilt of the panels that deflect the sun.[6] The irregularly shaped Museum Building in the center, conceptualized as a long bridge stretching over the expanse of trees and gardens that blankets most of the site, is punctuated on one side by a collection of protruding boxes in a variety of colors.[7] Finally, the University Building, which houses the gift shop and more offices, harmonizes with the Haussmanian architecture of the elegant residential buildings facing it across the street. A dark red-brown dominates the color scheme, meeting with something less than unanimous admiration. As one reviewer remarked of the southern façade, "the museum appears to be a rusting factory set within a Garden of Eden."[8]

Visitors enter through an opening in the wall of glass bordering the Seine. From there they follow meandering paths through the vegetation, pass by the outdoor amphitheater and the museum shop, and into the vast expanse of an airy white reception hall that connects to a variety of facilities. To one side is the Jacques Kerchache Reading Room, decorated on the ceiling with a photo collage depicting details of Kerchache's study. This spacious area—with bookcases, magazine racks, and computer terminals—has been aptly described by one member of the MQB team as "a sort of 'salon club' where people can sit comfortably at the end of their visit as they, for example, make plans for their next trip to Nepal."[9] Another side of the reception area leads to the top of the Claude Lévi-Strauss Auditorium where Jacques Chirac and Kofi Annan opened the inaugural ceremonies on 20 June in the presence of Rigoberta Menchú and other dignitaries. Elevators give access to the roof of

the Museum Building—an expansive terrace with a rare book room and a multimedia library for students and researchers at one end and a restaurant with a panoramic view of Paris, centered on the Eiffel Tower, at the other. A canal along the edge does duty as a guardrail.

Most museum visitors, however, will head directly for the white ramp that leads to the exhibition areas. This irregularly sloping incline (viewed by more than one reviewer as a less-than-successful variant of the Guggenheim Museum's spiral architecture) winds upward over 180 meters, circling around the storage area for the museum's collection of nine thousand musical instruments—a transparent five-story cylinder that transmits "musical murmurs" via vibrations in the glass. The monotony of their trek is broken by an installation consisting of kinetic images and texts projected on the floor and walls, all centered on the notions of *l'autre en soi* (the Other in the self), *le monde en soi* (the world in the self) and walking as a rite of passage.[10] From that bright open walkway, they pass into a low-ceilinged tunnel something like an underground passage in the Paris subway system, but darkened in order to prepare their eyes for the unusually dim lighting of the exhibition space. As one journalist who interviewed Nouvel about the concept expressed it, "This museum unveils its finery the way a young girl removes her gloves."[11] Museum press releases compare the ramp to a highway overpass, but also remark that visitors ascend it as if making their way upstream in a river.[12] The rushing-water sounds and images toward the end of the installation might also be seen as preparing visitors for the main exhibition space, explicitly conceived as a museological riverbed.[13]

A 9-meter-high "landscape of glass lozenges" on the northern side of the main building filters the light that enters the main exhibition area through a patchwork of tropical forest images glazed into the individually designed sections of glass. These are gently reflective and, together with an army of adjustable sunscreen panels, maintain conditions that afford modest amounts of natural lighting for the objects on display. Black mesh screens on the windows and ceilings further dim the overall environment.

The southernmost building, on the rue de l'Université, houses the bookstore and areas for collection management and educational programs. Jean Nouvel, apparently intrigued by Chagall's painting for the ceiling of Paris's opera house and the nighttime illumination of ceilings in Paris's Marais district, had already experimented with the integration of ceiling decoration in an earlier project in Switzerland.[14] Visits to the Oceanic section of the Porte Dorée museum seem to have given him the idea of calling on Aboriginal artists to decorate ceilings and walls for the University Build-

ing, where around-the-clock lighting would make their work visible from the street even at night.[15]

Negotiations were launched by the French ambassador to Australia and involved exchanges of letters between Jacques Chirac and Australia's prime minister, John Howard, before two Australian curators—Brenda L. Croft and Hetti Perkins—were put in charge of its implementation, collaborating closely with Philippe Peltier, an Oceanic specialist at the Quai Branly. Four men and four women representing a variety of Aboriginal groups were selected: Michael Riley[16] (Wiradjuri, New South Wales), John Mawurndjul (Kuninjku, Arnhem Land), Paddy Nyunkuny Bedford (Kija/Gija, East Kimberley), Tommy Watson (Pitjantjatjara, western Australia), Judy Watson (Waanyi, Queensland), Lena Nyadbi (Kija/Gija, East Kimberley), Ningura Napurrula (Pintupi, Central Desert), and Gulumbu Yunupingu[17] (Yolngu, Arnhem Land).

An article in the *Financial Times* of London noted that earlier protests over the use of Aboriginal imagery in the 2000 Olympic Games in Sydney contributed to the delicacy of the arrangements, and pains were taken to include a representative range of artistic expression, in order to guard against the possibility that visions of happy natives or noble savages would be read into the art.[18] The risk of such stereotypes continued nevertheless to hang over the project for some commentators, "concerned that the museum will perpetuate the view of Aboriginal art as ethnography, a view that has long disappeared at home and among knowledgeable international collectors."[19]

The designs were created in Australia, with "conception and production" entrusted to the architectural firm of Cracknell & Lonergan. Delicately handpainted artworks were reproduced in industrial-strength materials at many times their original size for their integration into their new, modern setting. "An aged Tommy Watson . . . was seen looking bemused as project manager Peter Lonergan held up a half-metre-square metal panel containing the hugely magnified dots he'd taken from a few square centimetres of Watson's original painting. . . . Heaven only knows what the old man made of it."[20] Beginning in September 2005 when their work was moved onto the building in Paris, the eight artists' participation became one of the most mediatized aspects of the overall project. Fueled in part by press releases from the Australian embassy, these masters of an art that Stéphane Martin lauded as "both ageless and contemporary"[21] were the subject of countless articles in France, Australia, and elsewhere. Press exposure was also bolstered by news of generous financial donations to the museum by the Australian government (AU $820,000) and foundations (notably AU$500,000 from the Harold Mitchell

Inscribed (in French, English, and Spanish) on the rue de l'Université wall of the Quai Branly Museum:[22]

LENA NYADBI
c. 1936 / Gija / East Kimberley, Western Australia
Jimbirla & Gemerre (Spearheads & Ciacatrice [sic]), 2005
Lena Nyadbi was taught to paint by the pioneering generation of artists who worked at the Warmun Aboriginal community, including Paddy Jaminji and Rover Thomas. Nyadbi commenced painting independently in 1998 and is now a member of Warmun Art Aboriginal Corporation. Her bold interpretation of customary designs has become the hallmark of the artist's work.

Jimbirla stones are found throughout the artist's father's country which is called Jimbirlan—the place of the spearhead. The gemerre designs strongly resemble traditional body scarification marks. The significance of this imagery is part of the artist's cultural heritage, known as the Ngarranggarni, which is intrinsic to Nyadbi's work.

PADDY NYUNKUNY BEDFORD
c. 1922 / Gija / East Kimberley, Western Australia
Thoowoonggoonarrin, 2006
Paddy Bedford was born at Bedford Downs Station in the East Kimberley. From a young age Bedford worked as a stockman while learning the traditional ways of the Gija people. He began painting with Jirrawun Arts in 1998.

Paddy Bedford's oeuvre reveals his intimate knowledge of his country and the Ngarranggarni. The ancestral stories of the Gija people as well as contemporary events are all part of the Ngarranggarni. *Thoowoonggoonarrin* refers to a stockyard in Bedford's mother's country, named after a fig tree that grows on the site.

JUDY WATSON
b. 1959 / Waanyi / North-West Queensland
Judy Watson is an accomplished printmaker and painter who has been awarded several international residencies. She was the Möet & Chandon Fellow in 1995 and co-represented Australia at the 1997 Venice Biennale. Watson's Waanyi heritage informs her observations of the hidden histories of the Australian colonial experience.

[1] *Museum piece,* 2006
Museum piece is based on drawings of objects in forgotten museum collections from the artist's notebook. The work offers a poignant memorial to the systematic dispossession of indigenous people and their culture.

[2] *Two halves with bailer shell,* 2006
Judy Watson's work often juxtaposes drawings of found natural objects against a richly coloured background. Inspired by a dream, in this work

blue represents memory and the shell is a recurring symbol of resistance and survival.

MICHAEL RILEY

1960–2004 / Wiradjuri-Kamilaroi / North-West New South Wales
Cloud, 2006 (seven images from the 2000 series of ten images)
Multi-award-winning photographer and filmmaker Michael Riley began his career in the early 1980s. He was a founding member of Boomalli Aboriginal Artists Co-operative, established in 1987 to promote the work of artists living in Sydney. *Cloud* was the last of Michael Riley's photographic series and combines the key themes of his art practice. In a dream-like sequence, iconic images representing the opposing values of aboriginality, christianity and pastoralism converge.

JOHN MAWURNDJUL

b. 1952 / Kuninjku / Western Arnhem Land, Northern Territory
John Mawurndjul lives at Milmilngkan, a remote outstation in Western Arnhem Land. He is locally renowned as a talented hunter and artist. His work has been exhibited around the world and has acted as a catalyst for the recognition of bark painting and other regional artforms as contemporary art.

[1] *Mardayin at Milmilngkan*, 2006
John Mawurndjul's early works of the late 1970's demonstrated the innovative rarrk (crosshatching) technique for which his work is celebrated today. This work symbolically represents djang (a sacred site) at Milmilngkan and the ancestral power of the secret Mardayin ceremony.

[2] *Mardayin*, 2005
Mardayin 2005 is a sculptural interpretation of a traditional lorrkkon (hollow log coffin) representing three places in the artist's country; Milmilngkan, Dilebang and Mukkamukka. It features an abstract image of a wayuk (water lily) symbolising the power of the Mardayin ceremony in the billabong at Mukkamukka.

NINGURA NAPURRULA

c. 1938 / Pintupi / Gibson Desert, Northern Territory / Western Australia
Untitled (Wirrulnga), 2005
Ningura Napurrula was born at Watulka in the remote Gibson Desert. She led a traditional bush life until her mid-twenties when she moved with her family to the Papunya settlement. Napurrula began painting for Papunya Tula Artists in the mid-1990s and is one of their most distinguished artist members.

Wirrulnga is a significant women's site in the artist's country. Rock embedded waterholes are shown in a landscape of sandhills and windbreaks.

(continued)

Ningura Napurrula's work is characterised by densely applied impasto, which echoes the painting of women's body designs for ceremony.

GULUMBU YUNUPINGU

c. 1945 / Gumatj / North-East Arnhem Land, Northern Territory
Garak, the Universe, 2006
Gulumbu Yunupingu is a senior member of a Yolngu family distinguished in politics and the arts. Yunupingu has great knowledge of bush medicine and is a respected advocate for the culture of her people. In 2004 she was awarded the premier national Aboriginal art prize.

The infinite expanse of the universe is literally represented by a gan'yu (star) filled night sky. Stars visible to the human eye are surrounded by those hidden in the depths of space. The stars represent ancestors and *Garak, the Universe* 2006 is a metaphor for the unity of all people.

TOMMY WATSON

c. 1935 / Pitjantjatjara / Gibson Desert, Western Australia
Wipu Rockhole, 2005
As a child Tommy Watson lived a traditional life in the Gibson Desert where he gained an intimate understanding of the environment and his Tjukurrpa (ancestral stories). Watson was one of the founding members of his local community art centre, Irrunytju Arts, in 2001.

Contemporary painting techniques and traditional visual language merge in Tommy Watson's work. Drawing on his knowledge as a senior cultural man and his early life experiences, Watson's vivid paintings evoke the physical, cultural and spiritual significance of his country. This work refers to an important rockhole site.

Foundation).[23] The official view from down under was that involvement in the MQB offered a unique opportunity to boost indigenous artists' international exposure and Australia's image in the world.[24]

Only one of the artists came to Paris to take part in the final realization of his contribution. John Mawurndjul watched with care as artisans brought in from Australia implemented his bark-painting-inspired design on the ceiling of the gift shop, but the accompanying "hollow log" painting was done by his own hand.[25] Working methodically, millimeter by millimeter, to apply the innumerable slender lines, he quickly captured the heart of the media. Article after article opened with images of this shy man "in white T-shirt and black jeans, sunglasses pushed back into his wild hair, dust on his boots."[26]

This still, crouched figure looks like a miniature ebony statue. . . . John Mawurndjul paints as if he were praying, with a mixture of concentration and serenity.[27]

> This strange ebony man, small and dry, with black hair and a salt-and-pepper beard . . . paints in silence, bringing together the symbols of another world, literally at the antipodes of our own.[28]

> His long frizzy hair makes his head look like a black sun. . . . This small, emaciated man replies to interviewers only indirectly, often by posing another question in the manner of Socrates. But mostly he just remains silent.[29]

Mawurndjul, who became a kind of poster boy for the Australian presence in the Paris museum, was featured, with the Eiffel Tower in the background, on the cover of the South Pacific edition of *Time* magazine (22 May 2006). One of my most riveting memories of 19 June, the day when the press was invited to preview the museum, was of dozens of journalists crowding excitedly around Mawurndjul, captivated by his extended discourse in Kuningkju, a language I assume few of his spellbound listeners could understand. Like Josephine Baker in the 1920s, he seemed perfectly constructed to charm Paris as an endearing, enigmatic antithesis of European civilization—the quintessential Other.

Most of the press coverage of the Australian presence was strongly celebratory. Some was not. There were worries that the escalating international visibility of Aboriginal art masked a "darker side [with] artists being lured away from desert communities . . . to sweatshops as far away as Melbourne . . . to be plied with fast money, drugs and alcohol in exchange for hastily completed canvases."[30] And arguments were made that, even though art represented the Aborigines' best source of income other than welfare checks, the promotion of it in the international art market represented a "glaring disconnect" with the "morass of misery, the despair of belonging but not belonging, the loss of faith, custom and dignity" in Aboriginal communities:

> The unvarnished view of the indigenous world presented by the media in the past two weeks illuminates the inflammatory slogan on one of Richard Bell's paintings: "Aboriginal art—it's a white thing.". . . Capital city audiences lap up Aboriginal culture lite, the easily assimilable derivatives that can be lovely but are not the real deal: the moodily hybrid choreography of Bangarra Dance Theatre, for example, or the glossily monochrome paintings by the younger generation of Kimberley painters who quote the less tidy but far more powerful imagery of their elders. Yet no one stopped for Delmae Barton, an elder of her community, and an elder-in-residence at Griffith University (and the mother of famous didgeridoo player William Barton), when she collapsed through illness at a busy bus stop in March and lay, in her own vomit, on the

footpath for hours. A report in the latest issue of the *Medical Journal of Australia* points out that indigenous Australians not only have a life expectancy almost 20 years less than non-indigenous Australians, but that gap is growing: between 1981 and 2000, it grew by two years for women, four for men.[31]

Others objected that meanings had been sanitized in order to produce a celebratory image in keeping with the museum's self-presentation. A *Time* magazine article, for example, underscored the environmental and social commentary in work by Judy Watson, which contrasted sharply with the museum's wall texts:

> For the 1997 Venice Biennale, [Brisbane-based] Watson created majestic canvases of gold and ultramarine which the Italians naturally likened to Tintoretto. If truth be known, they were of the toxic blooms lapping [Brisbane's] waterways. [In another work,] delicate series of mushroom-shaped ink washes in fact document the bomb tests at Mururoa Atoll. Some of the most exquisite prints are reserved for reproductions of 1940s letters she found in the [Brisbane] library, in which correspondents are told they cannot vote because of "a preponderance of Aboriginal blood."[32]

Very little at the Quai Branly Museum hints at social criticism. "Will Europeans [understand] the story of a 20th-century massacre that lies inside [Paddy Bedford's] painting?" asked an Australian journalist. "And, walking along the Rue de l'Université, will they pick up urban artist Judy Watson's references to French nuclear testing in the Pacific? [Will they see that Michael Riley's photographic images are] condemning the Christianity that was imposed to replace traditional Aboriginal beliefs?"[33]

Avoidance of allusions to such issues as French nuclear testing has to be seen, I would argue, as part of the museum's more general tendency to privilege harmony and nation-to-nation diplomacy over social criticism and attention to the interests of particular ethnic groups—a tendency that we saw earlier in its policy to tackle repatriation claims through diplomatic channels at the national level.[34] Australian Aboriginal art has, since the 1970s, been undergoing dramatic commodification unmatched anywhere else in the non-Western world, and that brings welcome benefits—an escalation in prices, expanded exposure, and new travel opportunities for Aboriginal artists.[35] But global promotion (and the managerial apparatus it requires) also carries a risk of overriding the original intent of individual artists when their creativity isn't fully in line with the outside world's needs or appetite. After Tommy Watson's wild red paintings were selected for inclusion in the museum, he

was not asked whether it was all right for Cracknell & Lonergan to add in some green. Lena Nyadbi's spearheads and scar marks, designed in contrasting white and black, were converted to gray-on-gray to suit the white wall on which it was installed, and when she refused to sign off on the result (objecting that it made her art look like sausages), she was threatened with severance from the project. Paddy Bedford's massacre painting, which evoked the 1920 poisoning of five Aborigines by white landowner Paddy Quilty, was to be sandblasted onto a ground-floor window.[36] But because a steel beam across the window was in the way, this ceased to be an option, and for months the intermediaries involved in Australia and France pushed ideas back and forth. Eventually a decision was taken (on the basis of photos) to substitute an amalgamation of two Bedford paintings. "The scale is changed, the story is meaningless, the artist's moral rights are trampled."[37]

Descriptions phrased in terms of fig trees, sacred sites, ancestral power, secret ceremonies, rock holes, the unity of all people, and the billabong at Mukkamukka contest no received wisdom and leave Aborigines in their traditional ethnographic niche of the European imaginaire. Set next to condemnations of massacres, French nuclear tests, and the forced suppression of native religions, politically correct mentions of "a poignant memorial to the systematic dispossession of Indigenous people and their culture" and "a recurring symbol of resistance and survival" come across as flaccid euphemisms. In this sense they form a perfect companion piece to what many viewed as a less than courageous whitewashing of colonial domination in the museum's exhibition area itself. More on that in the next chapter.

A River Runs Through It

The "River," an area that plays with the senses,
is based on the idea that the world is a labyrinth.*

By January 2006 the structure was in place and work began on the installation of its contents. The triumvirate of Africa, Oceania, and America had, even before the opening of the Louvre wing, been expanded by the addition of Asia, and the plan was to treat each of the four geographical areas in three ways—through aesthetic presentations of "exceptional pieces," assemblages of extensively documented ethnographic objects, and a database of images and information on the cultures represented.[1]

As the carefully selected artifacts began to assume their places in the exhibition plans, others were being scouted out for possible enhancement of the MQB's already impressive 300,000-plus holdings. Of course for collectors, a basic rule of thumb is that no collection is ever complete[2]—any assemblage, even one that boasts the entire combined holdings of two large national museums, can always use a little something. It was in that spirit that Jacques Chirac picked up the phone a number of times in 2005 to chat (presumably in his best American English[3]) with Michael Eisner, outgoing CEO of the Walt Disney Company. He knew that Eisner, having decided to mark his departure with a "philanthropic flourish," was seeking a new home for a fa-

*Musée du quai Branly, Activity Report for 2003, section 1.3.3 ("Synopsis of the space entitled 'the River'"), 47.

mous collection of African art that Disney had purchased twenty years earlier for an undisclosed sum. Pieces from the collection—525 objects collected by Paul and Ruth Tishman and valued at $20 to $50 million—had been exhibited in New York's Metropolitan Museum of Art in 1981 and later used by Disney as inspiration for some of the drawings in *The Lion King*. In spite of what Eisner termed Chirac's "increasingly aggressive" tone over the course of their conversations, the collection was, in the end, donated to the Smithsonian's National Museum of African Art, where curators pledged to keep at least sixty of its pieces on exhibit at all times.[4]

Earlier efforts to round out the Quai Branly collection had been more successful, thanks to an exceptionally ample acquisitions budget and recent changes in the legislation on tax deductions for museum donations. Compare, for example, the 23 million euros earmarked for new pieces at the MQB over a five-year period with the Musée de l'Homme's annual acquisitions budget of 12,000 euros.[5] As we've seen, Jean Paul Barbier had provided an important 276-piece Nigerian collection in 1996, through a sale to the MAAO, and topped it off with several donations. In 2003 the contents of André Breton's atelier were dispersed through public auction, and the State picked up 335 lots for 11.8 million euros, spreading its purchase among five museums, with the MQB receiving a healthy share.[6]

Financially comfortable supporters of the museum project had also joined in, contributing individual pieces that shone like gems in the museum's crown. A law passed in August 2003—a most propitious moment for the MQB's expanding collection—nearly doubled the financial incentive for donations by granting tax credits of 60 percent or, upon designation of the art as a "national treasure" or "of national interest," a whopping 90 percent. This resulted in significant embellishments to the MQB, including a statue (dated to the tenth to eleventh century) that AXA (the corporation once headed by Jacques Friedmann) purchased in 2004 from collector/dealer Hélène Leloup for 4 million euros and donated to the MQB.[7]

Notably lacking from the acquisitions program for the museum were objects that had not yet passed through the hands of art collectors and dealers. No provision was made for obtaining objects from their original settings (despite the advantage this would have had in terms of understanding their meaning to the people who made them), a decision that was well in line with the assertion often made in art-collecting circles that everything worth its salt has already been collected. In museums too, as Alban Bensa has remarked, "identity is glued to the past. The present and future [are thought to] provide nothing but degraded images of early humanity. As the curators' adage goes: If it's old it's better, and if it's recent it can't be authentic."[8] This principle

nicely supports the financial well-being of the art market, in that a limited stock means higher price tags. As objects circulate through the system, moving from one collector to the next, their financial value grows along with their reputation, and profit is taken at each transfer. It has often been remarked for the more mainstream art world that there's nothing quite as effective as death (or, in the case of primitive art, a declaration that no more is being produced) to raise the value of an artist's work. As Roger Boulay has pointed out, derogatory references in the discourse of French collectors to recently fashioned objects as representations of a "*style tardif*" reflect an across-the-board disparagement of art from the too-recent past.[9] Clearly, this favors high value for pieces already in the possession of collectors.

Once the collections of the MH and the MAAO had undergone their rigorous preparation at the Hôtel Berlier and been joined by some 9,000 new acquisitions, bought and donated,[10] the MQB was in possession of well over 300,000 objects, of which permanent exhibition spaces were designed to accommodate only about 1 percent. The selection—reflecting attention to "beauty, rarity, expressive force, anthropological and technical interest, and what they can tell us about the spirit and knowledge of peoples"[11]—was handled by the museological personnel (as well as the architect Jean Nouvel) with relatively little input from the "research and education" members of the team.

Another potential resource for ideas about the installation of exhibited objects might best be glossed as input from "native voices." Thinking in global terms, it seems fair to characterize the general trend toward the end of the twentieth century as one in which minority cultures were gaining influence in museum settings, having a say about whether sacred objects should be displayed, how exhibited pieces should be interpreted, and what should guide decisions about the return of objects to their homelands. Writing in the 1980s, I charged that major institutions around the world were opening their doors "more willingly to the objects themselves than to the aesthetic sensibilities that gave them birth,"[12] but this assessment began to lose its punch over the subsequent decade, as artistic traditions came to be presented more frequently according to "inside" perspectives, and as support for repatriation claims began to gain steam. Some of the change was visible even in France as, for example, the remains of the Musée de l'Homme's "Venus Hottentot" were at long last returned to the San people in South Africa shortly before the MH collections were transferred to the MQB.

Aspects of the ideology that undergirds French cultural identity, however, nurture opposition to this trend.[13] One encounter that amply illustrated French attitudes toward greater allowance for "native" perspectives and prac-

tices occurred during the MQB's inaugural week, as several hundred academics descended on the museum for a day of roundtable discussions. Each of the eight groups was charged with debating a particular theme: objects as art vs. ethnography, contemporary vs. traditional art, rights of ownership, nonmaterial cultural heritage, museums as urban institutions, international cooperation, and the nature of authenticity. But it was the group dealing with "museums as secular, ritual, or multipurpose spaces" that set the issue of native perspectives on fire. Essentially the group divided into two camps, each with strongly felt convictions. Anglophone curators from Australia, New Zealand, and Vanuatu led the argument in favor of respecting native beliefs and practices, calling on examples from both their own experience and that of Indian groups in Canada and the United States. Seddon Bennington, the chief executive of New Zealand's National Museum, explained that before an object was sent on loan to a museum in Australia, a Maori elder would be called in to talk to it, preparing it for the trip that was about to take place.[14] And another speaker told how the separate paths that divide men's and women's access to ritual sites in Vanuatu were replicated for male and female visitors to a museum exhibition of Vanuatu culture—even when the exhibition traveled to a museum in Switzerland. All this was met with stupefaction and outrage by French participants in the session, including anthropologists. Several women protested that they were not Melanesians, and so were not about to restrict their behavior according to Melanesian sexism. And the principle of *laïcité* was invoked as a reason not to condone the practice of religion—any religion—in a State museum.

*

Having, in the last chapter, left museum visitors at the end of the long winding ramp, let's rejoin them as they approach the dimly lit exhibition area. Their eyes adjusted by the dark passageway, they're now ready for viewing the objects on display. The first artwork they meet is the "pre-Dogon" statue donated by AXA, a tall wooden figure from the Bandiagara Plateau of present-day Mali (see this book's frontispiece). Stooping down to read the label that lies at ankle level, they are told that it dates from the tenth or eleventh century, and that its position, with arms raised, "indicates respect and allegiance." Visitors who've bought an audio tour will hear in greater detail how to interpret the body language of this historic African statue. The respect signaled by the raised arms, they are told, is "an attitude adopted in order to bring on the rains, which guarantee the harvest. This androgynous statue," it continues,

unites an image of virility (hair in chignon, prominent beard) and an extremely feminine image of maternity (elongated breasts). One could evoke the idea of a "woman-king," maker of peace and maker of rain, in connection with this statue. The figure represents a high dignitary, link between the world of men and that of the gods. We can see that from its jewels and hairdo. Two small figures are under the protection of the statue. The one on the right is a man, his arms crossed, as a sign that he is listening, and a knee to the ground, which is a mark of deference. The other little figure, kneeling in the feminine position of respect, signifies the continuity of the clan. To learn more about the androgyny of this figure, press the green button. [Green button:] Two other indices confirm the androgyny of this figure. First index: Note the seven bracelets on its wrist. The number seven, while representing an ideal of perfection, symbolizes divine unity for the Soninke and associates the number four (feminine) with the number three (masculine). Second index: Note the pendant in the form of a snake on its neck. This refers to Bida, a tutelary spirit and protector of the empire of Ghana before its decline.

A book edited by Germain Viatte, for sale in the museum shop, complements the description: "The raised arms, in addition to summoning the rains, are a gesture of apology. . . . [T]he hairdo and beard show that the figure is a lineage chief or a great king . . . and the small figures can be viewed as the fetuses of twins."[15]

And the previous owner of the statue, collector/dealer Hélène Leloup (who bought it in 1969 in Paris, from a Malian dealer[16]), provides yet further details:

The position of the head signals that this is an authoritarian chief who is conscious of being invested with total power. . . . The facial features reflect a dolichocephalic morphology characteristic of people from the Sahel region of the Sahara. . . . The serpent figure on the pendant is clearly identifiable as the tutelary spirit Bida from the empire of Ghana or Wagadou, which assured wealth and is revered even today in the region. . . . The scarifications (veritable sign of ethnic identity) are found on very few sculptures—essentially wooden ones from north of the Dogon Plateau and terra-cotta ones in a region that leads to the famous city of Djenné. . . . The small kneeling figure (a woman displaying respect for a chief, a father, or a husband) has adopted the position of a person in prayer. . . . Androgynous figures with raised arms are found in the Bondum region beginning in the sixteenth century and also, in a later version, "south of the Plateau.". . . The statue depicts a king who is also a religious leader, in an attitude that symbolizes his connection to God. This

"shamanic" role has always been present in the entire cultural region, as we can see from "Tellem" statues of the twelfth to fifteenth centuries. . . . A sovereign figure with breasts and children on the belly would illustrate the principle of matrilineal succession and the perpetuation of the lineage which existed in the Sahara, accompanied by strong matriarchal power. The transmission of power was based on this ancient cosmogonic notion of the "mother-deity," symbol of fecundity and lineage continuity. . . . It might also be an illustration of the ancient concept belonging to the ideology of the Mande, found throughout the Niger Basin, which says that if God created two sexes with different attributes, it's the realization of their union that creates the ideal of perfection. . . . The sexual ambiguity is resolved if we consider that matriarchy was the dynastic rule for certain kingdoms of the Sahara (and even today among Berber tribes and Tuaregs) and once was in Wagadou.[17]

As Bérénice Geoffroy-Schneiter (a prolific writer on primitive art and frequent author of articles about the MQB) summed up these assertions, the figure "embodies simultaneously power, wealth, and fertility."[18]

Fertility of the androgynous figure? Or fertility of the European imagination when it comes to primitive art? Given the delicacy of interpreting, even for a contemporary people, such cultural phenomena as body language or number symbolism or marks of leadership, and given the inevitable evolution of such matters over a period of a thousand years (unless one adopts the hypothesis that primitive cultures are static over time), one can only marvel at the richness and specificity of the interpretations provided on this ancient statue from a nameless culture about which very little is known except by extrapolation from ethnographic features that have been observed during recent centuries in the general region.[19]

Once they've admired the androgynous statue, museum visitors pass into the undulating path that represents a river irrigating the four geographical areas (Africa, the Americas, Oceania, and Asia). Nouvel's original idea was to install an actual channel of water flowing through the exhibition space, but practical constraints such as the weight that would have added to the building were insurmountable.[20] In keeping with the museum's tropical forest theme, the "River" was designed to provide a habitat for the "Serpent," a leather-covered structure that slithers sinuously through the exhibitions on each side of the River and provides the foundation for several types of contextualizing information as well as embossed images and texts in Braille for the blind. Blocking out views of the exhibition areas, it functions something like the massive walls designed to protect suburban neighborhoods from the noise and pollution of superhighways.

When the museum opened, however, all mention of the Serpent had been systematically deleted from the website and press releases, leaving only the metaphor of the River.[21] Perhaps a marketing survey determined that people felt uncomfortable at the idea of moving through the belly of a snake. For some, a stroll through the mud-colored passageways evoked, rather, "a journey through the great intestine"[22]—a bit like being on the inside track of a colonoscopy. But whatever metaphor was applied to the undulating leather walls, they kept their promise as a device to distance multimedia information from the viewing experience. As the head of the construction project put it, "We wanted to privilege [a sense of] mystery, to allow people to discover the work in itself . . . putting as much distance as possible between the object and the information relevant to the object."[23] The goal of separating aesthetics and information traces back, like so many features of this museum, to the architect. "Jean Nouvel wanted to create the effect of a disjunction between the aesthetic presentation of objects from different civilizations, capable of being considered entirely as works of art, and their scholarly presentation."[24]

More generally, conversations I had with numerous players in the project made it clear that the single most dominant voice in decisions regarding the exhibition of objects came neither from the (aesthetically leaning) "museological" nor the (anthropologically leaning) "scientific" wing of the museum's organizational structure, but from the architect. Jean Nouvel, who took pride in having "designed the building around the collections," was ("against all rules governing public projects and competition"[26]) awarded the contract for designing the displays as well. Even the dishes and glassware in the rooftop restaurant were designed by Nouvel. People told me he became a kind of self-appointed orchestra conductor for the entire physical plant and its contents, suffering few dissenting opinions, either about general exhibition policy or about the treatment of particular pieces.[27] (When I once alluded to the museum as a project authored by "Jacques et Jacques" [Chirac and Kerchache], a member of the MQB team corrected me: "No, it's been 'Jacques, Jacques, et Jean.'")

Staff members described his opposition to the inclusion of contextualizing photographs and films in proximity to the objects. And one senior member of the team who eventually resigned told me, "It was the architect who decided everything, from A to Z. When we arrived with carved posts measuring about three meters, we were told that Monsieur Nouvel's mezzanine was designed for objects no taller than a meter and a half."

As a result, the museum's two movie screens are hidden away in separate rooms at the extreme ends of the long exhibition space, and the objects on display are rarely accompanied by images of the human beings who made or used them except on video screens whose dimensions would make a television set from the 1940s seem like a wide-screen high-definition wonder in comparison. Nouvel's priorities clearly privileged the aesthetics of display over ethnographic elucidation. In the Asian area, chief curator Christine Hemmet told me that her idea of placing a mirror behind a Vietnamese textile from the 1970s in order to show the depiction on its back of American B52s dropping bombs was vetoed because it was judged incompatible with the overall style of the gallery.[28] And in the Americas area, I was shown the spot in a small, alcove-like angle of the building that had originally been occupied by an impressive Mayan representation of the "god of death." The large sculpture had, however, been moved back against a side wall in the narrow dead-end space. Nouvel's insistence on the change, I was told by an archaeologist involved in displays for that area, was that the earlier placement had interfered with the visitors' view of the Eiffel Tower, looming up in the distance beyond the alcove's (darkened) window.

Moving next from Mayans to Maroons, the display centered on a patchwork cape, which we met in an earlier chapter, illustrates the way architectural design (here, the form of a case) tended to trump ethnographic fidelity. In September 2005 when Richard Price and I spoke with the chief curator for the Americas, he was alarmed to learn that the cape was worn with the lines of its design running horizontally rather than vertically. But the solution was to add a corrective note in the label (a sort of permanent museological erratum) rather than to change the position of the object in the case itself. Clearly, the cape could have assumed its normal orientation if it had been allowed to extend onto the case's side panels. But the architect designed the case for a vertical object, so vertical is how the cape remains.[29]

Lorenzo Brutti provides another example of the MQB's attitude toward ethnographic precision, this one from Papua New Guinea, where he has conducted long-term fieldwork. In question were carved and painted boards from the front of a ceremonial house that were collected for the MAAO and are now exhibited in the MQB. (See the cover of Craig 1988 for a photo of the

boards in their original context.) Because the boards were shipped out from Papua New Guinea in 1965 through an airstrip in territory belonging to a people known as Telefolmin, they were entered into MAAO documentation as having been made by Telefolmin artists. In fact, however, they were taken from a house in the village of Bulolengabip, home to the Tifalmin—a completely different ethnic group, who speak a different language (Tifal rather than Telefol). When data on provenience were transferred to the MQB, Brutti attempted several times to point out the discrepancy (once by e-mail, then by a four-page letter explaining the different terms and giving an extensive bibliography), but no one was willing to make the correction.[30]

. . . Paramaka/Saramaka, Tifal/Telefol—does anyone on the staff of the MQB really care?

It seems possible that the design of the labels was also dictated by Nouvel's determination, in a Kerchachian spirit, to minimize interference with a purified visual experience. Whatever the origin, it certainly contributed to the general difficulty visitors had in learning about the pieces on display. The small lettering—all too often placed virtually on the floor—created a recurrent challenge for museum visitors attempting to discover the identity of objects. Some crouched down to read the texts, but I saw many others give up in frustration. A journalist for *Télérama* commented that

> the visitor needs to demonstrate tenacity. It's up to him to find some way to ferret out the information. The labels, which are difficult to decipher, leave visitors hungry for explanations, the tone of the audio guide does little to encourage curiosity, and the interactive stations are difficult to manipulate.[31]

There were also numerous complaints about the lighting, created partly by the intentional filtering of exterior daylight through images of lush tropical foliage glazed onto the windows.

> The long stretch of stained-glass, about 200 meters long by 9 meters high, is an anthology of landscapes linked to the origins of the works on display. This fresco filters the natural light in order to give the main gallery the interior atmosphere of a cave of discovery. . . . A trellis of diagonally crossing woodwork, together with the plant imagery, gives the exhibition its savage character.[32]

In a helpful spirit, one reviewer suggested that "visitors might be encouraged to take a small torch for use in some areas if only to avoid straining the eyes."[33]

The museum's depiction of the main exhibition area as a cave of discovery with a savage character is reinforced elsewhere in its self-descriptions. Despite claiming, for example, that "the garden's botanical vocabulary borrows nothing from tropical exoticism," the MQB press packet described the garden as "a setting that harks back to the riotous landscapes of the animist world, in which every living thing, from grass to tree, from insect to bird, whether high or low, faced mankind on equal terms of mutual respect." And it likens the "boxes" protruding from the Seine side of the main building to "huts rising up out of the forest."[34] (Viewing these boxes from the inside, Germain Viatte explains them as "a response to our intent to enshrine [*sanctuariser*] particularly sacred objects including human remains."[35])

All this fueled criticism from many camps. For anthropologist Alban Bensa, one of a number of people to dub the setting "kitsch," the resulting vision was "panexotic."

> The imagery of a deep forest, a labyrinth opening onto dark enclosures with soft contours is intended to plunge us into a dreamlike atmosphere, as if Nouvel was trying to put his childhood storybooks (*Tintin* comics, *The Jungle Book,* and so on) together with TV programs that follow rating services to sell whatever fantasies people want about "savages." This "Indiana Jones" side of *arts premiers* seems to reinforce widespread popular stereotypes in France about primitives living in nature, dreams, and the irrational.[36]

Art of Darkness

Going up that river was like traveling back to the earliest
beginnings of the world, when vegetation rioted on the
earth and the big trees were kings. An empty stream, a
great silence, an impenetrable forest.*

Several of the people I spoke with in Paris likened the exhibition area to a
"heart of darkness." So did *New York Times* critic Michael Kimmelman:

> If the Marx Brothers designed a museum for dark people, they might have
> come up with the permanent-collection galleries: devised as a spooky jungle,
> red and black and murky. . . . Think of the museum as a kind of ghetto for the
> "other," . . . an enormous, rambling, crepuscular cavern that tries to evoke
> a journey into the jungle, downriver, where suddenly scary masks or totem
> poles loom out of the darkness and everything is meant to be foreign and ex-
> otic. . . . The only thing missing are people throwing spears at you. . . . The
> atmosphere is like a discothèque at 10 A.M.[1]

Critics less focused on the world of print traced it, not to Joseph Conrad, but
to Francis Ford Coppola and Alain Resnais. "For me," wrote one reviewer,
"there was the unleashed bridge scene in *Apocalypse Now*, the regret and las-
situde of Marguerite Duras's [screenplay for] *Hiroshima mon amour*."[2]

*Joseph Conrad, *Heart of Darkness* (1899), part II, in *The Portable Conrad*, edited by
Morton Dauwen Zabel (New York: Viking, 1947), 536.

Consider, for example, the small windowless room containing *nkisi* ("nail fetishes") from Central Africa, a dark space that offers ample support for André Malraux's characterization of the study of primitive art as an exploration of the "night side of man."[3] How many museum visitors will emerge from this collection of fetish figures—all except two large ones imprisoned behind glass in wooden boxes just big enough to hold them—without having images of voodoo-esque pagan rituals creep into their imagination? People I spoke with during the opening week said it reminded them of the scare-producing fun houses in amusement parks; others saw the exhibition design as producing a kind of "peep show" vision of figures that seemed to be trapped inside tight little cages. The primitivizing effect is reinforced by the explanatory text accompanying the room's two large figures, which is credited, not to state-of-the-art ethnographic sources, but to a 1926 art catalog entitled *Primitive Negro Sculpture*.[4] But it was not just grotto-like rooms, jungle foliage, or outdated sources that led some visitors to find the museum "cringingly, even insultingly condescending."[5]

Many historians feel France has not come to terms with the real history of its colonial era. This idea of a jungle or a forest surrounding the museum, a place where you will discover the "dark continent," is a problem. It's as if these other continents are still savage, exuberant, dangerous and primitive. These are all the old clichés that still abound in France.[6]

Or, as an anthropologist put it, "This denial of history, emphasized by an architecture that's unwilling to deal with both the colonial past and current North/South relations, strikes me as the central flaw in the Quai Branly Museum."[7] And others saw problems in North/South relations on a more contemporary register. Mali's former minister of culture, Aminata Traoré, penned a scathing denunciation of the simultaneous exhibition of African treasures and expulsion of African immigrants under Sarkozy's new policy of "selective immigration," decrying the fact that people from the cultures represented in the museum would never have a chance to see the creativity of their own heritage.[8]

In providing contextualization for the objects on display, the MQB is particularly careful to "pay tribute to the travelers, ethnologists, anthropologists, collectors or artists [who] have proved capable of seeing through time and space a new vision, dignified and noble, of cultures hitherto little known or even despised . . . individuals who, by marking their period, have contributed to overturning received attitudes and developing new ways of

thought." Toward this end, the museum's pre-inaugural website (from which this quote is taken) offered mini-biographies of eight pioneer Frenchmen, plus James Cook and Bronislaw Malinowski.[9]

The ten-man presentation followed the same approach as that of the site's home page, where no mention was made of anyone from the societies whose arts are represented in the museum, but where European men were prominently featured and gratefully commended for their roles. Architect Jean Nouvel's name, front and center on the computer screen, led to three photos of the man, two of which connected to videos on his life and work. Smiling photos of the men standing behind corporate patronage—such as the presidents of Pernod Ricard, the financial group AXA, Schneider Electric, and Sony France—were a click or two away. And Jacques Kerchache, "connoisseur known for his infallible judgment, adviser to the greatest collectors, and tireless promoter of *arts premiers*," was immortalized in an interactive "mini-site," directly accessible from the home page.[10] On the current website, even a search under the name of (for example) "Guillaume Logé" will whisk you to the part of the site explaining that he's the person to contact if you

Fragments from the original MQB website: [11]

Louis Antoine de BOUGAINVILLE (1729–1811). As a soldier in the French army, he led an unsuccessful attempt to colonize the Falkland Islands. In a subsequent expedition he sailed to South America, crossed the straits of Magellan, and reached Tahiti, becoming the first French officer to have voyaged around the world. During a battle in the West Indies he was accused of cowardice for having retreated too soon, but under Napoleon he was appointed senator and given the title of Count.

André BRETON (1896–1966). The vibrant soul of Surrealism, he was also a passionate collector who surrounded himself with an eclectic assemblage of objects. He found in the exuberant sculptures of Oceania a wondrous, dreamlike force which was fundamental to his poetic vision of the world, an imaginary universe of reinvented space.

James COOK (1728–1779). This British navigator is famous for his voyages of exploration to the South Seas. His captain's log abounds in vital information on the cultures of Oceanians and North American Indians. At the close of his third voyage, Cook returned to Hawaii, where, after being deified by the natives, he was savagely killed.

Jules Sébastien César DUMONT D'URVILLE (1790–1842). Today Dumont d'Urville is known to art lovers as the person who informed the French government about the discovery of the Venus de Milo, but he was also a great

sailor and explorer. He took part (as second in command) in the exploration of the coasts of New Zealand and New Guinea and led an expedition to Polynesia during which he carried out important scientific work.

Louis Isidore DUPERREY (1786–1865). As commander of an expedition that lasted 32 months (1822–1825), he and his crew conducted ethnographic surveys of Indian groups, collected data on birds, fish, and lichens, and performed a study of the earth's magnetism. As a result of this latter, he became the first person to plot magnetic latitude and longitude.

Louis Claude de SAULCES DE FREYCINET (1779–1842). Taking part in several expeditions to the Pacific, he studied meteorology and the earth's magnetism. In 1820 a hurricane hit his ship and destroyed a large part of the collections that had been gathered. Stranded for two months in the Falkland Islands, he and his crew were picked up by an American vessel, which he bought and used to return to Europe.

Jean-François GALAUP DE LAPÉROUSE (1741–1788). Louis XVI wanted this experienced navigator to try to outdo Captain Cook in exploring the Pacific, and he sailed to Easter Island, Hawaii, Alaska, and the seas of China and Japan. After 13 members of his crew were massacred in Samoa, he commented, "Man that is almost a savage and in a state of anarchy is a more wicked being than the most ferocious of animals." He disappeared soon after in a shipwreck near the Solomon Islands.

Claude LÉVI-STRAUSS (born 1908). Professor at the Collège de France, he is the leader of French social and cultural anthropology, or more specifically structuralism. As a champion of the arts he has said, "The only irreplaceable loss would be that of the artworks that have been born over the centuries. For it is only through them that men both exist and differ. They alone bear witness to the fact that, among men in the course of time, something has happened."

Bronislaw MALINOWSKI (1884–1942). This British anthropologist of Polish origin passes for one of the pioneers of functional analysis. Immersing himself in the sociocultural universe of the Trobriand Islanders, he devoted himself to observation, at once rigorous and sensitive, of the people he encountered. His work marked a rupture with the evolutionist theories that held sway in the early 20th century.

Georges Henri RIVIÈRE (1897–1985). Chosen by Paul Rivet, director of the Trocadéro Museum of Ethnography, as second in command, Rivière helped to breathe new life into this institution, which had been in decline over 30 years. In spite of his many duties, first at the Trocadéro and then at the Musée de l'Homme, he eventually moved out to become director of the Musée des Arts et Traditions Populaires.

wish to rent space in the museum for a private function. On the other hand, entering the name of any of the Australian Aborigines who contributed their work to the museum comes up with "sorry, your search was empty!"

Notable for their absence were such figures as the early German African-ist Leo Frobenius and the German-born American anthropologist Franz Boas. If one were to consider the museum's mandate as a double tribute—one to *arts premiers* and the other to French civilization—a ten-person list that includes eight French men would have to be viewed with indulgence.[12] Even accepting a French bias, however, there would have been an argument for including in the list of "great figures" a few pioneers of French anthro-pology rather than men who sailed the seas, charted magnetic fields, and battled native populations (fathering some pernicious stereotypes of non-Western peoples in the process[13]). Marcel Griaule and Michel Leiris, to cite but two obvious candidates, were not only central figures of French anthro-pology, but also collected many of the objects that have been accorded *chef-d'œuvre* status in the galleries of the Louvre and Quai Branly museums.[14]

My first visit to the exhibition on 19 June 2006 had been amply prepared by many hours spent on the museum's website over the previous year and a half, so I was interested in how the early collectors would be presented in the museum itself. Passing by the statue from the cliffs of Bandiagara, I met them once again, portrayed on the leather Serpent, where I read the following:[15]

EXPLORER-COLLECTOR: TRAVEL FRAGMENTS.
Behind every artifact on display in the museum lurks a human adventure. The men and women who brought them back to France came from a wide variety of backgrounds. From the sixteenth century up to the present day, seafarers, missionaries, soldiers, adventurers and ethnologists have traveled the length and breadth of the earth, their journeys invariably filled with encounters and some enhanced by close ties subsequently forged with peoples from far-off lands. Each traveler has in turn given expression to his sensibilities, his doubts, his prejudices, and his sense of wonder.

EXPLORING-COLLECTING: MAGNETIC LANDS.
Collections are never complete. They tell the long story that begins with the exploration of the world by Westerners and then continues with colonial con-quests, ethnographical expeditions, and the discovery of these objects by artists in the early twentieth century. The way Western eyes view the Other, linked in one way or another to discovery—political and commercial inter-ests, scientific and aesthetic approaches—comes across in the musée du quai

Branly collections, which are a faithful mirror of this at once singular and plural memory.

This rosy portrayal of the encounters that produced the museum's collections is, of course, merely introductory. How does it play out in specific cases where the circumstances of an object's original collection are well documented?

One of the "boxes" of the African section includes, half hidden in the dark behind a slender, vaginally shaped opening much narrower than the object itself, a ritual figure used in the *Kono* cult that was encountered by Marcel Griaule and Michel Leiris in the course of the Dakar-Djibouti expedition of 1931–33. The accompanying label announces that "Michel Leiris describes the discovery of the boliw [*Kono*] in its sanctuary," and quotes his text:

> Inside the tiny structure on the right are some indefinable forms in a kind of nougat brown material which is none other than coagulated blood. In the middle is a large calabash filled with assorted objects including several flutes made of horn, wood, iron, and copper. On the left, hanging from the ceiling amidst a bunch of calabashes, a foul bundle covered with the feathers of different birds in which Griaule, who palpates it, feels that there's a mask.

The museum label ends at Griaule's tactile encounter with the mask. Leiris's published description, however, goes on to describe the acquisition of the *Kono* now on display at the Quai Branly:

> Irritated by the foot-dragging of the people [who have been making an annoying string of demands for a sacrificial offering], our decision is made quickly: Griaule grabs two flutes and slips them into his boots, we put things back in place, and we leave. [After some discussion with the villagers,] Griaule decrees, and has the chief informed, that since people are mocking and insulting us, it will be necessary for them to make amends by surrendering the *Kono* to us in exchange for 10 francs, and that otherwise the police hiding (he claimed) in the truck would have to take the chief and the village dignitaries into custody and drive them to San, where they could explain their behavior to the Administration. Dreadful blackmail! . . . We order the men to go inside and get the *Kono*. After they all refuse, we go in ourselves, wrap up the holy object in the tarpaulin, and emerge like thieves. . . . [The next day] we visit the village and abduct a second *Kono*, which Griaule had spotted when he slipped unnoticed into its special hut. This time it's Lutten and I who man-

age the operation. My heart beats very fast. Ever since yesterday's scandal, I understand much more clearly the gravity of what we are doing.[16]

What a fine opportunity the display of this *Kono* would have provided to raise the issue of changing ethics in the collection of artifacts![17] Here, the participant himself acknowledged the nature of the act and brought it to public attention in his published chronicle of the expedition. For him this colonial encounter (and others of the same nature) constituted a kind of wake-up call, inspiring him to become active in the promotion of respect for other peoples' cultures, including through the establishment of the International Council on Museums. "For religious objects or art objects transported to a metropolitan [European] museum," he wrote, "no matter how the people who possess them are indemnified, it's part of the cultural patrimony of the whole social group that is being taken away from its true owners."[18]

This perspective has not been adopted by everyone involved in primitive art. As collector Jean Paul Barbier (a member of the MQB planning committee) put it in a 2006 radio interview:

> Certain anthropologists claim that an African or an Oceanian who's deprived of his fetishes is a person who dies spiritually. Well, that's not true! Man is much stronger than that! If you take away a Sicilian woman's crucifix that she inherited from her grandmother, she doesn't give up her Catholic faith! She doesn't mope away in sadness. She goes to the next town, she buys a crucifix, she hangs it where the old one had been, and she returns to her prayers![19]

In general, bringing questionable collecting practices out of the closet has become a central concern of late twentieth- and early twenty-first-century anthropology, and it could certainly be argued that for a museum to edit them out of a field ethnographer's text represents a step backward in museological integrity. The display of an object like the *Kono,* where the famous collector himself made a point of the imperious methods employed, seems almost tailor-made for a follow-up to the declaration on the Serpent that "behind every artifact on display in the museum lurks a human adventure."

The exhibition of the *Kono* also brings us back to issues raised by the 2001 exhibition at the MAAO in which lighting effects were used to give Australian *churinga*s a "semi-invisibility." Was the slit-like window a subtle acknowledgment that this religious figure was never intended to be seen by non-initiates? That it carried sacred power? That the way it was acquired was shameful? Did this unusual display represent what Germain Viatte called

"our intent to enshrine [*sanctuariser*] particularly sacred objects"? Or was it a reflection of Jean Nouvel's goal of creating "a haunted space, inhabited by the ancestral spirits"? What, in short, were viewers expected to make of the presentation of this object, half hidden in a darkened "cave of discovery"? Given the explicitly articulated guiding principle of *laïcité*, it's clear that the intent was not to endorse in any way the religious beliefs of its original owners. Instead, it seems reasonable to read it as an attempt to evoke a generalized sense of mystery and exotic spirituality. Keeping native meaning at bay, on the principle that a museum is not the place for religious beliefs, it nevertheless projects an aura that supports Nouvel's vision of "the animistic and polytheistic cosmogonies whose sacred works are collected by the museum." Here, ethnographic specifics (native meanings) are eschewed on the grounds of secularism, but (French) stereotypes of primitive religion are maintained fully intact.

Walking on, but still in the African section of the MQB, we come to another of Nouvel's boxes, this one containing two statues that were housed in the royal palace of the kingdom of Dahomey at the end of the nineteenth century—one of Glele, the "lion king," and the other of his son Gbehanzin, the "shark king." The presentation of these objects raises questions of more general import concerning the museum's strategy and deserves critical analysis along several dimensions.

On a small video screen at the entrance, a series of images is accompanied by a text that fills in the background to their acquisition. First noting that the king of Dahomey "enriched himself considerably" by participating in the slave trade, it continues in the historic-present tense:

> King Glele, who reigns from 1858 to 1889, calls himself "the lion cub that sows terror." He wages war against the Nago, having the severed heads of Nago troops brought back as trophies. After the abolition of slavery in the middle of the nineteenth century, relations between the leaders of Dahomey and France deteriorate. The former allies become enemies. Colonial propaganda denounces the human sacrifices practiced by the kings of Abomey. Armed conflict erupts. King Gbehanzin resists from 1890 to 1893. His army is made up of thousands of women, the Amazons. The French troops are led by General Dodds. When the Dahomeans attack they are driven back by the French gunboats. Bas-reliefs [on the palace] illustrate the conflict and evoke the menace launched by Gbehanzin against the French soldiers. "The shark, in anger, disrupts the harbor."[20] On the 17th of November 1893 French troops enter Abomey. The old King Gbehanzin, his resources totally exhausted, sets the

Representation of Dahomean king Gbehanzin, the "shark king," made for the royal palace in Abomey. © Photo SCALA, Florence. Musée du quai Branly.

palace on fire. The troops bring objects from the palace back to Paris as the spoils of war.

Conveying colonial relations on museum labels or video screens is inevitably an exercise in gross reductionism—historical complexity whittled down to sound-bite proportions. It could thus be considered a limiting case of what anthropologists of the 1980s began referring to as "partial truths."[21] While every telling of a tale is an act of construction, with some details put in and others left out, museum media demand a particularly merciless level of selectivity, and that gives them special power to slant stories in one direction or another. How does this play out in the MQB's depiction of the way statues from the royal palace of the kingdom of Dahomey came to reside in Paris? We're told that kings Glele and Gbehanzin enriched themselves through participation in the slave trade, commanded armies of Amazons who beheaded

enemy warriors, proudly "sowed terror," committed human sacrifice, angrily disrupted the harbor, attacked the French but were driven back, menaced the French, set fire to their own palace, and were defeated. French fighting is either cast as self-defense or described in passive terms: "Conflict erupted." It's worth noting that this story takes place on African soil, not in Europe. Had the roles been reversed—that is, had Africans attempted to conquer Paris, as in Bertène Juminer's novel *La revanche de Bozambo*[22]—would the French have been portrayed as "menacing" the invading Africans?

It seems clear that a different selection from the range of documented facts (the same length and similarly partial) could have told the same story with greater empathy for the original owners of the museum objects. One possibility, drafted in the style of the MQB video screen's text, might read as follows:

> Under the leadership of King Glele (1858–1889), Dahomean troops resist the French occupation. In 1889 the lieutenant governor of French West Africa tries to impose a tax on all goods shipped through the Dahomean port of Cotonou. Glele refuses. Meanwhile, French missionaries call the Fon [Dahomeans] "barbarous heathens who need to be Christianized and civilized." Glele's successor, Gbehanzin, agrees to trade with the French only if they grant Dahomey unconditional independence. In 1890 the lieutenant governor of French West Africa blockades the coastline and declares war on Dahomey. It takes two years for the French to capture the capital, Abomey. Gbehanzin escapes into the bush and leads an armed resistance movement for another two years. In 1894 the French capture Gbehanzin and force him to sign a peace treaty, ceding the Dahomean coastline and roads. The deposed king is exiled to the island of Martinique, accompanied by a cousin, four of his children, five of his wives, and an interpreter. Meanwhile, France imposes colonial rule, which lasts until 1960, when Gbehanzin's dream of independence is finally realized through the establishment of the Republic of Dahomey.[23]

Wall labels, video screens, websites, and published guides . . . the commentary in each represents a choice about what kinds of information, and how much of it, to offer, and the Dahomey statues shed light on the MQB's general policy in this regard. The exhibit, the guidebook, and the website all identify these statues as "Kingdom of Dahomey, *Fon*, Benin, Abomey, 1889–1893," and indicate the materials, dimensions, donor's name, and inventory number for each. The video screen, as we've seen, carries a narrative about the kingdom and its conquest, and the museum guide has a one-paragraph equivalent (making no mention of the fact that the artist's iden-

tity is known). What might a less parsimonious release of background infor-
mation offer?

Let's follow a hypothetical couple who've just gone through the museum,
been intrigued by the statue of the "shark king," and want to know more
about it. Finding their way to the Jacques Kerchache Reading Room, they sit
down at one of the computers and look up the piece in question. There, next
to a photograph of it, they find (in French):

Designation: Royal anthropo-zoomorphic statue
Inventory number: 71.1893.45.3
Ethnic group: Fon
Region: Abomey / Zou / Benin / West Africa / Africa
Former collection: Musée de l'Homme (Africa)
Donor: Mr. Dodds

Description: Statue of a standing man whose head and torso evoke a shark.
Four fins are depicted at the level of the torso. The right arm is raised, the left
arm stretched out, fists clenched, scales indicted on the torso.

Height: about 1.6 meters

Usage: Said to represent Gbehanzin, the last king of Dahomey. Gbehanzin's
coat of arms shows a shark, reminiscent of the words he spoke to convey to
his people his intent to wage war on the French. The French, stationed in the
harbor of Cotonou, crossed the sandbar on a daily basis. Gbehanzin com-
pared himself to a shark: "The audacious shark has made trouble at the sand-
bar" ("gbo ouele fandan agbedui brou").

Date: between 1889 and 1893
Culture: kingdom of Dahomey
Materials and techniques: Wood, iron nails, pigments
Dimensions and bulk (height × width × depth, weight): 168 × 102 × 92 cm,
55,000 g
Exhibited: African area, AF 074-L1®
Cultural unit: Africa

Returning home, hungry for more information on this intriguing ob-
ject, they boot up their computer, conduct a quick search, and come upon
another description (http://www.metmuseum.org/explore/oracle/figures49
.html), courtesy of the Metropolitan Museum of Art in New York, where the
shark-king statue was once included in a temporary exhibit.[24]

DIVINATION PORTRAIT OF KING GBEHANZIN AS A MAN-SHARK

SOSA ADEDE (FL. CA. 1860–1900)

As an image of force and invulnerability, this monument represents the defiant response of King Glele's successor, Gbehanzin, to the prediction of a difficult reign. In his interpretation of Gbehanzin's resolve, the artist, Sosa Adede, depicted the metamorphosis of a mortal into the awesome being of a Dahomean king. The tragic nature of this work is that it was made for the king who presided over the Fon at the time of the subjugation of his people by the French. Despite his being armed with foresight and protective imagery, the shifting tide of history proved too powerful to overcome, and thus the subject of this divinatory likeness stands as a defeated figure.

This gigantesque monument of a man-shark is one of the most renowned royal Fa *bocio* sculptures linked to martial enterprises. Its role in the context of conquest is alluded to in one of Gbehanzin's court songs:

> Gaou [the war minister] made a "bo" for me, the shark
> I will try the "bo" to see
> If I try this "bo" in the land of no matter whom
> I will take his child as my child
> I will take his wife as my wife
> I will take his country as my country
> I will suppress all who are there
> And if someone is there
> He will say what happened.[1]

In its focus on the individual, Fa provided Dahomean royalty with an ideal alternative to the more communal and popular forms of Fon divination that predated its introduction. In the privacy of Fa consultations, highly trained male specialists acted as intermediaries with the spirit world.[2] Similar aesthetic characteristics distinguish *bocio* commissioned by popular patrons from those sponsored by individual kings. While commoner works (see cat. no. 40) reflect an anti-aesthetic in their overt display of the unrefined ingredients that empower them, royal *bocio* are invariably outwardly elegant and refined, concealing the materials within that endow them with power.[3]

Known as the "shark who made the ocean waters tremble," Gbehanzin was

1. Blier 1995, p. 330.

2. Edna G. Bay, *Wives of the Leopard: Gender, Politics and Culture in the Kingdom of Dahomey* (Charlottesville: University of Virginia Press, 1998), pp. 94, 256.

3. Blier 1995, pp. 30, 336.

the son of one of Dahomey's most illustrious kings, Glele.[4] Founded at the beginning of the seventeenth century, the kingdom of Dahomey rapidly expanded through military conquest until it reached its apogee in the nineteenth century. Gbehanzin's brief reign from 1889 to 1894 coincided with Dahomey's fall and conquest by French colonial forces. After his defeat, he was exiled to Martinique and died in Algeria in 1906.

Gbehanzin's divination sign, Aklan Winlin, foreshadowed a powerful enemy and a reign characterized by adversity and serious conflict.[5] Likewise, warnings of the dangers of the ocean were pervasive.[6] In an attempt to control and influence these predictions, an image believed capable of conquering and subverting them was given the form of a surreal predator regarded as invulnerable, whether on land or in the sea. Commissioned and publicly presented on the occasion of a king's enthronement, such works were believed to allow leaders to prevail in dangerous conflicts, and became icons that referred obliquely to their divination signs.[7]

In its fusion of human and shark features, this work embodies the transformative powers attributed to Dahomean kingship.[8] Incised scales create a textured pattern across the surface of the torso, and dorsal, frontal, and lateral fins project outward. The figure's dynamic stance—left arm extended forward, right arm extended laterally and raised upward—evokes both the powers of the god of metal, war, and technology, Gu, and the ferocity of Dahomey's troops.[9] The position of the stocky, muscular legs, the left leg forward with slightly bent knee, suggests a distribution of weight reminiscent of contrapposto. It has been suggested that the posture and gesture are derived from European prototypes. Local artists were aware of and influenced by outside artistic traditions through an expansionist policy of warfare against their neighbors, as well as by participation in transatlantic trade. This particular pose is shared by a group of life-size sculptures of Catholic saints acquired by Glele's father, Guezo, from the French.[10]

4. Blier 1998, p. 120.

5. It includes the phrase "Gbe hen azi bo aji jele" ("The earth holds the egg that the universe desires").

6. In this *du* sign, one of those verses portends: "The *ale* bird will lose itself in the ocean while singing." Anyone holding this sign is warned to avoid the sea, so as not to be swallowed up and destroyed by the forces that reside within. Blier 1995, p. 333.

7. Blier 1993, p. 191; Blier 1998, p. 120.

8. Blier 1995, p. 316.

9. Ibid., pp. 202–4.

10. Blier 1998, p. 120.

A related work by Sosa Adede honoring King Glele portrays him as a man-lion. Glele's *du,* Abla-Lete, in contrast to his son's *du,* promised a full, rich, and prosperous life (see cat. no. 48). Over the course of a reign that conformed to these optimistic expectations, Glele commissioned an extensive corpus of impressive works that rank among the most exceptional achievements in African art. These include two additional divination portraits whose imagery draws upon phrases associated with his sign—a copper-alloy warrior figure in the Musée Dapper (cat. no. 48) and an iron war god at the Musée de l'Homme, both in Paris.[11]

Members of the MQB staff have labored long and hard to construct a database that can supplement the limited ethnographic and historical information in the exhibition spaces. My hope is that the template being used as I finish writing this book (fall 2006) represents an early start on what will someday be a significantly more comprehensive compendium of data on each of the MQB's 300,000 objects. First on my own wish list for such an expansion would be acknowledgment of the artist (about whom, in this case, much is known), but bibliographic references to relevant scholarship, as on the Met's website, would also be very helpful. The bottom line is to show respect for the museumgoers' intelligence and curiosity, to recognize that some visitors (though of course not all) will want to explore further and will be grateful for the help that museum curators are well equipped to offer. If New York City can do it, why not Paris?

The statues of Glele and Gbehanzin were not the only treasures that had made their way from the royal palace of Dahomey to the Palace of Trocadéro and then the Palace of Chaillot, and finally to the "cave of discovery" at the Quai Branly Museum. A few steps from the video screen we come to the throne from which Glele ruled the kingdom. This imposing object, magnificently carved in scrolls and palmettes and studded with decorative tacks, was the seat of power for an extraordinarily omnipotent monarchy, and one can only imagine how impressive it must have looked with the ruler sitting high above his subjects on the broad curved seat. At the Quai Branly, however, it becomes just another museum object. There, squeezed into a nook barely big enough to hold it, the massive throne looks eerily like a tall refrigerator installed between kitchen cabinets with not an inch to spare. The space-saver setting for what was once an important symbol of uncontested power reinforces the image of a vanquished people. In opting for this trivial-

11. Blier 1993, pp. 191–92.

At a Sotheby's auction in Paris, on 3 December 2004, a buyer paid 142,400 euros (roughly US$189,000) for an important throne that once belonged to King Gbehanzin.

"This elegant throne, in the shape of a curule seat, rests on a high stand with open work geometric motifs. . . . In 1892, on the approach of the French troops commanded by Colonel Dodds, King Behanzin set the royal palaces on fire, and when the town of Abomey was captured, most of the treasures of this kingdom had disappeared. Dodds discovered a few items symbolising royal power hidden away in the capital, including this throne, the principal emblem of the kings of Abomey. On his return to France, he offered it to the Minister of the Navy, the grandfather of the present owner. Every king possessed several thrones that were used during major ceremonies. Among the works saved from the fire and brought back by Dodds was a second throne listed as having belonged to King Behanzin, which he presented to the Museum of Ethnography at Trocadero in 1895. It is now part of the collections of the Quai Branly Museum."[26]

izing display, the MQB has passed up a unique opportunity to pay homage to one of the last of the great African kings to resist European imperial domination.

Not surprisingly, the area devoted to Africa is dominated by three-dimensional objects—mainly figures and masks, but also musical instruments, stools, ceramics, and more. The exhibition includes fifty-three pieces from Cameroon, donated to the MAAO in 1992 by Dr. Pierre Harter, who required that they be exhibited as a unified collection. And there are examples of the rich arts of beadwork (developed throughout the continent, from South Africa to Ethiopia) and textiles (weaving from the Maghreb, barkcloth from the Congo, embroidery from Mali, and more). A final room of the Africa section is devoted to painted canvases that Marcel Griaule peeled off the walls of a Christian church in Gondar, Ethiopia, in 1932, toward the end of the Dakar-Djibouti expedition.[25]

If, after exploring the continent of Africa, we were to return to the top of the ramp and take another branch of the River, we could find ourselves surrounded by towering sculptures from Melanesia. Oceania (including Indonesia and the Philippines) is the largest of the four geographically defined areas, with 1,500 square meters of floor space (compared to 1,200, 770, and 600 for Africa, America, and Asia, respectively) and has benefited from the considerable curatorial experience of two senior Oceanists from the MAAO, Philippe Peltier and Yves Le Fur. Running along the southern side of the museum, away from the Seine, this part of the exhibition provides welcome relief from the grotto-like boxes of the African section, as the stunning artworks are afforded both more space and better lighting. Even those pieces containing human remains (particularly skulls), which abound in this area, are shown openly rather than in the dark "sanctuaries" that Nouvel intended to communicate respect for the dead. Here we're treated to objects ranging from the minuscule (such as ivory earrings from the Marquesas or a jade pendant from New Zealand) to the mon-

A throne belonging to King Glele of Dahomey, as exhib-
ited in the Quai Branly Museum. (The MQB also has a
throne that belonged to King Gbehanzin, in storage.)
Photo: Sally Price, 2006.

umental (including 3.5-meter-high slit drums from Vanuatu). The wide ar-
ray of masks, trophy skulls, and carved figures—incorporating everything
from hair, shells, and pigs' teeth to feathers, basketry, and coconut fibers—
help us understand the surrealists' fascination with Oceanic arts. And Aus-
tralian barkcloth and acrylic paintings show that the museum's general
avoidance of contemporary art has not been treated as a completely iron-
clad rule.

Returning, once again, to our point of entry, we can begin a stroll through
the Americas in an archaeological setting, with pre-Columbian artifacts such
as the Mayan "god of death" that we met in an earlier chapter. Here again,
the MQB has inherited collections of breathtaking beauty, representing so-
cieties ranging from Mesoamerica and the Caribbean to the Andean high-

lands. As the archaeological objects begin to be complemented by post-Columbian pieces, we find the exhibit suddenly shifting gears, as it becomes a forum for anthropological theories devised by a curator on the basis of his studies under Claude Lévi-Strauss. The overriding theme in this area is "transversal transformations"—or, as one of my interviewees put it, "fast-food structuralism." Placed between quotation marks or signed "E.D.," the labels present a vision that Emmanuel Désveaux might alternatively have elaborated in an academic publication of limited distribution. "Objects coming from different populations, be they near or far in space and time," he tells museum visitors, "resemble each other through their form and function. They make transformational groups, tokens of the uniqueness of Amerindian artifacts; even before being instruments in themselves they are regarded as instruments of meaning." Excerpts from two of his narrative labels may illustrate.

Sacks of different types, with origins ranging from Canada to Argentina, are explained in a text entitled "Metaphors of the Fringe":

> The fringe has multiple qualities. Its ability to be rooted in continuity prolongs the material quality of an object and lends it a spiritual dimension beyond its physical ingredients. The end purpose of the object is not the bottom of a bag or the end of a belt. The fringe has its own energy. When static, it accentuates the density of surfaces simply through gravity, while in movement it adds scope to gestures and their intentions. Because of the fringe, material is basically endlessly transformed from a state of continuity to a state of discontinuity and vice versa. The *kipu*, the Inca calendar, is based on the principle of the fringe, since it is used to grasp the passage of days—continuity—and to tick them off—discontinuity. It is circular, and thus denies an end to time. Folded away when not in use, it seems expressionless. But when unfolded and in use, it is radiant.

Or again, containers made of materials ranging from wood and terracotta to buffalo horn, and representing Inca, Taino, Zuni, Sioux, Kwakiutl, and Tlingit cultures (among others), are displayed in an area dubbed "Vitality of the Object":

> All containers evoke the idea of vitality, because living bodies are made of sap, blood, flesh, bone, viscera, sap, and in most cases a soul. Receptacles thus depict a plant, an animal, or a human being. Several lines of transformation are grafted onto this substratum: the Sioux spoon represents a bird's body at full stretch. Starting out as a container, the animal body becomes a support in Inca

mortar and seat or, the complete opposite, something contained with the Inca llama and its sacrificer. This logic culminates with the endless iconographic duplication—the *mise-en-abime*—of the Pueblo pot, which represents an X-ray cross-section of a deer. The close link uniting container and vitality is confirmed by ceramic objects laid in tombs, often pierced, as if killed.[27]

Video screens graphically reinforce the idea of "transversal transformations." As we watch, spellbound, the image of a Taino ceremonial seat carved in wood slowly morphs into a ritual millstone in basalt, which in turn evolves under our very eyes into a platter for ritual offerings, and so on. Native populations from the entire Western Hemisphere are thus united as variants on a theme, all in a near-manic homage to the master of twentieth-century French anthropology.

Once we make our way past the illustrations of transversal transformations, it becomes easier to admire the objects on display for their own artistic and ethnographic interest. There are beautiful examples of South American featherwork, expansive buffalo hides bearing drawings by Plains Indians, painted masks from the Pacific Northwest Coast, ivory figurines from the Arctic, reverse appliqué textiles from Panama, and much more—all handsomely displayed and labeled according to standard museum conventions.

Passing on now to the Asian exhibits, we finally meet a few representations of human actors, representations that have been noticeably absent elsewhere in the museum. Although this area is the smallest as measured in square meters, it is in the view of many (myself included) the most successful in communicating the place of displayed objects within their original cultural environments. Life-size photographs of real people complement the textiles that make up a large part of the exhibit, reminding viewers that the garments had not always been the static object of a museological gaze. And pull-out panels are used for the excellent collection of Asian textiles, making maximal use of the space assigned to this area without creating a sense of clutter. Ironically, the Asian exhibit may have drawn its greatest strength from the collection's most apparent weakness. While the MQB inherited world-class African, Oceanic, and American art from the MH and the MAAO, Paris's museum of Asian art, the Musée Guimet, was not involved in the musical chairs of the 1990s, and thus ceded virtually nothing from its exceptional collection to the new museum. As a result, the MQB collection has relatively few recognized masterpieces from Asia. Objects viewed as "ethnographic" or "folkloric"—objects of the sort that Kerchache excluded from the Louvre exhibit—thus take on a more central role in the MQB's Asian area than in other

parts of the main gallery. In the hands of Christine Hemmet, the only area curator to have come from the Musée de l'Homme and, in her own words, "more interested in the human beings than in their artistic production,"[28] the collection becomes the resource for a presentation that manages to breathe a little life into the cultural environments it showcases.

An anecdote from the inaugural week supports this reading of the Asian area. At the reception in the presidential palace, Jacques Chirac asked Maurice Godelier for his take on the museum. Without a moment's hesitation, Godelier told the president that what was needed was to commandeer six important masterpieces (no more, no less, he said) from the Musée Guimet and put them in the Quai Branly. Unlike the rest of the museum, he explained, the Asian area lacked "important" pieces. As Godelier recounts the incident, Chirac excitedly scanned the crowd for the director of the Guimet, pulled Godelier over with him, and announced with all his presidential authority that "Professor Godelier says we need six of your top pieces." At which the director blanched, mumbled something about "certainly no more than two," and attempted to change the subject.

Cultures in Dialogue?

The Musée du Quai Branly—there where cultures dialogue.*

Museums devoted to the exhibition of cultural difference trace their origins to the very earliest days of European exploration. Columbus brought Caribbean Indians back to Isabella, early sixteenth-century French ship owners collected "fetishes" in Africa, and Captain Cook returned from the Pacific with everything from barkcloth, jewelry, and weapons to a shark-tooth knife and a shell trumpet. Displays of the material spoils of imperialism began as royal cabinets of curiosity and gradually grew into the monumental museums and universal expositions of the nineteenth century. In France their passage through naval museums, alongside model sailing vessels and other memorabilia of maritime exploits, can be read as a direct reflection of their association with the nation's imperial ambitions. In all these settings, the exhibition of cultural difference was inextricably linked to the celebration of nationalism, colonial conquest, and the civilizing mission.

What, then, becomes of the institutionalized presentation of other cultures once imperialist ambitions are officially defined as a thing of the past?

*"*Le Musée du Quai Branly, là où dialoguent les cultures.*" Inscription on the podium where President Jacques Chirac delivered his speech at the museum's inauguration, 20 June 2006. In other environments, such as MQB posters, the motto was prefaced by "*Les cultures sont faites pour dialoguer*" (Cultures are made for dialogue).

As the celebration of colonial expansion through the display of exotic objects falls out of favor, and as (simultaneously) the boundary between viewer and viewed in this realm becomes increasingly blurred, what adjustments need to be made in the public institutions whose very job it is to present cultural difference? This question forms the vortex of the swirling controversies over what to do with primitive art in our current, allegedly postcolonial world. While museums always involve the orchestration of multiple goals, it will be useful to disentangle them for a few paragraphs, viewing them as if they were separable in order to reflect on the choices made in Paris. Four models seem particularly relevant to the discussion.

(1) One option is to highlight the objects' formal properties in order to promote an unmediated contemplation of their physical beauty. This approach isolates the display objects from both their ethnographic pasts as objects contributing to life in distant cultures and their historical pasts as the spoils of imperialism. The Pavillon des Sessions in the Louvre is a near-pristine embodiment of this approach, presenting objects as masterpieces of world art: treating them to spacious placement, ample lighting, and elegant surroundings, and conveying information on their original environments through minimalist texts or distantly placed computer terminals.

(2) Another possibility is to privilege the perspectives of members of the represented cultures and their descendants. Here, the emphasis is on respect for native voices and rights to cultural difference. Examples of this approach vary widely, from tribal museums in which members of a specific group present their own culture (such as the two cultural centers in Vancouver chronicled by James Clifford[1]), to national museums that embrace the cultural politics of peoples within its borders (such as Te Papa in New Zealand or the National Museum of Australia), to those encompassing whole families of cultural heritage (such as the National Museum of the American Indian in Washington). Even comprehensive museums such as the Smithsonian and the British Museum are beginning to integrate participation by native representatives in their permanent exhibition galleries.

(3) A third is to make colonial encounters part of the story, focusing on the circumstances in which collections were formed and the history of the production of knowledge about peoples outside of the European cultural orbit. Although this option, designed to promote historical consciousness about relations of domination that account for the distribution of the world's material patrimony, is often most vigorously implemented in temporary (trav-

eling) exhibitions, some museums are beginning to give it increased promi-
nence in their permanent galleries as well. The newly renovated halls of the
Museum of Ethnology in Vienna (to open in early 2008), for example, rep-
resent a concerted effort to move in this direction.

(4) A fourth model is to distance the cultures on display from both native
perspectives and the intrusions of the Western world, presenting them as
vignettes of a pre-contact past. This means "abstracting back from moder-
nity" to discover "authentic" (untouched) primitive societies—zooming
in on the feathers, nose-flutes, scarification motifs, and divinatory prac-
tices, but leaving out the Coke bottles, the cell phones, the Nike shoes, and
TV images of children dying of AIDS. Over the past several decades, this ap-
proach has lost its claims to legitimacy in most parts of the world and rep-
resentations of it are mainly limited to un-restructured museums from an
earlier era. The widespread assessment in the late twentieth century that
the Musée de l'Homme was virtually unsalvageable, for example, had much
to do with the tenacity of that museum's reputation as a site of essential-
ized visions of cultural difference from the late nineteenth and early twen-
tieth centuries.

Recent debates about the presentation of primitive art in museums have
shown increased attention to the upside and downside of different choices in
terms of the messages they send to museumgoers about art and cultural dif-
ference.[2] The challenge, of course, is to do everything at once, combining ap-
preciation of the exhibited objects as art with awareness of them as elements
of foreign lifeways, as witnesses to alternative cultural perspectives, and as
relics of world history—all this according to some kind of premeditated bal-
ance among the different agendas. The tension created between the first of
these competing concerns and the others has sometimes been glossed as a
tug-of-war between "art" and "anthropology," but that clearly fails at this
point in history to do justice to the complexities involved.

Where, then, has France's most recent and most magisterial attempt to
grapple with these choices ended up? Let's consider its relationship to the
four models one by one.

In a sense, the Pavillon des Sessions stole the MQB's thunder as a show
window for the aesthetic excellence of the nation's primitive art holdings. If,
during a visit to Paris, you want to commune with breathtakingly stunning
objects in a maximally elegant setting, or if you need confirmation that non-
European cultures have produced world-class masterpieces, the Louvre is
the place to go. Given that exhibition's existence in Paris's most heavily fre-

quented museum, it was generally agreed that the new museum would do well to adopt a complementary identity.

Bringing in native voices for some kind of participation was apparently raised as a possibility at the early stages, partly through Chirac's expressed interest in including "*peuples autochtones.*" This option was, however, rejected. In the context of museums around the world in the twenty-first century, the MQB stands out for the extent to which it passes up opportunities for integrating non-European perspectives. It seems safe to say that if the new Museum of the American Indian in Washington can be criticized (as it has been) for going to one extreme in terms of (near-exclusive) participation by native peoples, the exhibits designed under the guidance of Jean Nouvel come equally up for criticism by grazing the opposite end of the continuum. In the exhibits, objects are displayed with texts written by the Parisian curatorial team (art historians more than anthropologists), often on the basis of statements by the European collectors who owned them. It comes as no surprise, then, that the audio tours deliver their lessons in the voices of highly cultured men and women speaking classic French and treading carefully on terms from native languages, all of which prove adaptable to standard romance-language phonemes and accentuation. Nowhere do we hear the timbre or accent or intonation of, for example, a New Caledonian who is bilingual in French and Kanak, a Malian whose French resonates with African diction, or an Amerindian from the Guianas who has been schooled in French but speaks Kali'na at home. At the MQB we are very far away from the now-standard policy in North America (for example) that takes ethnic identity into account when actors are recruited to read scripts dealing with particular ethnic identities. And this choice reflects a much more significant commitment to European authority for interpreting the meaning of the objects on exhibit.

Treatment of the circumstances in which objects came to reside in Paris has been handled extremely selectively in the MQB. As a presidential project, the museum has a celebratory, nationalistic role to play, but many of the practices behind the museum's acquisitions, either in the colonial past or the not-so-distant 1990s, have been ill-suited to fill that agenda. Consequently, Djenné figures much like the birthday present that Jacques Chirac eventually returned to Mali, which have fueled such abundant (and at times enlightening) debates about the ethics of collecting, are exhibited without mention of the continuing traffic in illicitly exported archaeological materials. As we've seen, pillage of the royal palace in Dahomey is presented as part of France's triumph over a despotic king who practiced slavery and human sacrifice, and Michel Leiris's candid accounts of how the Dakar-Djibouti mission of the

"I am Inuit. Perhaps you know about my people because when I was young . . . a man from your country came to my people to get to know them and learn from them. His name was Paul-Émile Victor. . . . I would like to thank your president. It is true that the presentation of our people in the Musée de l'Homme, which I had the pleasure to visit before it was closed, was rather summary. If I remember, our whole world, our history, our traditions, our customs, and our way of life was reduced, on a raised platform, to two cases of objects and costumes and a life-size reproduction of a very pretty (but not very realistic) hunting scene, with a figure in traditional clothing, synthetic snow, and a speared seal.

"At the Musée du Quai Branly, I looked for my people. I saw so many beautiful objects in the beautiful dark cases. . . . Next to our objects there were several lines with brief description. I didn't understand. I didn't understand what a child could learn about us here. How will he know that our oral tradition traces our people back to the beginning of the world and that all humanity originated there? How will he know the whistling of the wind, the cry of the sea elephants, the crackling and explosions of ice that mix with our voices, or the silence of the snow that muffles the sound? Will he understand the meaning of the ice floes and their movement, the rhythm of time that's set by the long course of the sun, the smell of the ice, the waiting of the fisherman, the light that makes our eyelids wrinkle. . . . I was filled with hope of finding a presentation of all the civilization of the Inuits, and I came away with the feeling of having been parked in a big reservation for savages without culture who can't be mixed in with the great civilizations of the world that are presented in other museums.—Jo"

(Letter to the Editor, *Le Nouvel Observateur,* 12 October 2006)

1930s managed to steal ritual objects from sacred shrines is excised from the exhibition text.

Even in its temporary exhibits, one could argue that an opportunity has been missed. "Regarding the Other" is billed as a window on "the various different ways in which Europeans have perceived African, American and Oceanian cultures from the Renaissance to the present day." Yet what it showcases are largely perceptions without process, "tastes and mindsets" without acts of colonial domination. Surely one could argue that the two march hand in hand and deserve treatment as an indissoluble partnership.

Somewhere between Maurice Godelier's proposals for the museum and the inauguration in June 2006, the idea of creating a truly "postcolonial" museum had shriveled into something between nostalgia for a lost past and empty rhetoric. It wasn't that observers hadn't done their best to explain what a truly postcolonial museum would have entailed. In 2003, for example, Benoît de L'Estoile challenged the MQB organizers (though with some

"D'un Regard l'Autre" (18 September 2006 to 21 January 2007)
"Both thematic and chronological, the exhibition presents the various different ways in which Europeans have perceived African, American and Oceanian cultures from the Renaissance to the present day. The event is very much a manifesto for the new museum, and the remarkable assembly of artefacts it brings together is a clear demonstration of the inexhaustibility and richness of its ethnographic collections. Items are divided up into major thematic areas, putting them in the context of the tastes and mindsets of each succeeding era (the noble savage, the dawn of the world, etc.). Idols, exotic curios, fetishes, and primitive sculptures trace in turn the natural development of such changing perceptions, which constitute a history of Western culture in terms of its relationship with the Other."[4]

pessimism) to do better than to produce a posthumous homage to vanquished civilizations:

In this day and age a museum devoted to non-Western arts and civilizations needs to be a *postcolonial* museum in a triple sense—showing that the colonial period is an important part of our heritage, that we are living today in a world that continues to be deeply marked by colonial upheavals (from population displacements to conflicts near and far), and that the museum itself is the material and spiritual heir of the colonial era in both its fundamental concepts (such as "tribal") and its modes of presentation. We should not be denying this postcolonial situation, but rather accepting it consciously. The museum needs to confront history, not just by adding dates here and there, nor by depicting societies the way they were before the conquest, but by placing front and center the question of historicity. . . . Instead of trying to erase this past by the magic of a generous recasting, it should be making people aware of all that silently conditions their perceptions.[3]

Yet visitors to the MQB are rarely invited to step outside of a 1950s-style ethnographic present, rarely given the opportunity to venture beyond an exoticizing vision of non-European cultures that has long since been surpassed in both anthropological and art historical writing. Computers on the multimedia mezzanine, for example, offer information under such categories as shamanism, hunting and gathering, totemism, kinship, sacrifice, initiation, age groups, and cannibalism, but one searches in vain for any mention of (for example) colonialism, collecting, slavery, or tourism.

As the curator in charge of the history collections at the MQB put it, attempts to inject colonial history into the project were simply not successful. "This was a presidential project, so every effort was made to avoid risks, to prevent anything critical from being said."[5] In short, Model #3 has not been a priority in the organization of the Musée du Quai Branly.[6]

Where does this leave "The House That Jacques Built"?[7] Perhaps with more of the drawbacks that its two organ donors were faulted for than the

originators intended. From a purely visual perspective, the palm trees glazed into the windows and the cavelike exhibition spaces of the African area, together with the River and its Serpent and the turtle theme in the garden, could be seen as ironic transplants from the old colonial museum at the Porte Dorée, where the crocodiles in the tropical aquarium are still attracting enthusiastic crowds.

But it's not just a matter of the jungle environment and the MAAO—associations with the Musée de l'Homme have also come into play. Over the course of the MQB's inaugural week, I listened to the reactions of a large number of colleagues—American, French, British, German, Ghanaian, Kanak, Vietnamese, and others—who as participants in the day of roundtable discussions had been offered an early preview of the museum. For some of them, the displays conjured up images of museums in the 1980s. Others pushed the date back to mid-century. And the director of the ethnography museum in Geneva described the museography in an interview as "disagreeable, squeezed, and reminiscent of the nineteenth century."[8] Many of the people I spoke with were struck at how much the labels projected a vision of static societies living in a timeless "ethnographic present," a vision that grew out of early anthropological reports in which "authenticity" resided in an unchanging pre-contact past. The concern was that the museum would reinforce an "us/them" vision of alterity—a vision that can no longer lay claim even to the slender shred of legitimacy it once held. As Benoît de L'Estoile has remarked, "In its very conception, the museum is based on the idea, now largely discredited by anthropologists, that these societies have more in common with each other than with our society, that is that they are defined by their radical alterity."[9] (For some visitors, an us/them alterity was the whole point. One commentator, commending the museum for its "glittering" exhibition, wrote that the "magnificent" objects on display "define the mission of the museum—to demonstrate the great differences between the West and the rest of the world."[10])

Didn't the fact of relegating contemporary and "hybrid" objects to temporary exhibits risk turning the main exhibition area into a purveyor of images of a frozen, exoticized, "authentic" past? By skimming euphemistically over the colonial encounters responsible for the objects' presence in Europe (and deep-sixing the practices that have tarnished subsequent transfers of some of these objects), wasn't the museum bypassing a precious opportunity to bring important global issues to the attention of a wide audience? And didn't the presentation of objects at the MQB discourage multiple readings? Where, for example, was there recognition that an object in the permanent exhibition space would be understood very differently by a nineteenth-

century colonial officer, an early twentieth-century European artist, a 1950s art dealer, and a present-day museum visitor, not to mention the native sculptor responsible for creating it? In an interview about the Quai Branly Museum on NPR, Jim Clifford raised this question and dubbed the tendency to impose single meanings a "colonialist act."[11] Other American visitors to the museum (particularly those young enough to have grown up with the Internet and accustomed, as one colleague put it, to "poking buttons") felt that the installations were overly declarative and restrictive in their "interactive" engagements. Similarly, the multimedia stations seemed, from that point of view, too controlled, too closed off to the possibility of loose ends and multiple readings. Often it was a matter of guessing where, in the on-screen flowchart, to look for specific information rather than being able to conduct free searches.

But for many of the people I spoke with, the most important problem was that the knowledge, beliefs, and perspectives of native peoples have been largely brushed aside. As Kanak scholar Emmanuel Kasarhérou had put it a few years earlier, "You should not imagine that just by putting our objects in your museums you're letting us be the ones to speak about them."[12] We're returning here to the situation in the Louvre exhibits, where a European vision of a cock's comb symbolizing virility won the day over New Ireland understandings about a local bird symbolizing androgyny . . . and where the connoisseur's vision of a tender embrace of sensual lovers turned a blind eye to the natives' vision of a murderous stranglehold by a malevolent spirit. In the MQB, similar choices have been made. The horizontal pattern of a patchwork cape is turned ninety degrees because the architect designed a vertical case at that point in the exhibition's layout. A ceramic object from Peru and a wooden one from Alaska are shown together because structuralist theories born in France say they both represent vitality. A Mayan god of death is shunted to one side in order to privilege a view of the Eiffel Tower. And Kongo "nail fetishes" are explained via a quotation from a 1920s book authored by a French art dealer entitled *Primitive Negro Sculpture.*

French stereotypes of American political correctness (sometimes dubbed "hyperrelativism") conjure up a vision of museum policies in which the members of a given culture are the only people entitled to speak about it— blacks monopolizing the discourse on African American culture, American Indians on their traditions, and so forth. But that caricature fails to recognize the dominant move that has been altering the landscape in North American museums—a move more in line, in fact, with the MQB's self-characterization as "the place where cultures dialogue." As Jim Clifford points out, the shift is not unilineal or across the board—"the sense of con-

nection/responsibility vis-à-vis distant populations and their 'cultural property' is happening piecemeal and in specific exhibitions and historical/spatial situations."[13] An exhibit entitled Chiefly Feasts, for example, was one move in this direction, not by restricting the interpretations to native voices, but by attempting to build on dialogue between New York curators and representatives of Northwest Coast Indian societies.[14] The participation of native elders from Alaska in the documentation of nineteenth-century objects destined to be repatriated from the Smithsonian Institution is another.[15] In contrast, at the MQB, "dialogue" has generally been conducted at the level of diplomatic relations between nations rather than between the museum personnel and members of the cultures represented in its exhibition spaces.[16] Ambassadorial participation has been an important part of the undertaking, but when often-sacred objects of minority populations are involved, that kind of interaction does not constitute "cultures in dialogue." At the MQB, the microphone has remained firmly in the grasp of the European curators, experts on museology but all too rarely in direct or evenly empowered conversation with members of the artists' home societies.

Critics of the Musée du Quai Branly have lamented what they see as inadequate attention to key aspects of a world in which no cultural group has ever been frozen in time or closed onto itself. Where in the exhibitions, they ask, do we learn about the pivotal role of colonial encounters, the dynamism of cultural beliefs and practices, the ways in which cultural ideas move from one ethnic group to another? Where is there recognition that native visions can shed valuable light on the meaning of the objects on display, and in so doing expand our ability to think beyond familiar Eurocentric assumptions? From an early twenty-first-century perspective, the MQB has missed precious opportunities for meaningful cultural dialogue that would have led to greater consideration of these issues. After the initial flurry of largely positive reactions in the press (many centered on the architecture), a heavy dose of negative reactions, more often questioning the museum's conceptual underpinnings, began to stream in. As one reviewer commented, new projects like this "almost always get trashed" in Paris, but reactions to the Quai Branly have "seemed worse than most."[17]

Meanwhile, crowds are flocking to the new anti-palace on the Seine, with the first year's attendance clocked in at more than 1.5 million. Although the museum boasts that a significant proportion of these visitors come from that increasingly large segment of the French population whose ancestors are not the Gauls, the week that I spent in the museum a year after its opening suggests that this claim is little more than a combination of wishful thinking and public relations. The many challenges that the museum faces, as it moves

beyond the excitement of its inaugural year, include (in addition to practical adjustments in such matters as lighting and label copy) a greater effort to confront the full story of France's past as a colonial power, to invite meaningful participation by members of the fourth-world cultures represented in its collections, and to acknowledge the continuing dynamism of those cultures in the twenty-first century—in short, a willingness to build toward a more complete "dialogue of cultures."

An American in Paris

As an American who has spent much of my life in France (three years in Paris and the better part of twenty in the French Antilles), I am acutely aware of the delicacy of commenting on its culture and politics as an outsider, especially one coming from that politically hypercorrected land across the Atlantic. My affection for France and things French was originally sparked by the summer I spent as a sixteen-year-old au pair to five redheaded children in rural Normandy. Since then Richard Price and I have been both students and teachers in the Paris university system, our children finished their secondary education in a Paris lycée (one even going on to study at the École Normale Supérieure), and we have settled very happily in an outlying part of the French world, with a house in Martinique and research involvements in French Guiana. To borrow the language of the law of 23 February 2005, the presence of France has played a distinctly positive role in our lives, and we are most appreciative of its considerable offerings. None of which means that I avoid exercising my critical faculties about this or that aspect of French culture when it seems called for. Feelings about the United States run high among the French, combining fascination and resentment (and occasional condescension) in a particular mixture not seen anywhere else in the world. My hope is that readers of this book in France (which for the moment means

only those who have mastered, as the French like to put it, "the language of Shakespeare") will be able to understand it as a friendly critique, a sign of keen, enduring fascination with their cultural world.

My research over the past couple of years has frequently required the negotiation of contradictory documentation (on dates, places, and events) and potentially apocryphal stories (autobiographical and journalistic, self-aggrandizing and defamatory). Had I eschewed all attention to these twists and turns in the record and limited myself to the exclusive use of officially certified documents, I could have produced a dutiful account in the style of a dry scientific report, but it would have been leeched of almost everything that captured the imagination of those both inside and outside of the process as it was unfolding.

Readers who prefer to follow a more internally authorized (and celebratory) biography of the Musée du Quai Branly may wish to consult one of the lavishly illustrated books authored by the museum's staff (published with generous funding from the National Museums Board and displayed prominently in the MQB shop) or the museum's website: http://www.quaibranly.fr. The version of the website that I used most for this book, posted until June 2006, was a particularly rich in-house compendium of names, dates, and committee reports, as well as abundant data on the museum's history, architecture, collections, permanent and temporary exhibitions, documentary offerings, outreach programs, conservation techniques, academic seminars, and more. Rubrics of interest to the general public were available in French, English, and Spanish, though knowledge of French was required for some of its very detailed information, such as the number of meals sold each year in the staff cafeteria. I have found the post-June site considerably less informative and less searchable, but this may simply be a reflection of its newness.[1]

There were moments in my research that helped me to nurture a high level of tolerance for bureaucratic obfuscation. My determined efforts to pin down certain facts such as the dates of particular governmental meetings in some cases led to circular series of messages, both via e-mail and on impressive letterheads, in which one office would send me to another, which would send me to a third, and so on, and I would finally be forced to give up when the recommendations came back to the office I had first contacted. Among the replies I've received to requests for information ("We are not authorized to reply to . . ."; "I have no answer to your question about . . ."; "We don't understand what prompted your previous correspondent to refer you to us . . ."; etc.), my favorite, and surely the most gracious one, came from the presidential palace:

I must inform you that the services of the Presidency of the Republic are unfortunately not in a position to respond to your request.

Nevertheless, I think you will be pleased to know that I am sending you, through the mail, the official autographed portrait of Monsieur Jacques Chirac.[2]

And I was indeed pleased when, a few weeks later, it arrived in my mailbox.

Contributing Voices

It's a pleasure to acknowledge the contributions of many people to this book:
A number of colleagues kindly read and commented on drafts of the manuscript or substantial pieces thereof: Claude-François Baudez, Roger Boulay, Lorenzo Brutti, Gérard Collomb, Jeremy Eccles, Étienne Féau, Maurice Godelier, Jutta Hepke, Anne-Marie Losonczy, Patrick Menget, Fred Myers, Peter Redfield, Martine Segalen, Christopher Steiner, and Dominique Taffin.
Participants in the preparation of the Pavillon des Sessions or the Quai Branly Museum, some of them central players and others peripheral consultants, shared their knowledge and perspectives: Jean-Paul Bourdier, Hélène Cerutti, Hélène Dano Vanneyre, Marine Degli, Emmanuel Désveaux, Christian Feest, Sarah Frioux-Salgas, Christine Hemmet, Hélène Joubert, Sophie Leclercq, Yves Le Fur, Séverine Le Guével, Jean-Hubert Martin, Marie Mauzé, Jean-Pierre Mohen, Aurore Monod, Philippe Peltier, André del Puech, Anne-Christine Taylor, Trinh Minh-ha, and Germain Viatte. Special thanks to Margot Chancerelle, Marine Degli, and Nathalie Mercier for facilitating unlimited access to the museum for me in September 2005 and again in June–July 2006.
Others provided information and/or critical commentary on aspects of this project: Catherine Benoît, Alban Bensa, Jim Clifford, Kristin Couper,

Brenda Croft, Sarah Froning Deleporte, Elise Dubuc, Philippe Guyot, Elizabeth Harney, Michel Izard, Claude Lévi-Strauss, Philippe Mennecier, Peter Naumann, Andrea Schneider, and Baj Strobel.

Journalists Vincent Noce (*Libération*), Emmanuel de Roux (*Le Monde*), and Sylvie Santini (*Paris-Match*) kindly granted me interviews in 2005.

Several people helped me obtain recondite resources: Philippe Bourgoin (*Tribal Art*), Alain Brillon (*Libération*), Patrice Burel (francophonie.org), Jason Cross (Duke University), Michel Daubert (*Télérama*), Marion Didier, Marie-Hélène Fraïssé (Radio France), Paul Hellyer (William and Mary Law School Library), Céline Martin-Raget (Musée du Quai Branly), Harriet O'Malley (Australian embassy), and Valérie Saunier (*Figaro Magazine*).

Photographers Henri Griffith and Sophie Anita captured precious images of two central players in this book's story: a young Chirac rubbing shoulders with South American Indians in 1975 and Jacques Kerchache scrutinizing a Taino sculpture in 1994. Thanks to Gilles Colleu for help with the scans.

At the College of William and Mary, the staff at Swem Library skillfully facilitated access to documents. Meredith Holaday drafted the map. Mark Kostro handled research questions with creative thinking and flawless efficiency. Special thanks to Carol Roe, administrative assistant of the Department of Anthropology, for providing support wherever and whenever it was needed.

Solen Roth contributed to this project from beginning to end, generously offering her services as a research assistant, sharing findings from her own ongoing study of primitive art collecting in Paris, and commenting helpfully on a near-final draft of the manuscript.

At the University of Chicago Press, T. David Brent, Elizabeth Branch Dyson, and Erin DeWitt each offered enthusiasm, guidance, and expertise throughout the publication process.

A grant from the Wenner-Gren Foundation for Anthropological Research funded my research trips during 2005 and 2006. A fellowship from the National Endowment for the Humanities offered much-appreciated financial assistance during 2006. I gratefully acknowledge the support of these organizations, each one for the third time in my career, and salute their continuing contributions to the discipline of anthropology and to the humanities. As per the requirements of my NEH fellowship, I hereby affirm that any views, findings, conclusions, or recommendations expressed in this publication do not necessarily reflect those of the National Endowment for the Humanities.

It is my good fortune to be in a family of writers. Leah Price commented

usefully on drafts of this book from her perspective as a literary scholar. Niko Price, an editor at the Associated Press, helped me tighten up parts of the prose. And Richard Price took time out from writing *Travels with Tooy* (University of Chicago Press, 2008) to participate generously in this project, lending crucial advice at its conception, accompanying me during the research in Paris, and offering critical readings of the manuscript as it developed.

Notes

WHERE TO BEGIN

1. Fénéon 1920a–c.
2. Lévi-Strauss 1943. See also Lévi-Strauss 1975, vol. 1:8–9.
3. Apollinaire 1909.
4. Guillaume in Fénéon 1920b.
5. Anon. 1954.
6. Malraux 1976, 405, 408.
7. In capitalizing the word "State," I am following the French convention in which "*état*" and "*État*" are two unrelated words—one referring to such things as a "state of mind" or the "state of the art" and the other to matters of national authority.

THE PRIMAL MOMENT

1. Jacques Kerchache, quoted in Pradel 2000, 10.
2. Ottenheimer 1996, 42.
3. In interviews, both Kerchache and Chirac described this meeting as occurring in 1990 (Ottenheimer 1996; Pradel 2000), and most sources concur (Noce 2001; Michel 2002, 120). Chirac later wrote that he met Kerchache in 1992, and a few others have cited 1991 or 1992 (Chirac in Bethenod 2003, 6; Daubert 1997, 61; Delannoy 2002, 22; Dupaigne 2006, 29), but Marine Degli, who became Kerchache's personal assistant in 1990, has assured me that he and Chirac were already friends at that time.

Chirac was not present at the *francophonie* meeting that was held in the Royal Palm in 1990 (5–9 June), though he did preside at one there in 1992 (6–9 May). Critics have de-

scribed Chirac as suffering from "travel bulimia" and seized with relish on his choice of the Royal Palm for his yearly two- to three-week vacations. Inhabitants of the nearby French overseas department of Réunion objected in 2000 that, as president of France, he should have been bringing his business to their own beaches rather than to a neighboring island that was no longer even part of France. And an article in *Paris-Match,* "Bonne Vacances, Monsieur le Président," raised uncomfortable questions about who paid for his summer 2000 stay there (460,000 francs), sparking a flurry of articles in the press. After a television crew attempting to follow up on the story had their video cassettes confiscated by hotel security, journalists concluded that interest in presidential vacationing, especially so close to new elections, was highly inadvisable (Canard 1993a, 1993b; Bacque 2000; Lebegue 2000a, 2000b; Madelin 2002, 468–71 et passim).

4. http://www.clubairtravel.co.uk/mauritius/RP_suites.htm.

5. Ottenheimer 1996, 42.

6. http://www.wfmu.org/~bart/sg.html.

7. Martin Bethenod in Bethenod 2003, 199.

8. http://www.clubairtravel.co.uk/mauritius/RP_suites.htm and http://www.ecruise.co.uk/atlantis/det.php?pid=174&str=Royal%20Palm.

9. Pradel 2000, 10; Ottenheimer 1996, 42.

10. Ottenheimer 1996, 42–43.

11. Pradel 2000, 10.

12. Ottenheimer 1996, 42.

13. Kerchache 2001.

14. Romero 1998.

15. The two Jacques sometimes took trips together, for example, to Mexico and Easter Island (Marine Degli personal communication; Peyrani 1996).

THE PRESIDENT'S SECRET GARDEN

1. The first four paragraphs of this chapter are indebted to Jouve and Magoudi 1987, a biography based on interviews with Chirac.

2. Chirac, quoted in ibid., 99.

3. http://www.elysee.fr/elysee/francais/le_president/son_portrait/son_portrait.12308 .html.

4. Chirac, quoted in Jouve and Magoudi 1987, 86.

5. Chirac, quoted in ibid., 110.

6. Ottenheimer 1996, 43.

7. Anon. 1996b.

8. Ottenheimer 1996, 43.

9. Giesbert 2006, 338–41.

10. Apparently because it was being renovated during 1865–70 as a space for parliamentary sessions, though no sessions were ever held there because the renovation was incomplete at the fall of the Second Empire (Viatte 2000, 27, citing Geneviève Bresc-Bautier). It was later used for exhibitions of prints and engravings (Daubert 1996).

11. Degli and Mauzé 2000, 21.

12. Letter of 18 April 2000. According to his biographers, the content of this letter is not

unique. Philippe Madelin, in an often critical assessment of Chirac, reports that "when he visits museums, he does not hesitate to correct the dating of particular pieces" (2002, 797).

13. Liffran 2003.

14. English translation of Anders 1996.

15. Gerard W. van Bussel, "Ancient Mexican Treasures," http://www.ethno-museum.ac .at/en/collections/namerica/amexico.html.

THE PASSIONATE CONNOISSEUR

1. Chirac in Bethenod 2003, 6. In 1996 Chirac bestowed the Légion d'Honneur on Kerchache (Allaire 2000).

2. Jacques Friedmann in Bethenod 2003, 73.

3. Pradel 2000, 6.

4. This whole paragraph comes from Pradel 2000. Another journalist describes Kerchache as "the son of a prosperous biscuit merchant" (Peyrani 1996).

5. Noce 2001.

6. Anne Kerchache in Bethenod 2003, 29.

7. Pradel 2000, 6.

8. Ibid., 8.

9. http://webcamus.free.fr/biographie/amis/fouchet.html; Fontaine 2001.

10. This paragraph is taken from Sam Szafran and Anne Kerchache in Bethenod 2003, 153, 29; and from Pradel 2000.

11. De Roux 1994b.

12. http://www.mailartist.com/johnheldjr/YvesKlein; http://www.france5.fr/arts _culture/articles/W00369/69/.

13. Ibid. By the 1970s Kerchache had assistants for the collection of artifacts. In 1974 one of them rented a boat in Papua New Guinea and made a systematic tour of coastal funerary caves, retrieving the sculptures and leaving the island in haste. A complaint was lodged by the owners of the caves against the assistant, but Kerchache had already sold the pieces in Paris to an American collector who was eventually sued in New York by the government of Papua New Guinea. In the end, the collector was acquitted on the grounds that he had purchased the pieces in good faith (Guiart 2003, 148).

14. Szafran in Bethenod 2003, 154. See also Corbey 2000, 127.

15. Pradel 2000, 9.

16. Anon. 2000b.

17. Daubert 2003.

18. Anne Kerchache in Bethenod 2003, 29.

19. Pomian 2000a, 79.

20. Szafran in Bethenod 2003, 154.

21. From testimonials by Sam Szafran, Paul Rebeyrolle, Jean de Loisy, Michel Propper, Stéphane Martin, and Anne Kerchache in Bethenod 2003, 154, 135, 122, 43, 71, 30, 135. I have translated *jouissance absolue* as "climactic pleasure," though it could also be read as "absolute orgasm."

22. http://www.bibliomonde.net/pages/fiche-auteur.php3?id_auteur=988. See also Degli 2003.

23. Kerchache in Bethenod 2003, 185. André Breton expressed his love of art objects in similar terms: "I often feel the need to return to them, to see them as I'm waking up, to take them in my hands, to talk to them." (See the English- and Spanish-language versions of the Musée du Quai Branly website: Home > Explorations > Great Figures). Or again, the collector George Ortiz ("One falls in love with an object just the way one becomes enamored of a woman") describes a Buddhist figure about which he felt particularly passionate: "For a long time, each evening before going to bed I would go and caress it" (de Roux and Paringaux 1999, 330). See also Derlon and Jeudy-Ballini 2005, 153.

24. From testimonials in Bethenod 2003, 39, 43, 49, 153.

25. Couturier 2003. The Tintin series was created in 1929 by Belgian author/illustrator Georges Rémi, under the pseudonym Hergé, and became one of the most popular European comics of the twentieth century. It has often been criticized for its racist and colonialist caricatures.

26. Noce 2000a, 3.

27. De Roux 1998.

28. Anon. 1996b.

29. Jean-Jacques Aillagon, minister of culture, in Bethenod 2003, 35.

30. Monbrison in ibid., 113.

GOOD-BYE, COLUMBUS

1. See Kerchache (ed.) 1994.

2. De Roux 1996c.

3. Daubert 2000a, 11.

4. Pradel 2000, 10. The assertion that Paris hosted "the first exhibition in the world devoted entirely to this civilization" (a claim repeated in Gibson 1994 and elsewhere) is true only if one excludes exhibits organized in the very parts of the world that Kerchache was attempting to showcase in the Louvre. For example, two museums (one public, one private) in Santo Domingo that are devoted principally to Taino art and archaeology had already been putting on exhibits for decades, some even traveling to Madrid (García Arévalo 1977). Another in La Romana, Dominican Republic, devotes its central space to Taino culture (García Arévalo 1982), and an exhibit of pre-Columbian and contemporary Taino art, sponsored by a predominantly Puerto Rican cultural organization, took place at Rutgers University in 1973 (http://www.taino-tribe.org/t-exhibit.htm). The Gallocentric bias also showed up in depictions of Caribbean geography. An anthropologist writing in *Connaissance des Arts*, for example, reported correctly that the Taino occupied the Greater Antilles, but placed the Caribs "mainly in Martinique and Guadeloupe," neglecting their significant presence in neighboring (but no longer French-controlled) islands such as Dominica, St. Lucia, and St. Vincent (Duverger 1994).

5. Quoted in Blanc 1994, 48, 53, 55. For an endorsement of this same stereotype by collector Jean Paul Barbier, see "Artifactual Question Marks," below.

6. Kerchache (ed.) 1994, 141.

7. Daubert 1994, 9–10.

8. Rouse 1992, 9, 12, 13; Moscoso 2003, 298–302.

9. Moscoso 1986, 405–56.

10. García Arévalo 1994, 98.

11. Duverger 1994, 29, 41–43. These comments come from the same issue of *Connais-sance des Arts* in which Kerchache asserted that the image of Taino life as a terrestrial paradise was "real."

12. De Roux 1994a.

13. Wardwell 1998.

14. Quoted in Blanc 1994, 51. Kerchache's introduction to Taino art, thirty years earlier, had occurred in a rather different context. "It was during a stroll through the labyrinthine galleries of the Musée de l'Homme that Jacques Kerchache discovered, lost among a group of pre-Columbian objects, a remarkable ceremonial stool, or *duho,* probably belonging to a Taino chief" (Geoffroy 1994, 54).

15. Kerchache 1994, 157, 141, 150. Kerchache's "deduction" that the artists were chiefs and priests and that they underwent rigorous apprenticeships is essentially the same as those he made about artists in African and Oceanic societies, forming a leitmotif of his dis-course on art and lending unity to his vision of the place of art in society, regardless of which society it was.

16. D'Ans 1994, 11.

17. Rouse 1992.

18. "The face of the full figure is made from rhinoceros horn, which could have come only from Africa, and its style of carving is reminiscent of that continent. . . . The designs woven into [it] look African as well" (Rouse 1992, 159). This object had already been fea-tured in a magnificent volume published in the Dominican Republic in 1983 (Montás, Bor-rell, and Moya Pons 1983). See Chirac's ecstatic commentary, cited in Hauter 1994.

19. Hauter 1994. For a deconstruction of this genericizing gaze, see Price 2001.

THE STATE OF CULTURE

1. Grasset 1996, 188, 197. I do not know whether this is still the case today.

2. This paragraph is indebted to a summary of the structure of the French museum world in Grasset 1996, which acknowledges its debt, in turn, to Cabanne 1990. I am grate-ful to Dominique Taffin and Étienne Féau for further help in understanding the French museum world.

3. Grasset 1996, 196.

4. Germain Viatte, in Bounoure and Lehuard 2000, 25.

5. Barbier in Clément 2006. "Ceding" is the term used by Barbier.

6. Dias 1991, 109.

7. Tobelem 2005, 167.

8. Sallois 2005, 14. The following paragraphs lean heavily on this helpful guide (espe-cially pp. 11–13, 41–42), which lays out the history of laws governing museums in each cat-egory of the State-legislated system.

9. Ibid., 11–12.

10. Ibid., 12–14. See also Tobelem 2005, 160.

11. http://www.paris.org/Musees/dmf.html. For further details on the DMF as well as information on 1,285 French museums, see http://www.culture.gouv.fr/culture/min/index-dmf.htm.

12. Tobelem 2005, 160. Tobelem argues that this centralization of authority over museums runs the risk of privileging the major establishments (which in France means museums of fine art), pointing out that, unlike "Anglo-Saxon" countries, France has almost no museums for children, and that the network of history museums is "embryonic."

13. Ibid., 164.

14. Yet other museums have ministerial affiliations that do not enter the story we're concerned with here. For example, the Ministry of Justice has authority over the Musée de la Légion d'Honneur and the Ministry of Finance over the Musée de la Monnaie (currency) and the Musée de la Douane (customs) (Sallois 2005, 39).

15. Ibid., 27–28.

16. Not to be confused with the Museum of Modern Art of the City of Paris, which occupies the Palais de Tokyo. In 1937 these two museums of modern art were both installed in the Palais de Tokyo, constructed for the Universal Exposition of that year (ibid., 30).

17. Tobelem 2005, 166. Not all *établissements publics* come under the authority of the Ministry of Culture. The Quai Branly Museum, for example, is under the double tutelage of the Ministry of Culture and the Ministry of Education, reflecting its dual origin in the MAAO and the MH.

18. Schneider 1998, 105–6. I am grateful to Dominique Taffin for pointing out that aside from Jack Lang's years as minister of culture (1981–86, 1988–93), the 1 percent figure has generally been more of a goal than an achieved reality.

19. Shattuck 2005, 19. For an amply documented reading of how culture is supported in the United States, with implicit comparison to the way it works in France, see Martel 2006.

20. See Dubuc 1998, 73.

21. Shattuck 2005, 19, 22.

22. The Musée de l'Homme, for example, was inaugurated in 1938 by the president of the Republic (Dupaigne 1998, 650). Jacques Chirac also spoke at the inauguration of the Ethnography Museum in Hanoi (Chirac 1997).

23. Or, later, a museum of European/Mediterranean cultures.

24. Dupaigne 1998, 651.

THE GRANDEST MUSEUM IN THE WORLD

1. Hall 2005, 18.

2. Cressole 1990, 46.

3. www.explorion.net/f.w.blagdon-paris-as-it-was-and-as-it-is/page-32.html.

4. Jullian 1996.

5. www.etymonline.com/index.php?l=l&p=11, s.v. *louver.*

6. Géniès 2005.

7. http://www.diplomatie.gouv.fr/label_france/ENGLISH/REGION/musees/page.html.

8. Nineteenth-century debates about the introduction or exclusion of different categories of art in the Louvre were complex, politically inflected, and often polemical. An excellent essay by Geneviève Bresc-Bautier (1999) traces their history and places them in the context of changing hierarchies of artistic media; see also Goergel 1994 and McClellan 1994. The Musée Dauphin in fact represented a return, since a collection of naval artifacts

had been installed in the Louvre in 1748 (under Louis XV) and remained there until 1793 (Hillion 1996, 22). For more on the collections that moved among the Louvre, the Naval Museum, and the Trocadéro Museum in the nineteenth century, see Williams 1985.

9. Brisson and Coural n.d.

10. Santini 2005.

11. Kerchache (ed.) 2000, 17; Kerchache 2000, 45. See also Géniès 2005.

12. Degli and Mauzé 2000, 59.

13. Bresc-Bautier 1999, 65.

14. Santini 2000.

15. http://www.louvre.fr/llv/musee/mission.jsp?bmLocale=en (English version). Henri Loyrette assumed the directorship of the Louvre in 2001 and began turning the museum into a significantly more international, universalist institution. The "metamorphosis" of the museum involved instigating free Friday-night admission for young people, encouraging greater dialogue among the (previously very autonomous) curators of different departments, concluding agreements with Asian and Middle Eastern countries to promote cooperative conservation programs and archaeological excavations, and building stronger ties with institutions in the United States (Melikian 2006; Cosic 2006b).

16. http://perso.wanadoo.fr/fede.chasse59/louveterie.htm. I am grateful to Bertrand Decanter, directeur de la fédération départementale des chasseurs du nord (de la France), for help in learning about the *louveterie*.

17. See Schneider 1998 for an excellent history of the Musée d'Orsay.

18. "Visitor Policy at the Louvre: Aims and Objectives," http://www.louvre.fr/llv/musee/publics.jsp.

19. Tagliabue 2005.

20. Ferry 1885.

DOWN WITH HIERARCHY

1. Schneider 1998, 14, quoting François Chaslin, *Le Paris de François Mitterrand* (Paris: Gallimard, 1985), p. 27.

2. Edelmann and de Roux 1996.

3. Anon. 1996c. Or, as he put it in an interview published in *Le Figaro*, "I don't want to add to the *Grands Travaux*. All I want is for the Chaillot Hill to become a special place for the Civilizations and Arts that aren't in the Louvre" (*Le Figaro* 1996).

4. Apollinaire 1909.

5. Paudrat 1984, 158.

6. Fénéon 1920a, 1920b, 1920c. A "wham-bam" portrait of Félix Fénéon by Paul Signac was prominently exhibited at the 2004 opening of the newly designed Museum of Modern Art in New York (Hall 2005, 19), though it has since been taken down and returned to its owner (Lowry 2005).

7. Paudrat 1984, 152.

8. Guillaume, quoted in Fénéon 1920b.

9. Cressole 1990, 46.

10. Perrois 2000, 26; Paudrat 1984, 158–59.

11. Lévi-Strauss 1943, 175–82. See also Lévi-Strauss 1975, vol. 1, 8–9.

12. Anon. 1954.

13. Malraux 1976, 261.

14. Dubuc 1998, 83; Dupuy 2000.

15. Cressole 1990, 46.

16. Kerchache et al. 1990.

17. Conversation at the Laboratoire d'anthropologie sociale, 20 September 2005.

18. Or 70 percent (Hauter 1996).

19. Pomian 2000a, 80.

20. See, for example, de Coppet 2003, Dupaigne 2006, and Glorieux 2006. In an interview, Germain Viatte pointed out that Marcel Mauss used the term but gave no reference to the source (Flouquet 2006, 17); see also Claude Roy's 1965 book, entitled *Arts premiers.*

21. Chirac, quoted in Kerchache (ed.) 2000, 9; Adam 1995. For citations of Chirac's frequent declaration that "there is no more a hierarchy of cultures than there is a hierarchy among men," see (for example) Daubert 2000b; Leurquin 2000, 64; and Monier 2000, 40.

22. Monier 2000, 41. Earlier inspiration was surely provided by the 1984 blockbuster Primitivism in Twentieth-Century Art at New York's Museum of Modern Art and Paris's 1989 extravaganza Magiciens de la Terre.

23. Phillips 1995; Phillips 1996. See also Sieber 1996; Oguibe 1996.

24. Chirac (in his 1994 book, *La France pour tous*), quoted in Michaud 2004, 218. For further analysis of the contrast between French and American visions of cultural diversity, see Martel 2006.

25. *Laïcité* is often glossed as "secularism," but French texts on the subject make clear that the two are not precisely equivalent, either in their philosophical logic or their practical implementation. In the course of trying to explain the subtle difference, Christopher Caldwell (2003) cited Chirac's reaction to cases in which Muslim men had refused, on religious grounds, to let their hospitalized wives be treated by male doctors: "Nothing," Mr. Chirac said, "can justify a patient's refusing on principle to be treated by a doctor of the other sex."

26. Jackson 2006, 9. Joan Wallach Scott opens her study of sexual equality in France by calling attention to the unique concept of universalism that constitutes "a defining trait of the [French] system of republican democracy, its most enduring value, it most precious political asset [and] the guarantee of equality before the law. It rests . . . on the assumption that all citizens, whatever their origins, must assimilate to a singular standard in order to be fully French. . . . Defenders of the Republic have raised the flag of universalism, treating those who would recognize difference as, if not traitors, then as agents of American multiculturalism" (Scott 2005, 1).

27. Chirac, quoted in Guiral 2005. For a related argument from Canada, see the discussion in Ames 1994.

28. Sources: Agence France Presse for all entries except those from the European Information Service (22/6/94), *Sud Ouest* (14/11/94, 27/2/95, 13/1/96, 24/6/96), and *La Croix* (25/6/96). These events came just a few years after Chirac delivered his now-famous "noise and odor" speech: "Our problem is immigration overdose. We may not have more foreigners than before the war, but they're not the same people and that makes a difference. Workers from Spain and Poland and Portugal create fewer problems than Muslims and

Blacks. . . . You can hardly expect a French worker and his wife earning 15,000 francs, liv-
ing in a public housing apartment next to a man crammed together with three or four
wives and a couple of dozen kids who's taking in 50,000 francs of welfare benefits, natu-
rally without working . . . and if you add in the noise and the odor, well, the French worker
goes crazy. And it's not racist to say that" (Orléans, 19 June 1991, quoted in Michaud 2004,
217–18).

29. Chirac, quoted in *Le Figaro* 1996. Nonetheless, after the riots that plagued France in
November 2005, it was Chirac who put pressure on the heads of France's television chan-
nels to discontinue their long-standing tradition of all-white prime-time news anchors. In
2006 the appointment of Martiniquan Harry Roselmack to the eight o'clock news on TV1
was highly mediatized for "breaking a race barrier."

30. Six of the eleven official holidays in France are from the Christian calendar. The
others are New Year's Day, 1 May (International Workers' Day), 8 May (Victory in Europe
Day), 14 July (Bastille Day), and 11 November (Armistice Day). http://fr.parisinfo.com/
paris_guide/rub4547.html.

31. The law about naming babies, weakened progressively beginning in 1966, was not
fully rescinded until 1993. Now only names deemed prejudicial to the interests of the child
(Hitler, for example) are banned, with the public prosecutor of the Republic having the fi-
nal say in disputed cases. In 1999 a couple was denied permission to name their son Zébu-
lon (after a famous rock climber they admired), even though one of Jacob's sons in the
Old Testament was Zébulon, because the magistrate had memories of a 1960s television
program with an unsavory character of that name; the parents appealed, but lost. http://
www.affection.org/prenoms/loi.html; http://www.psychopsy.com/loi.html; http://www
.infobebes.com/htm/prenoms/loi_prenoms.asp. If the recent fad in Indonesia for naming
baby boys Osama catches on in France, magistrates may have to decide how to classify bin
Laden's place in history.

32. "Communitarianism" is viewed in France as a particularly destructive social ten-
dency. Even the word "community"—so often positive in English—can take on a pe-
jorative sense in French. When the French translation of my 1989 book, *Primitive Art in
Civilized Places,* was revised in 2006, all references to (ethnic) "communities" were sys-
tematically replaced by "more neutral" phrasing.

33. Silbert and Tovi 2005; *Libération* 2005.

34. Quoted in Le Cour Grandmaison 2005.

35. Loi no. 2005-158 du 23 février 2005 portant reconnaissance de la Nation et contri-
bution nationale en faveur des Français rapatriés. Article 4 of the law caused particular out-
rage among historians and teachers: see, for example, Vindt 2005 and Ligue des Droits de
l'Homme 2005. Widespread protests led to various suggestions for Band-Aid solutions
(e.g., downgrading the words "positive role" to "positive aspects" [Perrault 2006]), but all
were rejected on 29 November 2005 by the National Assembly, which voted, 183 to 94,
against reviewing the law (Thibaudat 2005). In February 2006, just days before the law's
first anniversary, a way was found to settle the matter without bringing it up for vote in the
Parliament: the sentence about school programs was declared "regulatory" rather than
"legislative," which allowed it to be declassified and removed by decree.

36. The MQB is apparently disregarding the law against gathering statistics on ethnic
background. "On Aug. 1 the museum started to collate figures on the cultural affinities of

its visitors in order to piece together a picture of its audience. Results are not yet available. But by his own calculations, [Stéphane] Martin estimates that about one quarter of attendees come from what he considers a new museum-going public" (Brothers 2006).

GETTING STARTED

1. For an insider's history of how the project developed, see Martin 2000a (or 2000b, a slightly expanded version of the same text).

2. De Roux 1995.

3. Ernenwein 1996.

4. The director of the Met, Philippe de Montebello, agreed. "I've rarely heard anyone propose such a nonsensical idea," he told an interviewer. "It's even insulting to the people concerned. Besides, it's inappropriate to cite the Metropolitan collections as an example, since we've always chosen to make them encyclopedic and truly universal. . . . But the Louvre has never tried to be an encyclopedic museum, so a decision to add a selection of *arts primordiaux* strikes me as something very much like political correctness" (de Montebello in Anon. 1996a).

5. For example, Jean Jamin (cited in Guilhem 2000) and Emmanuel Désveaux (in Avila 2004, 91; and Guilhem 2001).

6. Defenders of the Musée de l'Homme phrased their protests in terms of the threatened *démantèlement* (dismantling) of the museum. Journalists often wrote, rather, of *dépèçage* (dismembering), a word that also refers to the butchering of meat.

7. De Roux 1996a.

8. Madelin 2002, 791.

9. Jean Lebrat, Pierre Rosenberg, François Bellec, Henry de Lumley, Françoise Cachin, Jean-Hubert Martin, Bernard Dizambourg, Jacques Vistel, Claude-François Baudez, Christine Hemmet, and Jean-Louis Paudrat, respectively.

10. Friedmann Commission 1996a, 1996b. My copies of these documents were kindly provided by a member of the commission. See also Blanc 1997, 58; Gignoux 1996; and de Roux 1996b, 1996c.

11. *Le Figaro* 1996.

12. Dias 2001, 86.

13. De Roux 1997b.

14. Quoted in ibid. Others, approaching the subject from a more anthropological perspective, have also called for abandonment of the "false debate" between art and anthropology, citing its basis in outdated understandings of culture and alterity; see Galinier and Molinié 1998, 94.

15. From the MQB website: accueil > le musée > biographies > Germain Viatte.

16. De Roux 1997b.

17. Once the Louvre galleries were inaugurated, anthropologist Christian Coiffier pointed out that the inclusion of only seven objects from Asia, the part of the world that is demographically the most important, was a poor way to rectify a neglect of "three-quarters of humanity." Other imbalances also caught the attention of observers, who noted, for example, that there was but one object from the Olmec civilization, "the mother

of Mesoamerican cultures" (Anon. 2000a). (For comparison, there are four Taino pieces, perhaps reflecting Kerchache's 1994 involvement with that culture.)

18. Dupaigne 2006, 87–88.

19. Of the five Indonesian pieces, three are from the collection of Jean Paul Barbier, who wrote the introduction and one of the object commentaries for the catalog's Asian section. There's also a sculpture on loan from an ethnological institute in Taipei and a Filipino figure from Kerchache's own collection. Five of the seven pieces were (tax-credited) donations.

20. For a sampling of essays on native representation in museums at the time this issue was under discussion in Paris, see Krech 1994.

COHABITATION

1. As Annie Dupuis has written, the project gave art "a place that, if not exclusive, can at least be said to be preponderant. . . . We need to question the necessity of creating an establishment in which the aim is not to retrieve the objects' own histories but rather to present them sterilized of all cultural references in order to focus solely on their timeless and universal beauty" (1999, 479).

2. Chirac had not always been politically right-leaning. When he applied to Harvard Summer School in 1953 with the goal of perfecting his English, the Paris branch of the House Un-American Activities Committee denied him a visa on grounds of his past as a documented Communist sympathizer. It was only the pulling of well-placed strings that allowed him to realize his dream, during which he earned his pocket money by tutoring Latin and working as a dishwasher, and then waiter, at a local Howard Johnson restaurant (Madelin 2002, 64–65).

3. This "cohabitation" lasted until new presidential elections were held in 2002, at which point Chirac, reelected to the presidency, named the conservative Jean-Pierre Raffarin as his prime minister. Chirac's Socialist predecessor, François Mitterrand, had also experienced two periods of cohabitation during his presidency—the first (1986–88) with Chirac serving as prime minister, and the second (1993–95) with Édouard Balladur in that role.

4. My depiction of cohabitation in the committee has drawn on Dias 2001, 86–87; Godelier 2000, 2002; de Roux 1997e; and Viatte 1999.

5. Godelier 2002; 2003.

6. Pomian 2000b, 90–91.

7. The question of where to place European cultures in the new configuration of museum collections was brought up repeatedly in committee deliberations. The Friedmann Commission endorsed the inclusion of "traditional European societies except for France" in the proposed museum of *arts premiers*, noting that the future of European materials had been the subject of much discussion, with some members arguing that they should be given to the Museum of Popular Arts and Traditions (1996b, 8).

8. Godelier 2002; 2003.

9. Kerchache, quoted in Daubert 2000a, 16. Or again, "Art of the Western world is presented in our museums without evoking the artists' genetic baggage or reminding viewers

of the customs and traditions of the countries they come from. Are people born on the African continent or in the islands of the Pacific so different from us that they deserve to receive a radically different treatment?" (Kerchache, quoted in de Roux 1996c).

10. Kerchache, quoted in Daubert 2000a, 12.

11. Kerchache, quoted in ibid., 12, 16.

12. Viewing was not considered the only form of direct access. Caressing an object, too, was seen as a way of getting in touch (so to speak) with the artist's intent. See Jean Paul Barbier's endorsement of touching in Clément 2006 (third interview).

13. My use of a gendered pronoun here reflects the view under discussion.

14. Godelier and Kerchache 2000.

15. Crumley 2006.

16. *Libération* 2001a; Michel 2002, 122; Degoy 2002. The museum's president, Stéphane Martin, is said to have asked Chirac's help in getting Godelier out of the picture. The deterioration of collegiality was symbolized by small humiliations, such as making him request the key to his office each time he came to work and return it when he left.

17. Dubuc 1998, 82.

IN-HOUSE RUMBLINGS

1. At the inauguration of the Pavillon des Sessions, Chirac made a plea for "getting past, once and for all, the absurd quarrel between the aesthetic approach and the ethnographic or scientific approach" (Chirac 2000). And Viatte told a reporter that it was important to "open things up, defuse [the tension between] these camps that are turned inward on themselves and have tried for so long to ignore each other" (de Roux 1997b). But for some participants in the world of primitive art, there continues to be an ill-veiled animosity that shows little sign of softening. Viatte has dubbed the opposition between aesthetics and ethnography "inane," but illustrates his point with a Kerchache-like reading of a shield from the Solomon Islands. While alluding abstractly to the "interest in discovering the history of this object, the conditions of its use, and its real significance," his two-paragraph description sticks firmly to the object's aesthetic features (2006b, 66), as does the MQB catalog, where ethnographic commentary is limited to a cryptic remark that "such ceremonial weapons contributed to the power and prestige of the chief who owned them."

2. Warin 2005, 51.

3. A second argument against its acquisition was that the MH collection already included a number of masks from Teotihuacán, all of which were better examples of the form. For illustrations, see Kerchache (ed.) 2000, 370–74.

4. Jacques Kerchache's role in the selection of acquisitions contrasted sharply with procedures elsewhere in the world of Paris museums. Étienne Féau presents a useful summary of the steps through which such decisions were made at the MAAO, which involved a rigorous series of deliberations and reviews by formally constituted committees, operating as a system of checks and balances (Féau 1999, 928).

5. Those who dubbed her tactics "Ubuesque" were referring to a late nineteenth-century comedy by Alfred Jarry, *Ubu Roi,* which centers on a buffoonish king who wields absolute power and terrorizes his subjects.

6. My depiction of the secretary general's reign is based on interviews with journalists and numerous MQB employees, supplemented by Liffran 2003. See also Dupaigne 2006, 140–41, 172–73. At one point, I was told, employees circulated a petition denouncing the secretary general's "combination of incompetence, vulgarity, and neurotic behavior," saying that it had plunged them into an intolerable crisis. The letter of one curator asserted that the refusal to engage in even a small amount of debate had transformed the institution into a "war machine against the scholars." And a member of the architectural team slammed the door on his job, citing "hazing, contempt, violence, and favoritism."

7. Manuel Valentin, former curator of sub-Saharan collections at the Musée de l'Homme, in Raizon 2006.

A DREAM COME TRUE

1. Coppermann 2000. As of this writing, signs directing visitors to the Pavillon des Sessions continue to be few and far between compared to those for other parts of the museum.

2. Adam 1995. The frequent experience of people attempting to enter the Louvre through the Porte des Lions, only to find it closed, has led some to imagine that the Louvre was engaging in a form of "passive resistance" (Anne-Christine Taylor, speaking to a class at the École Normale Supérieure, 9 March 2006).

3. The Louvre galleries apparently did not consume all of Jean-Michel Wilmotte's creative energy. He was at the same time renovating Jacques Kerchache's two residences in the 13th arrondissement to create a single "*bel ensemble*" (Maurice Godelier, personal communication, 18 May 2006).

4. Quoted in Benhamou-Huet 2000.

5. Kerchache, quoted in Geoffroy-Schneiter 2000, 6.

6. Gruhier 2002, 76.

7. Santini 2000.

8. De Roux 2000.

9. Bourgoin 2000, 56.

10. Mark 2000, 8.

11. Pinte 2000.

12. Taylor 2006.

13. Dumont 2000.

14. Vavasseur 2000.

15. Coppermann 2000.

16. The catalog weighs 2.6 kilos (5.7 pounds). The English-language edition (now out of print) sold for $90. A photograph, catalog information, and brief ethnographic background on each of the works in the Pavillon des Sessions is also available on the website of the Quai Branly Museum.

17. Lorenzo Brutti, project manager for the CD-ROM, told me that Kerchache, whose explicit goal was to provide a direct experience between viewer and art object, argued against the inclusion of these cards in the galleries.

18. Pradel 2000, 11.

19. Kerchache 2001. This book was originally published as *Nature Démiurge: Collection d'insectes de Jacques Kerchache* (Paris: Fondation Cartier, 2000).

20. Fabrice Maze, *L'Œil à l'état sauvage* (Paris: Centre Pompidou, 2002), featuring scenes filmed in 1994. For a comprehensive interactive introduction to André Breton, see www.atelierandrebreton.com, a site by the Atelier André Breton (est. 2002).

21. *Jacques Kerchache, portrait,* a 2003 film by Jean-François Roudat (coproduction Musée du quai Branly/Forum des images). The jungle-bridge scene had also appeared in a film made in 2000 by Pierre-André Boutang, Guy Saguez, and Catherine Roulet, *La Joconde sourit aux primitifs*—a panegyric utilizing Kerchache's own collection of documents with a memorable scene in which he is gyrating lasciviously in the midst of dancers whose breasts are swinging to the beat of drums in the African bush.

22. Coppermann 2000.

23. Santini 2000.

24. Germain Viatte, interview at the MQB, 21 September 2005.

25. Rosenberg 2000.

26. Rosenberg, quoted in Anon. 2000a.

27. Rambert 2000.

28. Conversation at the Laboratoire d'Anthropologie Sociale, 20 September 2005. In a presentation to the Société des Amis du Musée (18 February 2005), Stéphane Martin predicted that the Pavillon des Sessions would close down in about fifteen years (Solen Roth, personal communication).

29. Boudin 2003, 43; MQB Activity Report for 2003, section 1.2.5.

30. Chirac 2003.

ARTIFACTUAL QUESTION MARKS

1. Noce 2000b.

2. Reuters 2000a; 2000b.

3. Noce 2000b; Riding 2000.

4. As chronicled by Bernard Fagg (1990), the first example of a Nok terra-cotta, a representation of a monkey's head, was discovered by chance in 1928, but it remained an isolated curiosity until a second was found fifteen years later. Widespread pillage began only in the 1990s (Robinson and Labi 2001). For vivid accounts of archaeological looting in Nigeria and its neighbors, as well as the traffic among dealers that follows, see de Roux and Paringaux 1999 (chapter 9) and Cherruau 2000. In 1943 Nigeria passed legislation prohibiting the exportation of archaeological and "indigenous" artworks, and strengthened the ban in 1953 and 1963. International conventions were passed by UNESCO in 1970 and UNIDROIT (International Institute for the Unification of Private Law) in 1995.

5. Baqué 2000. Harrie Leyten's edited book (1995) on problems in the handling of illicit traffic in cultural property (especially in Africa) offers an excellent introduction to the remedies that have been proposed through such organizations as UNESCO, UNIDROIT, and ICOM. Its caption to an illustration of a Djenné terra-cotta statuette from Mali notes that "all such statuettes circulating on the market have been looted" (69).

6. Noce 2000a.

7. *Libération* 2000b.

8. Noce 2000e.

9. Noce 2000c. Two Nok sculptures, dated 500 B.C.–500 A.D., and a Sokoto sculpture, dated 500–100 B.C., entered the Louvre's collection. See Kerchache (ed.) 2000, 114–23.

10. Noce 2000c. See also Henley 2000.

11. André Langaney, quoted in Warin 2005, 50.

12. Noce 2000g; 2000h; 2000i.

13. Noce 2000e; see also *Le Temps* 2000.

14. Faust 1991, quoting a *New York Times* article from 13 August 1990.

15. Agence France Press 2000; Robinson and Labi 2001.

16. *Libération* 2000a.

17. Noce 2000d.

18. Quoted in Robinson and Labi 2001. For Viatte's attempt to justify France's role in these events, see Viatte 2006b, 52, 54.

19. De Roux and Paringaux 1999, 141.

20. This whole paragraph is taken from Noce 2000e.

21. http://www.africaintelligence.fr/C/modules/search/search.asp.

22. Noce 2000f.

23. *Libération* 2001b.

24. Warin 2005, 51; Viatte 2006b, 54.

25. See, for example, Brown 2003.

26. Appiah 2006, 38. See Cotter 2006 for more reflections on these issues.

27. Lowenthal 2006. See also Lowenthal 1998.

28. Appiah points to an Italian law that allows the government "to deny export to any artwork currently owned by an Italian, even if it's a Jasper Johns painting of the American flag" (2006, 40), raising yet further questions about where to set the boundary between the ownership of an object and the right to control its future. Related to issues concerning ownership and rights of exhibition are questions about the ethics of scholarship and publication. Does research on unprovenanced materials fuel the incentives for illicit traffic? Or does a ban on such research constitute censorship of knowledge? For an introduction to the pros and cons, see Eakin 2006.

29. Appiah 2006, 40.

30. Ibid., 39.

31. Meier 2006.

32. Kerchache, quoted in Pradel 2000, 10.

33. Kerchache (ed.) 2000, 77, 269.

34. Ibid., 183. Information on pre-collection origins is also subject to manipulation. When Charles Ratton learned that a New Caledonian statue he was about to sell at auction was made by a convict in the French penal colony, he decided to list it in the catalog simply as "New Caledonia," thus implying that it was the work of a Kanak sculptor (Guiart 2003, 53).

35. Kerchache (ed.) 2000, 114, 118. A reviewer for *African Arts* was struck more generally by the paucity of information on the colonial context and collection history of objects in the exhibit (Petridis 2001).

36. Viatte 2006, figs. 3, 18.

37. Godelier 2003, 335. Danielle Gallois, author of the entry on the Guinea-Bissau statue in the Louvre catalog, found its history interesting enough to include it in some detail in the article (73–76). About half of her essay is devoted to the hostilities that preceded its "collection," which ran the gamut from sacred animals stolen and punitive raids conducted, to captives taken, villages burned to the ground, the king and two hundred of his subjects killed, and a treaty in favor of the French signed under duress. The CD-ROM says only that the statue was "collected by Commandant Aumont during a French punitive expedition in the Bissagos Archipelago in 1853."

38. The CD-ROM also offers ethnographic commentary on the general nature of societies in each of the four continents represented in the new Louvre galleries, as well as discussion of four universal themes along the lines that Godelier had proposed: the life cycle, rank and status systems, forms of power, and relationships with gods, spirits, and ancestors.

39. Langaney 2000. See also de Roux and Paringaux 1999, 148.

40. De Roux and Paringaux 1999, 144.

41. Gruhier 2002, 77. See also Annie Dupuis in Dorkel 2004, 85.

42. Dubuc 1998, 87; Balzli 2003.

43. Dubuc 1998, 87; Julienne 1997, 41; Romero 1998.

44. De Roux and Paringaux 1999, 141.

45. Kerchache (ed.) 2000, 290–93.

46. Langaney 2000; Jean-Pierre 2005. Fears about the inflationary effect of the new museum were, in fact, amply realized. To cite but one of many indications, a mask from Gabon went for a record 6 million euros at a Paris auction a few days before the MQB opened (Bensard 2006).

47. This discussion of the *uli* and the following discussion of a carved post from the Solomon Islands are taken from Brutti 2003, 21–26 (who draws on Derlon 1997, 110–23) and the CD-ROM (Godelier and Kerchache 2000). See also Kerchache (ed.) 2000, 285–87, 290–93.

48. English and French versions of the CD-ROM are subtly different; the English entry on this figure, for example, makes no mention of a cock's comb.

49. Clément 2006. The image of Oceania as an Edenic paradise where people plucked their food from trees or scooped it easily from the sea has been recognized as a Western stereotype since before Monsieur Barbier was born. As Bronislaw Malinowski wrote in 1922, "If we remain under the delusion that the native is a happy-go-lucky, lazy child of nature, who shuns as far as possible all labour and effort, waiting till the ripe fruits, so bountifully supplied by generous tropical Nature, fall into his mouth, we shall not be able to understand in the least his aims and motives" (1961, 58). As for visions of pre-Spanish "life in the Caribbean islands," see "Good-bye, Columbus," above.

50. Naffah 2000, 7; see also Guiart 2003, 93–98. Naffah also headed the team readying objects for the Quai Branly Museum—see "Preparing the Transplants," below. The preparation of objects for the Pavillon des Sessions was handled by the Centre de Recherche et de Restauration des Musées de France, housed in an underground area of the Louvre and endowed with state-of-the-art instruments, including a linear particle accelerator. I am grateful to Étienne Féau for giving me a tour of this very impressive facility.

51. Another example comes from Roger Boulay, author of the New Caledonia entries in Kerchache's catalog, who told me he was particularly struck by the age claimed for a decorative carving from a large ceremonial house. The carving is listed as dating from "the end of the 14th century–beginning of the 15th(?)"—with the results of C-14 testing in a footnote: "A.D. 1291–1397, with a probability of 100%." Boulay's comment: "The reaction of my friends and colleagues in New Caledonia, when I told them about this 'star' dating, was total stupefaction. They even decided to nickname me 'Mr. Fourteenth Century'! Everyone knows that the many large trunks of trees in the Kanak forests near Nouméa that are used to make masks and sculptures, which had been felled by colonists at the end of the nineteenth century, were often over 400 years old. And until the 1930s, sculptures were carved from trees felled by hurricanes—that is, the oldest ones" (e-mail of 11 July 2006).

52. Brutti 2003, 25, quoting Sandra Revolon's ("pre-polished") text for the ethnographic entry on the CD-ROM. (The published catalog that Kerchache edited for the Louvre sticks to aesthetic features and says nothing about tenderness or malevolence.) Maurice Godelier, a specialist on Oceanic cultures, confirms Revolon's information on this object (Godelier 2002).

53. Godelier and Kerchache 2000. "Roof finial of a large ceremonial house: aesthetics." See also the description of this object by Roger Boulay in Kerchache (ed.) 2000, 248–50.

54. Roger Boulay, e-mail of 21 July 2006.

55. Plagens 1989.

56. Delannoy 2002, 23.

TROUBLE AT THE TROCADÉRO

1. Dias 1991, 105–9; Dupaigne 1998, 648; Dubuc 1998, 74. For further details, see Nélia Dias's excellent history of the Trocadéro Museum (1991).

2. Here I am citing Dubuc (1998, 74), who cites Dias (1991) citing Krzysztof Pomian.

3. Dubuc (1998, 76), citing Jamin (1989, 114–15).

4. Dubuc 1998, 77.

5. See, for example, Maurice Godelier's remarks in Journet 1998, 19.

6. "Note sur la Réorganisation Conjuguée du Musée de l'Homme & de l'Institut d'Ethnologie de l'Université de Paris," Archives Nationales, Centre des Archives Contemporaines Fontainebleau 87007.4/ (typescript, 1941), 4.

7. Jean Guiart, director of the MH from 1973 to 1988 and one of the main players in what I have euphemistically referred to as "squabbles," has published a long diatribe (2003) in which he names names, with accusations involving positions given to one colleague's several (unqualified) mistresses, kickbacks from dealers to curators for arranging museum purchases, alcoholism in the museum building (leaving excrement and vomit to the janitorial staff), direct involvement by curators in thefts of artifacts, plagiarism, and more. This saga of heroes and villains (mostly the latter) leaves one skeptical about the fairness of individual accusations, but totally convinced that the atmosphere at the museum was far from collegial. Guiart was also responsible for the Oceanic section of the MAAO and attacks its personnel and procedures with equal aggression.

8. Dubuc (1998, 77), following the lead of Jamin (1989; 1991). In 1941 Paul Rivet was forced into exile in Colombia and returned to France only after the liberation of Paris, and in the postwar period the museum suffered from severely reduced budgets and limited personnel.

9. Dumont 1997, 106.

10. Oddon 1967.

11. A chair in prehistory was established in 1962, and in 1972 the chair in ethnology was divided between physical/biological anthropology and ethnography (Mohen 2004, 48).

12. Ibid.

13. Dupaigne 1998, 652.

14. The bottom line of Maurice Godelier's report to Jospin was clear: "This museum cannot be saved. We need to close it and make another one" (Godelier 1999, 300).

15. This whole paragraph is based on Dupaigne 1998.

16. Guilhem 2000.

17. Julienne 1997, 43.

18. De Roux 1990.

19. Viatte 1999, 291.

20. Héritier-Augé 1991; Dubuc 1998, 78.

21. Maurice Godelier, personal communication, 18 May 2006.

22. Godelier 1999, 299.

23. Lévi-Strauss 1954, cited in Jamin 1991, 114; 1998, 69.

24. Jamin 1991, 113; 1998, 69.

25. Dubuc (1998, 85) refers to funds for the renovation of the Musée de l'Homme that "appear likely to have been" set aside under Mitterrand's presidency in 1981.

26. This paragraph is based on de Roux 1987. See also Blotière 1997, 24–25, on de Lumley's hopes for MH renovation.

27. De Roux 1992.

28. De Roux 1995.

RESISTANCE MOVEMENT

1. Quoted in Cressole 1990, 47.

2. Dumont 1996.

3. Bernadette Robbe, quoted in Romero 1998.

4. Not every part of the francophone world has clung to the generic use of the word for man. Élise Dubuc points out, in discussing names for a newly conceptualized Musée de l'Homme in Québec: "There was no question of any name containing the word 'Homme.' Whatever the Académie may say, and even if it starts with a capital letter, it's no longer acceptable for the masculine to subsume the feminine" (1998, 89).

5. Vincent 1996.

6. Jullian 1996; Monier 1996; Vidal-Blanchard 1996. See also de Lumley 1996; 1997. In an edited volume entitled *Trésors méconnus du Musée de l'Homme* (1999), de Lumley valiantly attempted to call attention to his museum's continuing presence, despite the wounds being inflicted upon it.

7. Charbonnier 1996, 13. Dupaigne's book, *Le Scandale des arts premiers: La véritable histoire du musée du quai Branly,* was published in June 2006 to coincide with the inauguration of Chirac's museum.

8. Blotière 1997. The Naval Museum had been in the Palais de Chaillot since 1943. Bellec's naval colleague Éric Tabarly, arguably France's most popular navigator, was particularly bellicose about defending its prime location, asserting angrily that it was more important for the French to be educated about maritime history than about *arts premiers* (Hillion 1996), but his role in the debates ended precipitously in 1998 when he drowned at sea (http://www.ouest-france.fr/dossiershtm/tabarly/accident.htm).

9. *Libération* 1996.

10. Langaney 1997.

11. Patrimoine-Résistance Bulletin #2, http://www.patrimoine-resistance.org.

12. Romero 1998.

13. De Roux 1996b.

14. Friedmann 1998.

15. Romero 2001.

16. Michel 2002, 122.

17. Brédy 2001.

18. Lagarde 2002.

19. Jean Mennecier, quoted in Brédy 2001.

20. Gruhier 2002, 76.

21. Langaney, quoted in Warin 2005, 50. Or, as he told another journalist, "It makes no sense to perform an emergency evacuation of 250,000 objects, 95 percent of which are objects of daily life, for a museum that's going to exhibit 3,000 art objects" (Huet 2001).

22. Gruhier 2002, 76.

23. The 1998 colloquium, "Regards Anthropologiques sur le Nouveau Musée de l'Homme," was organized by Claude-François Baudez and Antoinette Molinié. Papers presented at the 1999 follow-up were published as a special issue of *Ateliers,* a journal cosponsored by APRAS and the Laboratoire d'Ethnologie et Sociologie Comparative de Nanterre (Baudez et al. 2001). A second colloquium on related themes was held the next year. Keith Hart, longtime observer of the French anthropology scene, glosses APRAS as "the keeper of the exotic flame," in contrast to the Association Française des Anthropologues (AFA), which he describes as "more explicitly engaged with contemporary society, but lack[ing] the other's institutional influence" (Hart 2006).

24. De Roux 2001.

25. Baudez, Martin, and Perrois 1996. The authors were an Americanist archaeologist, director of the Museum of African and Oceanic Art, and an Africanist cultural anthropologist, respectively.

26. Clifford 1988, 118.

27. This paragraph comes from ibid., 117–51. Quotes are taken from 118, 135, 140.

28. The expression comes from the *Magazine Littéraire,* in a special issue devoted to Claude Lévi-Strauss (4e trimestre 2003).

29. Alban Bensa in Caille 2006, 70.

30. Godelier, personal communication, 18 May 2006.

31. Price and Jamin 1988, 164.

32. Labarthe 2003; Steinmetz 2003.

COLONIES AND CROCODILES

1. J.-H. Martin 1999, 125.

2. This is said to be the largest bas-relief in Europe (ibid.).

3. Taffin 2002, 198.

4. Ibid., 213.

5. De Roux 1990.

6. Tripot 1910, 277–78.

7. Taffin 2002, 217. See also Guitart and Blanchard 1992.

8. Métraux 1978, 191–92 (diary entries for 28–30 May 1947).

9. J.-H. Martin 1999, 126.

10. Some of the curators did resist. One described to me his distress as he watched Kerchache march imperiously through the storerooms, fingering objects he wanted for the Pavillon des Sessions as if he were buying food in a supermarket: "All he lacked was the shopping cart."

11. Hillion 1996.

12. Viatte 2002, 11.

13. Agence France Press 2005a.

14. Speech by the minister of colonies on the occasion of the museum's reopening in 1935; cited in Taffin 2002, 183.

15. Gérard Collomb draws attention to the role of museums in sanctifying a heritage in which "territories historically linked to France through colonial ties are dressed in the new clothes of *départementalisation*" (1999, 333). During MQB planning sessions, there was apparently a fleeting acknowledgment of the link via discussion of the possibility of offering immigrants a reduced rate for entry to the museum (Dupaigne 2006, 185). And in the museum's inaugural week, when a general report on the eight roundtable discussions was conducted in the Claude Lévi-Strauss Auditorium, Mary Douglas raised the idea of setting aside special days for members of specific ethnic groups—a suggestion that was quickly, and somewhat condescendingly, dismissed by Catherine Clément as "hardly very French."

MUSICAL CHAIRS

1. Or, as one journalist put it, "the grand waltz of Parisian museums" (Gignoux 1996).

2. Eccles 2004.

3. Edelmann and de Roux 1996.

4. De Roux 1997c.

5. Féau 1999, 923.

6. A December 1996 article in *Le Monde* pointed out that "the game [of musical chairs] requires the elimination of one of the players" and suggested that the Musée des Monuments seemed to be the most expendable (Edelmann and de Roux 1996). An update written a year and a half later showed that the choices remained as complicated and thorny as ever (Edelmann and de Roux 1998). See also de Roux 1997c.

7. Guerrin 1997.

8. http://www.palaisdetokyo.com.

9. Primitivism in 20th Century Art: Affinity of the Tribal and the Modern.

10. See Colardelle 2002.

11. Conservation of collections in the *salle de France* suffered during the war, and it was closed in 1928 (Segalen 2005, 18–19).

12. Guiart 2003, 184.

13. Segalen 2005, 34.

14. Collomb 2006.

15. Segalen 2005, 95.

16. As with Chirac's new museum, discussion of the museum's content and mission often involved the choice of a name. Before settling on Musée National des Arts et Traditions Populaires, a number of others were proposed: "musée français," "musée d'ethnologie française," "musée de la tradition française," "musée de France," and "musée national populaire" (ibid. 144–45).

17. Ibid., 235.

18. De la Batut 2001.

19. Segalen 2005, 255, citing Jacques Sallois.

20. Segalen 2005, 235–36.

21. Jean Cuisenier, Jean-Claude Duclos, and others engaged in a heated exchange in *Le Débat* (Cuisenier 1991; 1992; Duclos 1992).

22. Only about a third of these were paid admissions (Segalen 2005, 214, 253, 278). Emmanuel de Roux, writing in *Le Monde*, cites figures of 42,500 in 1978 and 13,900 in 1995 (1997a).

23. Lebovici 2005b.

24. De Roux 1997a.

25. Ibid.; Lebovici 2005b.

26. Segalen 2005, 283; Colardelle 1998; de la Batut 2001.

27. Colardelle 1998, 115.

28. Segalen 2005, 285.

29. Ibid., 323.

30. De Roux 2005.

31. Silbert 2000.

32. A side benefit of this shift was that it created an appropriate destination for the Musée de l'Homme's European artifacts, which did not fit the Quai Branly Museum's profile.

33. Segalen 2005, 317.

34. The debates seem to have run their course by early 2006, becoming more of a lingering memory than a newsworthy activity.

35. Tagliabue 2005.

36. Naissance: Gestes, objets et rituels, through 4 September 2006, and Dragons: Entre science et fiction, through 6 November 2006.

37. Agence France Press 2005b; Romero 2006.

38. Riding 2005; Blottière 2005; de Baecque 2005.

39. François Mazières, http://www.archi.fr/IFA-CHAILLOT. The Cité was scheduled to open in three stages during 2005–7.

40. Lebovici 2005a.

41. http://www.art-z.net/expos_en_cours.htm.

42. Taylor 2006.

THE TURN TO CONCRETE

1. Jérosme 1998, 3.

2. De Roux 1998.

3. Vallaeys 2004. With time, another renaming took place, as the *musée des arts premiers* began to be referred to by its critics as the *musée des arts pillés* (museum of pillaged arts).

4. Dubuc 1998, 89; Jérosme 1998, 3.

5. De Roux 1998.

6. This argument had also been made in the late nineteenth century, when some voices protested that the Trocadéro Palace was "too far from Paris" (Dubuc 1998, 74).

7. Jérosme 1998, 3.

8. Champenois 1999.

9. Silbert 1999.

10. Champenois 1999; de Roux 1999; Dias 2001, 88.

11. Silbert 1999.

12. Bouzet 1999.

13. Brumback 2004.

14. http://www.villette-numerique.com/2004/pages/index.php?pg=21&auteur=Jean%20Nouvel.

15. Musée du Quai Branly 2006b, 1.

16. Champenois 1999; Anon. 2002, 76.

17. Chrisafis 2006b.

18. Taylor 2006.

19. S. Martin 1999, 5. Françoise Choay has pointed out that although Chirac envisioned the MQB as "a new type of cultural and scientific museum, simultaneously museum, cultural center, and place of research and education," that is exactly what the Musée de l'Homme had always been (Choay 2006).

20. Bazin and Bensa 2000.

21. Price 1999, 79–80.

PREPARING THE TRANSPLANTS

1. This section is based on Boudin 2003; Bounoure 2004; Chabod-Serieis 2004; Le Chatelier 2004; Mohen 2006; and Vallaeys 2004; as well as the MQB's pre-inaugural website. See also Naffah 2004.

2. Vallaeys 2004.

3. Bounoure 2004, 48.

BEHIND THE HAIRY WALL

1. The terra-cotta *chupícuaro,* which serves as the museum's mascot, is featured prominently on the MQB website, brochures, and publicity, as well as the cover of the catalog to the Louvre's Pavillon des Sessions and the CD-ROM *Chefs-d'œuvre et civilisations.* In spite of the ubiquitous use of its image in association with the Quai Branly Museum, the figure itself remains across town in the Louvre. It was purchased for a million francs in 1998 (Dupaigne 2006, 122).

2. Moniteur and Musée du Quai Branly 2005, 17.

3. The game of musical chairs was played out with positions as much as with buildings. When Mohen moved to the MQB, Christiane Naffah replaced him as director of the Centre de Recherche et de Restauration des Musées de France.

4. I felt very appreciative of the availability of MQB staff, which was apparently not extended to everyone attempting to write about the museum. As one of my correspondents told me in an e-mail, "I have found getting information on these projects—other than the official line—extremely difficult. You would think it was a national security issue the way the project is treated."

5. Any number of firsthand accounts, of course, document the contrary. To cite just one: the French expedition across the face of Africa in 1931–33 makes it clear that surreptitious confiscation of artifacts from living communities was very much the order of the day. For examples, see Price 2001, 68–81.

6. Viatte in Pomian 2000a, 82–83. Viatte explicitly defends the MQB's decision not to respect the international conventions regarding illicit traffic that are endorsed by the International Council of Museums' Code of Ethics on the grounds that they inhibit art historical research, much as George W. Bush refuses to comply with guidelines on torture spelled out in the Geneva Conventions, on the grounds that they inhibit intelligence on terrorism (Viatte 2006b; see also Viatte 2000, 17).

7. Martin in Blanc 2001.

8. The exhibition, Marc Couturier: Secrets, was curated in 2001 by Yves Le Fur, now adjunct director for permanent exhibits at the Quai Branly. My discussion is taken from Derlon and Jeudy-Ballini 2001/2002.

9. Derlon and Jeudy-Ballini 2001/2002, 206, 209.

10. For a discussion of this ideology, and Chirac's endorsement of it, see "Down with Hierarchy," above.

11. See Clifford 1988, 209; Steiner 2002, 404.

12. Rijksmuseum voor Volkenkunde 2005.

13. The dominant mood in France, as elsewhere in Europe, had been moving steadily to the right, building on the attitude toward immigrants that we saw during the mid-1990s and carrying it into the mainstream. The first round of the 2002 presidential election had given Le Pen more votes than the leading Socialist candidate, Lionel Jospin. As a result, the final election had a rightist candidate running against an extreme rightist, with no candidate on the left. (Official results for the first round were Le Pen 16.86%, Jospin 16.18%, and Chirac 19.88%) (http://www.conseil-constitutionnel.fr/dossier/presidentielles/2002/documents/tour1/resultat1.htm).

14. Sarkozy has committed himself to a policy of systematic expulsions and toughened procedures for family members to gain residence papers. The program he pushed through as the author of laws restricting immigration included a zero-tolerance anti-crime campaign and frequent police checks of French Arabs in poor neighborhoods. The "loi Sarkozy" of 2003 was designed to double the number of expulsions. His 2006 follow-up went even further, establishing a policy of "selective immigration" in which residence papers would be granted on the basis of employment contracts, but applications based on family ties would no longer be allowed. In June 2006, in an attempt to soften his image, he proposed giving residence papers to immigrant children born in France on the (astonishing) condition that they demonstrate an inability to speak their parents' language and a lack of any relationship to their parents' country of birth (Van Eeckhout 2006). "Ironically, Mr. Sarkozy, himself a second-generation immigrant, has been one of the loudest champions of affirmative action and of relaxing rules that restrict government support for building mosques" (*Le Monde* 2005b; Smith 2005a, 2005b).

15. Smith 2005a.

16. Rioufol 2005. Exactly a year later, with no perceptible improvement of conditions in the immigrant suburbs, violence broke out anew, leaving cars and buses torched, rioters jailed, and politicians scrambling for answers to the problem. See, for example, the articles in *Libération* (20 October), *La Tribune* (20 October), *Le Monde* (22 October), and *Le Figaro* (23 October).

17. Residents of the neighborhoods in question were not always clear on how they were supposed to assimilate more properly to what sometimes appeared to be a "baguette-and-beret" identity (Smith 2005c). As one Muslim commented, "They say integrate, but I don't understand: I'm already French, what more do they want? . . . They want me to drink alcohol?" (Smith 2005a).

18. While politicians faulted aspects of North African culture, people on the inside of the situation tended rather to cite aspects of French social politics such as the "overcrowded, underfinanced schools" in immigrant housing developments that were leaving their children unequipped to find employment (Sciolino 2005).

19. See Diaby 2005.

20. In amorous relations as in art, there is no hierarchy among men, and France's highest officials tend to observe the same definition of monogamy as men in other walks of life. This has become increasingly well recognized of late, as the private lives of public figures, traditionally shielded from scrutiny in France, have begun to appear in the news and on the Internet. The revelation shortly before President François Mitterrand's death that he had an outside daughter and the more recent coverage of Nicolas Sarkozy's ongoing tabloid-level lifestyle, for example, are due to this trend. For a taste, see Catalano and Chemin 2005; Anon. 2005, Deloire and Dubois 2006; and Madelin 2002, 411, 671, et passim.

21. Huet 2005.

22. Santini 2005.

23. Jeudy 2002, 249–50.

GLASS, GARDENS, AND ABORIGINES

1. Moniteur and Musée du Quai Branly 2005, 14. The "organic" quality is carried even into the handrails for stairs and ramps, which swerve and bend in apparent avoidance of an overly straight line.

2. Musée du Quai Branly 2006b, 11 (English version).

3. Ibid., 16.

4. Ibid.

5. Moniteur and Musée du Quai Branly 2005, 8. The threat of water damage to collections was raised by MQB critics Bernard Dupaigne and Jean Guiart, who each cited previous mishaps with underground storage in Paris. Dupaigne noted that other museums along the Seine had moved their collections away from the river as a protective measure and alluded to a June 2005 flood during which sewers overflowed and caused damage in the basement of the national library, where MH objects were in temporary storage, and the MQB, where documents had recently been brought from the Palais de Chaillot (2006, 189–90; see also Noce 2005). Guiart, writing before the MQB was built, made several technical arguments about the threat of water seepage and mold, and the risks of placing an extensive garden on top of the storage area (2003, 68–74 et passim). I've been told that the recommendations of Denis Guillemard, a specialist in preventative conservation charged with providing a report in 1999, were systematically ignored and that the MQB's storage facilities, though relatively uncommented in the media, represent one of the most problematic aspects of the museum.

6. Moniteur and Musée du Quai Branly 2005, 11.

7. The colors had reviewers guessing about how to see them—"yellow, red, and brown," said the Dutch newspaper *De Volkskrant*; "orange, red, yellow, and purple," said *Newsweek*; "concrete blocks the colours of sand, earth and, I think, aubergines," asserted the *Guardian*; and the *NRC Handelsblad* dubbed some of them blue (Obbema 2006; Dickey 2006; Glancey 2006; Moerland 2006). *L'Objet d'Art* called them "red, orange, and brown," but the photographs on the same page look very much like gray-blue and lavender (Caillaud-de Guido 2006, 36). The art magazine *Connaissance des Arts* played it safe, simply referring to "boxes of intriguing colors" (Blanc 2006, 10).

8. Rochon 2006.

9. Taylor 2006.

10. Designed by Trinh Minh-ha in collaboration with Jean-Paul Bourdier, the audiovisual component is explained in a plaque: "It is often said in Asia that the miracle is not walking on water but rather walking on land. To walk is to experience the indefinite and the infinite. . . . Traveling the ramp between images, sounds, and aphorisms, or between the spoken and the seen, is an initiatory walk crossing several Asian, African, and American cultures. . . . Meaning shifts with the walk and in response to the luminous appearance and disappearance of the aphorisms. Walking the ramp becomes like a rite of passage whose fluid movement through three phases—Transition, Transformation, and Opening—is suggested by the corresponding sounds and rhythms."

11. Andrieu 2006.

12. Musée du Quai Branly 2006b, 5.

13. Moniteur and Musée du Quai Branly 2005, 15. The metaphors that punctuate MQB literature sometimes become a bit jumbled. The "River" (exhibition space) runs through the "footbridge" (Museum Building) that spans the "forest" (garden areas), and a "Serpent" runs along the "River" on both banks, all of which forms a "cave of discovery"—or again, a "labyrinth."

14. In 1962 André Malraux, then minister of State for cultural affairs, commissioned paintings by Marc Chagall, which were installed in 1964 on the ceiling of the Paris Opera (the Palais Garnier, built in 1874, not to be confused with the Opéra de Bastille, built in 1989).

15. I am grateful to Solen Roth for sharing her interviews with Philippe Peltier and Séverine Le Guével, in which they discuss the background to this project (21 March and 10 April 2006).

16. Michael Riley died shortly after his work was selected.

17. Three months after the museum opened, Gulumbu Yunupingu was honored as Australia's "Visual Artist of the Year."

18. Eccles 2004.

19. Owens 2006. Earlier projects for the exhibition of Australian Aboriginal art in Paris had been permeated with similar concerns about the tension between displaying it as "art" or "ethnography." Fred Myers (1998) provides a detailed analysis of the complex negotiations that surrounded attempts in the 1990s to work out this and other tensions in plans for a 1993 exhibition, La peinture des aborigènes d'Australie, at the Museum of African and Oceanic Arts. The complex tangle of competing considerations involved personal, cultural, museological, and national agendas. Australian curators, for example, were attempting to free Aboriginal creativity from its reputation as an "ethnographic" art; MAAO curators were trying to counter both the museum's reputation as a "colonial" museum and its domination by African (as opposed to Oceanic) art; and the French government, which contributed generous funds to the exhibition, was using the occasion to express gratitude to Australia for large purchases of French satellites by the new Australian telecommunications system, Aussat. Myers's analysis makes it clear that, then as now, the various players in the drama—from diplomats, curators, anthropologists, and art agents to the artists themselves—faced daunting challenges in their uphill battle to produce a dignified representation of art from one culture in the institutions of another, given pasts laden with stereotypes and political histories in both settings.

20. Eccles 2006.

21. Button 2005.

22. These wall texts are the museum's only explanations of the Australian artists' work (outside of publications on sale in the gift shop). On the museum's website, descriptions of their art take on a decidedly abbreviated form—e.g., "Ningura Napurrula, a Pintupi from the west of Australia, created a work for the second-floor ceilings"; and "The themes of Aboriginal paintings are inspired by mythical events and usually illustrate the creation of the world." And allusion to the eight artists is limited to brief mentions in a section on patronage of the museum, where the kind of international cooperation that provided funds for the incorporation of their work in the building holds pride of place.

23. The Australian dollar is about US$0.75.

24. Kemp 2006.

25. "Decorated hollow logs are used for the ceremonial interment of human remains. In contemporary practice they are made for exhibition as sculptures" (Armstrong 2006, 27).

26. Button 2005.

27. Doutriaux 2005.

28. Biétry-Rivierre 2005.

29. Zawisza 2005.

30. Fitzgerald 2006.

31. Cosic 2006a.

32. Fitzgerald 2005.

33. Eccles 2004. In a similar spirit, Nicholas Thomas has pointed to misreadings of the art of another Aboriginal painter, Rover Thomas. Three of his paintings, for example, based on an incident in which a group of Aborigines were fed beef, bread, and ham laced with strychnine, depict both the poisoning and the place where the bodies were burned. Yet to Western viewers, these are seen simply in terms of their power as works of abstract art (Thomas 1996, 14).

34. Eagerness to promote a harmonious vision of European/Australian relations by avoiding allusions to conflict extended well beyond the museum. Diplomatic interests in both France and Australia, especially against the background of French nuclear tests in the Pacific and the two countries' divergent positions on the war in Iraq, turned the Australian art into an instrument for the expression of solidarity. The political, practical, and diplomatic apparatus required to pull this project off was enormous, drawing in a network of people—politicians, diplomats, lawyers, patrons, curators, art advisers, art agents, national art councils, local art cooperatives, architects, teams of hands-on artisans, and the firm responsible for the physical installation—that risked dwarfing the role of the eight artists, except of course in press releases.

35. For an excellent analysis of the role of the curators, art agents, and other culture brokers, both indigenous and foreign, in promoting Aboriginal art as it enters the international art market, see Myers 2002.

36. A handsome catalog of the eight artists' work, made for private distribution, was financed by the Australian government, the Musée du Quai Branly, the Harold Mitchell Foundation, the National Gallery of Australia, the Australia Council for the Arts, and Art Gallery NSW. It mentions that Paddy Bedford received his name from the then-manager of the cattle station where he was born, "the infamous Paddy Quilty, . . . one in a succession of white bosses who disenfranchised entire communities of traditional landowners." But it makes no mention of the role that Paddy Quilty's atrocities play in Bedford's art (Armstrong 2006, 22–25). When traumatic incidents that have had an influence on Aboriginal art are not the product of colonial violence, the catalog shows no similar reticence to discuss them: Lena Nyadbi's artistic tradition is traced to a man's dreams in which a woman who died in a car accident during a hurricane revealed her afterlife travels (Armstrong 2006, 34–37). The catalog offers stunning illustrations of the artists' designs as reproduced by Cracknell & Lonegan on the walls and ceilings of the museum, but unfortunately shows virtually no images of the designs as they were originally created by the artists.

37. Jeremy Eccles, e-mail of 14 July 2006.

A RIVER RUNS THROUGH IT

1. De Roux 1998.

2. Baudrillard 1994, 13.

3. Though it's not certain. Chirac has strong ideas about when it's appropriate to speak in the language of Shakespeare versus that of Molière. In March 2006, for example, he walked out of a European summit meeting in Brussels to protest a fellow Frenchman's use of English (*New York Times* 2006).

4. Sources for this paragraph are *Le Monde* 2005a; Olson 2005; Reynolds and Neuman 2005; and Trescott 2005. The objects exhibited in the Louvre include three on loan from the Walt Disney–Tishman African Art Collection—see Kerchache (ed.) 2000, 146–50, 199–203.

5. Delannoy 2002, 22, who takes the MH figure from Bernard Dupaigne, professor and former director (1992–99) of the department of ethnology. In mentioning the MQB acquisitions budget of 23 million euros, Stéphane Martin adds that donations are also an important source (Stern 2005). By the time the museum opened, between 8,000 and 9,000 objects had been acquired, about a third of them through purchase and the rest through donations (Bailey 2006; Bensard 2006, 27).

6. *L'Expansion* 2003. The pre–June 2006 website of the MQB included discussion of the Breton sale (with no mention of money) and expressed gratitude to his widow and daughter for the generous donation of important pieces from his collection; in the English-language version, this was found under: Home > Exploration > Rooms at the Louvre > 100 masterpieces > new sculptures.

7. De Roux 2004; Gignoux 2006. See also Blanc 2004; Richardin et al. 2006; and Viatte (ed.) 2006. The MQB website offers a direct link to a page devoted to this statue, lending further support to the implication in these texts that the statue has passed the "national treasure/national interest" test with flying colors. If so, the new law would mean that the statue cost AXA 400,000 euros but that the dealer received 4 million euros. For more on the statue, see "Art of Darkness," below.

8. Bensa 2006, 145. Germain Viatte reports that the acquisitions committee "resorted to the practice of obtaining an object from a researcher in the field" for only one of its several thousand purchases (2006b, 9).

9. Roger Boulay, e-mail of 21 July 2006. Taking an example of this attitude from another part of the world, one would have a hard time fitting the vibrant, innovative sculptures by living artists illustrated in Price and Price 2005 into French geographer/collector Jean Hurault's characterization of post–World War II sculpture by Maroons as an "impoverishment of their artistic sense and creative power" and a "general decadence" in their art (Hurault 1970, 90–92).

10. Jean-Pierre Mohen, in Bensard 2006, 27.

11. S. Martin in Musée du quai Branly 2006c, 8.

12. Price 2001 (orig. 1989), 126.

13. The complex ideological bundle that revolves around specifically French ideas about equality, cultural exceptionalism, freedom, *laïcité*, and national sovereignty is not easily reduced to a brief discussion. The ban on official recognition of ethnic identity is but one

consequence of a philosophy in which people are made "equal" by the erasure of difference. For a thoughtful analysis of these issues, see Scott 2005.

14. In contrast to the Quai Branly Museum website, where donors and patrons occupy a place of honor, the Te Papa Museum website offers rubrics on its repatriation program, relationships with native communities, and bicultural organization. Clearly, part of the difference in approach is due to the different mandates—exhibiting home cultures vs. foreign cultures—but one could argue that in the twenty-first century showing attention to issues such as repatriation should be equally relevant to both.

15. Viatte (ed.) 2006, 45.

16. Richardin et al. 2006, 74.

17. Hélène Leloup, "Grande Statue Djennenké," posted on the MQB website, http://www.quaibranly.fr/uploads/media/doc-1973.pdf. Leloup's 1994 book on Dogon statuary includes some twenty pages on "djenneké" figures, identifying the ownership of the statue in the MQB as "private collection" and saying nothing about its thousand-year past except that it "must have been hidden for decades in a forgotten cave" (1994, plate 2). At my request, the head documentalist of the museum attempted to find information about the statue's history prior to 1969 but came up completely dry. Assuming that a serious collector would not have bought such an exceptional piece without inquiring about its pedigree (i.e., collections it had been in previously), I wrote to Leloup asking for this information. Although she was kind enough to reply with reflections on the statue, she provided no information about its pre-1969 whereabouts. Its pedigree consists, then, of its hypothetical role in a vaguely identified tenth- or eleventh-century culture (a date based on laboratory tests that Leloup "paid for until significant results were achieved" [1994, 602]) and its thirty-five-year contribution to the Leloup collection, leaving considerable room for speculation about the thousand-year interim.

18. Geoffroy-Schneiter 2006, 38.

19. Note that the main French authority on Dogon statuary is also the country's most important collector/dealer of Dogon statuary. And that the main texts on the Quai Branly's androgynous figure were written by that collector/dealer, who eventually sold it to the MQB (via AXA) for 4 million euros. An article on laboratory analyses of the statue, published in the journal *Technè*, is careful to segregate Hélène Leloup's double role, referring only to "a Parisian dealer in African art" as the pre–Quai Branly owner, but to "Hélène Leloup, author of a 1994 book on Dogon statuary" as the authority on its meaning (Richardin et al. 2006, 74, 75). It alludes (in a parenthesis) to radiocarbon dating of the statue to the tenth or eleventh century but does not present the data. Instead, it shows that the statue was carved from *Khaya senegalensis* and notes that this species has become "very rare today" in the region because of the land's progressive dryness and the adverse effects of "human activity" on the environment (ibid., 76). It is not clear from the article at what point in the past thousand years the *Khaya senegalensis* trees became too rare to provide statuary such as the piece in the Quai Branly Museum. Finally, I would note that the piece most closely similar to the statue in question, a statue in the Metropolitan Museum of Art, has been dated to the sixteenth to twentieth century.

20. Interview with Anne-Christine Taylor, 23 June 2006. An earlier experiment with water had proved more feasible. In his design for the Culture and Convention Center in

Lucerne, Switzerland, he diverted lake water across a public piazza to channels deep inside the project (Ryan 1998). Further pursuing his interest in water, Nouvel recently made a splash with his design for programmable, "touch-sensitive" bathroom faucets (retail price: $2,090) that are controlled by "caressing a button" rather than turning a knob (Graff 2006).

21. The preliminary copy of the museum's glossy dossier that I was given in April (some eighty pages designed for distribution to the press) touted the Serpent as a central feature of the exhibition area. By the time I picked up a copy at the press preview on 19 June, the dossier had been considerably reworked, in the course of which the Serpent had been completely disappeared. In an interview published in the 23 June–6 July issue of *Le Journal des Arts*, however, Germain Viatte was still referring to an "undulating serpent winding through the continents" (Flouquet 2006).

22. Harding 2007.

23. Didier Brault, quoted in Moniteur and Musée du Quai Branly 2005, 7.

24. Jeudy 2002, 255.

25. Moniteur and Musée du Quai Branly 2005, 16.

26. Dupaigne 2006, 99.

27. Fayard 2006. I've been told that administrative offices also fell under Nouvel's strictures, which prohibited personnel from placing decoration on the walls of their work spaces.

28. See also Kimmelman 2006.

29. The other two errors that we had pointed out in September were not corrected. The label mistakenly attributes the cape to Saramaka Maroons (rather than to the Paramaka— people who are located several hundred miles from Saramaka territory and speak a different language). And it erroneously locates the village where the cape was collected in the French department of Guyane rather than the Republic of Suriname (even though the MQB website lists it correctly as Suriname). These infelicities are especially surprising since the original museum documentation from the Musée de l'Homme identifies the cape correctly as Paramaka, and a book in French that the curator had in his office gives full, correct information (Price and Price 2005, figs. 4.45, 4.56; see also Price and Price 1980, figs. 86, 113).

30. The orthographic convention "Telefomin" was corrected by linguists to "Telefolmin" in the 1960s. A search for pieces classified as Tifalmin, Telefomin, or Telofolmin in the museum's online catalog of objects gives no results.

31. Cachon 2006.

32. Moniteur and Musée du Quai Branly 2005, 12.

33. Tresilian 2006.

34. Musée du Quai Branly 2006b (English version), 7, 15.

35. Viatte 2006a, 28.

36. Bensa in Caille 2006, 70.

ART OF DARKNESS

1. Kimmelman 2006 and an audio slide show posted on the website of the *New York Times*. A *Boston Globe* correspondent read it in a more historical mode as "late-Victorian gloom" (R. Campbell 2006).

2. Rochon 2006. One reviewer commented, "The jungle metaphor is so overdone that it starts to seem silly, or condescending. A collection of large boxes in orange, red, yellow and purple protrude from the museum's outside walls, and resemble darkened huts from the inside" (Dickey 2006). Another characterized the museum as "an enormous, rambling crepuscular cavern that tries to evoke a journey into the jungle, downriver, where suddenly scary masks or totem poles loom out of the darkness and everything is meant to be foreign and exotic" (quoted in M. Campbell 2006). A third asserted that "the alternating use of darkness and subdued lighting creates the illusion of exploring mysterious caves and forests and stumbling upon the treasures of lost civilizations" (Moore 2006). A fourth asked how "these artefacts from civilisations continents and millennia apart bought, stolen or borrowed through 400 years of French colonial adventuring [have] come to be displayed with minimal explanation in a dark, confused jungle echoing with the sound of distant tribal drums like the worst malarial European nightmare of the dark continent?" (Gibbons 2006). And one visitor told me that the leather Serpent evoked, for him, the cartoon caves of Fred Flintstone.

3. Malraux 1952, 588. One of the many photographs of the museum posted on the Internet consists of a solid black rectangle entitled *Interior of Musée du quai Branly— with lights full on* (http://www.Flickr.com, photo by "mke 1963").

4. Guillaume and Munro 1926. The museum label cites the 1929 French translation.

5. Pearman 2006. Writing about the exhibits more generally, a reviewer from Australia commented, "The works are so spiritually powerful and seeped in tradition and symbolism, it somehow seems wrong not to be informed of their cultural and historical context. They seemed a little static, trapped, silent. Beautifully catalogued in their 'just for show' boxes there was something oddly reminiscent of the Chanel and Hermes display cases in the entrance hall of the Ritz Hotel" (Tuttle 2006).

6. Gilles Manceron, a historian of French colonialism, quoted in Chrisafis 2006a.

7. Bensa in Caille 2006, 72.

8. Traoré 2006.

9. The website was extremely useful for my research during 2005 and the first half of 2006. It was replaced by a totally new configuration (in my opinion considerably less user-friendly) when the museum opened.

10. The credits explained that the music for the audio component was selected (presumably in Paris) by Madeleine Leclair. It did not say, however, what the music was, where in the world it was performed, who played it, or who recorded it.

11. The biographies were placed under Home > Exploration > Great Figures—only on the English and Spanish versions of the site. The full entries, roughly 250–750 words, were in English or Spanish except for those on Breton, Lévi-Strauss, Malinowski, and Rivière, which were in French. Their absence on the French-language website was a mystery to me. Might it have reflected an assumption that the exploits of these men are common knowledge in France?

12. In light of the Musée de l'Homme's massive contribution to the MQB collections, it might seem surprising that the list includes Georges Henri Rivière, first assistant director of the Musée de l'Homme and later director of the Musée des Arts et Traditions Populaires, rather than Paul Rivet, the Musée de l'Homme's founding director. Does this reflect tensions between the MH and the MQB, or is it because, as the website said, Rivière

is known for having endorsed a reconciliation between ethnology and aesthetics while Rivet leaned strongly in the opposite direction?

13. For more on such stereotypes, see Grewe 2006.

14. Griaule led the famous Dakar-Djibouti expedition of 1931–33, chronicled in Leiris 1934.

15. These texts (presented in both English and French) are complemented by small black-and-white images, printed on the Serpent's brown leather, of historical figures from André Thévet (1516–1590) and Jules Crevaux (1847–1882) to Denise Paulme (1909–1998) and Claude Lévi-Strauss (b. 1908).

16. Leiris 1934, entries for 6–7 September 1931.

17. It's not that the story of theft was too complicated to convey in a brief museum label. In a description of the object entitled "Beating Heart," Michel Daubert took only a few lines to make the point for readers of the popular magazine *Télérama* (Daubert 2006). When the magazine *Tribal Art* asked Hélène Joubert, chief curator of the MQB's African section, to provide commentary on an object from that collection, she chose the *Kono* figure but made no mention of the way it was collected in her article (whose black type on a dark gray background is in any case almost totally illegible [Joubert 2006]).

18. Leiris 1950 (1969), 86. For more on Leiris's post-expedition position on relations between colonizers and colonized, see Leiris 1950 and Price 2004.

19. Jean Paul Barbier in Clément 2006.

20. "*Le requin en colère vient troubler la barre.*" The Metropolitan Museum of Art's website cites the epigram as "The shark who made the ocean waters tremble."

21. See Clifford 1986.

22. Juminer 1968.

23. This paragraph draws on Appiah and Gates 1999, 220, 550.

24. The statue was part of an exhibition in 2000 entitled Art and Oracle: African Art and Rituals of Divination. The Met's website also has a 1,400-word history of the Guinea Coast in the nineteenth century, with further contextualization.

25. An artist, Gaston-Louis Roux, who joined the expedition through his friendship with Michel Leiris, painted copies of the canvases, which were installed in place of the murals that he and Griaule pulled from the church's walls. The museum guide is mistaken in dating the removal of the paintings to 1931—see Leiris's diary entry for 3 August 1932 (Leiris 1934).

26. Taken from the Sotheby's catalog.

27. These transcriptions have been taken from the English-language versions of the labels. The French versions are equally impenetrable.

28. Quoted in Dufay 2005, 82.

CULTURES IN DIALOGUE?

1. See Clifford 1997, 107–45.

2. Not everyone has joined in this trend. Stéphane Martin's reply, when an interviewer asked him to comment on the difference between "an art gallery type display and an ethnographic display," was that "I don't really see the difference" (Naumann 2006).

3. De L'Estoile 2003, 57–58.

4. Taken from the MQB website (English version). The title echoes that of a 1957 novel by Louis-Ferdinand Céline, *D'un château l'autre*. This visually beautiful history of Western gazes on non-Western peoples begins with wonder and ends with aesthetic appreciation, passing through the construction of the "noble savage," associations with fear and mystery, idealization and denigration, the development of hierarchies, and more. Virtually no attention is given to anthropologists' attempts to learn about and convey the perspectives of natives on their own cultures. The exhibition ends, in a rather celebratory fashion, with a focus on twentieth-century artists and exhibitions curated by art historians such as Primitivism in 20th Century Art (New York, 1984) and Magiciens de la Terre (Paris, 1989). It thus reinforces the character of the permanent exhibitions, where (in the comparative context of ethnographic museums elsewhere) objects are presented largely from the perspective of European explorers, collectors, and artists, with relatively little information about the ways in which non-European artists and their fellows conceptualized the objects, their uses, and their aesthetic merits. Insofar as the result is a privileging of the aesthetic gaze, the website's assertion that this exhibit is "a manifesto" for the whole museum is certainly on target.

5. Nanette Snoep (the only Dutch curator at the MQB), quoted in Obbema 2006. Elsewhere, Snoep remarked that "the problem is that President Chirac didn't make the inclusion of colonial history a mandate of this museum" (quoted in Moerland 2006).

6. Another curator asserted that "it is now time to forget about colonialism and build on its foundations" (quoted in Béreau 2004, 99). Of course, one might legitimately contest the idea that "forgetting about colonialism" represents the best way to move beyond it.

7. Apologies to William Hone, who first turned "The House That Jack Built" from nursery rhyme to political commentary in 1819 as "The Political House That Jack Built" (see http://www.rc.umd.edu/editions/hone/jacktext.htm#acc2tx).

8. Jacques Hainard in Chardon 2006.

9. De L'Estoile 2003, 42n7.

10. Kovacs 2006.

11. Frank Browning, "New Paris Art Museum Finds Many Critics," *NPR Weekend Edition,* 13 August 2006. See also Clifford 2007.

12. March 2003 lecture at the Natural History Museum in Lyon, quoted in Roth 2006, 141.

13. E-mail of 11 August 2006.

14. Jonaitis 1991.

15. http://www.anchoragemuseum.org/changing_exb.asp.

16. The museum's role in international diplomacy has been particularly evident in Australia and New Zealand. Not only were Australian artists invited to contribute to the building, but New Zealand, in collaboration with Adidas, offered a most unusual artwork that now hangs in the museum—a four-meter-long canvas realized with blood samples provided for the purpose by every member of the national rugby team, the All Blacks. The inscription reads: "Bonded By Pride / Bonded By Determination / Bonded By Integrity / Bonded By Passion / Bonded By Blood, Sweat and Tears. Les Bleus et Les Noirs. Bonded By The Game. Impossible Is Nothing" ("Liés par le Jeu: All Blacks Give Themselves to the People of France," 18 November 2006, http://www.newswire.co.nz).

17. Goddard 2006.

AN AMERICAN IN PARIS

1. Even on the new (post–June 2006) website, much of the actual content in the "English" version is in French, and much of that in the "Spanish" version is in French or English. Oddly, some trilingual documents are posted only in French; Chirac's speech at the opening was handed out to the audience in a handsomely produced trilingual booklet, but on the website, when one clicks on "English" or "Spanish," the document comes up in French.

2. "*Je dois vous indiquer que les services de la Présidence de la République ne sont malheureusement pas en mesure de répondre à votre attente. Cependant, je pense vous être agréable en vous adressant, par voie postale, le portrait officiel dédicacé de Monsieur Jacques CHIRAC*" (4 February 2005).

Bibliography

Some of my sources were provided by colleagues in the form of clippings or photocopies. Many others were taken from Internet sites. When these lack full information (most commonly page numbers), I simply give as much information as is available to me. The 2005 website for the MQB provided much of my information on the museum but became unavailable in June 2006 when it was replaced by a new site with a restructured design, a different range of information, and a somewhat less user-friendly internal search engine.

Extracting information from the new website can be an exercise in frustration. To cite some random examples from November 2006: while the home page's search function coughs up seventeen entries for Picasso and forty-three for Kerchache, it gives nothing in response to Michael Riley, Judy Watson, or the other Australians who contributed their creativity to the building. There is also little consistency among the three languages: for example, in a random test the French site gave six results for "Indonésie" (you'll need accents for searching), but the English and Spanish versions gave only two for "Indonesia." And if you consult the online catalog by *appellation* (kind of object), you'll need to guess at the categories (in French), such as *couvre-chef, fétiche,* or *tabouret,* since there is no drop-down list of options from which to choose.

Adam, Guillaume. 1995. "L'art primitif aux guichets du Louvre." *Le Journal des Arts,* December.

Agence France Press. 2000. "France's Chirac Under Attack at UN Conference on Stolen Art," 15 November.

———. 2005a. "Jacques Toubon président de la Cité nationale de l'histoire de l'immigration," 25 February.

———. 2005b. "Le Musée de l'Homme sera réaménagé autour de l'Homme et la Nature," 10 November.

Allaire, Marie-Bénédicte. 2000. "Le Louvre s'ouvre à l'art premier." Reuters, 12 April.

Ames, Michael M. 1994. "The Politics of Difference: Other Voices in a Not Yet Post-Colonial World." *Museum Anthropology* 18 (3): 9–17.

Anders, Ferdinand. 1996. *Die Schätze des Montezuma: Utopie und Wirklichkeit.* Vienna: Museum für Völkerkunde.

Andrieu, Caroline. 2006. "On a déjà visité le Musée du quai Branly." *Aujourd'hui en France,* 8 April.

Anonymous. 1954. "L'art nègre ira-t-il au Louvre?" *Le Musée Vivant,* nos. 1–2:31.

———. 1996a. "À Louvre Ouvert." *Connaissance des Arts,* no. 528 (May): 100–103.

———. 1996b. "Musée des arts premiers." *Le Point,* 30 November.

———. 1996c. "Tornade sur le Palais de Chaillot." *Le Point,* 30 November.

———. 2000a. "Les arts premiers sont entrés au Louvre." *Le Nouvel Observateur,* 13 April.

———. 2000b. "Cinq questions à Jacques Kerchache." *Connaissance des Arts,* no. 571 (April): 46.

———. 2002. *Jean Nouvel.* Barcelona: te Neues.

———. 2005. "Entre le cœur et la raison d'État, Sarkozy brûle toujours pour Cécilia." *Le Placide,* 22 November.

d'Ans, André-Marcel. 1994. "Ah, ces Taïnos!" *La Quinzaine Littéraire,* no. 644 (1 April): 11–12.

Apollinaire, Guillaume. 1909. "Sur les musées." *Le Journal du Soir,* 3 October.

Appiah, Kwame Anthony. 2006. "Whose Culture Is It?" *New York Review of Books,* 9 February: 38–41.

Appiah, Kwame Anthony, and Henry Louis Gates Jr., eds. 1999. *Africana: The Encyclopedia of the African and African American Experience.* New York: Basic *Civitas* Books.

Armstrong, Claire, ed. 2006. *Australian Indigenous Art Commission/Commande Publique d'Art Aborigène: Musée du Quai Branly.* Paddington NSW, Australia: Art & Australia Pty Ltd.

Avila, Alin. 2004. "Entretien avec Emmanuel Désveaux." *Arearevues* 8:86–92.

Bacque, Raphaelle. 2000. "La polémique sur les vacances de M. Chirac gâche la rentrée du chef de l'État." *Le Monde,* 4 September.

de Baecque, Antoine. 2005. "L'offrande faite par l'État à l'antre du cinéma." *Libération,* 24 September.

Bailey, Martin. 2006. "Is President Chirac's Long-Awaited Museum of Non-Western Art a Success?" *Art Newspaper,* 11 August.

Balzli, Peter. 2003. "Swiss Dealer Caught Up in Chirac Museum Row." *SwissInfo,* 15 January.

Baqué, Philippe. 2000. "[Letter in] Retour sur l'ouverture de salles sur les arts premiers au Louvre." *Libération,* 22 April.

de la Batut, Virginie. 2001. "Le projet est ambitieux: Pièce maîtresse d'Euroméditerranée, il se veut le musée des Civilisations." *Le Point,* 19 October.

Baudez, Claude-François, Jean-Hubert Martin, and Louis Perrois. 1996. "Ethno-esthétique et mondialisation." *Le Monde,* 7 November.

Baudez, Claude-François, et al. 2001. "Temporalité et Muséographie," *Ateliers* 23. [Proceedings of a 1999 colloquium sponsored by APRAS and the Laboratoire d'Ethnologie et de Sociologie Comparative de Nanterre.]

Baudrillard, Jean. 1994. "The System of Collecting." In *The Cultures of Collecting,* edited by John Elsner and Roger Cardinal, 7–24. Cambridge, MA: Harvard University Press. (Orig. pub. 1968.)

Bazin, Jean, and Alban Bensa. 2000. "A propos d'un musée flou." *Le Monde,* 19 April.

Benhamou-Huet, Judith. 2000. "Arts premiers—entrée au Louvre et polémiques." *Les Echos,* 14 April.

Bensa, Alban. 2006. *La Fin de l'exotisme: Essais d'anthropologie critique.* Toulouse: Anacharsis Éditions.

Bensard, Eva. 2006. "Musée du quai Branly: Bilan contrasté d'un chantier polémique"; "Entretien avec Jean-Pierre Mohen." *Archéologia* 436 (September): 20–26, 27–29.

Béreau, Stéphanie. 2004. "Other Cultures in a Museum Perspective Exhibiting African Art: A Never-Ending Challenge for Museums / Les 'autres cultures' vues par les musées Exposer l'Art africain: Un défi sans fin pour les musées." *Art Tribal* (bilingual) 5:90–101.

Bethenod, Martin, ed. 2003. *Jacques Kerchache: Portraits croisés.* Paris: Musée du Quai Branly/Gallimard.

Biétry-Rivierre, Éric. 2005. "Le nouvel art des Aborigènes." *Le Figaro,* 10–11 September.

Blanc, Dominique. 1994. "Taïnos d'Hispaniola." *Connaissance des Arts,* no. 504 (February): 48–56. Reprinted as "Les Paradoxes Taïnos," in "Art Taïno: Les grandes Antilles Précolumbiennes." *Connaissance des Arts,* hors-série, no. 50:50–60.

———. 1997. "Arts premiers: Quel musée?" Interview with Jacques Kerchache. *Connaissance des Arts,* no. 539 (May): 56–60.

———. 2001. "Quai Branly: Le départ de Maurice Godelier." *Le Journal des Arts* 119 (19 January): 6.

———. 2004. "L'effigie Djennenké du Quai Branly." *Connaissance des Arts,* no. 622:114–17.

———. 2006. "La rencontre des mondes." *Connaissance des Arts,* hors-série, 5–10.

Blier, Suzanne Preston. 1993. "Art and Secret Agency: Concealment and Revelation in Artistic Expression." In *Secrecy: African Art That Conceals and Reveals,* edited by Mary H. Nooter, 181–94. New York: Museum for African Art.

———. 1995. *African Vodun.* Chicago: University of Chicago Press.

———. 1998. *The Royal Arts of Africa: The Majesty of Form.* New York: Harry N. Abrams.

Blotière, Bénédicte. 1997. "Le Musée de la Rédemption." *Archéologia* 330 (1 January): 20–27.

Blottière, Mathilde. 2005. "La Cinémathèque s'est installée dans le bâtiment futuriste de l'ex-American Center, construit par l'architecte Franck O. Gehry." *Télérama,* no. 2907 (1 October).

Boudin, Philippe. 2003. "Naissance d'un musée d'exception." *Tribal Arts* (été): 42–46.

Bounoure, Gilles. 2004. "Le 'chantier des collections' au musée du quai Branly." *Arts d'Afrique Noire* 131:46–50.

Bounoure, Gilles, and Raoul Lehuard. 2000. "Entretien avec Germain Viatte." *Arts d'Afrique Noire* 114:23–25.

Bourgoin, Philippe. 2000. "The Triumph of 'Remote Arts' at the Louvre." *The World of Tribal Arts* 23:54–56.

Bouzet, Ange-Dominique. 1999. "Nouvel pour les Arts premiers: L'architecte édifiera le musée du quai Branly." *Libération,* 9 December.

Brédy, Aude. 2001. "Le musée de l'Homme en colère: Le musée souffre d'avoir été laissé à l'abandon." *L'Humanité,* 17 December.

Bresc-Bautier, Geneviève. 1999. "Les musées du Louvre au XIXe siècle: Les collections archéologiques et ethnologiques dans le conservatoire de l'art classique." In *Le musée et les cultures du monde,* edited by Émilia Vaillant and Germain Viatte, 53–70. Paris: École nationale du patrimoine.

Brisson, Dominique, and Natalie Coural. n.d. "Le Louvre: The Palace and Its Paintings." CD-ROM 97/40, Windows/Mac. http://library.canterbury.ac.nz/art/art/art_mm .shtml.

Brothers, Caroline. 2006. "For Some, a Museum Hits Close to the Heart." *International Herald Tribune,* 17 August.

Brown, Michael F. 2003. *Who Owns Native Culture?* Cambridge, MA: Harvard University Press.

Brumback, Kate. 2004. "Paris Goes Primitive." Associated Press, 16 September.

Brutti, Lorenzo. 2003. "L'ethnologie est-elle soluble dans l'art premier? Essai de lecture ethnographique du musée du quai Branly par le regard d'un observateur partici- pant." In *L'Esthétique: Europe, Chine et ailleurs,* edited by Yolaine Escande and Jean-Marie Schaeffer, 13–36. Paris: Éditions You-Feng.

Button, James. 2005. "Artists' Stories Will Live on Forever in Paris Museum." *Sydney Morning Herald,* 10 September.

Cabanne, Pierre. 1990. *Guide des Musées de France.* Paris: Bordas.

Cachon, Sophie. 2006. "Dialogue des cultures ou parade exotique?" *Télérama,* no. 2959 (September).

Caillaud-de Guido, Laurence. 2006. "Les fleurons du musée du quai Branly." *L'Objet d'Art* 414 (June): 34–42.

Caille, Emmanuel. 2006. "Dossier: Le musée du quai Branly." *D'Architectures* 157 (August/September): 57–72.

Caldwell, Christopher. 2003. "In Europe, 'Secular' Doesn't Quite Translate." "Week in Review," *New York Times,* 21 December.

Campbell, Matthew. 2006. "Chirac Runs into Tribal Ridicule." *Sunday Times* (London), 30 July.

Campbell, Robert. 2006. "Paris Museum Is No Work of Art," *Boston Globe,* 15 October.

Canard, Jérôme. 1993a. "Chirac Tour-Opérateur." *Le Canard Enchaîné,* 20 January.

———. 1993b. "Son congrès dans l'hôtel"; "Rolls Royce du ciel"; "13 000 F la nuit." *Le Canard Enchaîné,* 10 February.

Catalano, Géraldine, and Ariane Chemin. 2005. *Une famille au secret: Le Président, Anne et Mazarine.* Paris: Stock.

Chabod-Serieis, Jean. 2004. "Connaître avant de restaurer: L'exemple du chantier des collections du MQB." *Art Tribal* 7:94–97.

Champenois, Michèle. 1999. "Jean Nouvel remporte le concours pour le Musée des arts et civilisations." *Le Monde,* 10 December.

Charbonnier, Jean-Michél. 1996. "Tant qu'il y aura un Musée de l'Homme." *Beaux Arts Magazine* 150 (November): 12–13.

Chardon, Elisabeth. 2006. "La beauté des objets ne suffit pas." Interview with Jacques Hainard. *Le Temps* (Geneva), 21 September.

Le Chatelier, Luc. 2004. "Totems et high-tech." *Télérama,* 1 September: 14.

Cherruau, Pierre. 2000. "Main basse sur les têtes rouges." In "Les Arts Premiers Entrent au Louvre," *Télérama,* hors-série, 85–88.

Chirac, Jacques [NB: During Chirac's presidency, all his speeches were available in full on the official site of the Élysée: http://www.elysee.fr/ under "interventions/discours et déclarations."]

———. 1997. "Allocution prononcée par M. Jacques CHIRAC, Président de la République, à l'occasion de l'inauguration du musée Ethnographique de Hanoï, le 12 novembre 1997."

———. 2000. "Discours prononcé par M. Jacques CHIRAC, Président de la République, Inauguration du pavillon des Sessions au musée du Louvre, le 13 avril 2000."

———. 2003. "Allocution . . . en hommage à M. Jacques KERCHACHE." Pavillon des Session, Musée du Louvre, 4 April.

Choay, Françoise. 2006. "Branly: Un nouveau Luna Park était-il nécessaire?" *Urbanisme* 350:4–9.

Chrisafis, Angélique. 2006a. "Chirac Leaves Controversial Legacy with Monument to African and Asian Culture." *Guardian,* 7 April.

———. 2006b. "Chirac Eyes His Legacy." *Guardian,* 21 June.

Clément, Anice. 2006. A series of five interviews with Jean-Paul Barbier. *A Voix Nue,* Radio France/France Culture, 16–20 January.

Clifford, James. 1986. "Introduction: Partial Truths." In *Writing Culture: The Poetics and Politics of Ethnography,* edited by James Clifford and George E. Marcus, 1–26. Berkeley: University of California Press.

———. 1988. *The Predicament of Culture: Twentieth-Century Ethnography, Literature, and Art.* Cambridge, MA: Harvard University Press.

———. 1997. *Routes: Travel and Translation in the Late Twentieth Century.* Cambridge, MA: Harvard University Press.

———. 2007. "Quai Branly in Process." *October* 120:2–23.

Colardelle, Michel. 1998. "Que faire des Arts et Traditions Populaires? Pour un musée des Civilisations de la France et de l'Europe." *Le Débat* 99:113–18.

Colardelle, Michel, ed. 2002. *Réinventer un musée: Le musée des Civilisations de l'Europe et de la Méditerranée à Marseille.* Paris: Réunion des Musées Nationaux.

Collomb, Gérard. 1999. "Ethnicité, nation, musée, en situation postcoloniale." In "Musée, Nation: Après les Colonies," edited by Gerard Collomb, *Ethnologie Française* 9 (July–September): 333–36.

———. 2006. "Review of Martine Segalen, *Vie d'un musée, 1937–2005." Ethnologie Française* 36, no. 2:361–63.

Conrad, Joseph. 1899. *Heart of Darkness*. Reprinted in *The Portable Conrad,* edited by Morton Dauwen Zabel. New York: Viking Press, 1947.

Coppermann, Annie. 2000. "Les trésors des mondes lointains rejoignent la Joconde." *Les Echos,* 17 April.

de Coppet, Daniel. 2003. *Les arts premiers*. Paris: Flammarion.

Corbey, Raymond. 2000. *Tribal Art Traffic: A Chronicle of Taste, Trade and Desire in Colonial and Post-Colonial Times*. Amsterdam: Royal Tropical Institute.

Cosic, Miriam. 2006a. "Dispossession Is a Sorry Business." *Australian,* 26 May.

———. 2006b. "Tenacious Cultural Renovator." *Australian,* 18 November.

Cotter, Holland. 2006. "Who Owns Art?" *New York Times,* 29 March.

Le Cour Grandmaison, Olivier. 2005. "Le colonialisme a la peau dure." *Libération,* 30 March.

Couturier, Elisabeth. 2003. "Le baroudeur des arts premiers." *Paris-Match,* no. 2819 (June 4): 26.

Craig, Barry. 1988. *Art and Decoration of Central New Guinea*. Princes Risborough: Shire Publications.

Cressole, Michel. 1990. "Louvre: La Bataille de la 8ᵉ Section." *Libération,* 16 March.

Crumley, Bruce. 2006. "Interview: Stéphane Martin Talks about the Audacious New Museum on the Banks of the Seine." *France Magazine,* summer.

Cuisenier, Jean. 1991. "Que faire des arts et traditions populaires?" *Le Débat* 65:150–64.

———. 1992. "Des musées de l'homme et de la société; oui, Mais lesquels?" *Le Débat* 70:178–87.

Daubert, Michel. 1994. "La revanche des Taïnos." *Télérama,* no. 2304 (3 September): 8–13.

———. 1996. "Le chantier de l'Homme." *Télérama,* 25 September.

———. 1997. "Ces masques qu'on s'arrache." *Télérama,* no. 2474 (11 June): 61–66.

———. 2000a. "Arts lointains à Louvre ouvert." In "Les Arts Premiers Entrent au Louvre," edited by Michel Daubert. *Télérama,* hors-série, 8–16.

———. 2000b. Editorial. In "Les Arts Premiers Entrent au Louvre," edited by Michel Daubert. *Télérama,* hors-série, 7.

———. 2000c. "Le futur musée des Arts et Civilisations (MAC)." *Télérama,* no. 2609 (15 January).

———. 2003. "Review of *Jacques Kerchache: Portraits croisés,* edited by Martin Bethenod." *Télérama,* no. 2782 (7 May).

———. 2006. "Coeur battant." In "Quai Branly: Le musée de l'autre," edited by Michel Daubert. *Télérama,* hors-série, 65.

Degli, Marine. 2003. "Jacques Kerchache, l'œil démiurge." *Tribal* 2 (printemps): 124–25.

Degli, Marine, and Marie Mauzé. 2000. *Arts premiers: Le temps de la reconnaissance*. Paris: Gallimard.

Degoy, Lucien. 2002. "Plus de deux mois de grève totale des personnels du Palais de Chaillot: Partie de bras de fer au Musée de l'Homme." *L'Humanité,* 18 January.

Delannoy, Pierre. 2002. "La guerre des musées." *Paris-Match,* no. 2754 (3 July): 20–23.

Deloire, Christophe, and Christophe Dubois. 2006. *Sexus politicus*. Paris: Albin Michel.

Derlon, Brigitte. 1997. *De mémoire et d'oubli*. Paris: CNRS Éditions.

Derlon, Brigitte, and Monique Jeudy-Ballini. 2001/2002. "Le culte muséal de l'objet sacré." *Gradhiva* 30/31:203–11.

———. 2005. "De l'émotion comme mode de connaissance: L'expérience esthétique chez les collectionneurs d'art primitif." In *Les cultures à l'œuvre: Rencontres en art,* edited by Michèle Coquet, Brigitte Derlon, and Monique Jeudy-Ballini, 147–64. Paris: Biro éditeur & Maison des sciences de l'homme.

Diaby, Mohamed (avec la collaboration de Damien Albessard). 2005. *Moi, Momo, 14 ans, ivoirien . . . et le plus jeune bachelier de France.* Paris: Jean-Claude Gawsewitch.

Dias, Nélia. 1991. *Le Musée d'ethnographie du Trocadéro (1878–1908): Anthropologie et Muséologie en France.* Paris: Éditions du CNRS.

———. 2001. "Esquisse ethnographique d'un projet: Le Musée du Quai Branly." *French Politics, Culture & Society* 19 (2): 81–101.

Dickey, Christopher. 2006. "Sex, Birth, Death and God." *Newsweek International,* 3–10 July.

Dorkel, Odile. 2004. "Pour en finir avec les arts dits premiers!" *Arearevues* 8:84–85.

Doutriaux, Géraldie. 2005. "John, peintre aborigène, décore le musée Branly." *Le Parisien,* 6 September.

Dubuc, Élise. 1998. "Le futur antérieur du Musée de l'Homme." *Gradhiva* 24:71–92.

Duclos, Jean-Claude. 1992. "Pour des musées de l'homme et de la société." *Le Débat* 70:174–78.

Dufay, Philippe. 2005. "Les Muses du Quai Branly." *Madame Figaro,* 10 September.

Dumont, Étienne. 2000. "Arts premiers: Le Louvre déploie enfin son antenne." *Tribune de Genève,* 13 April.

Dumont, Louis. 1996. "Non au Musée des arts premiers." *Le Monde,* 25 October.

———. 1997. "Pour l'avenir du Musée de l'Homme." *AFA Journal des Anthropologues* 71:105–8.

Dupaigne, Bernard. 1998. "Le 'Musée de l'Homme,' un monstre administratif." *Revue Administrative* 300:647–55.

———. 2006. *Le scandale des arts premiers: La véritable histoire du musée du quai Branly.* Paris: Mille et une nuits.

Dupuis, Annie. 1999. "Présentation." In "Prélever, exhiber: La mise-en-musée," edited by Annie Dupuis. *Cahiers d'Études Africaines* 39 (3–4): 479–85.

Dupuy, Gerard. 2000. "Vive les 'sauvages'!" (Editorial). *Libération,* 13 April.

Duverger, Christian. 1994. "Repères géographiques"; "Les Chroniqueurs et le mythe Taïno"; "Une société tropicale." Special issue, "Art Taïno: Les grandes Antilles Précolumbiennes." *Connaissance des Arts,* hors-série, no. 50:11, 25–29, 41–47.

Eakin, Hugh. 2006. "Archaeologists Debate Whether to Ignore the Pasts of Relics." *New York Times,* 2 May.

Eccles, Jeremy. 2004. "Aboriginal Originals Woo French." *Financial Times,* 20 December.

———. 2006. "Art World Away from Paris." *Canberra Times,* 3 June.

Edelmann, Frédéric, and Emmanuel de Roux. 1996. "Quand les musées parisiens jouent aux chaises musicales." *Le Monde,* 10 December.

———. 1998. "Les grands travaux parisiens et le casse-tête des 'dents creuses.'" *Le Monde,* 7 March.

Ernenwein, François. 1996. "Le premier chantier de Chirac. Le président de la République découvre le charme des grands travaux." *La Croix,* 9 October.

de L'Estoile, Benoît. 2003. "Le Musée des arts premiers face à l'histoire." In *Les arts*

premiers, edited by Francisco Bethencourt, 41–61. Paris: Centre culturel Calouste Gulbenkian/Jean Touzot.

L'Expansion. 2003. "La somme payée par l'État pour 335 lots de la vente André Breton," 18 April.

Fagg, Bernard. 1990. *Nok Terracottas.* London: Ethnographica Ltd.

Faust, Betty. 1991. "Collectors." *Anthropology Newsletter* 32 (1): 3.

Fayard, Judy. 2006. "The Art of Civilizations on Display in Paris." *Wall Street Journal Europe,* 23 June.

Féau, Étienne. 1999. "L'art africain au musée des Arts d'Afrique et d'Océanie: Collections et perspectives pour le musée du quai Branly." In "Prélever, exhiber: La mise-en-musée," edited by Annie Dupuis. *Cahiers d'Études Africaines* 39 (3–4): 923–38.

Fénéon, Félix. 1920a. "Enquête sur les arts lointains (Seront-ils admis au Louvre?)." *Le Bulletin de la Vie Artistique* 1, no. 24 (15 November): 662–69.

———. 1920b. "Iront-ils au Louvre? Enquête sur les arts lointains." *Le Bulletin de la Vie Artistique* 1, no. 25 (1 December): 693–703. Reprint; Toulouse: Éditions Toguna, 2000 (paginated 1–23).

———. 1920c. "Fin de l'enquête sur les arts lointains." *Le Bulletin de la Vie Artistique* 1, no. 26 (15 December): 726–38.

Ferry, Jules. 1885. "Les fondements de la politique coloniale. Discours prononcé à la Chambre des députés, le 28 juillet 1885." http://www.assembleenationale.com/histoire/Ferry1885.asp.

Le Figaro. 1996. "Interview de M. Jacques Chirac Président de la République," 23 November.

Fitzgerald, Michael. 2005. "Veiled in Beauty: Judy Watson's Finely Crafted Paintings Are the Lyrical and Spiritual Expression of Her Aboriginal Heritage." *Time Asia,* 5 December.

———. 2006. "Cultural Production Line: The Greed of Exploitative Dealers and Venal Practitioners Threatens to Devalue the Currency of Aboriginal Art." *Time Asia,* 22 May.

Flouquet, Sophie. 2006. "Genèse d'un musée du XXIᵉ siècle: 'Le musée est un lieu d'interrogation.'" *Le Journal des Arts* 240 (23 June–6 July): 16–17.

Fontaine, Jean-Pierre. 2001. "Un Homme Libre à Vezelay, Max-Pol Fouchet." *Lyonne Républicaine,* 16 July.

Friedmann, Jacques. 1998. "A propos du musée des Arts et des Civilisations: 'Avec le grand public et la communauté scientifique'" (reply to Romero). *Le Figaro,* 4 July.

Friedmann Commission. 1996a. "Annexes au Rapport de la Commission 'Arts Premiers'" (14 documents, unpaginated).

———. 1996b. "Rapport de la Commission 'Arts Premiers'" (typescript, 44 pp.).

Galinier, Jacques, and Antoinette Molinié. 1998. "Le crépuscule des lieux: Mort et renaissance du Musée d'Anthropologie." In "Musées d'ici et ailleurs." *Gradhiva* 24:93–102.

García Arévalo, Manuel Ant. 1977. *El Arte Taíno de la República Dominicana.* Madrid: Instituto de Cultura Hispánica. (Catalog for exhibition held 15 May–15 August 1977.)

———. 1982. *Altos de Chavón*. La Romana, Dominican Republic: Museo Arqueológico Regional.

———. 1994. "Les Indiens de Colomb." In *L'art des sculpteurs Taïnos: Chefs-d'œuvre des Grandes Antilles précolombiennes*, edited by Jacques Kerchache, 96–103. Paris: Musée du Petit Palais.

Géniès, Bernard. 2005. "Les mystères du Louvre." *Le Nouvel Observateur*, no. 2123 (14 July).

Geoffroy, Bérénice. 1994. "L'art des Indiens Taïnos." *Archéologia* 301:52–57.

Geoffroy-Schneiter, Bérénice. 1999. *Arts Premiers*. Paris: Assouline.

———. 2000. "Entretien avec Jacques Kerchache." In "Arts magiques." *Beaux Arts Magazine*, hors-série (April): 4–7.

———. 2006. "Afrique." In "Chefs-d'œuvre du musée du Quai Branly." *Beaux-Arts Magazine*, hors-série (June): 36–39.

Gibbons, Fiachra. 2006. "Musée des bogus arts." *Guardian*, 3 July.

Gibson, Michael. 1994. "Lost Eden of the Tainos: Objects from a Massacred Culture." *International Herald Tribune*, 5 March.

Giesbert, Franz-Olivier. 2006. *La tragédie du président: Scènes de la vie politique (1986–2006)*. Paris: Flammarion.

Gignoux, Sabine. 1996. "Remue-ménage autour du Musée de l'Homme." *La Croix*, 18 September.

———. 2006. "Le mécénat profite surtout aux grands musées." *La Croix*, 7 April.

Glancey, Jonathan. 2006. "How Does Your Gallery Grow?" *Guardian*, 26 June.

Glorieux, Isabelle. 2006. *Comment parler des Arts Premiers aux enfants?* Paris: Le Baron perché.

Goddard, Peter. 2006. "Branly-Bashing in Fashion, but Museum Sparks Plenty of Debate." *Toronto Star*, 26 August.

Godelier, Maurice. 1999. "Créer de nouveaux musées des arts et civilisations à l'aube du IIIᵉ millénaire." In *Le musée et les cultures du monde*, edited by Émilia Vaillant and Germain Viatte, 299–304. Paris: École Nationale du Patrimoine, *Les Cahiers de l'École Nationale du Patrimoine* no. 5.

———. 2000. "Unir art et savoir." In "Les Arts Premiers au Louvre." *Connaissance des Arts*, hors-série, no. 149 (April): 55–62.

———. 2002. "For the Museum Public: Combining the Pleasures of Art and Knowledge." Barbour Lecture, University of Virginia.

———. 2003. *Is Social Anthropology Indissolubly Linked to the West, Its Birthplace?* Korea: Ed. Kark & DWF.

Godelier, Maurice, and Jacques Kerchache, eds. 2000. *Chefs-d'œuvre et civilisations: Afrique, Asie, Océanie, Amériques (les Arts premiers au Louvre)* (CD-ROM). Paris: Réunion des Musées Nationaux.

Goergel, Chantal, ed. 1994. *La Jeunesse des musées de France au XIXᵉ siècle*. Paris: Réunion des Musées Nationaux.

Graff, James. 2006. "Flow Control: French Architect Jean Nouvel Takes the Bathroom Faucet into the 21st Century." *Time Asia*, 16 December.

Grasset, Constance Dedieu. 1996. "Museum Fever in France." *Curator* 39 (3): 188–207.

Grewe, Cordula. 2006. "Between Art, Artifact, and Attraction: The Ethnographic Object and Its Appropriation in Western Culture." In *Die Schau des Fremden: Ausstellungskonzepte zwischen Kunst, Kommerz und Wissenschaft,* edited by Cordula Grewe, 9–42. Stuttgart: Franz Steiner Verlag.

Gruhier, Fabien. 2002. "On veut vider le Musée de l'Homme." *Le Nouvel Observateur,* no. 1943 (31 January): 76–77.

Guerrin, Michel. 1997. "Un incendie au palais du Trocadéro a endommagé le Musée des monuments français et le Musée du cinéma." *Le Monde,* 24 July.

Guiart, Jean. 2003. *Variations sur les Arts Premiers.* Vol. 1: *La Manipulation.* Le Rocher-à-la-Voile: Nouméa.

Guilhem, Julien. 2000. "Art primitif ou patrimoine culturel? Le Musée du quai Branly en question." *Ethnologies comparées* 1.

———. 2001. "Santé et maladie: Questions contemporaines à propos du Musée du quai Branly." Interview, 11 June, with Emmanuel Désveaux. *Ethnologie comparée* 3.

Guillaume, Paul, and Thomas Munro. 1926. *Primitive Negro Sculpture.* New York: Harcourt, Brace & Company.

Guiral, Antoine. 2005. "Chirac mouche Sarkozy et disserte sur les discriminations." *Libération,* 13 December.

Guitart, Cécil, and I. Blanchard. 1992. *Du musée des Colonies au dialogue des cultures: Pour un projet de service au MAAO.* Typescript, 88 pp. Paris: Musée des arts d'Afrique et d'Océanie.

Hall, James. 2005. "Choice without Voice: How New York's Museum of Modern Art Has Changed for the Worse." *Times Literary Supplement,* 25 February: 18–19.

Harding, Jeremy. 2007. "At Quai Branly." *London Review of Books* 29 (4 January).

Hart, Keith. 2006. "Letter from Europe." *Anthropology Today* 22 (2): 18.

Hauter, François. 1994. "Jacques Chirac: 'Des sculpteurs dignes des plus grands.'" *Le Figaro,* 1 March.

———. 1996. "Jacques Chirac: 'Les arts premiers doivent être au Louvre.'" *Le Figaro,* 21 January.

Henley, Jon. 2000. "Louvre Hit by Looted Art Row." *Observer,* 23 April.

Héritier-Augé, Françoise. 1991. *Les musées de l'Education nationale: Mission d'étude et de réflexion.* Paris: La Documentation française.

Hillion, Daniel. 1996. "L'amiral Bellec aux postes de combat"; "Le 'coup de gueule' d'Éric Tabarly"; "L'un des plus anciens musées du monde"; "À Paris et sur la côte." *Le Marin,* 30 August.

Huet, Sylvestre. 2001. "Musée de l'Homme—refus de déménager sans ménagement." *Libération,* 28 November.

———. 2005. "L'Islam reprend ses esprits." *Libération,* 30 November.

Hurault, Jean. 1970. *Africains de Guyane.* The Hague: Mouton.

Jackson, Julian. 2006. "The Many in the One Indivisible." Review of *La vie en bleu,* by Rod Kedward. *Times Literary Supplement,* 20 January: 9–10.

Jamin, Jean. 1989. "Le musée d'ethnographie en 1930: L'ethnographie comme science et comme politique." In *La Muséologie selon Georges Henri Rivière: Cours de muséologie/textes et témoignages,* by Georges Henri Rivière, 110–21. Paris: Dunod.

————. 1991. "Les musées d'anthropologie sont-ils dépassés?" In *Le Futur antérieur des musées*, edited by Danielle Benassayag, 111–15. Paris: Editions du Renard/ANFIAC.

————. 1998. "Faut-il brûler les musées?" In "Musées d'ici et d'ailleurs." *Gradhiva* 24:65–69.

Jean-Pierre, Olivier. 2005. "La dernière folie de Chirac." *Le Cri du Contribuable*, October: 10–11.

Jérosme, Nathalie. 1998. "Arts Premiers: Chirac préfère le quai Branly." *Journal des Arts*, 13 February: 1, 3.

Jeudy, Henri-Pierre. 2002. "Quand le musée fait œuvre." In *Le musée cannibale*, edited by Marc-Olivier Gonseth, Jacques Hainard, and Roland Kaehr, 249–61. Neuchâtel: Musée d'ethnographie.

Jonaitis, Aldona, ed. 1991. *Chiefly Feasts: The Art and History of the Kwakiutl Potlatch.* New York: American Museum of Natural History; Seattle: University of Washington Press.

Joubert, Hélène. 2006. "L'Afrique au Musée du quai Branly." "Quai Branly Museum Interviews." Supplement to *Tribal Art*, June/July: xii–xiii.

Journet, Nicolas. 1998. "Un musée pour les cultures: Entretien avec Maurice Godelier." In "Anthropologie: Nouveaux terrains, Nouveaux objets." *Sciences Humaines*, hors-série, no. 23:19–20.

Jouve, Pierre, and Ali Magoudi. 1987. *Jacques Chirac, Portrait Total.* Paris: Éditions CARRERE.

Julienne, Marina. 1997. "Art ou science: Quel avenir pour le musée de l'Homme?" *Eurêka* 22:37–43.

Jullian, Marcel. 1996. "Musée de l'homme, musée de la vie." *Le Monde*, 14 March.

Juminer, Bertène. 1968. *La revanche de Bozambo.* Paris: Présence Africaine. Published in English as *Bozambo's Revenge; or, Colonialism Inside Out.* Washington, DC: Three Continents Press, 1976.

Kemp, Rod (Australian Minister for the Arts and Sport). 2006. "Australian Indigenous Art a Centrepiece of the Musée du Quai Branly." Media release, 8 May.

Kerchache, Jacques. 1994. "Les Taïnos." In *L'art des sculpteurs Taïnos: Chefs-d'œuvre des Grandes Antilles précolombiennes*, edited by Jacques Kerchache, 140–57. Paris: Musée du Petit Palais.

————. 2000. "Arts premiers au Louvre." *Connaissance des Arts*, no. 571 (April): 42–45.

————. 2001. *The Hand of Nature: Butterflies, Beetles, and Dragonflies.* London: Thames & Hudson.

Kerchache, Jacques, ed. 1994. *L'art des sculpteurs Taïnos: Chefs-d'œuvre des Grandes Antilles précolombiennes* (avant-propos par Jacques Chirac). Paris: Musée du Petit Palais.

————. 2000. *Sculptures: Afrique, Asie, Océanie, Amériques.* Paris: Réunion des Musées Nationaux.

Kerchache, Jacques, et al. 1990. "Pour que les Chefs-d'œuvre du monde entier naissent Libres et Égaux." *Libération*, 15 March.

Kimmelman, Michael. 2006. "A Heart of Darkness in the City of Light." *New York Times*, 2 July.

Kovacs, Steven. 2006. Letter to the Editor. *International Herald Tribune,* 8–9 July.

Krech, Shepard, III, ed. 1994. "Echo Homo: Voices of Representation in Museums." *Museum Anthropology* 18 (3).

Labarthe, Gilles. 2003. "Le Musée de l'Homme claque ses portes." *Le Courrier,* 15 March.

Lagarde, Stéphane. 2002. "La crise de nerfs du Musée de l'Homme." Radio France Internationale, 11 April.

Langaney, André. 1997. "Les vertus du musée de l'Homme." *Libération,* 18 June.

———. 2000. "Le 'musée des voleurs.'" *L'Humanité,* 16 June.

Lebegue, Thomas. 2000a. "Et Chirac prend des vacances à 460,000 francs." *Libération,* 25 August.

———. 2000b. "Chirac n'aime pas raconter ses vacances." *Libération,* 1 September.

Lebovici, Élisabeth. 2005a. "A Paris, la tradition se perd un peu plus." *Libération,* 5 September.

———. 2005b. "ATP: La messe a été dite dans l'indifférence." *Libération,* 7 September.

Leiris, Michel. 1934. *L'Afrique fantôme.* Paris: Gallimard.

———. 1950. "L'ethnographe devant le colonialisme." *Les Temps Modernes* 58:357–74. Reprinted in *Cinq études d'ethnologie,* 83–112. Paris: Gonthier-Denoël, 1969.

Leloup, Hélène, William Rubin, Richard Serra, and Georg Baselitz. 1994. *Statuaire dogon.* Strasbourg: D. Amez.

Leurquin, Anne. 2000. "A Remarkable Entry to the Musée du Louvre in Paris." *World of Tribal Arts* 23:64–66.

Lévi-Strauss, Claude. 1943. "The Art of the Northwest Coast at the American Museum of Natural History." *Gazette des Beaux-Arts* (New York): 175–82.

———. 1954. "The Place of Anthropology in the Social Sciences and Problems Raised in Teaching It." In *The University Teaching of the Social Sciences.* Paris: UNESCO. Reprinted in Claude Lévi-Strauss, *Structural Anthropology,* 346–81. New York: Basic Books, 1963.

———. 1975. *La voie des masques.* 2 vols. Geneva: Albert Skira.

Leyten, Harrie, ed. 1995. *Illicit Traffic in Cultural Property: Museums Against Pillage.* Amsterdam: Royal Tropical Institute; Bamako: Musée National du Mali.

Libération. 1996. "Le Muséum s'oppose au projet du Trocadéro," 5 October.

———. 2000a. "Alerte sur le pillage d'œuvres nigérianes," 28 September.

———. 2000b. "Nok: Le musée français démenti," 2 December.

———. 2001a. "Arts premiers—Godelier a jeté l'éponge," 22 January.

———. 2001b. "Pièces noks—compromis en vue," 15 December.

———. 2005. "Les États-Unis digèrent mal l'exception," 21 October.

Liffran, Hervé. 2003. "Huit ans de malheur pour les arts premiers"; "Les aventures de Chirac au pays des artistes." *Canard Enchaîné,* 27 August.

Ligue des Droits de l'Homme. 2005. "Pétition de la LDH: Le mépris de l'Histoire et des victimes," 18 April. http://www.ldh-toulon.net/spip.php?article592.

Lowenthal, David. 1998. *The Heritage Crusade and the Spoils of History.* Cambridge: Cambridge University Press.

———. 2006. "Heritage Wars." *Spiked,* 16 March. Reprinted from http://www.spiked-online.com/index.php?/site/article/254/.

Lowry, Glenn D. 2005. "Reply to Hall." *Times Literary Supplement,* 29 April: 29.

de Lumley, Henry. 1996. "Quel vision pour le musée de l'Homme?" *Libération,* 14 February.

———. 1997. "L'Homme est un tout, son musée doit lui ressembler." *La Recherche* 300 (July–August): 8–9.

de Lumley, Henry, ed. 1999. *Trésors méconnus du Musée de l'Homme: Dans le secret des objets et des mondes.* Paris: Cherche Midi.

Madelin, Philippe. 2002. *Jacques Chirac: Une biographie.* Paris: Flammarion.

Malinowski, Bronislaw. 1961. *Argonauts of the Western Pacific.* New York: E. P. Dutton. (Orig. pub. 1922.)

Malraux, André. 1952. *Les Voix du silence.* Paris: Gallimard.

———. 1976. *L'Intemporel.* Paris: Gallimard.

Mark, Peter. 2000. "The Future of African Art in Parisian Public Museums." *African Arts* 33 (3): 1, 4, 6, 8, 93.

Martel, Frédéric. 2006. *De la culture en Amérique.* Paris: Gallimard.

Martin, Jean-Hubert. 1999. "The Musée des Arts d'Afrique et d'Océanie and Its Future Outlook." In "Out of the Ordinary: Museums of Ethnology on the Eve of the Third Millenium," edited by Gerard W. van Bussel and Alex Steinmann. *Archiv für Völkerkunde* 50:125–32.

Martin, Stéphane. 1999. "Dossier, le Musée du Quai Branly." *Culture et Recherche* 73:4–5.

———. 2000a. "Genèse d'un projet." *Connaissance des Arts,* no. 571 (April): 47–52.

———. 2000b. "Visions croisées." In "Les Arts Premiers au Louvre." *Connaissance des Arts,* hors-série, no. 149 (April).

McClellan, Andrew. 1994. *Inventing the Louvre: Art, Politics, and the Origins of the Modern Museum in Eighteenth-Century Paris.* Berkeley: University of California Press.

Meier, Barry. 2006. "Antiquities and Politics Intersect in a Lawsuit." *New York Times,* 29 March.

Melikian, Souren. 2006. "The Vision Behind the Louvre's Metamorphosis." *International Herald Tribune,* 8 September.

Métraux, Alfred. 1978. *Itinéraires 1 (1935–1953): Carnets de notes et journaux de voyage.* Paris: Payot.

Michaud, Yves, ed. 2004. *Chirac dans le texte: La parole et l'impuissance.* Paris: Stock.

Michel, Nicolas. 2002. "Bras de fer autour d'un musée." *L'Intelligent (Jeune Afrique),* nos. 2170–2171 (12–25 August): 120–22.

Moerland, René. 2006. "Primitieve, herstel, verre kunst." In "Cultureel Supplement." *NRC Handelsblad,* 3 June: 19.

Mohen, Jean-Pierre, ed. 2004. *Le Nouveau Musée de l'Homme.* Paris: Odile Jacob/ Muséum national d'histoire naturelle.

———. 2006. "Science et conservation: Musée du quai Branly." *Technè* 23.

Le Monde. 2005a. "La collection africaine de Disney échappe à M. Chirac," 4 October.

———. 2005b. "Nicolas Sarkozy fixe un objectif de 25,000 immigrés en situation irrégulière expulsés en 2006," 29 November.

Monier, Françoise. 1996. "Le musée et les prédateurs." *L'Express,* 27 June.

————. 2000. "La revanche des primitifs." *L'Express,* 13 April.

Moniteur and Musée du Quai Branly. 2005. "Musée du quai Branly: Un chantier de collection." *Le Moniteur: Les documents du Moniteur,* December.

Montás, Onorio, Pedro José Borrell, and Frank Moya Pons. 1983. *Arte Taíno.* Santo Domingo: Banco Central de la República Dominicana.

Moore, Molly. 2006. "In Paris, It's the Summer of Museums." *Washington Post,* 25 June.

Moscoso, Francisco. 1986. *Tribu y clases en el Caribe antiguo.* San Pedro de Macoris, Dominican Republic: Universidad Central del Este.

————. 2003. "Chiefdoms in the Islands and the Mainland: A Comparison." In *General History of the Caribbean.* Vol. 1: *Autochthonous Societies,* edited by Jalil Sued-Badillo, 292–315. Paris: UNESCO.

Musée du Quai Branly. 2006a. *Le guide du musée.* Paris: Musée du quai Branly.

————. 2006b. "Un musée composite: Une architecture conçue autour des collections." (A 16-page full-color document included in a thick informational packet published two months before the museum's opening.)

————. 2006c. "Un musée passerelle: Une institution muséographique, scientifique et culturelle originale au service du dialogue des cultures et des civilisations." (A 48-page full-color document included in a thick informational packet published two months before the museum's opening.)

Myers, Fred R. 1998. "Uncertain Regard: An Exhibition of Aboriginal Art in France." *Ethnos* 63 (1): 7–47.

————. 2002. *Painting Culture: The Making of an Aboriginal High Art.* Durham: Duke University Press.

Naffah, Christiane. 2000. Préface. "Cultures du Monde." *Technè: La science au service de l'histoire de l'art et des civilisations* 11:7–9.

Naffah, Christiane, ed. 2004. *Le chantier des collections du musée du quai Branly: Conservation préventive à l'échelle d'une collection nationale.* Paris: Musée du Quai Branly.

Naumann, Peter. 2006. "Making a Museum: 'It Is Making Theater, Not Writing Theory.'" Interview with Stéphane Martin. *Museum Anthropology* 29 (2): 118–27.

New York Times. 2006. "Brussels: Chirac Exits as Frenchman Speaks English," 24 March.

Noce, Vincent. 2000a. "Le Louvre s'ouvre enfin aux arts premiers"; "Kerchache, un flibustier au musée"; "Comment deux statues volées sont exposées." *Libération,* 13 April.

————. 2000b. "Chirac s'enflamme, l'Unesco boude." *Libération,* 14 April.

————. 2000c. "Art nok, espèce menacée." *Libération,* 20 April.

————. 2000d. "Après les plaintes du Nigeria et du Niger. Statuettes Nok: Exposées au Louvre, saisies à Drouot." *Libération,* 22 April.

————. 2000e. "Paris conforte l'archéo-trafic." *Libération,* 16 November.

————. 2000f. "Le musée des Arts premiers annonce un nouveau nok en stock." *Libération,* 18 November.

————. 2000g. "Paris s'enlise dans l'affaire des Nok." *Libération,* 23 November.

————. 2000h. "Aucune pièce n'est sortie légalement du pays"; "L'ambassadeur du Nigeria à Paris." *Libération,* 23 November.

————. 2000i. La France amie des pillards. *Libération,* 27 November.

————. 2001. Mort du pilier des arts premiers. *Libération,* 10 August.

————. 2005. Le futur musée du quai Branly, les pieds dans l'eau et sur la brèche. *Libération,* 3 October.

Obbema, Fokke. 2006. "Dit Is Een Presidentieel Project, Dus Ieder Risico Is Vermeden." *De Volkskrant,* 21 June.

Oddon, Yvonne. 1967. "Note au sujet du déplacement des services scientifiques annexes du Musée de l'Homme." (Two-page typescript on International Council of Museums letterhead, dated 28-12-67.)

Oguibe, Olu. 1996. "Review of *Africa: The Art of a Continent,* edited by Tom Phillips." *African Arts* 29 (3): 12–15.

Olson, Elizabeth. 2005. "African Art Is Donated to Museum." *New York Times,* 30 September.

Ottenheimer, Ghislaine. 1996. "Chirac, fan secret des arts premiers." *L'Express,* 17 October.

Owens, Susan. 2006. "Paris Dreamtime." *Australian Financial Review,* 27 April.

Paudrat, Jean-Louis. 1984. "From Africa." In *"Primitivism" in 20th Century Art: Affinity of the Tribal and the Modern,* edited by William Rubin, vol. 1:125–75. New York: The Museum of Modern Art.

Pearman, Hugh. 2006. "Eastern Eye." *Sunday Times* (London), 23 July.

Perrault, Guillaume. 2006. "L'article sur le '*rôle positif*' de la colonisation sera '*réécrit.*'" *Le Figaro,* 5 January.

Perrois, Louis. 2000. "Les 'Arts Sauvages' au Louvre." *Arts d'Afrique Noire* 114:26–37.

Petridis, Constantine. 2001. "Arts of Africa, Asia, Oceania, and the Americas." *African Arts* 34 (3): 74–76, 95.

Peyrani, Béatrice. 1996. "Jacques Kerchache: L'ami du genre primitif." *L'Expansion,* 24 October.

Phillips, Tom. 1996. "Africa: The Art of a Continent." *African Arts* 29 (3): 24–35.

Phillips, Tom, ed. 1995. *Africa: The Art of a Continent.* London: Royal Academy of Arts.

Pinte, Jean-Louis. 2000. "Musée du Louvre: Les arts premiers en tête." *Le Figaro,* 19 April.

Plagens, Peter. 1989. "All the Way from Darkest . . ." *Newsweek,* 18 December: 76.

Pomian, Krzysztof. 2000a. "Un musée pour les arts exotiques: Entretien avec Germain Viatte." *Le Débat* 108:75–84.

————. 2000b. "L'anthropologue et le musée: Entretien avec Maurice Godelier." *Le Débat* 108:85–95.

Pradel, Jean-Louis. 2000. "Jacques Kerchache: 'L'art est tout sauf démocratique.'" *L'Événement du jeudi* 37–38 (3 August): 6–11.

Price, Sally. 1999. "Raconter l'art." In *L'art c'est l'art,* edited by Marc-Olivier Gonseth, Jacques Hainard, and Roland Kaehr, 77–92. Neuchâtel: Musée d'ethnographie.

————. 2001. *Primitive Art in Civilized Places.* 2nd ed. Chicago: University of Chicago Press. (Orig. pub. 1989.)

————. 2004. "Michel Leiris, French Anthropology, and a Side Trip to the Antilles." *French Politics, Culture & Society* 22 (1): 23–33.

Price, Sally, and Jean Jamin. 1988. "A Conversation with Michel Leiris." *Current Anthropology* 29 (1): 157–74.

Price, Sally, and Richard Price. 1980. *Afro-American Arts of the Suriname Rain Forest.* Berkeley: University of California Press.

———. 2005. *Les Arts des Marrons.* La Roque d'Anthéron: Vents d'ailleurs.

Raizon, Dominique. 2006. "Musée du quai Branly: Nostalgie du musée de l'Homme." Radio France Internationale, 17 May.

Rambert, Francis. 2000. "Jacques Kerchache: 'Pas de hiérarchie des cultures.'" *Le Figaro*, 13 April.

Reynolds, Christopher, and Johanna Neuman. 2005. "Disney's African Art Finds a Home." *Los Angeles Times*, 30 September.

Reuters. 2000a. "Arts Premiers/Un faux au Louvre, affirme un spécialiste à Tahiti," 18 April.

———. 2000b. "Polémique sur une statuette des 'Arts Premiers,'" 19 April.

Richardin, Pascale, Hélène Joubert, Vincent Mazel, Agnès Lefebvre, Thierry Borel, and Daniel Vigears. 2006. "Art et croyances de la falaise au X–XIᵉ siècle à travers des analyses de laboratoire: Entretien avec un ancêtre." *Technè* 23:74–78.

Riding, Alan. 2000. "Chirac Exalts African Art, Legal and (Maybe) Illegal." *New York Times*, 25 November.

———. 2005. "A New Life for a Has-Been, a Gehry Building." *New York Times*, 25 October.

Rijksmuseum voor Volkenkunde (Leiden, Netherlands). 2005. "Van der Laan geeft Maori-hoofd terug aan Nieuwe-Zeeland," 8 November. http://www.leiden.ethnology.museum/inhoud.aspx.

Rioufol, Ivan. 2005. "Rébellion contre le 'modèle français.'" *Le Figaro*, 11 November.

Robinson, Simon, and Aisha Labi. 2001. "Endangered African Art." *Time Europe*, 18 June.

Rochon, Lisa. 2006. "Thorns in Paris's Garden." *Globe and Mail*, 13 July.

Romero, Anne-Marie. 1998. "Ombres et Lumières sur le Musée des Arts et des Civilisations." *Le Figaro*, 30 June.

———. 2001. "Mur de silence autour du Musée de l'Homme." *Le Figaro*, 22 November.

———. 2006. "Le nouveau musée de l'Homme est en marche." *Le Figaro*, 14 February.

Rosenberg, Pierre. 2000. "Éditorial." *Louvre: Programme trimestriel avril, mai, juin 2000*, 2.

Roth, Solen. 2006. "Objets des Autres et relations (post)-coloniales à l'altérité. Master 2 Recherche, 'Dynamique des cultures et des sociétés.'" Département de Sociologie et d'Anthropologie, Université Lumière Lyon 2.

Rouse, Irving. 1992. *The Tainos: Rise and Decline of the People Who Greeted Columbus.* New Haven, CT: Yale University Press.

de Roux, Emmanuel. 1987. "La rénovation du musée de l'Homme: Un paradis en perdition?" *Le Monde*, 18 June.

———. 1990. "Les musées meurent aussi." *Le Monde*, 10 October.

———. 1992. "Trois musées endormis." *Le Monde*, 8 September.

———. 1994a. "L'art Taïno au Petit Palais: Éclats d'un paradis perdu." *Le Monde*, 25 February.

———. 1994b. "Le combat primitif de Jacques Kerchache." *Le Monde*, 17 March.

———. 1995. "Jacques Chirac veut ouvrir le Musée du Louvre aux arts primitifs." *Le Monde*, 18 November.

———. 1996a. "Pour la création d'un grand musée des arts primitifs." *Le Monde,*
8 February.

———. 1996b. "Le Trocadéro va devenir le palais des arts 'primitifs.'" *Le Monde,*
16 September.

———. 1996c. "Le président de la République lance le Musée des arts premiers"; "Les
Africains et les Amérindiens seraient-ils si différents de nous?" *Le Monde,* 9 October.

———. 1997a. "Le musée des arts et traditions populaires secoue sa poussière."
Le Monde, 3 January.

———. 1997b. "Germain Viatte s'explique sur sa mission au sein du musée des arts
premiers." *Le Monde,* 25 March.

———. 1997c. "Le musée de la Marine cherche toujours son toit." *Le Monde,* 28 June.

———. 1997d. "Grands travaux—Les chantiers se bousculent sur la colline de Chaillot."
Le Monde, 13 October.

———. 1997e. "Trois questions à Maurice Godelier"; "'Musée des arts premiers': Enjeu
culturel de la cohabitation." *Le Monde,* 28 November.

———. 1998. "Le Musée des arts et des civilisations ouvrira quai Branly en 2004";
"Chiffres et programme du projet Branly." *Le Monde,* 15 July.

———. 1999. "Le vrai démarrage d'un projet ambitieux." *Le Monde,* 10 December.

———. 2000. "Les sculptures de quatre continents font leur entrée au Louvre";
"Portrait—Jacques Kerchache, globe-trotter et tête chercheuse." *Le Monde,* 14 April.

———. 2001. "Le Musée de l'homme est en crise, sur fond de 'guerre civile.'" *Le Monde,*
13 December.

———. 2004. "La loi sur le mécénat connaît ses premiers effets, spectaculaires." *Le
Monde,* 12 July.

———. 2005. "Le Musée des arts et traditions populaires ferme ses portes." *Le Monde,*
23 June.

de Roux, Emmanuel, and Roland-Pierre Paringaux. 1999. *Razzia sur l'art: Vols, pillages,
recels à travers le monde.* Paris: Fayard.

Roy, Claude. 1965. *Arts premiers.* Paris: R. Delpire.

Ryan, Raymund. 1998. "Lakeside Spectacular: Architect Jean Nouvel's Design of a
Cultural Center in Lucerne, Switzerland." *Architectural Review,* October.

Sallois, Jacques. 2005. *Les Musées de France.* 3rd ed. Paris: Presses Universitaires de
France (Collection "Que Sais-Je?").

Santini, Sylvie. 2000. "Sculptures maya et masques zoulous vont voisiner avec la
Joconde." *Paris-Match,* no. 2656 (20 April): 95.

———. 2005. "Arts de l'Islam en majesté au Louvre." *Match du Monde,* no. 6 (January–
February): 120.

Schneider, Andrea Kupfer. 1998. *Creating the Musée d'Orsay: The Politics of Culture in
France.* University Park: Pennsylvania State University Press.

Sciolino, Elaine. 2005. "Immigrants' Dreams Mix with Fury in a Gray Place Near Paris."
New York Times, 12 December.

Scott, Joan Wallach. 2005. *Parité! Sexual Equality and the Crisis of French Universalism.*
Chicago: University of Chicago Press.

Seely, Hart. 2006. "Jack's House." *New York Times,* 31 March.

Segalen, Martine. 2005. *Vie d'un musée, 1937–2005.* Paris: Éditions Stock.

Shattuck, Roger. 2005. "In the Thick of Things." *New York Review of Books,* 26 May: 19–22.

Sieber, Roy. 1996. "Review of the exhibition 'Africa: The Art of a Continent.'" *African Arts* 29 (3): 68–72.

Silbert, Nathalie. 1999. "Jean Nouvel va construire le musée des Arts premiers à Paris." *Les Echos,* 9 December.

———. 2000. "Le musée des civilisations de l'Europe et de la Méditerranée prend ancrage à Marseille." *Les Echos,* 6 April.

Silbert, Nathalie, and Laurence Tovi. 2005. "L'Unesco adopte la convention pour la diversité culturelle." *Les Echos,* 21 October: 6.

Smith, Craig S. 2005a. "Immigrant Rioting Flares in France for Ninth Night." *New York Times,* 5 November.

———. 2005b. "Riots Spread from Paris to Other French Cities." *New York Times,* 6 November.

———. 2005c. "France Faces a Colonial Legacy: What Makes Someone French?" *New York Times,* 11 November.

Steiner, Christopher B. 2002. "Art/Anthropology/Museums: Revulsions and Revolutions." In *Exotic No More: Anthropology on the Front Lines,* edited by Jeremy MacClancy, 399–417. Chicago: University of Chicago Press.

Steinmetz, Muriel. 2003. "Razzia officielle au musée de l'Homme." *L'Humanité,* 3 March.

Stern, Jérôme. 2005. "Musée du quai Branly: Le grand chantier de l'ère Chirac." *La Tribune,* 7 April.

Taffin, Dominique. 2002. "Les avatars du musée des Arts d'Afrique et d'Océanie." In *Le Palais des colonies: Histoire du Musée des Arts d'Afrique et d'Océanie,* edited by Germain Viatte, 179–221. Paris: Réunion des Musées Nationaux.

Taffin, Dominique, ed. 2000. *Du Musée colonial au musée des cultures du monde.* Paris: Maisonneuve et Larose.

Tagliabue, John. 2005. "Louvre Gets $20 Million for New Islamic Wing." *New York Times,* 28 July.

Taylor, Anne-Christine. 2006. "Le Musée du Quai Branly: Pour une anthropologie de l'art." Lecture and debate, École Normale Supérieure, Paris, 18 January.

Le Temps. 2000. "Jacques Chirac, pilleur?" 28 November.

Thibaudat, Jean Pierre. 2005. "La France a bien eu un rôle positif outre-mer . . . selon la loi." *Libération,* 29 November.

Thomas, Nicholas. 1996. "Cold Fusion." *American Anthropologist* 98 (1): 9–25.

Tobelem, Jean-Michel. 2005. *Le Nouvel âge des musées: Les institutions culturelles au défi de la gestion.* Paris: Armand Colin.

Traoré, Aminata. 2006. "Droit de cité." Article published in *L'Humanité* (30 June), as well as *Libération* (20 July), and other publications.

Trescott, Jacqueline. 2005. "Behind the Masks, Plenty of Smiles." *Washington Post,* 30 September.

Tresilian, David. 2006. "Museum of the Oppressed." *Al-Ahram Weekly On-Line* (Cairo), 29 June–5 July.

Tripot, J. 1910. *La Guyane: Au pays de l'or, des forçats, et des peaux rouges.* Paris: Plon-Nourrit.

Tuttle, Jayne. 2006. "The House That Jacques Built." *Sydney Morning Herald,* 1 July.

Vallaeys, Béatrice. 2004. "Branle-bas pour Branly." *Libération,* 12 April.

Van Eeckhout, Laetitia. 2006. "720 familles étrangères pourraient être régularisées." *Le Monde,* 6 June.

Vavasseur, Pierre. 2000. "Première foule pour les arts premiers." *Le Parisien,* 17 April.

Viatte, Germain. 1999. "For a Museum of Arts and Civilizations." In "Out of the Ordinary: Museums of Ethnology on the Eve of the Third Millenium," edited by Gerard W. van Bussel and Alex Steinmann. *Archiv für Völkerkunde* 50:291–99.

———. 2000. "Inauguration des salles du musée des arts d'Afrique, d'Asie, d'Océanie et des Amériques au pavillon des Sessions du Louvre." *Revue du Louvre,* April: 13–28.

———. 2002. Introduction to *Le Palais des Colonies,* edited by Germain Viatte, 9–17. Paris: Réunion des Musées Nationaux.

———. 2006a. "D'ailleurs et d'aujourd'hui." In "Quai Branly: Le musée de l'autre," edited by Michel Daubert. *Télérama,* hors-série, 26–29.

———. 2006b. *Tu fais peur, tu émerveilles: Musée du quai Branly acquisitions 1998/2005.* Paris: Musée du quai Branly & Réunion des musées nationaux.

Viatte, Germain, ed. 2006. *Chefs-d'œuvre dans les collections du musée du quai Branly.* Paris: Musée du quai Branly.

Vidal-Blanchard, Jocelyne. 1996. "Le 'oui, mais . . .' d'Henry de Lumley." *Le Progrès,* 22 September.

Vincent, Catherine. 1996. "L'ambition de Buffon est plus que jamais d'actualité." Interview with Henry de Lumley. *Le Monde,* 9 October.

Vindt, Gérard. 2005. " 'Positive,' la colonisation?" *Alternatives Economiques* 238 (July–August): 84–87.

Wardwell, Allen. 1998. "Review of *Taino: Pre-Columbian Art and Culture from the Caribbean,* edited by Fatima Bercht et al." *Art Book* 5 (4): 58.

Warin, Clothilde. 2005. "Fallait-il un nouveau musée?" *Epok* 56 (June): 48–51.

Williams, Elizabeth A. 1985. "Art and Artifact at the Trocadero: Ars Americana and the Primitivist Revolution." In *Objects and Others: Essays on Museums and Material Culture* (History of Anthropology, vol. 3), edited by George W. Stocking Jr., 146–66. Madison: University of Wisconsin Press.

Zawisza, Marie. 2005. "John Mawurndjul, l'Aborigène du quai Branly." *La Vie,* 15 September.